NETSUKE FAMILIAR AND UNFAMILIAR

NETSUKE

AND

FAMILIAR UNFAMILIAR

NEW PRINCIPLES FOR COLLECTING

by Raymond Bushell

New York • WEATHERHILL • *Tokyo*

First edition, 1975
Second printing, 1989

Published by Weatherhill, Inc., New York, and Tanko-Weatherhill, Inc., Tokyo, with editorial offices at 8–3 Nibancho, Chiyoda-ku, Tokyo 102, Japan. Protected by copyright under terms of International Copyright Union; all rights reserved. Printed and first published in Japan.

Library of Congress Cataloging in Publication Data: Bushell, Raymond / Netsuke, familiar and unfamiliar. I. Netsukes–Collectors and collecting. I. Title / NK6050. B874 1976 / 736'075 / 75-22420 / ISBN 0-8348-0115-9

FOR FRANCES
MY NUMBER ONE WIFE

CONTENTS

Preface • *9*

Credits • *11*

I PRINCIPLES FOR COLLECTING • *15*

II FAMILIAR AND UNFAMILIAR NETSUKE • *87*

 1 Adopted and Adapted Netsuke, with Figs. 1–12 • *89*
 2 Amateur Carvers, with Figs. 13–26 • *92*
 3 Asiatic and Oceanic Subjects, with Figs. 27–38 • *94*
 4 Bamboo Netsuke, with Figs. 39–50 • *96*
 5 Bamboo Seals, with Figs. 51–59 • *98*
 6 Bits and Pieces, with Figs. 60–74 • *100*
 7 Buddhist Netsuke, with Figs. 75–92 • *103*
 8 Christian Netsuke, with Figs. 93–99 • *106*
 9 Colored Netsuke, with Figs. 100–108 • *107*
 10 Doll and Toy Netsuke, with Figs. 109–23 • *109*
 11 Earthy Netsuke, with Figs. 124–40 • *111*
 12 European Subjects, with Figs. 141–57 • *115*
 13 Gourd Netsuke, with Figs. 158–70 • *118*
 14 Humorous Netsuke, with Figs. 171–83 • *120*
 15 Ingenious Netsuke, with Figs. 184–203 • *123*
 16 Ittōbori Netsuke, with Figs. 204–16 • *128*
 17 Kagamibuta Netsuke, with Figs. 217–48 • *130*
 18 Lacquer Netsuke, with Figs. 249–70 • *136*
 19 Manjū Netsuke, with Figs. 271–95 • *139*
 20 Mask and Face Netsuke, with Figs. 296–321 • *144*
 21 Materials, with Figs. 322–53 • *148*
 22 Metal Netsuke, with Figs. 354–64 • *152*

23 Mingei Netsuke, with Figs. 365–72 • *154*

24 Miscellaneous Netsuke, with Figs. 373–85 • *156*

25 Mokugyo Netsuke, with Figs. 386–94 • *159*

26 Negoro Netsuke, with Figs. 395–410 • *161*

27 Okimono-Type Netsuke, with Figs. 411–15 • *164*

28 Outsizes and Miniatures, with Figs. 416–40 • *165*

29 Porcelain and Pottery Netsuke, with Figs. 441–68 • *170*

30 Rare Animals, with Figs. 469–503 • *174*

31 Rare Carvers, with Figs. 504–19 • *181*

32 Rare Subjects, with Figs. 520–62 • *184*

33 Ryūsa Netsuke, with Figs. 563–71 • *193*

34 Sashi Netsuke, with Figs. 572–88 • *195*

35 Seals, with Figs. 589–98 • *199*

36 Shishi, with Figs. 599–619 • *201*

37 Silk Seals, with Figs. 620–25 • *204*

38 Simplified and Abstract Netsuke, with Figs. 626–57 • *205*

39 Simulated Materials, with Figs. 658–65 • *210*

40 "Sōken Kishō" Types, with Figs. 666–78 • *212*

41 Stag-Antler Netsuke, with Figs. 679–93 • *214*

42 Treatment of Animals, with Figs. 694–732 • *217*

43 Treatment of Subjects, with Figs. 733–69 • *223*

44 Unusual Shapes, with Figs. 770–79 • *228*

45 Unusual Types, with Figs. 780–90 • *230*

Appendices • *233*

1 Carvers Represented • *233*

2 Netsuke with Inscriptions • *236*

3 Netsuke with Kakihan Minus Signature • *236*

4 Uncommon Materials Illustrated • *237*

5 Collections Represented • *238*

Bibliography • *241*

Glossary-Index • *243*

PREFACE

What I have written here is directed toward collecting effectively, satisfyingly, and economically. It is a series of specific suggestions, policies, and principles, with a backdrop of related observation and comment. It is tailored for the collector of netsuke. The nomenclature and examples are those with which he is familiar. The illustrations are limited to netsuke. However, if the principles enumerated are valid, they must withstand a test: they must be equally valid for any art collector, whatever may be his particular interest.

A related and equally important purpose is to expand the horizon for collecting netsuke. To put the matter quite simply, too many collectors are chasing too few netsuke—those few that over the years have been targeted as the choicest of prizes. Tending to be overlooked in the rush for the prizes is a considerable variety of types and classes that offer their own particular interest and fascination. To some degree, these overlooked classes are fertile fields for investigations and discoveries. Netsuke collecting is still in its infancy. New directions and new goals beckon the individualists among collectors.

A few explanatory notes are in order here. First, the names of netsuke carvers, of other Japanese artists associated with netsuke, and of Japanese writers about netsuke are given in the customary Japanese order: surname first, given name last. The names of all other Japanese—for example, dealers and collectors—are given in Western style: given name first, surname last. Second, Japanese long vowels are indicated by macrons in the names of netsuke carvers and other persons associated with the arts and crafts, in technical terms, in the names of books given in Japanese, and in the names of legendary and historical persons and other netsuke subjects but not in familiar or Anglicized words like "daimyo" and "shogun," place names, or the names of collectors and other present-day Japanese persons. Third, the names of legendary and historical Chinese figures who

served as subjects for the netsuke carvers, as well as those of certain Chinese literary works, are given in their Japanese versions.

Fourth, the terms "sale," "auction," "sales gallery," "public sale," and "public auction," as used here, refer to public sales by auction bidding, such as those held regularly at Sotheby's and Christie's in London. Private sales between dealer and customer are excluded. Figures quoted are taken from netsuke sales in London, since it is the central marketplace for Japanese art. Prices given are in dollars and sterling based on the exchange rate prevailing at the time of the sales and are approximate.

Fifth, in the captions the names of certain carvers are followed by the parenthetical notation NH (for *Netsuke Handbook*) together with a number, indicating that these carvers are listed in the index of carvers at the back of *The Netsuke Handbook of Ueda Reikichi*. The number is that of the biography in this index and not a page number. Again, in the captions, the designation "Ex ———— Collection" indicates netsuke that have been dispersed.

Finally, camera enthusiasts may be interested to know that I photographed the netsuke shown in this book with a Mamiya RB67 (6 by 7 centimeters), using high-speed Ektachrome film.

CREDITS

THE JAPANESE racial wisdom maintains that were a man to live for ten thousand years, he could not repay one ten-thousandth of his obligation to his forebears. It is a humbling thought and quite an appropriate one to reflect my feeling of indebtedness to those who contributed to the formation of this book.

Those whose thoughts I used are recorded in the Bibliography. Those whose netsuke I used as illustrations are listed in Appendix 5. Japanese collectors are named in the book but not located, since they wished, without exception, to protect their privacy. Furthermore, the list excludes collectors who requested absolute anonymity. Many collectors offered to make their fine collections available, but my rather radical requirements did not always mesh with the superb quality of these collections. Among such collectors are, alphabetically, Virginia Atchley, Arthur Bakalar, Larry Caplan, Jacques Carré, Burnie Craig, Donald Creasy, Harry and Alice Creech, Admiral Benton Decker, Bertram Denton, Kenneth and Lleslie Detwiler, Leo Ephrussi, Irving Gould, Charles Greenfield, Amedeo Guffanti, Mark Harding, Misha and Rebecca Hauter, Eugene Jaffe, Harold Jonas, Arlette Katchen, Donald Korzypski, Bert Krouner, Joseph Kurstin, George Lazernick, Martin Lewis, Marcel Lorber, John Mang, Donald Mendelsohn, Ann Meselson, George Myers, Martin Newstead, Daniel Rouvière, Mark Severin, Andrew Somlyo, Igor and Iris Tonkonogy, Hubert Weiser, and many others.

Cornelius Roosevelt and Charles Mitchell read the manuscript and made wise and useful suggestions. F. J. Sear, Mark Severin, Jacques Carré, Neil Davey, and William Tilley furnished considerable data about early collectors and collections, sales, and prices. Kenshiro Ishii, Kenzo Imai, and Susa Omi solved many difficult meanings, symbols, and inscriptions. Their rare knowledge of Edo and Meiji customs and practices deserves preservation almost as much as do the crafts that incorporate these customs and practices. Kazuo Itoh and Yasushi Ouchi deciphered many

difficult signatures. Tokuo Inami and John Harding, sword and *tsuba* experts, cast much light on *kagamibuta* and metal netsuke. Peter K. Shimojo was most helpful with porcelain and pottery netsuke that lie within his sphere of expertise. Hideko Wakayama gave generously of her knowledge of dolls and dollmaking. Walter Lutz, a specialist in bamboo crafts, proved a reliable informant about bamboo species and characteristics. Masatoshi, some of whose netsuke are shown here, was a rich source of information about techniques and materials and about the people and practices of the Edo period. Don Brown furnished many rare items and references from his extensive library of Japanalia. Misagi Ashida, Satoko Nakajima, and Atsuko Takahashi cheerfully complied with inordinate demands on their secretarial services. Miriam Yamaguchi is the factotum of the publisher's dedicated staff. She is composed of lubricating oil, flywheel, spark plug, and smiling sunshine. Without her, the machinery that transforms a hodgepodge manuscript into a clean book would not function quite so smoothly. Ralph Friedrich, senior editor of Weatherhill, made wise editorial suggestions, each one of which was a measurable improvement.

Besides the few I have remembered, there are hundreds whose names are long forgotten along with the occasions when they imparted facts, insights, and revelations that I have assimilated over the years and here and now put forth as my very own.

Credits customarily end with the author's touching submission that while praise may be heaped on others, the blame for errors is his alone. Of course I *am* responsible for errors, and I hope they will be pointed out relentlessly. But there is a but. However much the experts may perforate my claim to correctness, I will refuse to act like a craven fraud, to bow my head in penance, or even to look overly shamefaced. The group of netsuke I have assembled here touch many areas in which I am more interloper than protagonist. I do not pretend to match the knowledge of the specialists at each of their specialties: history and folklore, porcelain and pottery, metalwork and lacquer, Noh and Kabuki, materials and techniques, crafts and calligraphy. To state the matter simply, I welcome corrections while I crave compassion.

Once again I offer to correspond on any aspect of netsuke. Behind my apparent altruism there lurks the hope that someday, somewhere, an unknown correspondent will be my open sesame to a great collection, lost

for generations in a romantic mansion or a harbor warehouse. Letters may be addressed to me at the Sumitomo Building, Suite 832, 1-4-4 Marunouchi, Chiyoda-ku, Tokyo 100, Japan.

PRINCIPLES FOR COLLECTING

COLLECTORS' COMPLAINTS What prompted this book is a mounting chorus of protest against the increasing costs of netsuke. The chorus, like frogs on a well bucket, sings a fugue with mixed voices of annoyance, irritation, regret, anguish, frustration, and bitterness, expressed in such phrases excerpted from conversations and correspondence as:

"I can't afford to collect any more."

"Netsuke are dreadfully overpriced."

"I've been priced out of the market."

"The joy's gone out of it."

"I wish I'd begun collecting five years ago, when prices were reasonable."

"Collecting is for the rich."

"Prices are completely unrealistic."

"It's an investor's market now, not a collector's."

The popular palliative that prices for fine things have always been high, while true enough, is watery balm for the collector whose extended limit for a coveted netsuke is doubled, tripled, and quadrupled all around him. It offers no solution to the problem of the average collector when price exceeds purse.

My purpose is to probe the problem of the increasing cost of collecting netsuke, to seek explanations, and to search for solutions. The problem of how to collect despite prohibitive costs may seem insoluble *without more money,* but solutions of differing degrees of satisfaction do exist. There are ways to participate in the joys of collecting at bargain prices. There may be a price to pay, but it is reduced, and a part of the price payable is not measured in currency. In the words of the bond brokers, there is a system for "beating the market."

The voices of the protesters are projected against three main targets: investors, rich collectors, and runaway prices. To begin, we should sift these protests one by one for substance.

THE INVESTORS The typical investor is identified by his lavish purchases at the sales galleries. He accumulates until the time when he has a sufficient number of netsuke for his own sale, which is often arranged at the same gallery where he made many of his purchases. The sale is anonymous and is usually described as "A Very Fine Collection: The Property of a Gentleman." To be less conspicuous, the investor may divide his netsuke into small groups and slip them into a series of sales described as "The Property of Various Owners." A recent comparison of an investor's buying and selling prices in the case of identifiable netsuke indicated a tripling or quadrupling of his investment in a period of three to five years. The investor is blamed for elevating netsuke prices brutally and for squeezing out the average collector ruthlessly. He is accused of prostituting collecting in the sordid interest of profit. Is the investor culprit or is he scapegoat?

It is self-mollifying to think of the investor as mercenary, since his motive is to profit, and to think of the collector as commendable, since his motive is to build a collection. In black-and-white contrast the investor is pictured as a greedy professional, the collector as a pure amateur. There may be comfort in the distinction. But the case against the investor is not proved by making distinctions.

The investor is akin to the dealer. The motive of both is profit. Rationally, there is no more justification for finding fault with the investor because he buys for capital appreciation than there is for finding fault with the dealer because he buys for profit. In effect the investor is a shopless dealer who freezes his stock for a few years before disposing of it. Like the dealer, the investor risks his capital. He buys for resale. He is bound to a superior level of artistic judgment and to an astute appraisal of trends and tastes for his financial success. He must buy the "right" netsuke. Unless he understands desirability and quality, his resale is unlikely to yield the necessary amount of profit—a profit that must be sufficient to exceed his original cost, plus the gallery's commissions and the freezing of his cash for a period of years.

THE INVESTOR'S RISK These requirements do not burden the collector. The collector spends his money, but he does not risk it. As long as he loves his acquisition, he has a good return for his investment. He

need not worry whether his purchase will increase in value. His mistake—if it is one—will not hurt unless he recognizes it as a mistake. He may in fact make many mistakes, objectively or critically speaking, but be quite happy with them. The investor drowses in no such euphoria. Loss of investment is the implacable penalty for his mistakes. The collector may or may not be knowledgeable; the investor must be.

It is for this reason that most investors were originally collectors. They evolved into investors through a variety of experiences. Some sold a first collection out of necessity, the sale proving so profitable that they decided to make second and third collections for investment. Some simply developed a liking for the game. Some collect and deal concurrently and appear to enjoy the one as much as the other. Some use the profit on what they sell to reduce the cost of what they buy.

Not all investors in netsuke are successful. It is not called the art *market* without reason, and it is no less a market than the stock market or the commodities market. Like these, it is risky. Many investors who were ill advised or ill prepared were severely burned. Others who purchased first and learned second are nursing their disasters in silence, waiting hopefully for inflation to get them even. The voracious investor totally ignorant about netsuke but blindly inspired by sales statistics to a frenzy of wholesale purchasing is as fictitious as the legendary *kirin*.

INVESTOR'S EFFECT NEGLIGIBLE Investors are a very tiny number when compared with dealers. Not only is the group a small one, but also the investor buys for himself alone. His is a solitary voice. By comparison, the dealer buys to keep his stock fresh and sufficient, to satisfy special requests, and to execute the commissions of clients. The dealer speaks for a numerous company, even including incipient collectors: the passersby aroused by the netsuke display in his shop windows. It follows that the investor's effect in raising prices is quite minor. Dealers as a group are reported to buy as much as 80% of the total values of some auctions. Relatively speaking, the investor is a negligible factor in the explosion of netsuke prices. He accounts for no more than a puny part of the total activity of the netsuke world. The charge against him is an exaggeration. He is a scapegoat, and the blame for rising prices must be sought elsewhere.

THE DIFFICULTY OF AESTHETIC CHOICE In writing law a judge is limited to what is necessary to decide the case. Anything beyond what is necessary is termed obiter dicta and is not binding. The saying is that judges decide cases; they do not write law. Nevertheless, a judge is occasionally carried away with the force of his reasoning and applies it to collateral matters not at issue. I hope I will be forgiven for inserting here a few obiter dicta of my own. Like the judge's, it may be good law or it may be bad law, but since it is not binding, it will injure no one.

The dealer (including the investor) is in search of profit on netsuke; the collector, in search of netsuke for their own sake. This is basically true. It does not follow, however, that the collector is unaffected by commercial considerations or that he is unresponsive to the valuations of the marketplace or that his desires for acquisitions are uncontaminated by extraneous influences. The fact is that it is extremely difficult, if not impossible, to practice a selectivity motivated solely by pure love of beauty. The soul-searching honesty of immaculate aesthetics is beyond most of us. My point may become clear when we attempt to distinguish between the intrinsic and extrinsic qualities of a netsuke.

INTRINSIC QUALITIES AND EXTRINSIC INFLUENCES What is intrinsic or inherent in a netsuke is the technique of the craftsman, including his material, combined with his creativeness as an artist. Under strict interpretation of the intrinsic concept of beauty, this quality invests the object once for all when it leaves its creator's hands. After that, everything else that befalls it is extrinsic and subject to the dictates of the marketplace. Under this rigid definition age and patina are not part of intrinsic quality, since they were not wrought by the artist but by time and handling. Even the signature may be considered extrinsic, since it is an identification only and is not part of the design nor of the creation of the essential object. Admittedly, so strict an interpretation of intrinsic quality is hard to swallow. A contrary case may be easily made out for the signature as an artistic embellishment, for age as a result of the period when the artist worked, and for patina as a partial result, at least, of his process of polishing and staining. But even though we accept signature, age, and patina as intrinsic qualities of the object itself, we have still to contend with a formidable array of extrinsic influences. Among these are the status

of the carver; his popular appeal; whether he or his style is in disfavor or riding a vogue; the region in which he worked; its standing; the collectors who owned the piece previously; its use as illustration; the opinions of dealers, critics, and connoisseurs; whether similar pieces have appeared on the market recently and the prices they fetched; the condition of the netsuke; whether the subject is enjoying a trend; and a host of others. One or another of these extraneous considerations may not influence some collectors as much as others, but they do affect all of us to some extent. In any case they certainly influence the valuations that the market places on the netsuke and consequently the prices we must pay for acquiring them.

A TEST OF FIDELITY TO INTRINSIC QUALITY Some collectors may maintain that they are impervious to all extraneous considerations. For them I would propose a few questions as a test. If Kaigyokusai had carved his netsuke in bamboo, would you be so eager to own them? If Kaigyokusai had not signed his name, would you pay as much for one of his animals? Can you separate the netsuke in hornbill from the value of the material? Would your valuation be the same if the netsuke had not been pedigreed in prominent collections or illustrated in important books? Would you desire the piece as badly if the carver's identical model had not brought so high a price? There are many collectors whose first question is "Who signed it?" for an indication of value rather than "How good is it?" for an indication of quality. Even the gods Ebisu and Daikoku work their abacuses to tally the market.

MATERIAL AS INTRINSIC QUALITY Material is an aspect of intrinsic quality. The rarity or purity of the material probably affected the carver at least as much as it does the collector. We can imagine beautiful material inspiring a carver to his supreme effort. We can imagine the satisfaction of the artist with a material so totally appropriate to his design that the one is married to the other. Material must complement subject and treatment; otherwise the work may fail before it begins. In another aspect the difficulty of working certain materials, their proneness to split or chip, their insensitivity to detail, their intransigence, and their peculiarities demand a greater technical proficiency. They require of the craftsman an

inordinate expenditure of time, patience, and effort. We are inclined to admire and value his product in some proportion to the difficulties he surmounted in coping with his material.

DISTINCTIONS BASED ON APPRECIATION When a distinction between collectors and dealers is based on their appreciation of netsuke, it is subject to considerable skeptical erosion. There are collectors who know the price of everything and the value of nothing. There are collectors who will not make a purchase unless convinced it is a bargain. There are collectors who practically demand an assurance from the dealer of a prospective increase in value. There are collectors whose proudest boast is for the netsuke they acquired through their bargaining and cunning or through the dealer's ignorance. No criticism is directed at collectors who carefully husband their meager allocations in seeking good value for what they spend. The criticism is for those collectors whose primary concern is with price and who search for bargains to an extent that distorts or warps their standards, with the result that quality is relegated to secondary status behind the bargain.

On the other hand, there are dealers who cherish each and every netsuke that passes through their hands, whether arriving as a purchase or departing as a sale. There are dealers who will deliberately overpay for netsuke they love, knowing how doubtful it is that they will be able to dispose of them profitably. There are dealers who handle and study their netsuke with as much tenderness and appreciation as collectors bestow on their favorites. Surely Frederick Meinertzhagen and W. W. Winkworth, among other dealers, have contributed as much as any collectors to our knowledge of netsuke.

Like many aficionados with memories to relate, I have on occasion been the beneficiary of undeserved bounty from collectors and dealers alike. Leaping promptly to mind are collectors Hindson (Fig. 742) and Levett (Fig. 521) and dealers Meinertzhagen (Fig. 495) and Imai (Fig. 603). Their underpriced generosities would have been unthinkable from either price-minded collectors or profit-minded dealers.

DEALERS AND COLLECTORS In Europe and America, dealers, on grounds of both principle and policy, do not generally collect the cate-

gories of art in which they deal. It is unfair, if not immoral, for the dealer to compete against his clients and patrons. It is also poor policy. Clients soon desert the dealer who retains his better acquisitions for his private collection. Apparently this principle or policy is not compelling among Japanese dealers. Quite a few have netsuke collections, some well publicized, others secret. What astonishes the Westerner about the Japanese dealer-collector is that an offer of the absolute price of temptation, the proverbial king's ransom, will not induce him to part with a netsuke that is a unit of his collection. Should he finally agree to sell a piece, it will be for some reason other than the price. Some of these dealer-collectors have taken their fine collections into retirement with them as a source of solace and pleasure in their old age.

If one importunes and finally prevails upon a Japanese dealer-collector to part with a treasured piece, he must be prepared to pay whatever price is asked. To protest the price would cause a serious loss of face and probably terminate all transactions. However, a behavioristic pattern operates as a safeguard to maintain a reasonable balance. Since the buyer is at the dealer's mercy, the dealer must exercise the noble restraint of the samurai. The price is usually fixed at a point slightly below exorbitant. Never mind! The finest pieces most of us own are those we paid too much for but had to have.

COLLECTORS AS DEALERS The evanescence that sometimes characterizes the demarcation between dealer and collector is expressed in an observation containing a modicum of truth: the collector often spends the first half of his life in finding acquisitions and the second half in disposing of them. The same thought is tersely expressed as "every collector a dealer." The insinuation is usually voiced by dealers with a tinge of chagrin. Sometimes a dealer feels victimized when an old client forces an undesirable exchange on him, and at other times he is annoyed to find a favored customer—usually the one he "taught everything he knows"— competing against him at the auctions. Tastes change; the beginner's "finds" are the mature collector's eliminations. Yesteryear's prize may be this year's cull. Almost every collection benefits from an occasional heart-twisting reappraisal. The removal of duplications, inferiors, and suspects elevates the quality of the remainder. To the extent that he ex-

changes, sells, or swaps, the collector is in some small sense a dealer.

Probably the purest of collectors nurtures the hope that his acquisitions will appreciate in value, if not for profit then for vanity, for confirmation of his artistic judgments. Like the player in a friendly game of cards, he may not care about the penny stakes, but his will to win is strong, if only to demonstrate his cleverness and superiority. He may not be concerned about the cost of his netsuke, but he relishes the recognition of his artistic acumen, a recognition that is best rendered by a steep rise in price.

RICH COLLECTORS The second target of the protesters is the rich collector who allegedly "monopolizes the choice netsuke" like Benkei seizing 999 swords at Gojo Bridge. The rich collector is not individually identified. It may be realistic to suggest that the supremely rich are more likely to collect French impressionists, Chinese porcelain, or period furniture than netsuke. Netsuke are not currently recognized as important collectibles in the wealthiest circles. Certainly the rich are not concentrated in collecting netsuke. The collector may be characterized—I started to say stigmatized—as rich merely because he is the one who wins too many bids. But let us concede for the sake of discussion the reality of the rich collector for whom money is no concern, cost no consideration, and price no obstacle. Does this Croesus diminish the opportunities for acquisitions to such an extent that the average collector is precluded from collecting? As with the protest against the investor, the blast against the moneyed collector should be sifted for substance.

A bottomless purse of itself does not assure a superb collection unless accompanied by knowledge and connoisseurship—no more than the richest matron will be beautifully gowned, unless, like a *tennin* elegantly draped in undulating scarves, she possesses good taste and a sense of style. Admittedly, the moneyed collector who is also a connoisseur is a formidable opponent at any sale. Fortunately for the rest of us, however, the moneyed connoisseur cannot and does not buy all the best netsuke in all the cities of the world. He cannot be physically present at all the shops and sales. He does not prevent others from finding fine netsuke in places and channels outside his circuit. He is not inevitably and inexorably contesting our choices. Even when confrontation is direct, our wealthy competitor may ignore or pass up many superb pieces. Differences in taste

and connoisseurship often operate to the advantage of the poorer collector. Furthermore, his devotion of more time to the search for prizes may compensate for his more modest means. Diligence and perseverance sometimes flush the quarry that eludes the big gun. The incontrovertible proof of this statement is the large number of fine collections that are owned by individuals of ordinary means and limited budgets.

EXORBITANT PRICES Runaway prices are the third complaint with which we must deal. It is platitudinous to note that whether a price is cheap or dear is relative. There is no fixed point for high or for low. A price that is "high" because it approaches the top of the market is not thereby exorbitant, extortionate, or runaway. It may be high yet cheap for the rarity and uniqueness of the one piece. It may be low yet extravagant in view of the crudeness or mediocrity of another.

A brief survey of netsuke values during the century and seven years since the introduction of netsuke to the West in 1868 may help to set our gauges and establish our guidelines. Perhaps we can find an answer to the burning question of whether netsuke are overpriced.

OBSERVATIONS OF PIONEER COLLECTORS Before examining specific prices we may find enlightenment in a few comments and observations of our pioneer authorities about costs. Some of their information imparted indirectly or inferentially is as significant as figures on a price tag. These early comments are interesting and even fascinating, especially when we keep in mind the years when they were made.

In 1888, Seymour Trower, one of the first great netsuke collectors, wrote as follows in his "Netsukés and Okimonos" in *Artistic Japan*: "And the netsuké has, at present, the advantage of relatively small cost; we cannot all possess Henri II or Limoges enamel, but any one with the means to collect at all, can by the expenditure of a little time and judgement get together carvings such as no country but Japan has ever produced."

A few paragraphs later he writes: "Collectors are few to-day, and regarded by the orthodox curio buyer and curio dealer as little better than amateurs of outlandish toys; but their numbers are likely to increase, as the quarry grows scarcer and more expensive."

In 1889 Marcus Huish, in his book *Japan and Its Art,* disparaged both the British Museum and the Victoria and Albert for their neglect of netsuke ("neither Museum, so far as I know, possesses a single netsuke") and their purchases of crude, commercial carvings to represent Japanese sculpture. "Modern ivory-work," he wrote, "which can be reproduced at will is represented by some garish screens at South Kensington [Victoria and Albert Museum], and much of the carved tusk work which is to be found in every shop. A screen which has little Art merit, figures in the accounts for last year as having been purchased for £150! a sum which would have acquired a quite *representative collection of netsukes.*" (Italics supplied.)

In 1889 the sum of £150 was the equivalent of about $750. Imagine a representative collection suitable for a great museum at such a price—like Kakkyo finding a pot of gold.

In 1894 Edward Gilbertson, another of the first-generation collectors, wrote as follows in his article "Japanese Netsukes" in the *Studio* (London): "Good specimens of the work of the eminent men of the eighteenth and nineteenth centuries are becoming more and more rare, and we have chiefly to rely on the dispersion of the older collections from time to time. They have consequently become much more costly, the higher class of wooden netsukes especially. The day has gone by when we saw them at Christie's strung together like onions, seven or eight in a lot, and sold for a third of the price we should now have to give for a single one."

As the reader will note below, Mr. Gilbertson's collection was sold twenty-three years later, in 1917. The highest price paid for one of his netsuke was £10.50 ($50).

In 1904, in his *Queer Things About Japan,* Douglas Sladen, an author of travel books, wrote: "All netsuke which are old and attractive are worth buying if you can get them at a moderate price. From 2½d. [5¢] to 5d. [10¢] was, in my day, a moderate price in Japan, and, unless the netsuke is quite worn out with friction, anything up to half a crown [62¢] is dirt cheap in England. Some of the netsuke I bought for a few coppers in Japan are worth a good many pounds. . . . I bought netsuke in Japan when they seemed good bargains at Japanese prices, and when I see netsuke in England which look good bargains at English prices I buy them. . . ."

Apparently Mr. Sladen was a confirmed bargain hunter. The group of

sixteen that illustrate his account are genuine but of moderate quality.

Mr. Sladen notes: "There are also many genuine specimens to be picked up in London itself, since most people who go to Japan bring some home and *lose them*." (Italics supplied.)

Mr. Sladen's language is as "quaint" as the netsuke he describes. However, Seymour Trower wrote in much the same vein when he said, in "Netsukés and Okimonos": "Ladies, not always tolerant of curios, spread them about on cabinets and mantelpieces. This, of course, is a pity, for although the netsuké is a tough object, it may easily get swept away by a careless visitor or more careless housemaid, and I have known some real art-treasures thus to disappear forever."

The Reverend L. B. Cholmondeley was the chaplain to the British Embassy in Tokyo. In 1923, in his article "More Information About Japanese Netsuke" in the *Connoisseur* (London), he wrote: "And let me say for the satisfaction of collectors, or would-be collectors, that I believe in London, and elsewhere in England, as good netsuke, and as cheap, can be picked up today as they can be in Japan, where they are becoming very scarce and where absurd prices are often asked for them."

That great connoisseur Frederick Meinertzhagen had already collected netsuke for sixty years when, in 1956, he wrote *The Art of the Netsuke Carver*. He observes that for the first twenty years following the Meiji Restoration (1868) thousands of netsuke were shipped to Europe and America and that the history of netsuke from that time on was largely the history of their distribution among foreign collectors.

He notes that the finest "first-generation collections" of netsuke were sold at auction in the first quarter of this century. "It was a time," he writes, "when netsuke were not only *plentiful but cheap*." (Italics supplied.) While Meinertzhagen says nothing about specific prices, he does tell us that during this period good netsuke were customarily sold in department stores, antique shops, junk shops, and *toy shops*.

The eminent expert W. W. Winkworth reviewed the status of netsuke collecting in 1949. In "The T. S. Davy Collection of Netsuké" in the *Antique Collector*, he wrote that there were too few collectors to form a society or to publish a journal, that it was at most a minor sideline for a handful of dealers, that the field remained static, that new collectors developed very slowly, that collecting was confined to a small circle, and

that private collections remained far too big for comfort. Mr. Winkworth's final paragraphs are worth verbatim quotation: "At present netsuké are under-capitalised. There is no reason why a rare netsuké, like a rare stamp, should not be worth several hundred pounds, but only one celebrated piece has ever fetched more than about £50 [$140], the famous 'wrestler-group' illustrated in 1914 in the Behrens Collection catalogue, which was sold for £225 [$1,094]. Today a first-rate netsuké seldom goes above £35 [$129]; excellent specimens can be had for as many shillings, and even rare and sought-for examples often do not go much above £10 [$37].

"Prices have remained very little higher than they were in prewar days, and the Streatfield sale prices, of over twenty years ago, would seem, today, about the average, or even above it."

In 1951 another famous expert, Mark Hindson, discussed the status of netsuke in his article "Netsuké Artists" in the *Antique Collector*. Here he counsels discretion because prices are increasing and notes that at a recent auction a crane group fetched £32 ($90)—the same piece that had sold for as many shillings (32 shillings then equaled $8) in the Behrens sale of 1914.

Mr. Hindson writes: "It is one of the joys of netsuké collecting that pieces can be found done even by humble peasants for their daily use which are yet true creations." And a few sentences later: "These unsigned pieces can happily still be obtained for less than £1 [$2.80] in shops of small dealers. . . ."

Mr. Winkworth furnished an article on netsuke in 1966 for *Antiques International* (London). Here he writes: "During the last three years I have been forming a collection for a relation of mine, Mr. Harry Wight. I have often been able to get interesting things for less than £20 [$56]; and a masterpiece can often be found for under £50 [$140]." In view of Mr. Winkworth's eye for the exceptional, it is safe to venture the opinion that Mr. Wight's collection is first class.

So much for observations and comments, but what were the general price movements following the introduction of netsuke to the West as a virgin article? What will one hundred years of buying and selling reveal about current values? Clearly a few records and statistics are necessary for the drawing of conclusions.

LONDON SALES London sales have been selected for discussion and comparison because London maintains its position perennially as the central marketplace for the miniature Japanese arts. Using the same marketplace tends to assure a certain continuity of values and prices. Until the early 1960s Glendining was the principal auction gallery for important netsuke sales. All the sales quoted were held there until about 1964, when Sotheby and Christie's took over. In these early sales, netsuke were usually sold in lots of one to four or five pieces. Perhaps less than one-third were individually lotted.

Only important collections have been utilized in order to insure that quality is high and mediocrities are eliminated. A constant level of the qualities compared for price changes tends to be assured by the fairly substantial number of netsuke that passed from important early collections to important later collections. The necessity of safeguarding against the error of comparing disparate qualities is clear from the following excerpts:

Seymour Trower, the owner of the first collection for sale that we will discuss, wrote in "Netsukés and Okimonos": "The first netsukés imported into Europe were choice and correspondingly costly, but no sooner was a market created than we were inundated with specimens of very inferior quality, including much utterly worthless rubbish."

This English comment is echoed from the opposite side of the world in Japan. I quote from Naoteru Uyeno's *Japanese Arts and Crafts in the Meiji Era*: "While the other native forms of sculpture declined greatly in the early Meiji Period [1868–1912], ivory sculpture alone found great popularity; and this was entirely due to the interest of foreigners. At the beginning, it was the small netsuke carvings which interested foreigners with their intricate, clever carving of curious native customs. This interest soon spread beyond the circle of foreigners in Japan, and developed into a lively export trade."

It is a slight digression but an amusing one to note here that in addition to their complaint about "utterly worthless rubbish" the early commentators complained about rising prices. From our vantage point of fifty or a hundred years, 5 shillings ($1.25) seems of much the same order of magnitude as £1 ($5), since either price is absurdly cheap for a good netsuke, but to the contemporary collector the percentage increase was

shocking. Whether "plentiful and cheap" in the first ninety years of netsuke collecting or "scarce and expensive" in the last fifteen years, the rubbish and price laments bridge the years, retaining their perennial status as irritating constants in the cost equations.

The following comments and recapitulations begin with the Trower Collection in 1913. Some price lists are unfortunately unavailable, but the evidence is nevertheless uncontradicted that until the Fletcher sale of 1960 netsuke suffered the doldrums. The price line was practically horizontal.

TROWER COLLECTION SALE In his introduction to the impressive catalogue of the Trower Collection, Henri Joly, of *Legend* fame, wrote that Mr. Trower "began to gather netsuké as far back as October 1876, and his last purchases date from June 1910."

Name of collector: Seymour Trower
Date of sale: March 31 to April 7, 1913
Number of netsuke: 1,879
Number of lots: 864
Average netsuke per lot: 2.2
Total price: £2,158 ($10,488)
Average price per netsuke: £1.15 ($5.58)
Number of lots reaching £10 ($49) or more: 10
Highest price for a single netsuke or lot: £20 ($97)

The highest price realized—that of £20 ($97)— was paid for an ivory skull signed Asahi Gyokuzan. The second highest price was £13.50 ($66). The Ichiyūsai *manjū* illustrated in *Collectors' Netsuke,* Fig. 241, fetched exactly £2 ($10) and included two other *manjū* in the lot. The Sanshō laborer illustrated in *Collectors' Netsuke,* Fig. 246, sold for £6 ($29) in a lot of two. The exchange rate in 1913 was £1 to $4.86.

BEHRENS COLLECTION SALE The largest of the first-generation collections was the Behrens Collection, immortalized in a massive catalogue edited by Henri Joly. The catalogue describes 5,639 netsuke, with 970 illustrated. In his preface Mr. Joly writes as follows: "In fact Mr. Behrens might be said to have made a corner in uncommon specimens of netsuke

and inro; he developed a fondness for the strange, quaint, out-of-the-way pieces which led him to pay the highest prices on record at the Gillot and Bing sales amongst others, and of many specimens here illustrated we may safely say that no duplicates can be found."

The sales catalogue, which furnishes the basis for the recapitulation below, does not correspond by lot numbers to the Joly catalogue of the Behrens Collection. The enormous size of the Behrens Collection—the Joly catalogue lists 5,639 netsuke alone and includes *inrō, tsuba,* and miscellanea—necessitated some precaution against swamping the market. The collection was divided into three portions that were sold in successive years. Each portion is recapitulated separately.

Name of collector: W. L. Behrens

Date of sale: first portion, December 1–8, 1913

Number of netsuke: 2,253

Number of lots: 912

Average netsuke per lot: 2.5

Total price for all netsuke: £2,901 ($14,099)

Average price per netsuke: £1.28 ($6.25)

Number of lots reaching £10 ($49): 23

Highest price: £225 ($1,094) for the famous "wrestler group" (see pages 37–39), illustrated in the Behrens Collection catalogue, Plate XXI, No. 465

Second highest price: £35 ($170) for an ivory *manjū* of the Forty-seven Rōnin, signed Kyōmin and illustrated in Plate XXI, No. 1120

Third highest price: £31 ($151) for a monkey troop on a pine tree, signed Hidemasa and illustrated in Plate XXIX, No. 1614

The dramatic scene of Moritō holding the severed head of his beloved (*Collectors' Netsuke,* Fig. 304; Behrens Collection catalogue, Plate VIII, No. 379) brought £6.25 ($30). The *rakan* holding a huge rosary (present book, Fig. 84; Behrens Collection catalogue, Plate IX, No. 414) brought £2.10 ($10).

Name of collector: W. L. Behrens

Date of sale: second portion, May 18–23, 1914

Number of netsuke: 1,989
Number of lots: 619
Average netsuke per lot: 3.2
Total price for all netsuke: £1,552 ($7,543)
Average price per netsuke: £.78 ($3.80)
Number of lots reaching £10 ($49): 4
Highest price: £29 ($141) for a large unsigned ivory rabbit
Second highest price: £24 ($117) for a wrestler group in wood, signed Itsumin and illustrated in Plate XLIV, No. 3686
Third highest price: £13 ($63) for an unsigned laughing foreigner in ivory, illustrated in Plate XL, No. 3301

Name of collector: W. L. Behrens
Date of sale: third portion, November 1–6, 1915
Number of netsuke: 1,234
Number of lots: 336
Average netsuke per lot: 3.7
Total price for all netsuke: £1,282 ($6,230)
Average price per netsuke: £1.04 ($5)
Number of lots reaching £10 ($49) or more: 7
Highest price: £16 ($78) for a large ivory Chōkarō, illustrated in Plate LVIII, No. 4555
Second highest price: £13 ($63) for a lot of five
Third highest price: £12 ($58) for a "hollowed out" ivory ball (*ryūsa?*) of the animals of the zodiac, signed Kaigyokusai Masatsugu

GILBERTSON COLLECTION SALE Edward Gilbertson's writing on netsuke has been quoted earlier among the observations of pioneer netsuke collectors. In 1917, when his collection was sold, the exchange rate was £1 to $4.76.

Name of collector: Edward Gilbertson
Date of sale: third portion, July 23–26, 1917
Number of netsuke: 427
Number of lots: 144
Average netsuke per lot: 2.9

Total price: £498 ($2,370)
Average price per netsuke: £1.17 ($5.56)
Highest price: £10.50 ($50)

The record price for the sale, £10.50 ($50), was paid for a *yamabushi tengu* described as "fine minute work." It was the only netsuke in the sale to reach £10. A report of the sale in the *Times* (London) noted with apparent astonishment that "the wood netsukés included one which brought 10 guineas [£10.50]." The Masanao figure group illustrated in *Collectors' Netsuke,* Fig. 120, fetched exactly £2 ($10).

SALES OF OTHER COLLECTIONS The sales records of a number of other collections are given here in chronological order, covering the period from 1918 to 1960. Details missing from some recapitulations do not result from oversight but from unavailability despite diligent efforts to discover them.

Name of collector: Henry T. Reiss
Date of sale: February 25–26, 1918
Number of netsuke: 1,913
Number of lots: 577
Average netsuke per lot: 3.3

W. W. Winkworth made me a present of a marked copy of the Reiss catalogue. The notations in the margins indicate old and new owners of many pieces, including those the marker himself once owned. Unfortunately, he did not note prices. One of his notations reads: "F. M. [Meinertzhagen] attended this sale and many of them are recorded in his card index."

Name of collector: Michael Tomkinson
Dates of sale: first portion, December 5–9, 1921; second portion, April 24–28, 1922; third portion, June 26–29, 1922
Number of netsuke: 1,609
Number of lots: 591
Average netsuke per lot: 2.7
Total price: £2,347 ($11,172)
Average price per netsuke: £1.46 ($7)

Number of lots reaching £10 ($48) or more: 15
Highest price: £12.60 ($60)
Second highest price: £12 ($57)

Name of collector: Col. J. Bellhouse Gaskell
Dates of sale: March 11, 1926; June 15, 1926
Number of netsuke: 1,164
Number of lots: 695
Average netsuke per lot: 1.7

Name of collector: P. Adam
Date of sale: March 31, 1936
Number of netsuke: 232
Number of lots: 119
Average netsuke per lot: 1.9

A catalogue, apparently marked by a person who attended the Adam sale, indicates that he bought twelve lots, paying only £2 ($10) for the most expensive one. Among his purchases were a Minkō tiger, a Tomokazu monkey, and a Mitsuhiro "group of fruit on a twig," probably loquats. Another of his acquisitions, an Ikkōsai *takarabune,* was one of only eleven netsuke illustrated in the catalogue.

Name of collector: A. E. Tebbutt
Date of sale: December 16, 1943
Number of netsuke: 562
Number of lots: 183
Average netsuke per lot: 3

Name of collector: Dr. H. A. Gunther
Date of sale: June 12, 1944
Number of netsuke: 430
Number of lots: 153
Average netsuke per lot: 2.8
Total price: £1,229 ($4,953)
Average price per netsuke: £2.86 ($11.50)
Number of lots exceeding £10 ($40): 44

The highest price paid was £18.50 ($74) for an ivory Benten riding in

a carriage, signed Masamitsu. The second highest price was £16.50 ($66) for an ivory Mongolian archer. A Mitsuhiro ivory goose brought £15.50 ($62). The Kokusai coin-headed dancer illustrated in *Collectors' Netsuke*, Fig. 230, brought £7.50 ($30). Of the forty-four lots exceeding £10 ($40), all but twelve were multiple lots. In 1943 and 1944 the pound was equal to $4.03.

> Name of collector: Col. H. S. J. Streatfeild (as given on catalogue cover)
> Date of sale: March 2, 1950
> Number of netsuke: 279
> Number of lots: 109
> Average netsuke per lot: 2.6
> Total price for all netsuke: £1,009 ($2,825)
> Average price per netsuke: £3.60 ($10)
> Number of lots exceeding £10 ($28): 32
> Highest price: £32 ($90) for a Masanao ivory rabbit
> Second highest price: £26 ($73) for a Kinkō Sennin signed Yoshitomo

A fine Tomotada *kirin* brought £15 ($42). Between September 1949 and November 1967 the pound was equal to $2.80.

> Name of collector: Isobel Sharpe
> Date of sale: June 24, 1957
> Number of netsuke: 248
> Number of lots: 205
> Average netsuke per lot: 1.2

According to my own recollections and those of other collectors and of dealers, the Isobel Sharpe sale started the first tremors of an earthquake in prices, a straining at the confines of the £20 ($56) or £30 ($84) crust, like the underground wriggling of the *namazu*. But it was not until the Mark Fletcher sale that a strong surge changed the direction of the price line from horizontal into an upward slant.

> Name of collector: Mark Fletcher
> Date of sale: July 6–8, 1960
> Number of netsuke: 673 (all in individual lots)

Total price: £11,608 ($32,502)
Average price per netsuke: £17 ($48)
Number of lots exceeding £30 ($84): 84
Highest price: £150 ($420) for a gold netsuke of two puppies
Second highest price: £110 ($308) for a cormorant group in wood signed Ryūsen Zōsai
Third highest price: £90 ($252) for an unsigned ivory wild-boar group

The Fletcher sale (which included a few lots from the collection of Henry Clifford) was the first in which each netsuke represented an individual lot. Fletcher successfully concealed his identity and the existence of his sizable collection during his lifetime—quite a difficult feat. Almost all his purchases were made under the pseudonym of Mr. Martin by a single confidant. The identity of Mark Fletcher was not revealed until his death and the disposal of his collection at Glendining.

The Fletcher sale was the last opportunity to buy netsuke that could still be characterized as "plentiful and cheap." It marked the end of an era that had stretched through ninety years, affording a golden opportunity to gather gems at trinket cost. Following the Fletcher sale, interest intensified, demand increased, and prices soared in a sharper and sharper ascent. If an explanation is sought, it will probably be found in a combination of circumstances and factors forming together an irresistible tide: the thousands and thousands of foreign troops stationed in Japan; the waves of tourists from Europe and America; the publication of books and articles about netsuke; investment counselors extolling art objects; the political barriers against imports from China, which drove dealers and collectors to reappraise Japanese arts; the increased affluence, leisure, and culture of numerous people; the recognition of netsuke as a form of sculpture; and the realization of their limited availability. Nine decades of bargains for an exclusive group of devotees came to an end. Almost abruptly the era of plentiful and cheap was followed by fifteen years, thus far, of scarce and expensive.

BREAKING THE ONE-THOUSAND-DOLLAR BARRIER One thousand dollars was long regarded as an uppermost limit, a magical barrier to

an advance in the price of netsuke. For many years it seemed to be as impassable as the barrier where guards challenged Benkei and Yoshitsune. The famous wrestler group of Sessai was an exception. It brought 5,200 French francs ($867) at the Bing sale in Paris in 1906 and £225 ($1,094) at the Behrens sale in 1913. The record was subject to some discount as an anomaly, a one-time-only freak event. The next highest price at the Behrens sale was only £35 ($170). The wrestler group was hotly and stubbornly contested in the 1906 sale, with Behrens and Albert Brockhaus, the author of *Netsuke,* as the finalists in the bidding, like a confrontation between dragon and tiger.

The Sessai wrestler group appears to be an instance of extraneous influences eclipsing inherent quality in setting a record price, as discussed earlier. It may be of interest to evaluate this netsuke as an exercise in the separation of intrinsic quality from extraneous influences, although we cannot enjoy the advantage of a hand-held examination. The carving conveys the intensity of titanic struggle and surging strength. Facial expressions and straining muscles are well registered. The burly figures stand 12 centimeters (4.8 inches) tall. Netsuke of so large a size are usually either of the *sashi* type or are slender single figures, whether *sennin, rakan,* or Dutchmen. Where there is a second figure, it is usually an attribute in smaller size—for example, the toad of Gama Sennin, the dragon of Handaka Sonja, or the foghorn of a Dutch sea captain. Two large juxtaposed figures are excessively bulky even for a wrestler's netsuke. Most figures may be slenderized, but wrestlers must be massive. However, much more than size calls the piece into question. The wrestlers are designed so that the right leg of one and left leg of the other jut out in a clear violation of the requirement of compactness. The feet of the wrestlers are spread too far apart for the composition of a proper netsuke. A similar subject by Miwa in *The Netsuke Handbook,* Figure 71, though the contest there is between Niō and *oni,* may be viewed for comparison. The piece is about 7 centimeters (2.8 inches) tall—quite large, but still little more than half the size of the Behrens wrestlers. More important, the legs of the antagonists are closer together and wrapped around one another for strength, sturdiness, and compactness. The design is a satisfactory composition for a netsuke, while the design of the Behrens piece is not.

In his description of the Sessai piece (No. 465 in the catalogue) Joly quotes from Behrens's notebook as follows: "Notice the boldness of the work where the artist has left his chisel marks unpolished, though it is not very well adapted to its purpose. All authorities hitherto have styled it a netsuké and the hole under the lifting man's left elbow seems intended for a cord. . . ." The acknowledgment that the carving is not well adapted to its purpose and the assurances, which by their very necessity carry a note of uncertainty, that the piece is a netsuke and that the hole "seems intended for a cord" confirm my belief that the wrestler group is an *okimono* and not a netsuke. Otherwise so fine a carver as Sessai would have carved holes at the center of the back for proper support and balance instead of allowing the piece to dangle by an elbow, a most amateurish, awkward aperture for attachment of the cord. If it *is* a netsuke, it is the only example known of Sessai's misplacing his *himotōshi*.

There is more. Joly writes in the same description: "It will be noticed that the carver split the wood and glued it up again in the carving; the crack in the left foot is especially conspicuous in the photograph in Bing's catalogue."

Again, if it *is* a netsuke, it is the only one known in which Sessai deliberately split his material and glued it back together. The Iwami carvers sometimes split and rejoined black persimmon or *umoregi* to facilitate the carving of recessed insects as an enhancement of their final results, but it does not appear that there existed any possibility of artistic advantage for Sessai in deliberately splitting the wood in so bold a composition entirely devoid of delicate or minute carving.

A final doubt about the wrestler group is provided by Joly himself in his description of a similar wrestler group carved by Itsumin, Plate XLIV, No. 3686. Joly quotes the Behrens notebooks to the effect that the Itsumin group is almost certainly later than the Sessai and "has not nearly its power." First, Joly contradicts Behrens by stating that "both Sessai and Itsumin worked in the XIX century." Then he continues: "The present specimen [Itsumin] is in *one* piece free from any repairs, just as it left the carver's hand; it is so shaped as to stand quite firm on three legs [the Sessai required artificial support], yet the legs are of sufficient strength and the position of the arms sufficiently well adapted to receive a cord, for the piece to be legitimately described either as a netsuké or an okimono. Mr.

Behrens' opinion as to the power of this work is a purely personal matter; *de gustibus non disputandum*." Apparently Mr. Joly himself marveled at the influences that catapulted the price of the Sessai wrestler group like a carp leaping a cascade.

Thus far we have discussed intrinsic quality as perceived in the Behrens wrestlers. We have argued that it is more *okimono* than netsuke and that it probably did not justify a record price. In such case the price can be explained only in terms of extraneous considerations quite distinct from inherent quality. What, then, were these extraneous considerations? The piece was written about extensively. It was illustrated in two positions in Gonse's book *L'Art japonais,* in two positions in the Bing catalogue, in Migeon's *Chefs-d'oeuvre d'art japonais,* in Joly's *Legend in Japanese Art,* and perhaps in other literature as well. Brockhaus referred to it as "a celebrated piece" that "has often been illustrated." Bing, a connoisseur-dealer, would not part with it. Other experts vied for it. It brought $867 in 1906. These influences of literature, illustration, opinion, price, and pedigree do not add one whit to the carving that Sessai made. However, they apparently combined into a hypnotic aura and a contagion of acquisitive frenzy that had more effect on the market price than inherent quality or the character of the carving as a genuine netsuke. Many collectors may have seen the piece through eyes other than their own. The collector's frailty and suggestibility are often capable of alchemizing opinions, pedigree, provenance, and publicity into a reassuring "objectivity." It is well to remember that pedigrees sometimes serve to perpetuate prior questionable judgments and even downright mistakes.

In our own "modern times," on May 30, 1963, in Cologne, Germany, a stag-antler representation of Tenaga and an octopus brought DM4,800 ($1,200). No explanations were necessary. The price was clearly a valid contemporary evaluation. In a London sale on July 2–3, 1964, two Iwami-school netsuke, one a boar tusk carved with centipedes and the other an ivory cicada and acorns, signed Bunshōjo and illustrated in *The Netsuke Handbook,* Fig. 135, fetched £360 ($1,008) and £390 ($1,092), respectively. (The Iwamis were from my own collection, sold at a time when I found myself netsuke-rich and cash-poor.) By the time of the Hindson sale a few years later (1967–69), $1,000 was no longer a ceiling price but had become a floor price for superb netsuke.

THE NEW SURGE IN PRICES The Hindson Collection is the last thus far of the great comprehensive collections to be dispersed by public sale. It comprised some 1,309 netsuke that were evenly distributed in number and quality and were sold in seven sessions between June 1967 and June 1969. The average price climbed from $260 (£93) at the first session to $886 (£369) at the seventh session, a clear measure of the rate of increase in the price of netsuke in the short span of two years. The highest individual price paid was $6,720 (£2,800) for an ivory cat signed Kaigyokusai.

At the conclusion of the sale many dealers and collectors concurred in prophesying a price decline as sober valuation succeeded acquisitive frenzy. The renown of the Hindson name, they said, underlay the inflated prices. They were wrong. An anonymous collection of 238 netsuke sold in October 1972 averaged $1,038 (£432) per piece. The Hindson record price of $6,720 (£2,800) for the Kaigyokusai cat was equaled twice and exceeded four times. An Itsumin horse fetched $7,680 (£3,200), a Masatsugu ivory ape $9,120 (£3,800), a Gyokusai severed head (*Collectors' Netsuke,* Fig. 207) $10,080 (£4,200), and a Natsuo *ojime* $16,800 (£7,000). The October 1972 record lasted three months. It was broken in December 1972 with $17,280 (£7,200) for a Kaigyokusai puppy group and again in November 1973 with $27,563 (£11,025) for an Okatomo horse. In the words of some wit, "The Okatomo is the horse that cost more per ounce than Secretariat, the champion thoroughbred." No doubt these record highs, amazing as they are, will soon be outdated.

Sixty-three netsuke purchased at the Hindson sale were resold in October and December 1972. The increase was almost fourfold, and it demonstrated the remarkable acceleration of prices within a period of five years or less.

Seven more netsuke from the Hindson sale were resold in July 1974 in London. These seven pieces brought £12,560 ($30,144), an increase of more than six times over cost.

A tiger and cub signed Tomotada sold in London in April 1964 for £350 ($980). In April 1970 the same netsuke sold for £1,050 ($2,520). In December 1972 the identical netsuke tripled again in price, fetching £3,200 ($7,680). It is the tiger and cub illustrated in *Collectors' Netsuke,* Fig. 8. One wonders what the next price may be. Will it triple still another time?

Two conclusions are quite obvious. Until the 1960s prices were absurdly cheap. The price line was flat and barely slanted enough to keep pace with the cost of living. Starting with the 1960s, prices began to increase rapidly, and the increase, steep as it was, appears to be accelerating. The collector whose buying occurred before the 1960s and whose disposal occurred in the 1970s crossed a time bridge of gold. For example, Mr. E. R. Levett acquired his collection in the 1940s and 50s, when the Tebbutt, Gunther, and Guest collections came on the market. The total cost of the twenty netsuke that he disposed of at Sotheby on February 28, 1973, was probably about £250 ($1,007). His highest cost for any one netsuke was probably no more than £20 ($80). These twenty pieces fetched £27,520 ($66,048). Before attributing Mr. Levett's financial triumph to luck and circumstances, it is well to bear in mind that he was competing at the sales against such experts as Meinertzhagen, Winkworth, Hindson, and others. Had he not selected with discrimination, he might have acquired twenty mediocrities that Sotheby might have declined to accept for sale.

We have probably overdemonstrated that prices have risen like a *hō-ō* bird during the last fifteen years. Our purpose is not the habitual one these days to prove that netsuke are a great investment but to determine whether or not current prices are excessive.

THE JUSTIFICATION FOR CURRENT PRICES For nine decades following their introduction netsuke were as cheap as bric-a-brac. Contemporary collectors themselves often said so, and that is certainly strong proof. Another evidence of cheapness is the enormous size and quality of the early collections. Behrens amassed over 5,000, d'Ennery over 3,000 (now in the Musée d'Ennery in Paris), and Gonse, Hayashi, Brockhaus, Gilbertson, de Goncourt, Weber, Fletcher, Hindson, Brundage, Greenfield, and many others more than 500 or 1,000. Many of these same individuals simultaneously collected other Japanese material: *inrō* and lacquer, swords and sword furnishings, sculpture, and prints. These were vast comprehensive collections such as would be more appropriately housed in museums and institutions than in private homes. These enthusiasts exercised their artistic judgments on a great abundance and variety of netsuke, picking and choosing at will. Despite the greater affluence of

our present society, such huge collections are unlikely ever to be duplicated. It is not only a matter of financial limitation but also of limited availability. Had netsuke been adequately priced on their merits, collections of 500 or 1,000 pieces would have been rare instead of commonplace.

What were some of the reasons for the cheapness and prevalence of good netsuke for so many years preceding the early 1960s? A portion of the explanation starts with Japan. The use of netsuke declined in Japan following the adoption of Western clothes and the discard of the tobacco pouch. Suddenly there were more netsuke than users, more shops than clients, and more *netsuke-shi* than patrons. Fortunately there was, concurrent with its demise in Japan, a birth of interest in the West that led to "a lively export trade." The wholesalers and *netsuke-shi* found a substitute for their dwindling domestic market. Netsuke flooded the West. They were sold in antique shops, department stores, junk shops, and toy shops. Serious collectors formed a small circle, an esoteric coterie quite isolated from the general public. As for the public at large, the mass of purchasers, netsuke were trivial objects classed with bric-a-brac. They "were funny little men doing quaint things," an addition to the cabinet, something for the mantelpiece, a nominal gift for a spinster aunt, a knickknack of no great value or price.

Netsuke suffered through an inevitable comparison with Chinese art. The incomparable porcelain of China, the fabulous archaic bronzes, and the precious beauty of jade were treasured for centuries in Europe prior to the first glimpses of Japanese crafts. Oriental dealers boasted that they did not handle Japanese art, and certainly not netsuke, as though to do so might sully their reputations. As Mr. Winkworth pointed out, there was little profit in carvings so cheap as netsuke. They dealt in the "finer" —and more expensive—articles of "genuine" Oriental art. The very availability of netsuke tended to cheapen them. It is a cynical aphorism that we tend to value things according to their cost. One is reminded of the Gallic insight into human nature: "Do not give your heart too quickly or too easily," says the French woman of experience. "Make your lover suffer a little. He will value you all the more for what you cost him." How could netsuke be regarded as important when they were valued in shillings and pence? How could anything so cheap be an art object?

One wonders how much the tiny stature of the netsuke militated against it. The idealist would like to believe that the value of an art object rests on quality alone, but the realist knows that size counts. Even the great impressionist painters are sometimes priced by the square inch. Although the superb craftsmanship and artistry of a fine netsuke is undiminished by its Lilliputian dimensions, the appreciation of quality is sometimes offset by the attitude of the marketplace toward dollhouse size. Small size means small price. Market attitudes have finally changed with regard to netsuke, and netsuke are now equated with jewelry. They have long since surpassed their weight in gold.

Japan's militaristic mien, her invasion of China, and the Pacific War propelled a wave of revulsion against her. For almost two decades Japanese products were patriotically boycotted in the West. Netsuke suffered the general abhorrence of things Japanese and, when offered for sale, had to be sacrificed.

The period of the early 1960s to the present has been remarkably eventful in terms of price increases. It was the beginning of a strong, sharp surge in netsuke prices. After ninety years the unpoached preserves of a small sophisticated circle of collectors began to crack like the egg of a hatching *tengu*. The excitement of a strange, fascinating world of miniature sculpture spread like a fire carried by a *bakemono* in a sieve, igniting the interest of groups of aficionados in many countries. One collector was supplanted by one hundred. An obscure, recondite category of art took the stage to a universal audience.

Present prices are high, in some cases a hundredfold higher than they were. But increasing prices are not the same as runaway prices, just as high prices are not the same as excessive prices. A high price may be fully justified and warranted. The collector does not exist who would disagree with the assertion that the netsuke at its best is unique and incomparable, an example of supreme miniature sculpture and a gem in a better sense than a jewel because it will never be mined again. Is it not inconsistent and impractical, then, to expect a superb objet d'art to be priced like a trinket? The ridiculously high price about which we hear so many complaints is in fact a belated movement to a justifiable level. For so long was the netsuke concealed in esoteric seclusion, undiscovered, and undervalued that we came to expect these abnormal circumstances

to continue. Netsuke are at last more fully recognized and more widely appreciated; more people have discovered them and more people are collecting them. The price ascent is the more sudden and steep because it was so long deferred. Even now it is difficult to say whether the balance is completely corrected. Specimens of Chinese porcelain have reached the million-dollar mark. While netsuke and porcelain are not comparable, the price of the one tends to erase any absurdity in the price of the other. Bevis Hillier, the editor of the *Connoisseur,* wrote in the *Times Saturday Review* that "many netsuke are sculptures of the highest order" and that, were they magically increased to similar dimensions, "many of them could upstage Henry Moore or Brancusi." If there is merit in this observation, netsuke prices in the thousands of dollars should be regarded as normal rather than runaway. In the words of classroom science, we have been looking through the wrong end of the telescope.

PRICES IN JAPAN We have considered prices in the West, but what were the domestic prices of netsuke in Japan during the same period of time, the century since 1868? It does not seem that Japanese shops maintained regular books of account. If they did, the records have long since been discarded or destroyed. They are not available today. In the absence of records I have talked with old curio dealers—septuagenarians and octogenarians—whose fathers were dealers before them. Their recollections are in agreement. When they were young men, average netsuke sold for 25 sen or 50 sen (12½¢ or 25¢) and fine netsuke for ¥1 or ¥2 (50¢ or $1). These were substantially the same prices that prevailed in their fathers' time. K. Yokoyama, the eighty-eight-year-old proprietor of a Kyoto antique shop, recalls that when he began his apprenticeship netsuke for export were sold by the *masu,* a square container used for measuring rice and other commodities. Average netsuke sold for ¥3 ($1.50) per *masu* and better-quality netsuke for ¥5 ($2.50) per *masu.*

There was little price change until the 1920s and 1930s, when there emerged a group of merchant princes, industrialists, and rich politicians. Japanese customarily wore no jewelry nor adornments, and the netsuke and tobacco pouch afforded these affluent individuals their only opportunity for a display of sartorial opulence. Their demands ignited a temporary flare in prices, particularly in Tokyo and Osaka. This new moneyed

class sent the prices of elegant netsuke soaring to ¥50 ($25) or ¥100 ($50), and, in the recollection of one old dealer, to a record of ¥150 ($75). Kaigyokusai, Tōkoku, Gyokusō, and Sōko were usually the carvers of these record netsuke. Confirmation of these prices may occasionally be seen in dealers' notations marked in auction catalogues of the period. There were no official price lists. Even today the public is excluded from auction sales in Japan. Sales are the private province of the dealers' associations. There is a monetary law against soliciting funds from "numerous and unspecified persons." The law is strictly enforced and effectively precludes the public auction sale as we know it in the West. With the start of militarism and the "China incident" in the 1930s, displays of opulence were regarded as unpatriotic. The vogue for elegant netsuke collapsed like an *oni* taking refuge in a bean bin.

Mr. U. A. Casal was famous for his lacquer collection. His long residence in Japan dated from his arrival in 1912 until his death in 1964. He also collected about 700 netsuke. His daughters state that he bought most of his netsuke in the period between 1930 and 1940. He kept meticulous records, which show a range of prices for his netsuke from 50 sen (18¢) to a high of ¥20 ($7.50). It should be noted that from 1930 to 1940 the yen ranged in value from about 50¢ to 25¢ (Bank of Japan index). An arbitrary average of ¥1 to 37¢ has been used here.

My own experience with netsuke prices began in 1945 in Japan, where I have continuously resided. They started at about $1 or $2 (¥15 or ¥30) in 1945 and have reached perhaps $10,000 (¥3,000,000) today for a special Kaigyokusai or Sōko. The price increase in Japan was gradual but relentless until 1963, when the report that a stag-antler netsuke representing Tenaga and an octopus had brought $1,200 (DM4,800) in Cologne was picked up by Japanese newspapers, radio, and television. It was the shot heard round the world in terms of Japanese awareness. Most younger Japanese did not even know what a netsuke was; it had to be explained. I recall visiting a Tokyo dealer a day or two after the stupendous news. When I asked the price of a netsuke, he looked at me with a peculiar glint in his eye, his lip curled in a half-smile, and he said, "Maybe I should ask $1,200." Strangely, his ironic stance made me feel slightly thievish as I thought of the many netsuke he had sold me over the years for a fraction of current values.

For some years following the end of the Pacific War (1945) it was difficult to know the true cost of a netsuke. The rate of exchange was arbitrarily fixed by the Supreme Commander for the Allied Powers (SCAP) at ¥15 to the dollar. It was a most unrealistic rate, but it was continued with occasional increments until it was fixed at ¥360 to the dollar. A more realistic medium of exchange was the carton of cigarettes, which was valued at about ¥200. It was a great time for nonsmokers. Cartons cost only 50¢ but were rationed to one a week. However, as captain of a crashboat, I had considerable flexibility and resources, all contrary to regulations.

It may be of some interest to cite the costs of a few of the netsuke illustrated in *The Netsuke Handbook* as representative purchases of the period between 1945 and 1948. The first parenthesis shows the price based on the official exchange rate, the second parenthesis the price based on the carton of cigarettes. The six instances are listed in order of purchase.

> Anraku *karako* on water buffalo, Fig. 55: ¥1,400 ($93) ($7)
> Mitsutoshi basket of fish, Fig. 188: ¥200 ($13) ($1)
> Shuōsai temple servant, Fig. 203: ¥1,000 ($67) ($5)
> Porcelain Gama Sennin, Fig. 89: ¥150 ($10) (75¢)
> Tomochika rat group, Fig. 79: ¥1,200 ($80) ($6)
> Mitsusada cow, Fig. 187: ¥300 ($20) ($1.50)

I am almost ashamed to make the admission, but I balked at paying the then exorbitant price of ¥5,000 ($333) ($25) in 1946 for the Kaigyokusai crane shown in Fig. 147 in *Collectors' Netsuke*. Kenzo Imai, the purchaser and present owner, did not hesitate. I lost it!

WHY NETSUKE WERE CHEAP IN JAPAN We have considered some of the reasons why netsuke were so cheap in the West. Obviously they could not have been sold cheaply in the West had they not been bought cheaply in Japan. It may be of interest to examine the reasons why they were cheap in Japan—reasons so entirely different from those that influenced prices in Europe and America.

In the West we think of the *netsuke-shi* as an artist and of his carving as sculpture. We regard him as we would if he had practiced his profession

in our own country, and we accord him a certain prestige. This is a reasonable attitude for Europeans and Americans, but it leads to error when we attempt to transfer our attitudes and our frame of reference to Japan. In class-regulated Japan the *netsuke-shi* ranked below the farmer in status. He was a mere craftsman occupying the identical rank of umbrella makers, carpenters, basket weavers, potmakers, and a host of other journeymen. Even though ranked above the merchant, who was at the bottom of the social order, he did not enjoy the merchant's wealth nor exert his influence. His livelihood, in keeping with his position, was usually a bare subsistence.

It is hard to believe that in so art-conscious a country as Japan the concept of sculpture as a universal art form did not exist. Sculpture was divided into numerous crafts. Each craft, whether its members were carvers of Buddhist images, of architectural decorations, of household panels, or of netsuke, was separate and distinct, with its own traditions, techniques, and nomenclature. The very words denoting art and fine art (*geijutsu* and *bijutsu*) did not enter the language until after the Meiji Restoration (1868), when the need for them arose with the study of Western art theories and practices. During the entire history of netsuke the craftsmen who made them never enjoyed a hint of the prestige that we in the West customarily accord the artist.

Just as no generalized concept of art existed, there was no distinction between art for art's sake, fine art, and art for use: applied art. Actually all art in Japan is for use. Painting, whether applied to screens (*byōbu*), sliding doors (*fusuma*), or hanging scrolls (*kakemono*) is functional. Equally surprising to us is a distinction that we take for granted in an area where the Japanese make none. The Japanese do not distinguish between painting and calligraphy. They see them as facets of the same discipline, and these arts are included in the single term *shoga*. The implements and training are substantially the same for both. However, there was a social division in art, as we use the term, that always existed in Japan. It was a decidedly class-conscious distinction. Painting, calligraphy, and poetry were traditionally the pleasures and pursuits of the aristocratic and samurai classes. These upper classes practiced painting, patronized painters, and collected *shoga*. The three arts of painting, calligraphy, and poetry

were often combined in a single *kakemono*. Obviously the upper classes were educated and literate. The *netsuke-shi,* as craftsmen, required no education and were often illiterate or semiliterate.

The point to which I am leading is that the Japanese did not *collect* netsuke. Japanese collections were not begun until well along in this century and then in imitation of the European and American example. It is true, as Ueda Reikichi writes, that the Japanese vied with one another in sporting elegant netsuke and owned selections of netsuke appropriate for various occasions, but they were all bought for use and not as specimens for a collection. For example, our Western dandy may acquire a large selection of ties for his wardrobe, but his acquisitions do not make him a collector of ties, any more than our Japanese dandy with an assortment of netsuke for all occasions is a collector of netsuke. Both buy for use. Their goals are sartorial elegance, not collections. The distinction is crucial.

The cost of a netsuke, like the cost of a tie, was the low price of a piece of wearing apparel and not the high price of a collector's item, an objet d'art, or an example of miniature sculpture. Like the price of his obi or his *geta,* the price of his netsuke was determined by the cost of the material and the craftsman's hours of labor. The price for both material and labor was very cheap. The *netsuke-shi* was paid as a journeyman and not as an artist. The effect of the Japanese attitude on the export price was as overwhelming as a bronze bell balanced against a paper lantern.

COLLECTING BY SUBTERFUGE The first groups of "solutions" to the problem of collecting despite high prices are not solutions at all; they are subterfuges. In law an important distinction is made between avoidance and evasion. Avoidance is lawful; evasion is unlawful. For example, if an individual incorporates his business in order to escape his personal tax liability, his act constitutes avoidance and is lawful, but if an individual fails to file a tax return, his act is an evasion and is unlawful. As our avowed purpose is to collect netsuke rather than to *not* collect them, the "collector" who resorts to some subterfuge or expedient to dodge and desert the acquisition of netsuke commits the "crime" of evasion. From the viewpoint of our commitment to netsuke, his evasion is utterly unlawful, and even sinful. However, since these subterfuges and deviations are actually

practiced by collectors-in-desertion, it is necessary to describe their chi-
canery. They may be classified under three headings: book collectors,
photograph collectors, and collectors of collectors. Let us deal with them
in the order given.

Book Collectors. Some evasive "collectors" satisfy their appetites for
netsuke by accumulating books, periodicals, articles, and catalogues about
netsuke, especially those that are well illustrated. They maintain close
relationships with bookdealers who specialize in Oriental art or in curious
and esoteric material. They are listed on the special inquiry files of the
bookdealers and are promptly notified whenever stocks of netsuke ma-
terial or sales catalogues are available. Their pleasure in netsuke is ob-
viously achieved by substitution. It is wholly vicarious.

An exponent of this device of netsuke-by-book is F. J. Sear, a friend in
Cornwall, England. Aided and abetted by his son, who is himself a biblio-
phile, Mr. Sear maintains a close watch of the stocks of rare and Oriental
bookshops. Among his finds are the personal copy of the author, Henri
Joly, of *Legend in Japanese Art;* copy number one of the *Catalogue of the
W. L. Behrens Collection* (limited to 100 copies), which belonged to Henri
Joly, the cataloguer (it contains a fine portrait of Mr. Behrens); and Joly's
private notebook, in which he listed the names, with their Japanese char-
acters, of hundreds of netsuke carvers.

Mr. Sear maintains records and indexes of the outstanding netsuke col-
lections disposed of by public sale in recent years. He is able to furnish
the provenance of many important netsuke, when and where purchased,
the original cost, subsequent sales, and the various price changes at re-
sales. For example, his records indicate which Hindson netsuke were re-
sold and their new prices. He relishes his hobby of recording and tracing
netsuke. He may safely claim to be one of the few practitioners of the pro-
fession of detective of netsuke. Doubtless Mr. Sear's records will become
more and more useful and valuable as time goes on. His self-appointed task
keeps him in happy contact with the subject of netsuke, which he loves,
while free of the financial burden of collecting, which, in retirement, he
can no longer afford.

Photograph Collectors. Some ex-collectors enjoy a vicarious and bargain-
basement pleasure in collecting photographs of netsuke. They examine,
study, assort, classify, and dote happily on their pictures, photographs,

and illustrations with a passion almost equal to that of the owners of the originals. Certainly the greatest exponent of this school of collecting photographs as a substitute for netsuke was Franz Weber of Vienna. This delightful gentleman tackled the task of publishing a monthly netsuke magazine—the first such attempt—almost single-handedly. The issues were mimeographed in English and German, and the illustrations were actual photographs pasted to the pages. The first issue appeared in May 1960. Unfortunately publication of the magazine was interrupted in 1961 by his untimely death.

The magazine, however, was not his main netsuke endeavor. His chief effort was concentrated on his "archives," as he liked to call them. This was a formidable project to secure photographs of all the netsuke in the world above a certain minimum quality. His appetite for photographs was insatiable. At the time of his demise he had completed many volumes of photographs. It was once suggested to him that a photographic record limited to museum collections might be a more practicable undertaking, since museum collections were relatively static and permanent. The intrepid Mr. Weber refused to consider a diminution of his goal. He wanted a complete photographic archive of the world's netsuke, and nothing less.

Collectors of Collectors. Hans Conried is a character actor well known to Hollywood, Broadway, radio, television, and repertory. In addition to netsuke and other familiar categories of Japanese art, he has collected folk toys, dolls, and votive pictures (*ema*). Having made many choice netsuke acquisitions in Japan and the United States in the 1940s and 1950s at $25, he is understandably reluctant to pay $2,500 for similar quality today. As Mr. Conried says, he now collects collectors who collect netsuke. As he travels extensively with his repertory group, he visits many cities and meets many collectors. A public figure, warm and witty, a raconteur and dialectician, he is the sort of guest a host invites again and again. Wherever Hans may be performing, there is usually a collector nearby delighted to have him for a netsuke evening. He is constantly adding collectors to his collection, and delighting in *their* netsuke. There are others who adhere to this method of collecting by subterfuge, but Mr. Conried is a pioneer and an exemplar.

These are three groups of evaders. They share the common bond of having begun as conventional collectors. Almost all retain their collec-

tions, some of which are very fine. Somewhere along the ascent to higher and higher prices they finally rebelled, whether for reasons of price or principle. They found themselves without the stomach or the heart to pay the required price or to accept the proffered quality. Who can find fault? They still enjoy their old but static collections, and they have found a new way to expand their netsuke interests while sublimating their acquisitive desires.

It is normal for collectors to find pleasure in related and marginal activities: exhibitions, museums, meetings, conventions, dealers' shops, flea markets, or just mingling with fellow enthusiasts at the auction sales. But most of us must collect flesh-and-blood netsuke for our happiness, whatever the cost.

THE COMPREHENSIVE COLLECTION Now to deal with our main theme, lawful avoidance: how to continue collecting while avoiding error, extravagance, and excessive cost.

As he shows his acquisitions, a collector sometimes makes one or another of the following statements somewhat apologetically:

"This piece isn't very good, but I thought I ought to have an example of the material."

"I bought this one because I needed the type."

"I've given up trying to find this artist in decent quality; I was lucky to get this one at all."

"I bought this for subject, since I didn't have it."

"I suppose every collection should have one of these."

Why should any collector feel compelled to buy a netsuke when his heart isn't in it? To the extent that he makes purchases of things he doesn't really want, he is not collecting but accumulating. He is not expressing himself, his own interests, his own tastes and preferences, but those of someone else. He is collecting by rote and by popular demand, by what he feels is expected of him and of his collection. If this kind of collecting is carried to the extreme, to the ultimate reductio ad absurdum, he makes a collection for everyone else but not for himself. What is the purpose of a collection if not to delight the owner and to make a personal statement of his interest in the art?

There is another aspect of the "ought-to-have" collection in lieu of the

"what-I-like" collection. If one acquires netsuke because they fill voids, blanks, and gaps in his collection and continues on this course, he will as a logical conclusion accumulate examples of all types, materials, periods, areas, artists, and subjects. His collection will eventually be fully representative and will encompass the universe of netsuke. It will be a Comprehensive Collection. It is the type of collection many collectors easily amassed during the plentiful and cheap era of netsuke collecting before the 1960s.

The Comprehensive Collection is best suited to function as a study and teaching collection. It includes examples to illustrate almost any point about the subject that the student might wish to learn or the teacher might wish to illustrate. Since it covers all phases and facets of the subject, it is necessarily of considerable size. It is the proper collection for the museum or institution. Comprehensive Collections, like other collections, may be found on various levels of quality from ordinary to superb. Quality would have little effect on its usefulness as a tool for learning and teaching. What all Comprehensive Collections have in common, regardless of quality, is their horizontal formation. They cover the entire field—a characteristic that gives the collection, in geometric terms, its level plane. It need not deal with any particular phase in depth. It therefore stands in contrast with the vertical line of the in-depth collection, which is specialized or limited to particular aspects. The Specialized Collection will be discussed later.

There is certainly no fault to find with the collector whose interest and predilection lead him to the Comprehensive Collection. It is a commendable goal if it is his pleasure to represent fully the various aspects, phases, and facets of netsuke. He can explain and demonstrate any direction the netsuke compass shows just as completely as the zodiac netsuke portrays the twelve animals. The point is that our comprehensive collector is then expressing *his* interest. In the modern idiom he is "doing his own thing." The objection is to the practice of the collector whose haphazard acquisitions "by popular request" are leading him willy-nilly in the direction of the Comprehensive Collection, which he might be the first to disclaim as his goal. To the extent that he buys what he neither needs nor likes, he is committing the utmost extravagance. He pays for third-party approval and wastes his money on netsuke that do not satisfy *him* most of all.

If that oracle of good sense, Fukurokuju, the long-headed god of wisdom, could speak to us, he might say, "Save the money that you would spend on netsuke you *ought* to have and spend it instead on the netsuke you *want* to have. Take the piece that satisfies your heart's desire and reject the one that leaves you unaffected, even though it be the object of great acclaim. Your acquisitions should elate your spirits; they need not stir the envy nor win the approval of your colleagues. As a sincere collector, you do what you should when you listen to new suggestions and contrary opinions patiently and consider them thoughtfully but extract only so much as commingles naturally with your own taste and bent."

DAMAGE, REPAIRS, AND RESTORATIONS Damage, repairs, and restorations are of frequent occurrence in netsuke. It would be surprising were it otherwise. Netsuke were in common use for generations over hundreds of years, subject to heat, cold, rain, and wind as the farmer, carpenter, merchant, and samurai went about their work. Netsuke often suffered damage in routine and rugged activities. They swung hazardously from their cords when removed from the obi. Frequently an old netsuke will show a singed or blackened area where the smoker habitually leaned against the hibachi as he relaxed and warmed himself.

Repairs involve the original material. Small repairs include smoothing or resurfacing chips, closing cracks, replacing eyes, and other such minor mending. Larger repairs may require such operations as the reattachment of an original member that has broken off. Unlike a repair, a restoration requires new material, the fashioning of a new part to replace the original that has been lost or destroyed. Damage requiring restoration is generally much more serious and difficult than damage requiring repair. Like the cure worse than the disease, some repairs and restorations are uglier than the damage they try to heal or conceal.

Collectors' responses to damage are as varied as their responses to the netsuke themselves. Reactions are frequently uncertain, unsettled, or confused, and when they are not, they may be strongly biased. The same collector who accepts one type of damage with equanimity may shudder with the horrors from another as though from touching a *bakemono*. For some the devotion to a fine but damaged piece may be as undiminished as a mother's love for her lame child or as Mōsō's for his senile parent.

The collector says, "I wanted the netsuke, but it was damaged." Behind the statement one senses a quandary, a dilemma, a perplexing question that takes a variety of forms when prompted into frank expression: "Is it wise to buy a damaged netsuke?" "Can a damaged netsuke enhance a collection?" "Does the reduced price justify the damaged acquisition?" An attempt to respond forthwith to the general question with general answers will often disintegrate into compounded confusion and vague generalities lacking content. The problem is that more than one factor is involved. No answer may be final or entirely satisfactory, but certainly the most sensible beginning is to clarify the factors and narrow the issues. To gain an understanding of some of the factors may help those of us who suffer from "damage vacillation," even though we may not be provided with categorical instructions. We begin with a few observations and narrow specific questions before we attempt, like Shōki gripping an *oni,* to tackle the general question.

When is a netsuke a damaged netsuke? In Oriental art, whether bronze, jade, lacquer, ukiyo-e, or porcelain, condition plays an important part in determining value. Although netsuke are subject to the same standards, some modification of the definition of perfect condition is applied in their particular case. For example, lacquer or ukiyo-e in absolutely pristine condition would justify topmost prices, while the identical state in netsuke, as though fresh from the carver's workshop, would generate suspicions that would undermine a topmost valuation. An antique netsuke in unused state is, in the eyes of the marketplace, simply unbelievable. Netsuke must be secondhand. They are expected to show some signs of wear: a faint erosion of surfaces or markings, wear at the *himotōshi,* or color changes wrought by handling. Similar signs of wear—a scratch, smudge, or chip in the case of lacquer; a wormhole, fading, or fold in the case of ukiyo-e—would be positive defects. For netsuke, however, signs of wear are practically requisites for supreme approval. But the wear on a netsuke must be slight and not so far advanced as to suggest imperfection. In other words, the signs of use must stop at the stage that supports authenticity and go no further. The demarcation between wear that authenticates and enhances and wear that is detrimental and detracts is fixed—usually but not always—with a fair amount of agreement among collectors. Nevertheless, the point is clear that perfect condition in a netsuke is not the

same unused and unworn state as perfect condition in lacquer, prints, and other categories of Oriental art. In relation to netsuke we must accept the Japanese verdict that only Kannon, the goddess of mercy, is perfect.

What is the relationship between damage and age? Most collectors will agree that cracks, minor chips, surface erosions, tiny repairs, and similar small defects are acceptable in direct relationship to the age of the netsuke. For example, an age crack in an eighteenth-century Tomotada would be regarded less seriously than it would be in a nineteenth-century Mitsuhiro, and in the Mitsuhiro less seriously than in a twentieth-century Sōko. The average collector is more lenient in his demand for excellent condition in judging older netsuke than in judging younger ones. The identical damage ignored with equanimity in an Okatori rat may cause the ready rejection of the same model by Ransen. This attitude is certainly rational and logical. The older a netsuke is, the longer it has been subject to accidents and exposed to the elements, the more wear and injury it may be expected to have sustained during its lifetime. The doctrine of fair wear and tear applies.

What is the relationship between damage and value? We are bound to recognize the unyielding decree of the marketplace that a netsuke commands a considerable premium for its excellent condition. Perfect state means peak price. Related corollaries are equally true. Small damages, slight cracks, a few chips, or a minor erosion will reduce the value of the identical netsuke, in some cases quite considerably. If we increase the damage to major proportions—an open crack or split, heavy chipping, severe erosion, an obvious repair or a large restoration—we may reduce the same fine netsuke we have under consideration to the price of a mediocrity.

DAMAGED NETSUKE: TO BUY OR NOT TO BUY? Many a collector boasts that he will not buy a piece unless it is in perfect condition. Should he discover damage of which he was unaware, he disposes of the netsuke despite its merits. There is no fault to find with the collector who demands perfect condition and is willing to pay peak prices. The perfectionist is quite understandable. The art advisers approve his attitude as an investment policy. They assert that it is the art objects in the best condition that show the greatest increase in price. However, investment ap-

preciation is not every collector's concern, and not every collector can afford premium prices.

At the opposite extreme from the collection of perfect specimens, or Perfect Collection, as we may call it, is the collection of damaged netsuke —the Damaged Collection, so to speak. A collection of damaged pieces would certainly be acquired on the cheap, though it might well contain, however dismaying the damage, a sprinkling of great carvers and great netsuke. Although I know of no one who deliberately set out to make a collection of damaged netsuke, I have met two or three collectors who evidence no concern about condition. It is a factor that carries little weight with them in making their selections. The large proportion of netsuke in poor state in their collections range in degree of damage from mere imperfections to irreparable breakages.

As a brief diversion it is amusing to imagine such a collector offering examples from his collection to illustrate not carvers, subjects, and materials but types of damage: cracks, splits, chips, erosions, effacements, and obliterations; perhaps some fractures and extirpations for the doctor-collector; some contusions and abrasions for the claim adjuster; and some mayhem and lacerations for the lawyer. There is no intention to be scornful. A collection of damaged netsuke is not unimaginable, nor is it necessarily an absurdity. The collector who acquires damaged pieces is not ipso facto a radical or a dolt. An example from another field may impress the reader as much as it did me.

A friend has a collection of fine period Korean celadons, each a masterpiece of form, color, and design. On close examination each and every pot without exception exhibits the telltale gold-lacquer marks and outlines of a repair or a restoration. Not a single pot in her entire collection is whole. Yet the pleasure the collection affords her is affected only mildly by their broken and repaired state. Their inherent beauty is undiminished. No doubt the knowledge that her acquisitions are based on a love of Korean celadons per se rather than on their market value adds more to her pride than is subtracted by their condition. Hers is a true love, for it is not affected by defects. (Some collectors disdain this attitude as a form of reverse snobbism.) The cost of this imperfect collection was a minor fraction of its cost in perfect condition, assuming availability. The

same measure of admiration might be due to a collection of superb netsuke, albeit replete with specimens that are damaged and repaired.

Our discussion thus far may have set the stage for a return to the general question about acquiring damaged netsuke. We will try to answer by means of concrete examples.

The Masanao dog in Fig. 715 is badly damaged by mutilation. One ear is chipped, one paw is badly chipped to the point of near obliteration, another paw is broken off, and only a stub remains of the tail. Apparently no attempt at restoration was made.

Let us try to evaluate this netsuke, concentrating on it as an artistic effort while we shut our eyes to all other considerations. The piece is quite obviously a genuine eighteenth-century carving genuinely signed Masanao. The color and patination are rich and warm. The modeling, anatomy, musculature, composition, pose, and form are Masanao at his best. The damage, though terribly severe, does not alter these intrinsic qualities. The animal is incomplete, but like the Venus de Milo or the Rashōmon witch bereft of her arm, it is not destroyed. We can enjoy the dog's superb color, carving, and composition almost unaffected by the mutilation of the ear, paws, and tail. Its cost at a sale would be a fraction of its value in perfect condition. Notwithstanding the strict application of the standards of the marketplace, its artistic appeal as a superb carving for the collector concerned only with quality may be considerably greater than that of a lesser or an ordinary Masanao in perfect condition.

The Okatomo cow-horse (Fig. 479) is badly damaged. The type of damage is quite different from that of the mutilated Masanao dog. The damage is the result of excessive wear, the irreversible effect of erosion, effacement, and obliteration. The damage is irreparable. If the animal ever had markings for body hair, hide, or coat, no vestige of them now remains. Whatever surface markings there may have been are obliterated. So extensive and deep is the erosion that the very shape of the body has been altered beyond recall. What remains, then, of the original carving? It is clearly an authentic Okatomo of proper age and with a thick rich patination. Despite the extensive erosion, the equine body and bovine head are clearly distinguishable, and the anomalous horse's mane and cow's tail retain most of their original detail. Were the creature intended to be all

horse or all cow, the damage would be fatal. Fortunately, the damage, extensive as it is, does not impair the essential rarity and uniqueness of the bizarre cow-horse. (See caption for Fig. 479 for explanation of this animal.)

At a public sale it might be the perfectionist's rejection and the marketplace's depressed valuation. For the collector who combines a sharp eye for rarity with an indulgence for damage, it might be a "find" at a bargain price.

The ludicrous animal in Fig. 702 has suffered major surgery: the entire left hindquarter has been restored, and other limbs are suspiciously discolored. How shall we evaluate this weird animal? It is signed Gyokkō: a middle-nineteenth-century carver. It is quite amusing. The animal seems to be chuckling with enjoyment. We may sense that the carver had fun with it. The ivory bone held in the animal's jaws is somehow incongruous. The design, although original, lacks compactness; it does not make an ideal netsuke. The beast might be a wolf, but the ears are too short. One wonders whether other repairs, now undetectable, thwart positive identification of the animal's genus. Could it be a distorted badger?

Obviously some collectors will find pieces like this weird animal desirable, some will not, and others may be undecided. The pros and cons are numerous, and the additions are unlikely to tally closely among any group of collectors. This is to be expected. Such variances are normal and natural. What does not vary is that the damage will exert a measurable impact in reducing the price, although it exerts only a controversial effect on desirability.

If we may deduce a principle from these examples, it is that a netsuke may suffer major damage yet retain its uniqueness and original quality, or it may suffer minor damage that severely compromises its merits. Despite the mutilation of the Masanao dog and the erosion of the Okatomo cow-horse, they are desirable acquisitions. But had the damage been reversed —had the dog suffered the erosion of the cow-horse and the cow-horse the mutilation of the dog—neither would have retained a fragment of its uniqueness and desirability.

Every collector must answer to his own satisfaction to what extent the

ugliness of the damage mars the beauty or rarity of the piece. Despite all that may be said in order to clarify the factors and to fix guidelines, the ultimate decision about the acquisition of damaged netsuke is no less subjective than it would be were the netsuke *undamaged*. Our responses to damaged netsuke are like those of the Three Wine Tasters to sakè.

Repairs and restorations will ordinarily disturb the collector concerned with intrinsic quality much less than they will the collector whose mind is on market value and appreciation. Repairs and restorations will often detract only mildly or moderately from basic considerations of craftsmanship and originality. A fine old carving is no less a fine old carving because at some point in its long history a limb was broken and mended. The marketplace rules otherwise, and the quality collector may get a bargain when a fine but damaged netsuke is offered. For him the art and craft of the carving tends to submerge the repair. The penalty imposed for imperfect condition disturbs his appreciation of the repaired netsuke no more than the resting lizard disturbs the pumpkin.

We have focused attention on the decree of the marketplace that penalizes the damaged netsuke. We have also reported the pragmatic advice of the art experts that it is the perfect specimen that appreciates the most. It is possible, if not probable, that these standards will not persist and prevail. Art values, like styles, are subject to occasional shifts and reappraisals. There could occur a general reaction that would establish new or modified criteria that would base value more on intrinsic quality and less on the extraneous consideration of condition.

THE DAMAGE SPOTTER Somewhat tangentially I would like to take note of the collector who prides himself on his eagle eye, his inordinate ability to spot the most minor defect or damage. Owing to its miniature proportions and minuscule markings and decorations, a netsuke one has owned for ages and has examined numerous times may suddenly reveal a defect. When we ourselves discover damage after a long period of ownership, we suffer the remorse of a confessed vandal, like the penitent *oni* begging Buddha to cut off his horns, in fear that we ourselves, by our own carelessness, may have caused the damage. We ask ourselves whether we could have failed to notice the damage when we acquired the piece and

at all the other times when we fondled and examined it. (Unless the damage shows the garish color of newly exposed material, it is almost certainly an old but unnoticed defect.)

More often, however, it is our colleague of the piercing vision who spots the injury. Our emotions on being advised of damage to a heretofore perfect little gem are of course mixed. We like to know all we possibly can about our own netsuke, but the damage dismays us. Besides, we would like to discover their faults ourselves and not be told about them by a visitor who was only supposed to look. Occasionally someone will point out to us alleged damage that, to our great relief, we find is fancied or imagined or that results from the spotter's ignorance of the subject. We sometimes experience a tinge of annoyance with this expert finder of damage, this defect fetishist. Our annoyance with the damage spotter burgeons if we know that detecting damage is his only claim to expertness. He boasts about his sharp vision. "No damage gets by me," he says. In his inordinate, abnormal concern with damage he is like the specialist in pathology examining diseased tissue under a microscope or the monkey searching for lice. We do not mind so much if our owl-eyed friend is genuinely interested in netsuke. The damage spotter we resent is the one whose expertness is limited to imperfections and who has very little knowledge of the general lore of netsuke. He needs no reading, no study, and no application for his gratuitous field of endeavor. He needs only visual acuity and a morbid fascination with defects. He can exercise his exaggerated concern free of all sensitivity to craftsmanship and artistry.

UNSIGNED NETSUKE Unsigned netsuke offer an area in which substantial savings may be made without sacrifice of quality. Meinertzhagen estimated that about half of all netsuke are unsigned. His estimate appears to be generally accurate. In most collections centered on quality a separation of the signed and unsigned netsuke will produce two groups roughly equal in number. Variations from equal distribution stem from collectors' partialities. For example, the unsigned netsuke in the Hindson Collection comprised only 30% of the total. This was due to Hindson's interest in the carvers and their "schools." On the other hand, the unsigned netsuke in the Mellin Collection (Christie's, November 1973; the sale included the record $27,563 Okatomo horse) comprised 58% of the

total because of Mellin's partiality for the early-eighteenth-century ivories, which are usually unsigned. However, a balance that is roughly equal between signed and unsigned netsuke is more the rule than the exception.

If we now select from the groups of signed and unsigned netsuke those that are of outstanding quality, we will find that we have selected as many from the unsigned as from the signed group. I dare say that the illustrations chosen for this book tend to substantiate this statement. When we go to the sales, however, we find incontrovertible evidence that signed netsuke fetch considerably more than unsigned ones. For example, if one had bought all the unsigned netsuke at the Hindson sale, the average cost would have been almost $100 less per piece than that of the signed pieces. If one had bought all the unsigned netsuke at the Mellin sale, one's average cost would have been about $305 less per piece than for the signed ones. We may take for granted that Hindson and Mellin applied the same taste and judgment in the selection of their unsigned netsuke as of their signed. The irresistible conclusion is that the collector may acquire as fine quality but at a lower cost when he buys unsigned netsuke.

SIGNED COLLECTIONS There are collectors who insist upon signed pieces; they want to see signatures on their acquisitions, and they reject unsigned specimens. In a word, they are assembling Signed Collections. As in the case of those who build Perfect Collections, there is no fault to find with the collector who prides himself on his preponderance of signed netsuke and who rarely acquires an anonymous specimen. He will, of course, pay a premium for the endorsement value of the signature, even though there is no inherent superiority of a signed netsuke over an unsigned one.

The question that confronts the collector is, Does the signature justify the additional cost? The collector concerned with market values and potential appreciation will decide that it is; the collector concerned with aesthetics and quality may decide that the signature is not worth the additional cost. Admittedly, signature has not a particle of effect on the basic beauty of the object, no matter how much it has on the price.

SIMILAR OR IDENTICAL MODELS, SIGNED AND UNSIGNED Let us consider two netsuke that are almost but not quite identical. They are

siblings but not twins or, if twins, fraternal but not identical. One is signed, the other is not. In such a case it may be difficult to calculate an honest weight, a fair "plus" for the signature. Even though we may accept as fact that both the signed and the unsigned were carved by the same hand, slight variances in size, shape, pose, color, polish, or *himotōshi* are as difficult to tally for or against the signed sibling as it would be to check a badger's subscription list. The aesthetic problem is to base our choice between the two on quality alone and to ignore the marketplace and investment advisers who are fairly screaming their praise of the signature like the chanters in Noh. We may need the moral counterpart of the physical strength of an *oni* armed with a club if we are to limit the weight of a signature in the aesthetic balance.

No such uncertainty confronts the collector in the case of two netsuke that are identical twins, one the mirror image of the other. Model, size, color, patina, age, treatment, carving—all are as identical as confronting dragons on a *mokugyo,* except that the one is signed, the other is not. In such cases we are forced inescapably to admit that the difference in cost is the precise price for the signature. We find such duplicates from time to time in Ikkan rats, Tomotada cows, Tomokazu turtles, Masanao sparrows, Okatomo quails, Sukenaga frogs, Toyomasa dragons, and many other models. Ascription may be made most confidently in the case of the unsigned twin; the proof is self-evident in the identical piece that bears the signature. But the ascriptions are not acceptable substitutes for collectors who demand signatures. The collector who is satisfied with the unsigned twin will usually have his model at a considerable discount.

It is fair to ask why the identical piece was not signed, and, lurking behind the question like a grinning graveyard ghost behind a tombstone, there may be the suspicion that the twin was not really carved by the same artist. We may imagine that even though the netsuke are visually identical, some subtle distinguishing feature will eventually manifest itself. At this late date such a hope is as unlikely of fulfillment as mercy from Adachigahara. Netsuke originated as a craft. Traditionally, craftsmen did not sign their names. Until the nineteenth century neither the *netsuke-shi* nor his patron considered a signature beneficial. Simple habit, custom, and tradition would explain the absence of signatures on the earlier netsuke. Historically speaking, which requires due regard for the Japanese frame

of reference, the need is for an explanation of how netsuke came to be signed rather than for an explanation of why netsuke are unsigned. An explanation of the origin of the custom of signing will be found below on pages 65 and 66.

CONCERN WITH SIGNATURE The concern with signature often seems unduly exaggerated. Some collectors search for a signature before they look for quality. They ask, "Who signed it?" before they ask, "How good is it?" This cardinal concern with signature before quality is certainly a warping of values and a reversal of artistic priorities. Our first consideration should be for the elements of quality. Without quality the greatest signature is a worthless endorsement. We should be buying the netsuke, not the name.

The approach of some collectors is even more absurdly tilted toward signature, like Raiden precariously leaning out of a cloud. They are concerned about the *fact* of a signature—any signature—with hardly a regard for the identity or status of the carver. Their first question is "Is it signed?" not even "*Who* signed it?" If it is signed—no matter whose the signature may be—it is thought to be somehow better. This is certainly a case of buying a signature instead of a netsuke.

Not all collectors demand signed netsuke with an eye to market values. For many a collector the value of the signature is the assurance of authenticity that it affords. Any misgivings he may have, any lack of confidence in the opinions of others or in his own judgment—these are submerged in the security of a signature. The signature, like the endorsement on a check, tends to bolster his confidence and to support his judgment against whatever doubts there may be. It serves him as a warranty or a certification.

On the other hand, the collector who chooses the unsigned twin at a reduced cost demonstrates a confidence in his knowledge and in his recognition of quality. Being primarily concerned with quality, he readily chooses unsigned netsuke at a lower price than equivalent netsuke bearing signatures at a higher price. What is even more advantageous for the confident collector is that he is unlikely to be deceived by false signatures or, regardless of signature, by netsuke of dubious quality. He relies on quality, not on signature. He relies on contents, not on labels. For him a signature

may confirm or corroborate craftsmanship and style, but he will never accept it as a substitute for quality.

THE REASON FOR UNSIGNED NETSUKE What is the explanation for unsigned netsuke? It is the earlier netsuke that were usually unsigned. Why is this? The carving of netsuke in Japan, like the carving of their Chinese prototype the toggle, originated as a craft and not, like painting and poetry, as an art. Just as Chinese toggles were never signed, neither were the earlier netsuke. So long as netsuke were produced by craftsmen, the practice of anonymity was by custom absolute. The craftsmen of the earlier netsuke did not *refrain* from signing their names out of modesty or in order to conceal their identities. It never occurred to an artisan, a craftsman, or a member of a journeyman guild to sign. His contemporaries who carved Buddhist images or musical instruments or decorative panels or architectural pieces or any other carved work did not sign. Why should he? The very idea of carving his name on his product would appear preposterous to the traditional Japanese craftsman, a crazy conceit like Komachi, who could find no man good enough to marry.

THE EXAMPLE OF NEGORO NETSUKE Perhaps the best example of a type of netsuke that was produced by craftsmen working together as a commune or guild is the Negoro lacquer netsuke. Negoro lacquer was developed by the priests of the Negoro Temple in Wakayama centuries ago. The priests employed a splotched red-on-black lacquering technique in producing a variety of common articles for everyday use. When a demand for netsuke arose, the craftsmen associated with the temple employed their familiar lacquer techniques and methods for the creation of suitable models. Indications of the craftsmen's-guild origin of Negoro netsuke are seen in the models that are perfectly functional, simple, and sturdy; in the decoration, which is minimal; in the small number of models; in their constant repetition; and in the absence of signatures. Negoro netsuke are similar in this respect to Otsu-e (pictures made in Otsu), the souvenir paintings so popular with travelers on the Tokaido. A limited number of designs were evolved through communal judgment and a sense of fitness for the particular purpose. Cooperating craftsmen handled the materials and brushes. They painted in a spare, economical

technique. They worked rapidly, spontaneously, and unself-consciously. They constantly repeated the same familiar designs. The paintings satisfied a popular need and were cheap. Otsu-e paintings, like Negoro netsuke, were the products of a guild craft and not of individual artists.

The Negoro netsuke that are more elaborate than the customary models and are signed are not the product of the guild craftsmen but of the individual *netsuke-shi* who employed a similar technique. No doubt they were made by craftsmen who quit the Negoro guild and struck out on their own as individual art craftsmen. They elaborated the models and techniques they learned as apprentices and craftsmen of the guild and, as *netsuke-shi,* frequently carved or lacquered their signatures.

EARLY UNSIGNED TYPES Other types of early netsuke that were generally unsigned are Chinese and other foreign articles and figures like those illustrated in the *Sōken Kishō: sennin* and *rakan;* the figures of Chinese, Mongolians, Micronesians, Dutchmen, and other foreigners; the familiar *shishi;* and the seal netsuke. Another common type of early unsigned netsuke is generally executed in ivory. It is the smaller-size *sennin,* pilgrim, or *rakan,* usually portrayed with his attribute on a truncated seal base. The single common bond among these groups, except for the Dutchmen and other Europeans, is the Chinese character and style that permeates them. The Japanese know such carvings as *tōbori,* meaning "Chinese-style carving," and *tōbutsu,* or *karamono,* meaning "Chinese-style articles." Even the *shishi* so common in early netsuke is known as the *karajishi,* or Chinese lion. Kyūichi Takeuchi, one of the first professors of sculpture in the new European-style Tokyo Art School (1887), stated that early netsuke were ivory seals and that even the handles were carved in the Chinese style. Whether by reason of the habits, customs, and traditions that bound the craftsmen; whether by the example, precedent, or proximity of Chinese prototypes; or whether by simple emulation of Chinese principles, the earlier netsuke were usually unsigned.

HOW CRAFT PRODUCTS CAME TO BE SIGNED In keeping, then, with craft customs early netsuke carvers did not sign their work. For identical reasons craftsmen in other fields such as pottery and lacquer were likewise anonymous. Kakiemon, Kutani, Nabeshima, and Satsuma were

not signed; neither were lacquer articles. A change occurred, however, in early Edo times, when such famous potters as Ogata Kenzan, Ninsei, and Mokubei and such famous lacquerers as Hon'ami Kōetsu, Ogata Kōrin, and Ritsuō signed their names. What is the explanation?

These artists were born into upper-class families. They were literati. They were painters first and as painters followed the custom of signing their work. They were also rebels and radicals vis-à-vis their age and their class. They were impatient of academic and class restrictions. They desired freedom as artists, and they were sufficiently affluent and independent to break away from conventional, traditional, and academic restraints. They were interested in the crafts practiced by the lower classes. They studied the media, methods, and techniques of clay and lacquer. They developed fresh styles. They were not ordinary craftsmen, and they were not bound by guild restrictions and guild anonymity. As aristocratic independent artists, they signed their names on their products. More than their names, they placed their indelible influence on the plebeian crafts of pottery, porcelain, and lacquer.

The example of these rebels who broke with class and tradition came at the time when the demand for netsuke began to sweep the country. They inspired the netsuke carvers to work independently, to develop individual styles, to create designs, to portray new subjects, to experiment with media, and to identify themselves with their work by signing. The netsuke carver evolved from the ordinary craftsman and the artisan into the art craftsman and the individual artist. He was no longer the *netsuke-kō,* the netsuke worker; he had become the *netsuke-shi,* the netsuke carver. Nevertheless the art continued to be rooted in the craft. The habits and customs of the craftsman atrophied slowly and continued to influence the attitudes of the *netsuke-shi.* This would explain why early carvers like Tomotada, Okatomo, Masanao, Kokei, Minkō, and Tomokazu continued to carve the same models repeatedly, while many of the later carvers, who were further removed from the craftsman's mentality, constantly created new designs and relatively infrequently repeated themselves. The burgeoning demand in the middle Edo period fortified the *netsuke-shi* in his self-reliance and independence, though many carvers continued to rely on the support of guild and fellow craftsmen.

PEDIGREED NETSUKE Some netsuke have impressive pedigree and illustrious provenance. They may have been "originally" acquired by Gonse, Behrens, Trower, or Tomkinson, dispersed to Meinertzhagen, Winkworth, Tebbutt, or Gunther, and from them passed to Sharpe, Fletcher, Hindson, or Levett. Acquisition by a succession of prominent collectors seems to fortify belief about quality and authenticity in the manner of a Shinto rite of purification. Some netsuke have been illustrated and discussed in important reference books such as Joly's *Legend* or Weber's *Koji Hoten* and in various articles. A netsuke singled out in so signal a manner attains an aura of excellence like that of a Kaigyokusai animal.

The market assesses a premium for the netsuke that is pedigreed or illustrated, and many collectors are content to pay the additional price. Pedigreed and illustrated netsuke are widely regarded as good investments. Collectors are proud to own a prestigious netsuke. Their own names are added to the registry of collectors or connoisseurs who have owned or praised it. They are enrolled in a renowned company. They share the bond of ownership with great collectors. They are elated with the knowledge that their very own netsuke were once handled and cherished by a first-generation pioneer, an important name in the history of netsuke, or a prominent collector. Besides, pedigree and illustration foster a comforting assurance of authenticity and quality.

Again, there is no fault to find with the collector who seeks netsuke with good pedigrees. Provenance, illustration, and reference, as in the case of the perfect netsuke or the signed netsuke, carry a premium. The additional payment for the pedigree may make good investment. However, these attractions should be recognized for what they are: entirely extraneous elements and considerations. They have no relationship to the artistry and craftsmanship imparted by the carver. They are the life story of a netsuke subsequent to its birth, the events that occurred in its history after its creator was finished with it. They are the things that persons other than the carver did with the netsuke and said about it. They are not the innate, inherent attributes that affect the quality of the netsuke as art. They do not in any way improve or diminish the netsuke; they do not change the netsuke into a better one or a worse one. From a purely aes-

thetic point of view, famous ownership and frequent illustration add nothing to beauty and quality. The collector whose eye is centered on quality alone will pay much less for an equivalent netsuke even though it is owned by no famous collector, reproduced in no reference book, and praised in no popular article.

One will occasionally find a netsuke that, although fully pedigreed, is nevertheless defective or dubious in some important respect or that generally lacks great merit. It is well to remember that "mistakes" may be perpetuated by pedigree as well as quality. Pedigree in netsuke began after 1868 in Europe and America. There is no pedigree in Japan, the country of origin, nor in the centuries prior to 1868. The Japanese preference for anonymity and security, whether collecting or dispersing, generally precludes Western-style catalogues, publications, exhibitions, displays, and public sales—the very practices by which pedigrees are established. Thousands of netsuke that foreigners have carried out of Japan since the end of World War II are the equal of those exported previously, but they are only now gradually building pedigree, provenance, illustration, and reference.

NAME SALES Sometimes a public sale is that of the property of a prominent collector. The collection is well known to dealers and collectors alike, by reputation if not by personal association. A considerable anticipation is engendered. Bidders will wonder whether the entire collection will be sold or whether some insider has already "creamed" the best pieces. The catalogue describes the sale as "An Important Collection of Netsuke" or "A Very Fine Collection of Netsuke, the Property of So-and-So" or "Fine Netsuke from the So-and-So Collection." The profuse illustrations attest to the importance of the sale. It is a "name sale."

Other collections at public sales are the property of someone famous, though the person's fame derives from reasons unconnected with netsuke. The collection may be the property of a person of royalty or title, an important artist, or a prominent politician. These also are name sales.

Name sales of both types attract a great crowd, including dealers, collectors, and dilettantes. An atmosphere of tension and expectancy builds, the undertone increases, and excitement transfers from one to another in a contagion. Everyone marvels at the heat of the bidding, even those who

are themselves contributing to it. Exceedingly high prices are paid. Even more notable is the amount of the bidding for pieces of quite ordinary quality. Mediocrities in terms of quality are no longer mediocrities in terms of price. Name and snob appeal appear to be making prices inflate like a blowfish.

DEALERS' SALES Another type of public sale is nameless. It is described as "Fine Netsuke in Wood and Ivory, the Property of Various Owners." The catalogue may have a plate or two of illustrations, or it may be entirely unillustrated. Occasionally an effort is made to give a name to what is in reality a nameless sale by a description such as "The Property of Dr. So-and-So and Various Owners." A careful examination of the contents of the catalogue reveals that the property of Dr. So-and-So consists of a few unimportant lots, perhaps only three or four out of a total of more than two hundred. These nameless sales are infrequently attended by collectors and dilettantes. They are known as "dealers' sales," either because they are attended almost exclusively by the trade or because a large number of the lots are furnished by dealers from their stocks. While it is true that netsuke capable of being characterized as unique, extraordinary, outstanding, or superb are less frequently offered at dealers' sales, it is also true that buying hysteria is entirely absent, bidding is sober, and the prices paid are usually based on a full measure of value.

PRICE DISCREPANCIES BETWEEN SALES Many dealers and collectors have remarked about the discrepancies in prices realized for netsuke of equivalent quality from one auction to the next. The difference in the type of auction, whether name or nameless, may account for much of the price differential. What is especially remarkable is the difference in prices for standard models such as Tomotada cows, Tomokazu rats and turtles, Okatomo quails, and Masanao sparrows between the name sale and the dealers' sale—a difference that cannot be explained by differences in quality.

 In any sale, whether name sale or dealers' sale, there may be a sleeper, a piece of considerable merit that for some inexplicable reason sounds no alarm, as does the *yamabushi* blowing his conch, to alert astute collectors and dealers. Perhaps, in the crowded excitement of the presale viewing,

hurried and superficial scrutiny is sufficient to register obvious quality, while deeper qualities of subtlety, refinement, and rarity in a few pieces are overlooked. These are the sleepers for the hawk-eyed collectors. Sometimes the catalogue description is inadequate, ignoring or missing an interesting point of quality.

Much more surprising than wild variations in price for equivalent quality in sequential sales is the discrepancy in one and the same sale. Anomalous valuations are sometimes stunning; a superb netsuke begs for a bid while a mediocrity soars to thrice its worth. Often no satisfactory explanation can be found, though many will be ventured: buyers had already exhausted their budgets, potential bidders had previously acquired similar models, or some expert had deprecated or depreciated the piece. Perhaps chance and mood, even weather, play a larger part at auctions than we imagine. Factors concerned with the catalogue, the descriptions, and the illustrations certainly affect bidding. An unillustrated netsuke in an otherwise profusely illustrated catalogue leads to an inference that its quality is below the standard of the others. A poor illustration likewise tends to discourage bidding by those who have not viewed the sale. The partialities, preferences, and prejudices of the cataloguer inevitably color his descriptions, which in turn influence the bidder who relies on them. Some unusual facet, some recondite symbol or meaning, some interesting allusion to a proverb, practice, or custom may be missed or omitted, so that an exceptional piece passes notice as an ordinary specimen. By the same token an optimistic ascription or a flowery description often entices the collector who is easily influenced or romantically suggestible. Whatever the reason, it is a fact that absurdly high prices and ridiculously low prices frequently concur at one and the same sale.

THE KNOWLEDGEABLE COLLECTOR'S STRATEGY The knowledgeable collector who looks for quality will not be influenced by great name or by snob appeal. He may prefer the dealers' auctions, feeling that there he will more likely find bargains. When he attends the name auctions, he will bid for the unnoticed or overlooked sleeper, but he will retreat from the contagious contests for popular masterpieces that, like the badger teakettle, grow too heated. This course is not in conflict with the excellent maxim "Buy the best quality you can afford." The advice, when

expertly trimmed, is to buy the best quality but not necessarily to look for it where it is popularly assumed to be, nor to acquire it at absurd cost.

Quality netsuke at bargain prices may sometimes be found in the shops of dealers. Not every dealer is a netsuke expert, but even the expert dealer is inevitably influenced in fixing his prices not only by his costs but also by his prejudices and preferences, his personal likes and dislikes, and his arbitrary opinion about what a particular piece is worth. It is often said that art objects, including netsuke, of course, are blind or half-blind like Japanese masseurs. The "blindness" is in the subjectiveness of value, the impossibility of determining a precise value or of scaling uniform increments for higher or lower quality. Netsuke cannot be precisely priced like a *koku* of rice. At my initial meeting with that Dickensian character W. W. Winkworth, I did not know whether or not he was a dealer. Nor did I know whether or not he would sell any of the hundreds of netsuke scattered here and there about his rooms. In fact I worried that he might find my question brash and offensive. His characteristic response was priceless: "You can buy anything you want. If I don't like it, it's a bargain; if I like it, the price is exorbitant." Most of his prices were £3.50 ($13), the popular price in 1949 for a "good" netsuke, but I had to pay his "exorbitant" price of £40 ($147) for the sea horse (*The Netsuke Handbook,* Fig. 184) because it was one he liked. (In 1949 the rate of exchange for the pound was $3.68.)

CHARACTERISTIC STYLE FOR TOP VALUE To warrant a top valuation, a signed netsuke must accord with the style, subject, and material that are regarded as characteristic of the carver. For example, the Kaigyokusai that establishes a record is his animal in flawless ivory, beautifully posed and formed and elegantly finished. Any variance from typical and characteristic is almost certain to be reflected in a lower valuation. The interest in and competition for the carver's uncharacteristic medium, technique, or treatment are at a reduced level. It is the carver's characteristic work—the *unmistakable* work—that arouses the stiffest competition.

Is this double standard justified? The matter is certainly controversial. The affirmatives say that Kaigyokusai's typical ivory animals were carved in his golden period and are worth more. However, a few observations may be relevant. As a creator, the artist sees the world with fresh eyes.

In his effort to express what he sees he must attempt, test, essay, and experiment with media, with techniques, with designs, and with treatments. He must learn how best to materialize his visions and insights. His efforts are ordinarily a mixture of successes and failures. Some of the successes may please his clientele more than they do him, the carver, while some failures may be so only in the reactions of disappointed patrons. Some art failures, and some successes, are failures and successes only temporarily. A decade or a generation sometimes reverses the judgments. It may be reasonable to suggest that the carver is most conventional when he repeats his popular models to meet the demand and most creative when he experiments with an unfamiliar medium, a new design, or an unusual treatment. His innovative failure may be more interesting, more worthy, than his reduplicated success. Whatever may be his talents and genius, they will be brought to bear as much on his uncharacteristic work as on his popular models.

The higher valuation for the characteristic product may stem from a lack of confidence in our understanding of the artist, from a weakness in our connoisseurship. The carver's characteristic product falls within the expert's sundial and compass; authenticity and genuineness are less open to question. The uncharacteristic work—simply because it is uncharacteristic, though it may be equally authentic—is subject to doubt and uncertainty, not because of poor quality but because of our poor perception. A sounder understanding of the carver's technique and style is essential for the correct decision on the question of authenticity when the model, treatment, or material is unusual for the particular carver. This appears to be the main reason for a lower valuation for the carver's uncharacteristic product: the risk of authenticating error is greater. The imbalance of this attitude is glaring when one considers that the most likely candidate for the fraudulent signature is the carver's typical model—for example, the Kaigyokusai monkey in ivory. Incidentally, Kaigyokusai is a good example to illustrate our point. This great artist carved *manjū, ryūsa, sashi,* and *kagamibuta,* and he worked in ebony, *umoregi, umimatsu,* boxwood, marine ivories, and combined materials. He carved minuscule landscapes as well as single figures. He did not concentrate all his talent and all his genius on ivory animals of a single period.

What identifies the work of Kaigyokusai is not his "characteristic"

model or material but his characteristic *style,* his particular artistry and genius. He "signed" his work regardless of type, subject, or design with his purity, polish, and elegance; in short, he identified himself with his inimitable style, the product of his individual hand, eye, and mind. The style that is his special identification is more impossible to copy than his signature, his material, or his model. This is true of any fine carver. When his carving characteristics and style are recognized, the carver's atypical model may be a more satisfying acquisition than his typical.

FADS AND TRENDS Fads, trends, and vogues do not exert the sudden life-and-death effect on netsuke that they do on the products of modern art, like the deities playing *go* for births and deaths. However, interest in a certain carver or a particular type tends to flare and surge now and then in direct reaction to a record price or to an important article. For example, the record Okatomo horse aroused a sharp increase in interest and price for carvings signed by Okatomo and his followers. Like Kagesue and Takatsuna racing to meet the enemy, collectors pursued netsuke signed Okatomo. Spurred by hopes of finding the equal of the record horse, they paid excessive prices for Okatomos of secondary quality. In racing terms, they paid win prices for place and show pieces. Following the Hull Grundy article there was a sudden sharp increase in the price of Nanka and Nan'yō map netsuke of old Japan. Her article on the stag-antler netsuke of Kokusai was equally catalytic.

In those cases where overlooked and undervalued netsuke are spotlighted to reveal their true worth, the increase in price is most proper. The new price accords with quality. In other cases, however, the response is not so much to quality as to the tendency to join popular movements, to go with the crowd like pyramiding turtles and clustering mice. The president of a great auction gallery wisely noted that fads, vogues, and trends in art come and go, but quality and good taste endure. The collector who assiduously searches for quality rather than for the "in" carver or the trendy model will in the long run pay less and have more. Vogues and trends are temporary; quality is permanent.

THE ANIMAL COLLECTION We all know that earlier Western collectors found their main interest in people, legends, and customs. That

interest is now much diminished; it has been superseded by an overriding interest in animals. Many collectors declare that they want only animals in their collections. If the collector desires to collect animals out of a sincere interest and a natural predilection, he may form a Specialized Collection (see below) of considerable satisfaction and pleasure. However, if he is influenced by the jingle of coins in the marketplace like cash on a string, he might be wise to consider one or two matters. Although the earlier emphasis on legends has been supplanted by the present preference for animals, there is no certainty that the current interest will not revert to legends or transfer to some new aspect. Like the smiling Indian elephant in procession, the public taste moves ponderously and irresistibly but without our knowing its ultimate destination. Furthermore, the *netsuke-shi* who carved the animals that are in such great demand today carved innumerable other subjects as well. They devoted the same craftsmanship and artistry to the one subject that they did to the other. Allowing for the differences in talent and technique that cause one carver to excel in animals, another in people, and still another in flora, it is certainly safe to say that an artist's skill is not affected by his choice of subject. His talent and genius will be displayed in his people and flowers as well as in his animals. His quality will be substantially constant regardless of subject. However, because of the popular preference, the collector must pay a higher price for his exclusive selection of animals. He forgoes the advantage of lower cost of equivalent quality in nonanimal subjects.

THE BEST COLLECTION Some collectors want to have nothing but the "best." They want the best Kaigyokusai, the best Mitsuhiro, and the best horse. Whatever acquisitions they make must be "best of class." They aim at a collection that will be of zenith quality in each and every piece. It is hardly informative to point out that the competitions for the best Kaigyokusai, the best Mitsuhiro, and the best horse are the hottest and costliest. Winning bids are always at record levels, and the collector must be prepared for an exceptionally high unit cost. The collector in pursuit of such rare examples joins the hounds in pursuit of the fox—a small pack, it is true, but much too large for the rarity of the quarry. The number of Kaigyokusais is limited, but the number of collectors is virtually unlimited.

The first question to ask about such an ambition is whether the goal of the Best Collection is attainable. The answer is no, for the reason that what is best in art is neither definable nor measurable in absolute terms. On the contrary, it is variable and subjective. While our collector of the best will not acquire the Best Collection, he may acquire a superb collection, one that is superb in the unanimous opinion of all connoisseurs. However, some collections of superb quality have attained the rank despite the absence of a single Kaigyokusai. In this respect, collecting netsuke does not differ from collecting ukiyo-e, postage stamps, rare books, or Chinese porcelain. There are great collections of ukiyo-e that do not contain an unpublished Sharaku, of postage stamps that do not contain a British 1840 Penny Black, of rare books that do not contain a Gutenberg Bible or a Shakespeare folio edition, and of Chinese porcelain that do not contain a Ku-yüeh Hsüan. Possibly the reason for the sense of deprivation of the collector who finds the Kaigyokusai, Mitsuhiro, or horse beyond his grasp is his proximity in time to the easy availability of these rarities prior to the 1960s. Although fine examples of Kaigyokusai have been acquired by many living collectors—Atchley, Birch, Carré, Gercik, Greenfield, Severin, Weil, Wrangham, and others—the gap in a collection is no justification for frustration or despair. Even without a representative work of Kaigyokusai, superb collections not only are in existence but also are currently abuilding, and others are in a nascent stage of formation.

There is a characteristic of the Best Collection that should be pointed out here as an aid to an understanding of the Specialized or Vertical Collection, which we will discuss later. The Best Collection is on the rarified level of peaks, pinnacles, and summits. It does not descend to plateaus, foothills, and valleys that stretch out between. It is an assemblage of superb examples without any particular relationship except for the fact that all are netsuke. The collection will demonstrate that netsuke are marvels of miniature sculpture. It will also tell us a little about the subject itself. It is, however, lacking in standards, comparisons, and relationships; it is lacking in depth. In geometrical terms the Best Collection resembles the previously discussed Comprehensive Collection. Both rest on horizontal planes, although the Best Collection attains the more rarified atmosphere of a high plateau, like a Kagetoshi pavilion in the clouds.

THE QUINTESSENTIAL COLLECTION Charles Mitchell suggested a type of collection that he applied most successfully to ukiyo-e, a field in which he is a recognized expert. He calls it the Quintessential Collection. He describes the planning and composition of the Quintessential Collection in substantially the following words:

"I had a predetermined limit of 120 prints with a predetermined breakdown according to periods, artists, subjects, and formats. Approximately 25% of the prints were primitives, 50% in the middle period, and 25% in the late period. Each of the six most important artists had to be represented by at least six prints. All other major artists had to have a proportionate representation, and interesting minor artists had to have some representation. The breakdown by subject was 30% actors, 25% beautiful women, 15% erotica, 10% genre scenes, 10% historical subjects, and 5% each birds-and-flowers and comic prints. All of the various formats and techniques had to be covered by the collection in about the same proportion as they occurred in the art itself. It was fun plotting all this out, and it certainly posed many problems in the course of collecting to fill the blanks, but in the end I had something that could be called a Quintessential Collection, and a viewing of the 120 prints would give someone an accurate idea of what ukiyo-e was as a whole."

The Quintessential Collection is easily applicable to netsuke. Instead of ukiyo-e *formats* we would have netsuke *types*. Instead of primitive prints we would have eighteenth-century netsuke. Instead of major and minor artists we would have a range of carvers in our signed examples. Materials have no place in prints but are important to netsuke and would be extensively represented. The Quintessential Collection is quite well adapted to netsuke. It offers the prudent collector important advantages.

Before the collector can embark upon his quest for the netsuke that will compose his Quintessential Collection, he must determine how many pieces he will acquire, which aspects of the art are major and should be emphasized, which aspects are minor and need only thin representation, and finally the percentages he will devote to each facet of the art so that it may be viewed in its entirety. His acquisitions are deliberately plotted and planned in advance with pencil and paper. As the collection takes form and purchases are made, the spaces on the plot are checked off. Thus the Quintessential Collector must be prepared with prior knowledge of

the art and with a thoughtfully deliberated plan. He must know types, classes, materials, periods, regions, subjects, carvers, techniques, treatments, and styles in order to make intelligent decisions about his ideal representations and percentages. The economical benefit of familiarization and study of the subject prior to making acquisitions is obvious. Our largest percentage of errors will usually occur in our initial burst of enthusiasm when we are introduced to the art and each and every netsuke seems wonderful, fresh, and free of flaws.

The Quintessential Collection by its very nature as a deliberately planned operation tends to eliminate certain collecting errors. Many collections grow by haphazard accumulation. The collector buys a piece because it is attractive or of good quality or a bargain or because he feels rich that day. Although he consistently buys good quality, he may find himself loaded with more of a particular type, model, or subject than he needs. His acquisitions are fine, except that they are sometimes duplications or repetitions. Like wild gourds, his collection just grows and grows with no apparent limit in size or balance in representation. A fixed numerical limit and a predetermined plan accord purpose and significance to each acquisition. The plot and plan of the Quintessential Collection requires that each piece shall fill a space and represent the specific aspect of the art for which it was intended. It must "fit" as an integral unit of the entire representation of the art. The one netsuke may serve to represent several different aspects of netsuke. For example, it may represent *manjū* as a type, walrus tusk as material, Ebisu as a subject, Kōgyoku as a carver, and high relief as a technique. Obviously there should be no waste, no misspent money, and no duplication in a Quintessential Collection.

Even though limited to fifty or a hundred units, the Quintessential Collection may be sufficient numerically to represent accurately and adequately the art of netsuke as a whole. As netsuke increase in scarcity and expensiveness, the smaller collection becomes more rational and practical. Collectors may find the Quintessential Collection, with its built-in safeguard against error and waste, a prudent and economical method of collecting.

It is never too late for the collector to turn the direction of his acquisitions into a Quintessential Collection, though it will require the formulation of a game plan and the elimination of netsuke that do not belong.

The Quintessential Collector must have the tenacity to adhere to and persevere with his plan and to refrain from acquisitions, however alluring, that do not fill the voids in his plan. Like Daruma in meditation, he must permit nothing to distract him from his goal. When his collection is completed, he will have the satisfaction of showing, like Hotei opening his treasure bag, a relatively small collection that is nevertheless representative of the art as a whole.

THE SPECIALIZED COLLECTION The Specialized Collection stands in geometric contrast with the horizontal forms of the Comprehensive Collection and the Best Collection. Its form is vertical. It is the in-depth collection. It is the favored collecting approach of critics and connoisseurs whose axiom is "Collect in depth." What does the term mean, and why is it wise to "collect in depth"?

We begin with analogies from the fields of postage stamps and Chinese porcelain. These hobbies have stood the tests of greater numbers and longer time than netsuke. The philatelist soon learns that amassing a few stamps from this country and a few from that, a few of this period and a few of that, a few of one type and a few of another, and a few misprints makes a poor collection. It is an assemblage of unrelated specimens, except for their common classification as postage stamps. It is the juvenile and amateur approach to philately. The knowledgeable collector *specializes,* whether in French colonial stamps or nineteenth-century Canadian stamps or floral stamps or triangular stamps, but he always collects according to his special interests. Likewise the thoughtful collector of Chinese porcelain does not assemble one example each of various periods, areas, types, and glazes but concentrates on Ming blue-and-white or Sung or K'ang-hsi monochromes or Ch'ing export ware. This is the in-depth collection or Specialized Collection. It tells the story of a particular aspect, its origin and development, its flowering and decadence, its evolvement, modifications, and offshoots. It shows standards, relationships, and comparisons. It informs, demonstrates, and teaches. We learn from it and expand our knowledge. Between the high walls of its narrow edifice it reveals the whole story of a specific aspect of the art. It is an eminently effective collection.

Each member of the Specialized Collection is related in some way to

every other member. Each unit gains something from the other units of the collection. Thus the collection as a whole is worth more than the total of its individual pieces. It exemplifies the maxim "A good collection is greater than the sum of its parts." It forms a true collection and it is more valuable as a collection than the totality of the units of which it is comprised.

How may the principles of the Specialized Collection be applied to netsuke? Let us suppose that a collector notes a few pieces signed Tomohisa. (The names of any other little-known carvers will serve as well.) He is attracted by Tomohisa's bold, rough designs, his healthy functionalism, the honest wear and the heavy patination of solid, sturdy wood. He gradually comes to the conclusion that Tomohisa is a fine middle-period carver relatively unnoticed and unreported. He feels that he is not appreciated at his true worth. He decides to collect Tomohisas. By assiduously watching the shops and auctions over a period of time, he gathers together an impressive number of Tomohisas.

What has our hypothetical Tomohisa collector accomplished?

1. He has amassed a unique collection. In numbers and in depth there is no comparable collection of Tomohisa.

2. His collection affords the basis for a survey and history of Tomohisa as a carver: his technique, treatment, and style; his subject matter; his first efforts, development, best period, and late work; his ability and standing; his peculiarities and singularities; his successes and failures; how he compares with other carvers of similar style in the same period; and his probable relationships to other carvers as teacher or apprentice.

3. He has made a contribution to our knowledge of netsuke. He has filled in some of the gaps and voids in our information about Tomohisa. His collection is instructive. It arouses our appreciation and respect.

4. He has revealed a good deal about himself; his personal relationship to netsuke; his individual interests, preferences, and taste.

5. He has accomplished this at low cost. He collected Tomohisa when his merit was unrecognized and at a time when competition for his work was low and limited. Moreover, he acquired not only Tomohisa's "golden period" but also his early work and late work; not only his signal successes but also his telling "misses." As a "complete" collection his Tomohisas are more valuable than the sum of the individual pieces. If his judg-

ment about Tomohisa's quality is correct, the marketplace may eventually reflect an increase in its valuation of Tomohisa, much to the credit of his "discoverer."

The advantages of the Specialized Collection are considerable. It is a collection that is inspired by the collector's individual interests, tastes, and predilections. It accords with his personality and character, even with his whims and idiosyncrasies. It is *his* collection, based on his choice of those aspects of the subject that he finds most appealing and interesting. The collection reflects himself as much as the geisha's image is reflected in her bronze mirror.

An important advantage of the Specialized Collection is the cost, which will be much lower than the cost for an assemblage of choice but unrelated examples. Since the purpose of the in-depth collection is to tell a complete story, it will include examples of crude origins and decadent terminations acquired at low cost as well as the carver's superb flowerings at higher cost. Many specimens and examples, although important for standards, comparisons, and relationships, will cost considerably less than unrelated rarities. The Specialized Collector is apt to find himself a "loner" in the pursuit of his goal. He faces minimal competitive interest from the mass of collectors. Despite the lower cost, the interest and effectiveness of the Specialized Collection may be greater than that of some Best Collections.

Perhaps the most exciting prospect open to the Specialized Collector is that of uncovering a carver, a technique, a type, or a subject that for one reason or another is unnoticed, neglected, ignored, or unappreciated. He has the opportunity to pursue his natural partialities and preferences and at the same time to focus attention on some hitherto overlooked group of netsuke. In recent years a considerable volume of literature has been published that has led directly to reappraisals of individual carvers, classes, types, and materials. The possibilities are quite numerous. They are waiting for their rediscoverers.

A collector shocked her colleagues with the declaration that she intended to limit her collection to the animals of the zodiac and to dispose of all the rest. Someone asked, "Do you mean twelve netsuke?" No, no, she hastened to explain, she wanted zodiac sets in ivory, wood, stag antler, metal, and other materials. She wanted signed sets by Minkō, Masanao,

Ikkan, Tomokazu, and other carvers. She wanted unsigned sets. She wanted an outsize set and a miniature set. She wanted a set of family groups and a set of conjugal mates. She wanted examples of all the zodiac combinations, including examples of the twelve-in-one tour de force. She enumerated many other zodiac rarities.

Her goal illustrates how diversified a Specialized Collection may be, even within narrow confines such as the zodiac animals. Her collection will fall short of full attainment, but it will furnish standards, comparisons, and nuances about the animals of the zodiac—a richness and depth that can only be obtained in a Specialized Collection.

EXAMPLES OF SPECIALIZED COLLECTIONS Actual instances of successful Specialized Collections may be inspiring or at least suggestive. H. A. Gunther, a doctor of medicine, collected and lectured on netsuke of medical interest, which he classified as anatomical, therapeutical, pathological, and obstetrical. To her everlasting credit, Anne Hull Grundy focused attention in her articles on the stag-antler netsuke of Kokusai, the map netsuke of Nanka and Nan'yō, botanical netsuke, and the unique netsuke of Iwami. The Horodisches, a husband-and-wife team, collect, study, and write about Kamman, one of the Iwami carvers. An actress, June Graham, collects Noh masks and other theatrical netsuke. Cornelius Roosevelt collects macabre and grotesque subjects. Both Mark Severin and J. van Daalen study the materials of netsuke and have made Specialized Collections of materials. Adolph Kroch owns a fine collection of pottery and porcelain netsuke representing many famous kilns and potters. Anthony Murray collects vegetable and fruit netsuke. U. A. Casal, being primarily interested in lacquer, made a large Specialized Collection of netsuke in this medium. Giichi Omoto was fascinated with wrought-iron and cast-metal netsuke and collected many hundreds of examples. An anonymous Japanese collector of swords and *tsuba* made a cognate collection of remarkable *kagamibuta*. These are a few actual instances of collectors who followed their deepest interests in forming collections that are a reflection of themselves.

The choices for Specialized Collections are as endless as the space the Dutchman searches with his spyglass. They are as multitudinous as the seeds of the cucumber, aubergine, and pomegranate. They are as varied

as the human personality and as diverse as human interests. Once we discard the shackles and fetters of the Best Collection, once we break away from conventional responses to the marketplace like Asahina Saburō tearing the suit of armor from Soga no Gorō, our imaginations tend to run amuck with ideas both ordinary and radical for Specialized Collections. Penchants and proclivities may take the reins like Gentoku and his horse recklessly hurdling a ravine and lead collectors to choices that are no more predictable than the lightning bolts of Kaminari.

LEARNING THE SUBJECT The ultimate preparation available to the collector who would like to find higher quality at lower price is at once the most elementary and the most sophisticated preparation of all. It is to learn the subject, to learn it as sincerely as Shaen studying by the light of glowworms. No one knows instinctively what a good netsuke looks like, nor does anyone know intuitively the elements that constitute a good netsuke. The collector must absorb the basics in a gradual accretion of understanding. Likewise, good taste in netsuke is not an instantaneous revelation. It is usually a gradual development. Most collectors readily concede the improvement of their tastes over previous years. Good taste, like the Four Gentlemanly Plants, requires careful nurturing and tending for a mature blossoming.

An eye for sculpture may be an innate quality, an almost intuitive understanding. But sculpture is not always netsuke, although the reverse is categorically true. Sculpture is a free form, and the netsuke is not. It is a restricted form, and the restrictions must be learned to be understood and appreciated. A natural good eye means a head start, an enviable beginning, but it is not enough. Just as a good ear without musical training will not enable one to play the flute as sweetly as Yasumasa, so also a good eye will not assure a fine collection without some application and study.

The collector who boasts "I do not know anything about netsuke; I just buy what I like" makes a statement that is not very profound. Of course he buys what he likes. If he doesn't buy what he likes, what does he buy? If he doesn't buy what he likes, he had better not collect. The collector who doesn't know anything about netsuke will benefit by learning. If he should be blessed with innate good taste, he may develop expertness by listening and looking, like gifted students who earn degrees

without cracking a book. For most of us, however, reading, discussing, examining, and studying are an essential though happy regimen for graduation to connoisseurship. The emotional response to a superb netsuke may be as intense for the collector who never learned types, materials, legends, subjects, origins, history, and other "technical" information as for the expert, just as the emotional response to music may be as great for the listener who cannot hum a tune as for the trained musician. But the intellectual pleasure, if not the emotional response, of the musician is profoundly enhanced by his understanding of theme, harmony, and counterpoint. So also is the intellectual pleasure greater for the collector who understands subject, history, material, carver, allusion, proverb, and meaning.

Some collectors seem to have a positive propensity for choosing bad netsuke—carvings that are best classed as non-netsuke. They may be bulky *okimono* types or brittle angular compositions of minutiae or commercial crudities. "Whatever they are," say knowledgeable collectors, "they are not netsuke." They are utterly unfunctional or clumsy atrocities. Our misguided friend exhibits his non-netsuke "treasures" with such obvious pride and pleasure that one is placed in a quandary between insipid pretense and brutal honesty. Perhaps the better course is to avoid outright condemnation and to attempt a patient explanation of the basic requirements of a good netsuke and a gentle comparison of his selections with those preferred by recognized experts. If the explanations and demonstrations fail to register after a few efforts, and irritation and frustration begin to mount, it may be best to desist and to accept the situation. The collector loves his *okimono* netsuke, his unfunctional monstrosities, and his commercial crudities—and loves them faithfully despite confrontation with genuine examples and rational explanations. In such cases further insistence would appear to be a deliberate effort to undermine his pleasure, which one should no more try to do than to deprive a *karako* of his spinning top. He is entitled to the protection of the maxim of the ancient hedonists: "If the pleasure is equal, pushpenny is as good as philosophy." Our collector of non-netsuke has one advantage: his non-netsuke usually cost less than sophisticated choices.

To summarize, if netsuke are worth the money they cost, they should be worth the time and effort they require to understand them. Learning

netsuke, like learning any art form, is a gradual accumulation, a slow development of visual and critical acuity, a crystallization of standards, and finally a complete rapport with the subject. There is no magic formula and no secret shortcut. The road is as tortuous as the *sennin's* forest path and as wondrous as Momotarō inside a peach.

THREE LEVELS OF COLLECTORSHIP The benefits of study may be perceived on three levels. At the basic level the collector learns the distinguishing characteristics of a netsuke; its use and function; materials and how to recognize them; types and classifications; origin, development, and decline. He begins to distinguish old from new, genuine from copy, crude from fine, and commercial from craft. He learns that *baku* and *kudan* are rare, that Mitsuhiro was a great carver, that marine ivory glows with a special luster, and other minutiae. He may make some poor choices, but he will learn to rectify his errors.

Oriental dealers, and some collectors too, advise neophytes in maxim form: "Buy your experience." It is a variant of "Learn by your mistakes." They mean by this that the toll for mistakes exacted by the purse makes the most unforgettable lesson of all. The advice is tinged with cynicism. It is true, of course, that experience is a great teacher and we must all learn from her, but there is no wisdom in buying first and discovering the mistake second. As the Chinese sages reasoned, the experience by which one learns need not be one's own. One can learn from the experiences of others and save oneself costly errors. The capsule advice of the numismatists "Buy the book before the coin" is much sounder advice. The coin book distinguishes the genuine from the counterfeit and gives dates, identification marks, and values. The coin collector avoids mistakes at the small cost of the book and the time to study its pages. In the same way the cost of a good library on netsuke may be less than that of the purchase of one netsuke that was priced for fine quality but was actually inferior.

At the intermediate level, to which serious study and application should bring the collector, he will be better informed than the majority of Oriental dealers, except for those few who are specialists in netsuke. There is no exaggeration in this declaration. For most Oriental dealers the netsuke is only one small item among a large stock of numerous categories. Many do not even pretend to be knowledgeable, except the less **reliable**

ones, whose expertise rises in direct proportion to the ignorance of the customer. The intermediate collector knows after the first few comments whether the dealer is knowledgeable and the extent to which his statements may be relied upon.

The advantage to the intermediate collector who knows more about netsuke than the dealer is considerable. The inexpert dealer will often price his stock unevenly, particularly when he has acquired a collection as a lot. The collector enjoys the possibility of acquiring better netsuke at lower prices. The intermediate collector is not overawed by the dealer, and at the auction sales he makes his choices and fixes his limits confidently.

At the third level the collector is an expert in his own right. His standards and opinions, developed over a period of time, are his own. He knows that there will always be controversial netsuke, conflicting opinions, disparate valuations, and questionable standards, but he is also aware that disagreements among experts are limited to a tiny proportion of netsuke. In the larger areas there is near total accordance among experts. Therefore an opposing opinion, however vehement, will not unsettle him. When he shows a fellow expert—a dealer, for example—his latest prize, which he felt lucky to acquire for $1,500, and the dealer says with feeling, "What an exquisite netsuke! If I owned it, you could not buy it from me for less than $500," his feelings are no more ruffled than is the plumage of the stately phoenix.

The expert's standards may or may not accord with popular standards. He may judge a favored model as repetitious, a favored carver as commercial, or a favored technique as overrated. He may feel that some carvers of the earlier periods were commercial, just as some are in the later periods. He may regard the clamor for certain carvers, subjects, and techniques as more indicative of temporary trend than of permanent quality. On the other hand, he may perceive an allusion, a meaning, or an interesting treatment in some neglected netsuke. He may recognize some quality or some originality in an unappreciated carver. He may collect certain overlooked netsuke that according to his standards are undervalued. If his judgments are established in the crucible of time, his bargains of yesteryear may be the record breakers of next year.

NETSUKE FAMILIAR AND UNFAMILIAR Our familiar and unfamiliar netsuke are separated into forty-five categories. (See Table of Contents.) The categories have no particular relationship. They were selected for their interest and availability and out of a desire to expand our netsuke horizons. Numerous other categories that might have served the purpose as well or better will occur to collectors. Any of them may be suitable subjects for Specialized Collections. A collection that illustrates proverbs, *sennin,* inlays, toys, techniques, foods, fish, or clothing and styles may be as interesting as a collection based on the work of an unrecorded carver.

With equal appropriateness "familiar and unfamiliar netsuke" might be called "common and uncommon netsuke." "Common" here is not used in the sense of ordinary, mediocre, or commercial. The sense is "popular and appealing to a large segment of the Japanese in contemporary Edo times." "Common" has the sense of familiar. Western collectors may find little excitement in common netsuke such as gourds, *mokugyo,* dolls, and seals, but it is salutary to remind ourselves, lest we feel superior, that it was the Japanese who created and nourished the art. The *netsuke-shi* catered to the good taste of their patrons, who wore the netsuke on their persons and who preserved the masterpieces we now cherish in our collections. If they appreciated and loved some common ones, perhaps we should look more sharply at them for some *uncommonness* we may not have perceived. Perhaps there are common netsuke that do not deserve to be neglected, ignored, or unappreciated.

As for uncommon netsuke, many are uncommon for reasons other than mere good quality. Some are unusual, rare, extraordinary, or unique because of an exceptional aspect. They may be superb as well as uncommon, but uncommonness, not quality, was the basis for their selection. As in the case of common netsuke, which we tend to dismiss as ordinary, we may dismiss uncommon netsuke because we do not recognize some rarity, whether of subject, symbol, allusion, proverb, technique, or treatment. We are the losers when we view the art through the facile but forced frame of Western conceptions. We are the gainers when we try to perceive the art through Japanese eyes and with some understanding of Japanese aesthetics.

FAMILIAR AND UNFAMILIAR NETSUKE

SIZE OF ILLUSTRATIONS

Illustrations are approximately life size except for the larger netsuke, which have been reduced to approximately two-thirds to one half life size. The following is a list of the figures that are reduced in size.

4	79–80	182	331	479	619	740
7–9	82	187	338	497–98	626	742
11	84	194	353	504	669–70	746
19–20	88	196	365	506	673	749
25	93	247	367–68	509–10	676	751
29–30	95–96	265	370–71	513	678	759
32	121–22	271	378	523–25	690–91	761–62
35–38	130–31	275	380–81	528	693	768–71
43	138	295–97	393	545	703	773–75
47	142–43	299	414	554	709–10	778–79
59	145–48	302	416–26	556	718	786–87
63	154	312	458	572–88	733–36	789
76–77	156	320–22	476	598		

ADOPTED AND ADAPTED NETSUKE 1

Because of their attractiveness, suitability, and exoticism, articles of foreign origin were sometimes utilized as netsuke. We may say that the foreign article is adopted when no alteration is necessary to make it function as a netsuke. We may say that it is adapted when some alteration or modification—often the addition of cord holes (*himotōshi*)—is necessary before it can be used as a netsuke. The Siamese chessman (Fig. 1), the Tibetan silver seal (Fig. 7), and the Javanese kris handle (Fig. 11) are examples of articles of probable foreign origin used as netsuke, though quite similar models were copied by Japanese carvers. The Siamese chessman is an example of adoption, since no modification of its original form was necessary. There is an obvious place for the attachment of the cord. The Javanese kris handle is an example of an adapted netsuke. An aperture was provided for the attachment of the cord. The handle may also have been shortened.

Figs. 2 and 9 show what appear to be articles of Oceanic origin adapted as netsuke. The base in Fig. 2 is engraved with a seal. As is well known, the Japanese naval, fishing, and merchant fleets frequently visited the islands of Micronesia and Melanesia—a fact that accounts for the occasional conversion of South Sea articles into netsuke.

Chinese toggles were frequently utilized as netsuke. Those shown in Figs. 5, 8, and 10 appear to belong to this category. The porcelain *karako* in Fig. 12 may or may not have been produced in a Japanese kiln, but similar pieces were fired in China for export to Japan. We know that many *tsuishu* (red lacquer) *inrō* were made in China for sale to the Japanese.

The quandary over the answer to the question whether an antique netsuke is foreign in origin or a Japanese copy of a foreign article is clearly indicated by the ambiguity of the Japanese terms. *Tōbori* may mean a Chinese carving or a Chinese-style carving. *Tōbutsu* and *karamono* may mean a Chinese article or a Chinese-style article. Some of the netsuke illustrated in the *Sōken Kishō* as well as some of the netsuke illustrated here may be netsuke of foreign origin, or they may be Japanese netsuke simulating foreign articles. Opinions will assuredly differ in some cases. The uncertainty is particularly true in the case of seal netsuke. (See Category 35.) Early Japanese craftsmen were strongly influenced by Chinese teaching and technique in carving the handle of the seal and engraving the base. Moreover, Japanese seals were customarily engraved with Chinese-style characters. An analogy may be seen in the case of some early paintings in which it is difficult to distinguish between the work of the Chinese artist who lived and taught in Japan and the work of the Japanese artist who studied and applied Chinese painting methods.

In Japan a main source of foreign articles and replicas used as netsuke was the *getemonoya*: the secondhand or junk shop. Invariably these exotic foreign pieces were attached to pouches and purses of cloth, hide, or leather showing considerable age and use. They found their way into the *getemonoya,* which were usually overlooked or ignored as sources of unusual netsuke. Dimly lighted, dusty, and congested with broken furniture, these shops were altogether unpromising. It is no wonder that most collectors passed them by. During the past decade, however, even these *getemonoya* have been depleted of their stocks of netsuke.

1. Siamese chessman. Ivory. Unsigned. Collection of Melanie and Ben Grauer. The base is an engraved seal. A similar piece is illustrated in the *Sōken Kishō*.

2. Oceanic faces (two views). Wood, with attached metal bits to represent facial features. Unsigned. The base is an engraved seal. It is slightly visible in one of the two views. The *himotōshi* can be seen in the other view. The engraving is a later addition.

3. Chinese shoes. Wood. Unsigned. Ex Hazel Gorham Collection. This netsuke is replete with felicitous symbols. The monkeys are attached to a man's shoes by plugs in the form of a woman's shoes. The meaning is conjugal happiness: walking through life in mutual support. The monkeys symbolize easy birth and generations of numerous sons succeeding one another. For explanations of the puns and rebuses in such designs, see Schuyler Cammann: *Substance and Symbol in Chinese Toggles*. The identical model is carved in both China and Japan. A strong proof of the Japanese origin of this example is the fine finish on the *inside* of the shoes—an attention to detail generally ignored by the Chinese craftsmen.

4. Jurōjin, deer, and sacred mushroom. Bamboo. Unsigned. For another example of the subject, see Fig. 415.

5. Chinese god of wealth (Liu Hai). Boxwood. Unsigned. Collection of Brigette Horstmann Johnston.

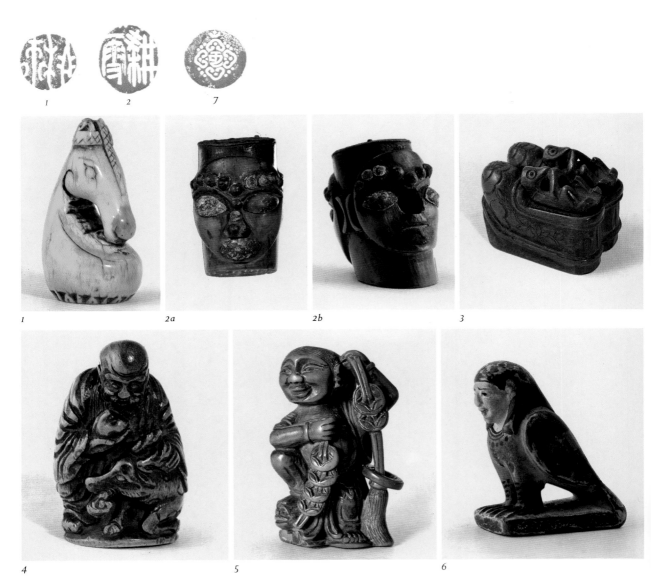

1 2 7

1 2a 2b 3

4 5 6

6. Egyptian deity. Colored wood, probably paulownia. Unsigned. The general signs of wear, the erosion of the cord hole pierced through the base, and the attachment to an old pouch tend to confirm that this exotic piece was carved in Japan, though certainly from a foreign model.

7. Tibetan seal. Silver. Unsigned.

8. Lotus, crab, frog, and insect. Wood. Unsigned. The stems, on which there is *ukibori* pimpling, are entwined for the cord attachment.

9. Oceanic head (two views). Wood. Unsigned. The animalistic feature of mouth and teeth is visible in the horizontal view.

10. Chinese Gama Sennin seated on a toad. Bamboo. Unsigned.

11. Javanese kris handle. Indonesian ironwood (*tagayasan*). Unsigned. A similar piece is illustrated in the *Sōken Kishō*.

12. Chinese child (*karako*). Porcelain. Unsigned. Some *inrō*, particularly of *tsuishu*, and some netsuke were made in China for the Japanese market. It is sometimes difficult to ascertain whether a particular porcelain netsuke was fired in China or in Japan. The illustrated *karako* is an instance. According to one porcelain expert, the perfect positioning of the *himotōshi* and the cobalt blue, which is a shade not found in Chinese porcelain, prove Japanese origin—most likely the product of one of the kilns around Imari. An equally eminent expert is equally certain of Chinese manufacture. He maintains that the face and posture of the *karako* are pure Chinese and that marked affinities with elements of well-known types of Chinese porcelain leave no doubt of Chinese origin. The criteria indicating Chinese origin appear to be balanced against those indicating Japanese origin.

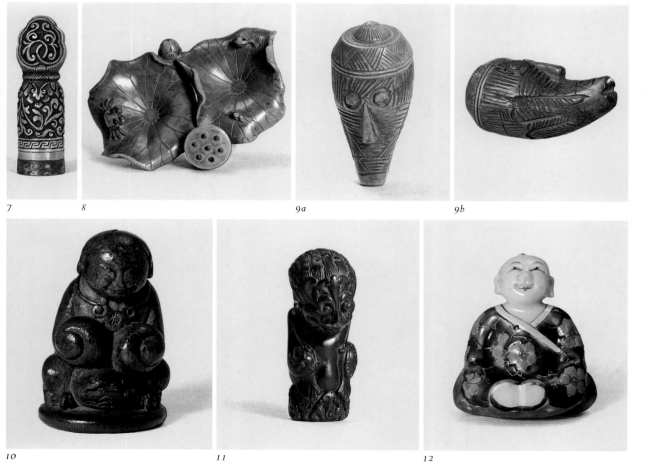

7 8 9a 9b

10 11 12

2 AMATEUR CARVERS

There is no definite status of amateur in the art of carving and certainly no clearly defined category of amateur netsuke carvers. In the history of Japanese art we find references to amateur painters. These were usually members of the leisure class who painted for their own amusement and pleasure. For them, painting was an aesthetic activity like composing poetry and identifying incense. They were amateur in the sense that they were not concerned with the financial reward of the professional painter. The Nara-e-bon paintings of the Edo, or Tokugawa, period that illustrated the tales and romances (*monogatari*) of a previous era are examples of amateur painting.

There seems to be no analogous amateur activity in fashioning netsuke, though there are some well-known carvers who created netsuke as a hobby or pastime. The reputations and financial returns of the hobby carvers as *netsuke-shi* deprive them of a claim to the amateur status of the anonymous Nara-e-bon painters.

As we are not burdened with a specifically defined category of amateur carvers, the illustrations selected here are of a type of netsuke that may qualify as amateur work. These are attractive stones, shells, burls, and roots that a man in need of a netsuke might have found and fashioned for his own use, saving the money that he would have spent for a netsuke and using it instead for the purchase of the tobacco to fill his empty pouch. His more ambitious or more talented neighbor may have spent less time in selecting the material and more time in carving, as suggested by the more sophisticated of the illustrations. Amateur carving should not be confused with *mingei,* as discussed in Category 23.

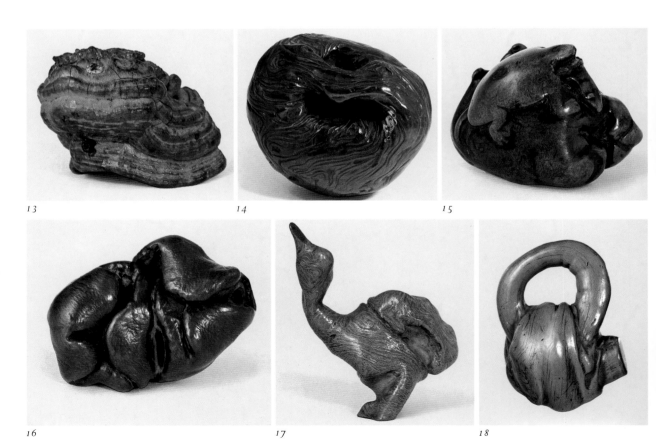

13

14

15

16

17

18

13. Frog. Monkey's chair (natural mushroom). Unsigned. The monkey's chair grows in the decay of pine trees. It is as solid and dense as wood when dried. The frog's mouth is reddened, the eyes metal.

14. *Mokugyo* shape. Burl. Unsigned. The handle of the "*mokugyo*" serves for the cord attachment.

15. Turtles. Burl. Unsigned. The carver saw the turtles in this random burl, emphasized them by cutting and polishing, and accented one of them by inlaying crude metal eyes.

16. Abstract shape. *Daidai* (bitter orange) rind. Unsigned. The thick, easily removed rind is shaped by thumb pressure and lacquered. It hardens to the density of wood. *Daidai* also means "generation after generation," and the fruit is often used in felicitous New Year's decorations.

17. Bird shape. Root wood. Unsigned. A netsuke like this calls for a seeing eye to discern the bird in the chance shape of the root. All else is minimal cutting, shaping, and making cord holes.

18. Knot. Wood. Unsigned.

19. Mollusk. Bamboo. Unsigned.

20. Fish shape. Root. Unsigned.

21. Stone. Unsigned. The sea shaped the piece and started the *himōtoshi;* an amateur did the rest.

22. Monster-headed reptile. Root wood. Unsigned.

23. Drum shape. Wood. Unsigned. This single-block carving has a rattling "pebble" inside.

24. Monkey face. Burl. Unsigned. Collection of Abram and Lou Gercik.

25. Daruma. Root wood. Unsigned. Sometimes embedded volcanic material forms the face.

26. Twisted ball. Bamboo. Unsigned. The ball is twisted, probably from one of the varieties of *sasa,* the smallest of the bamboos. It is formed of a single length, since only two ends are visible.

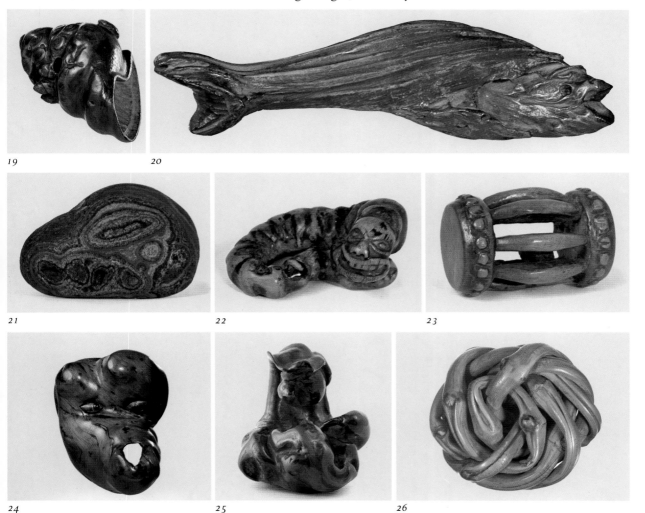

19

20

21

22

23

24

25

26

3 ASIATIC AND OCEANIC SUBJECTS

With only twelve netsuke, the illustrations for this category represent a considerable variety of peoples: Chinese, Mongolian, Taiwanese, Indian, Malay, Ainu, and Oceanic. The netsuke furnish an instance of the interest that may be generated by a Specialized Collection (see main text) and the rapidity with which such a collection may be built. One like this would have a particular appeal for those with a bent toward ethnology and the races of man. It may be worth noting that these examples are clearly Japanese in origin, though Ainu netsuke are included for geographical reasons.

27. Seated Chinese. Ivory. Unsigned. The Chinese wears a pigtail, which is not visible in the illustration. His stretched arms indicate that he is practicing a form of static exercise.

28. Two-hatchet Chinese. Ivory. Unsigned. The inscription, reading "Kokusempūriki," is the name of one of the 108 bandit heroes of old China whose murderous exploits are related in the *Suikoden* and graphically portrayed in the "blood and guts" prints of Toyokuni, Kunisada, and other ukiyo-e artists.

29. Malay. Wood. Unsigned. Ex Isobel Sharpe Collection. Ex Mark Hindson Collection, No. 1298. Illustrated in Neil Davey's *Netsuke,* Fig. 1188. The sarong is the main indication that the figure represents a Malay.

30. Regal person mounted on *shishi.* Wood. Unsigned. The toylike figure

31 33

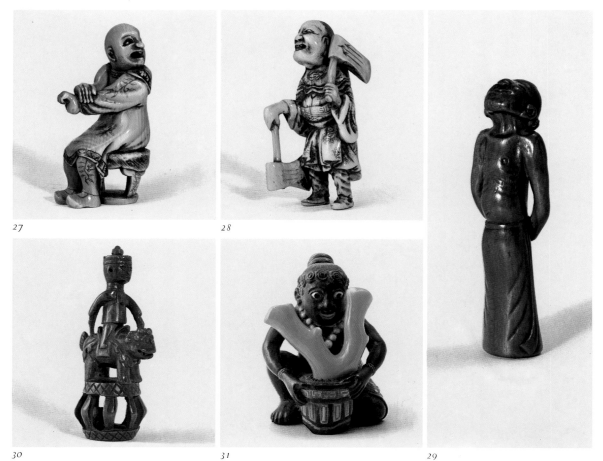

27 28

30 31 29

wears a crown and is mounted on a caparisoned *shishi* that stands on a drum enclosing a loose pellet. The origin and significance of this peculiar piece are uncertain.

31. Coral fisherman. Wood, with inlays of coral, stone, metal, and lacquer. Seal signature on metal label: Mune (a single character). The figure represented is an aborigine (*dojin*) of one of the Micronesian islands.

32. Seal. Wood. Unsigned. This seal exhibits the characteristics of pure Ainu carving.

33. Ganesha. Wood. Unsigned. The elephant-headed deity originated in India, where he is the god of wealth and worldly wisdom. Like Daikoku, he is particularly popular with tradesmen and merchants. He is portrayed here closely embracing his mirror image. The base is engraved with a seal.

34. Ainu. Ivory. Unsigned. The "Hairy Ainu" persist in small clusters of population around Sapporo in northern Japan, but they are gradually being submerged in a sea of Japanization. Their Caucasian origins are still visible in their hairiness, though other "white" characteristics have all but disappeared. Their customs and traditions play a large part in preserving their racial distinctiveness.

35. Ainu. Wood. Unsigned. He carries a flenser, as used by a whale or walrus fisherman.

36. Mongolian archer. Ivory. Unsigned. The position of his right arm and hand indicates that he has just released an arrow.

37. Mongolian archer. Wood. Unsigned. The double-curved bow is characteristic of the Mongolian archer.

38. Taiwanese (Formosan). Wood. Unsigned. The Taiwanese aborigine is rarely portrayed in netsuke. The omission is quite surprising in view of Japan's intimate association with the island.

32 33 34

35 36 37 38

4 BAMBOO NETSUKE

Bamboo is extremely prolific, ubiquitous, and cheap. It grows so fast—a yard a day in some species —that it reaches its full height in a single season, quite unlike the growth of trees measured in decades if not centuries. The single word "bamboo" suffices for most needs, but the craftsmen who work with bamboo employ an extensive vocabulary to identify species, parts, and characteristics. In most cases there are no English equivalents. We are reminded of the delicious complaint of the frustrated translator who said that every word in Arabic stands for itself, its opposite, and something to do with a camel. Most bamboo netsuke are carved from *chikkon,* a term that includes both the true root (rhizome) and the underground portion of the culm, or stem, which are solid. Other bamboo netsuke are carved from the hollow culm or from certain species that have solid or partially solid culms. As may be noted in the illustrations, *netsuke-shi* often selected rare and abnormal bamboo growths for their efforts.

The abundance of bamboo and its negligible cost have a most purifying influence on the artists and craftsmen who fashion it and on the collectors who treasure it. Since the price of the material is inconsequential, the product stands solely and squarely on the craftsmanship and artistry with which it is endowed. There is no fine, rare, or costly material to intrude on a pure artistic judgment. In contrast with the case of the netsuke in lustrous ivory or rare wood, there is no allocation for material to confound an aesthetic appreciation of the bamboo netsuke. The collector who treasures his bamboo netsuke does so solely for their artistry.

39. *Manjū.* Bamboo. Unsigned. The speckling resembles that of a type of bamboo known as *gomachiku,* or sesame-seed bamboo, which is simulated by the sharply defined fiber-bundle endings in this example.
40. The Six Great Poets, or Rokkasen (two views). Bamboo. Unsigned. The markings on the reverse side are those of what is known as *toramonchiku,* or tiger-mark bamboo. They are found on the skin, or bark, of certain species. For other versions of the subject, see Figs. 121 and 570.
41. Fox. Bamboo. Unsigned. The unknown carver took marvelous advantage of a rare abnormal bamboo growth. The lean, feral character of the fox seems almost to have carved itself.
42. Carp. Bamboo. Unsigned. Made from the rhizome, or true underground horizontal root.
43. Bird. Bamboo. Unsigned. Made from the part of the culm (in trees we would say stem or trunk) that grows underground and corresponds to root. "Bamboo root" (*chikkon*) is used loosely to include the underground section of the culm, or stem, although the true root is the rhizome that travels parallel to the earth, binding all the bamboos in the clump together like a chain.

39 40a 40b

44. Kannon. Bamboo. Unsigned. Although the piece is unsigned, the *tomobako* (original box) bears the inscription "Showa 18 [1943] at Gojo [section], Kyoto, Fusae humbly carved." The remarkable story of Fusae Shimizu—better known by her art name Senshū—and her dedication to carving Kannon has been frequently published. Her work began as a contribution to the war effort. She assisted her father in the family enterprise of bamboo carving. Father and daughter carved thirty-three bamboo Kannons to send to front-line soldiers for attachments to their pocket Buddhas as protective amulets (*o-mamori*). Transportation to the front broke down, and the plan failed. (Fig. 44 shows one of the thirty-three intended for the soldiers.) Out of this frustration grew Senshū's ambition to carve one thousand Kannons. She is fascinated by the subtle challenge of imbuing a bit of bamboo with spiritual grace. She had the benefit of her father's teaching, and she clearly recalls his advice: "Use your knife economically. Select your bamboo to best advantage. Cut near the node, where a natural spread suggests Kannon's flaring robe. The goddess's figure must stoop a little to show that she carries the burden of humanity, yet her shoulders must be strong enough to show her power." Simple as they seem, Senshū spends at least ten days on each Kannon. Some years she makes only a few; one year she made only one. She finds peace of mind essential for a successful effort. The face poses her most difficult challenge. She must summon intense concentration to instill a profound sense of spirituality in her carving. She says that she carves bamboo Kannons with her heart. She despairs at age sixty-one of completing one thousand Kannons. Her last was her three-hundredth (Fig. 45). In comparing the two efforts shown here, she feels that the face of Kannon has matured, just as has her own. The narrow waist of the Kannon serves for attachment of the cord.

45. Kannon. Bamboo. Unsigned. *Tomobako* signed and sealed "Senshū tō."

46. Rhinoceros beetle. Bamboo. Unsigned. Made from a selected node of Hotei-chiku, or Hotei-belly bamboo.

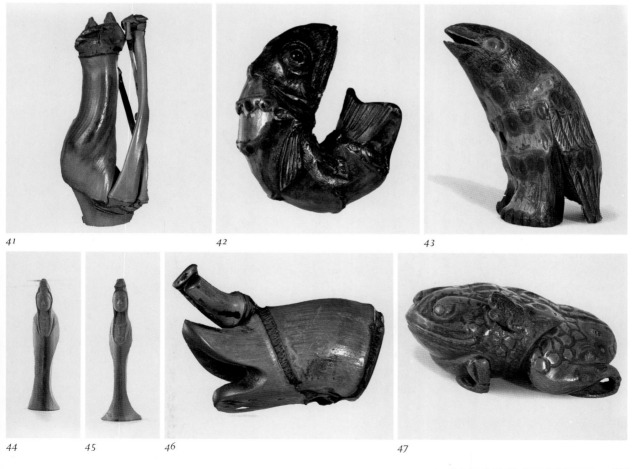

41

42

43

44 45 46 47

47. Frog and young. Bamboo. Unsigned. The frog is carved from the underground portion of the culm—a portion characterized by *higene* (whiskers roots), which, like tangential braces, lend additional support. The baby frog is secured to its mother by a peg and an eyelet for attachment of the cord.

48. Leaf. Bamboo. Signed: Keisai. A rare bamboo growth cleverly carved and treated.

49. Raconteur (*rakugoka*). Bamboo. Signed: Heian [Kyoto] Yoshitomo. Made from *kikkōchiku,* a variety of bamboo shaped like alternating tortoise shells. When the bulge of the carapace is less exaggerated, the variety is known as Buddha-belly or Hotei-belly bamboo.

50. Sparrow. Bamboo. Signed: Chōzan. Made from the solid part of the underground culm.

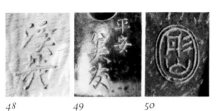

48 49 50

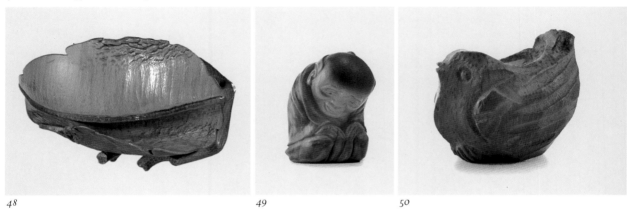

48 49 50

5 BAMBOO SEALS

In view of the cost of the material, the seal maker would not usually carve the handle of the seal until he had had a discussion with his client and they had agreed upon a suitable subject. Of course he would never engrave the base until his client had chosen the characters or monogram he wanted carved. It was wasteful to precarve seals no one might order. The seal maker maintained a stock of blank seals in various materials from which his clients could choose according to their requirements or affluence. An aristocrat might select semiprecious stone or silver, a tradesman coral or ivory, and a farmer ordinary wood or bamboo.

In contrast with many other materials, bamboo, as we have already noted (see Category 4), was prolific, ubiquitous, and cheap, and some seal engravers filled idle moments by practicing their art on it. If no one took a liking to their carved bamboo handles, the loss was negligible. The bamboo seals illustrated are the products of traditional seal engravers who carved the handles for pleasure and self-expression. I purchased most of them for ridiculous pittances during the period from 1945 to 1950. The seal makers were perplexed by the strange foreigner who bought so many of their bamboo handles but never ordered a seal to be engraved.

The old-style seal shops are fast disappearing. The descendants have little incentive to continue their fathers' profession. The traditional hand carving is being replaced by the smooth-lathed handle and the rubber stamp.

51. Bon *odori* (Bon Festival dance). Unsigned. Unengraved. The Bon *odori* is a community folk dance performed by young and old alike at the summertime festival known as Bon, or the Feast of Lanterns. The movements and gestures are very simple. The netsuke, like those in Figs. 54, 55, 58, and 59, was carved from a particular variety of bamboo that is solid or almost solid and, in this regard, unlike other varieties of bamboo, which are hollow. Thus these five examples are carved from the culms and not from the roots.

52. Badger. Unsigned. Engraved seal. Made from the rhizome (horizontal root) connecting the bamboos in a grove or clump.

53. Weird bird. Unsigned. Engraved seal.

54. Man playing a *shakuhachi* (flute). Unsigned. Unengraved.

55. *Shishi*. Unsigned. Unengraved.

52 53

51 52 53

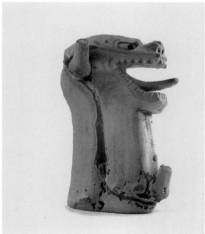

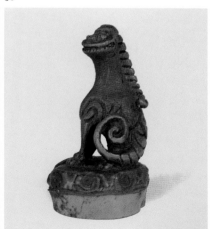

54 55 56

56. Fantastic animal. Unsigned. Unengraved.

57. *Shishimai* (lion dance). Unsigned. Unengraved. Made from the wall of an exceedingly large culm that developed an unusual texture through severe weathering.

58. Man astride badger. Unsigned. Unengraved. Two or three nodes at the same joint are a most abnormal growth. It is the rarity of the material that probably attracted the craftsman to his selection of it.

59. Camel. Unsigned. Unengraved.

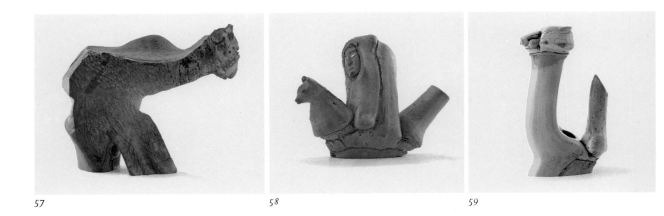

57 58 59

6 BITS AND PIECES

A netsuke may be unimportant and unpretentious, even insignificant, yet retain some element of interest or amusement that justifies one's pleasure in owning it. Some of the bits and pieces shown here seem to have been carved from remnants of material too small or too oddly shaped for a full-sized, full-time effort. However, not all bits and pieces are undersized. Some seem to have been carved for fun and amusement or as a casual gift for a child or a neighbor. Sometimes the carving is excellent, even though the finishing and polishing—a laborious process—is incomplete. The collector may read in some of these bits and pieces that a capable carver temporarily dispensed with concern about critical opinion—dropped his guard, so to speak—and unpretentiously and unselfconsciously turned out a hobby piece just for fun. However modest in conception and execution, some bits and pieces are well worth collecting, even if not worth a great price.

Another type of bits-and-pieces netsuke is the representation of common objects—for example, a bridge post, a signboard, a garden basket, or a charcoal log. A netsuke classed as belonging to bits and pieces should not be confused with bad netsuke or with a carver's third-rate effort.

60. *Kappa*. Stag antler. Unsigned.

61. Cash on a string. Stag antler. Unsigned. Copper coins (*zeni*) were current in early Edo times. One of the two coins here is coin of the realm; the other is stamped to show that it is legal tender only within the jurisdiction of the daimyo of Sendai.

62. Tea caddy (*natsume*). Wood with ivory cover. Unsigned. The wood is lacquered to suggest glaze.

63. Bamboo node and leaves. Stag antler. *Sashi* type. Unsigned.

64. Bridge post. Wood. Unsigned. A bridge post of the type used for the original Nihombashi (Bridge of Japan) in Edo, from which all distances in Japan were measured. This bridge was the eastern terminus of the Tokaido highway, which passed through fifty-three stations (the subject of Hiroshige's famous series of prints) and had its western terminus at the Sanjo Bridge in Kyoto.

65. Bridge post. Buffalo horn. Unsigned. This post is more ornate that the one shown in Fig. 64. Whatever the variation, the cupola is an integral element of the Japanese bridge post. It is a variant of the flaming jewel that symbolizes Buddhism (see Fig. 235). It may be related to a similar architectural element of the Russian Orthodox church.

66. Basket for winnowing. Stag antler. Unsigned.

67. Bell. Pulverized fragrant wood solidified with rice paste. Unsigned. Inscription: "Manshu miyage" (souvenir of Manchuria). The face and hair style are those of an unmarried Manchurian girl. The bell tinkles with the movement of a loose pellet. This is a special type of netsuke sometimes used by women for attachment to a purse.

68. Horseman. Stag antler. Unsigned.

69. Signboard (kamban). Wood. Unsigned. The characters are those for *shigure*, which may be poetically rendered as "autumn drizzle." Such a signboard might be that which carries the name of a guest room in a Japanese inn (*ryokan*) or of a teahouse.

70. *Kinuta* (wooden mallet). Signed with a *kakihan*. Main inscription: "Patience." Second inscription: "Work at night." The *kinuta* is a wooden mallet used in olden times for softening straw for weaving and for fulling cloth. There may be two allusions. The inscription "Patience" suggests the maxim "True patience lies in bearing what is unbearable." The admonition "Work at night" may be an ironical reference to the

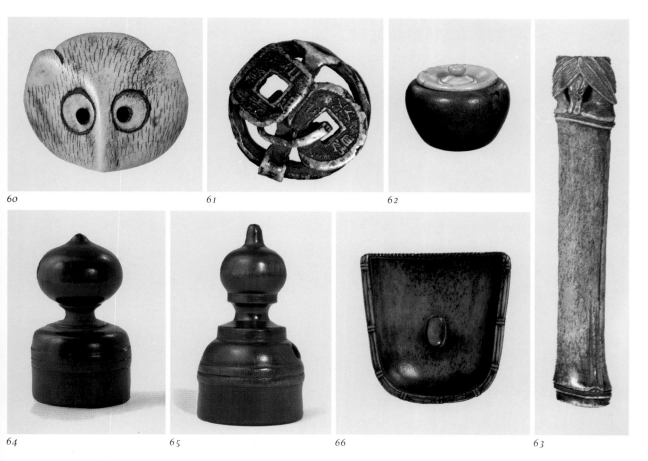

60 61 62

64 65 66 63

harsh burdens placed on the Edo-period peasants, who had to till the fields by day and weave straw sandals by night. The second allusion is suggested by the object itself, the wooden mallet. In the famous Noh play *Kinuta* the wife dies of loneliness as her lord passes the years in the capital. She wonders whether her husband hears her heart, which pounds as loudly as the *kinuta* with which she beats cloth to ease her suffering.

71. Three animals. Tooth. Signed: Masatoshi tō. Inscription: "Kemono santō." *Kemono* is the word for hide- or fur-bearing animals, *san* means "three," and *tō* is a counter for large animals. The tooth is probably that of a bear, which makes the third animal.

72. Merchant's strongbox. Ebony. Inscription: "Nan'yō made [*saku*] at the request of Mr. Kudō." The characters inlaid in silver read: "Gold, twenty thousand *ryō*." Despite the label, merchants' strongboxes rarely contained money, which would have been an invitation to robbery. A *ryō* was a gold weight equal in value to the *koban,* the most common gold coin in the Edo period. The coin weighed 18 grams. One *ryō* equaled 4,000 copper cash. One copper cash, or *zeni,* was the customary price of a cup of tea in Edo times.

73. Face. Bamboo. Unsigned.

74. Boy eating sweet. Boxwood. Unsigned. The *himotōshi* is formed by the separation of the boy's hand from his body. The boxwood, unstained and unpolished, is in its own natural blond color.

67 70 71 72

67 68 69 70

71 72 73 74

Buddhist subjects and symbols portrayed in netsuke appealed to the devout, for whom religion was life. Most Buddhists in Edo and Meiji times made a *henro,* or pilgrimage, at least once in their lives. The *henro* is a circuit of a certain number of temples of a particular Buddhist sect. Depending upon the sect, it comprises visits to twenty-four, twenty-five, thirty-three, or eighty-eight temples.

The most famous pilgrimage is the one to the eighty-eight temples of the Shingon sect. The temples are scattered around the island of Shikoku. The pilgrimage on foot covers more than seven hundred miles and usually requires two months.

The purpose of the *henro* in olden times (and often today as well) was not only to assure salvation but also to serve as a once-in-a-lifetime chance to escape for a while from routine drudgery. The pilgrim traditionally wore a reed hat, white garments, and straw sandals and carried a staff. He often wore a netsuke similar to those shown here, which symbolize religious ceremony, belief, or practice.

It is somewhat strange that the Japanese carved netsuke representing Daruma (Bodhidharma), who brought Zen to Japan, the Niō, who guard the temples, and other Buddhist deities, even treating them with jocularity and ridicule, but not Kannon. The goddess of mercy is regarded with a respect and veneration that discouraged her portrayal in netsuke. She is therefore rarely found in netsuke, and, when she is, it is usually a netsuke of the Meiji-Taisho period (1868–1926).

75. *Rakan* with *shishi.* Boxwood. Unsigned. Ex F. Webb Collection.

76. Itinerant priest. Wood. Unsigned. Wandering priests are often ascetics who show little concern for bodily needs or comforts. They are scantily clad even in the cold of winter. The priest in the illustration carries a knuckle rattle to announce his presence when he begs for alms.

77. Basūsen. Wood, thinly lacquered. Unsigned. Basūsen, one of the Twenty-eight Blessed Ones of the Myoho-in, is rarely seen in netsuke. This appears to be a replica of the original statue.

78. Angel. Light lacquered wood. Unsigned. This may represent one of the *tennin,* or *apsaras,* Buddhist angels who float among clouds, though usually draped in trailing scarves. Celestial nymphs are sometimes painted on temple ceilings above the figure of Buddha.

79. Niō. Bamboo. *Sashi* type. Signed: Kyōen, with *kakihan.* Inscription: "Copied Heijo [old name of Nara] Daikegon-ji [temple], left *kongō.*" The *kongō* (see Fig. 82) is a Buddhist implement symbolizing a thunderbolt. It is a personification of the Niō who guards the left side of a temple gate. See also Fig. 85.

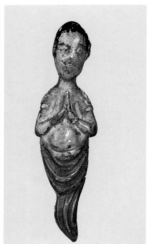

75 76 77 78

80. *Nyoi*. Lacquered wood. *Sashi* type. Signed: Yūsō, with *kakihan*. The *nyoi* is a ritual implement, a high priest's scepter, used in Buddhist ceremonies. It is said to "point the way."

81. Ox of hell (Gozu). Wood. Signed: Dōkei. The ox-headed demon Gozu is paired with the horse-headed demon Mezu, the two being aides to Emma-ō, the king of hell, in scourging the wicked.

82. *Kongō* (Indian *vajra*). Burnished gold lacquer. Unsigned. The *kongō*, a ritual implement of Esoteric Buddhism, is hyperbolically identified as the "thunderbolt" or the "indestructible mace." The term is a generic one for various types named according to shape and number of prongs. The burnished gold lacquer simulates the gilt bronze of the usual *kongō*.

83. Kannon. Coral. Signed: Bungyo (NH 25). The use of eroded stone coral suggests that Kannon is meditating in a seaside cave, a favored site for such practices. The material harmonizes with Bungyo's conception and complements his treatment. The netsuke may be an exception to the above observation that Kannon netsuke are of the Meiji era or later.

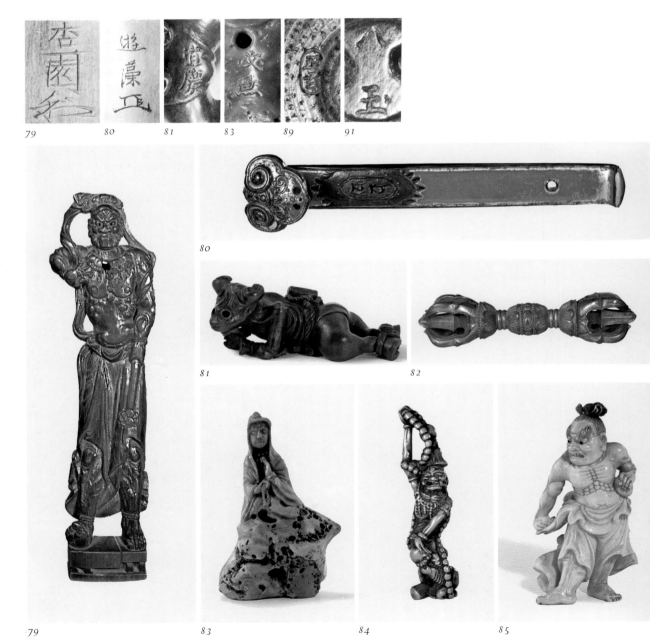

79 80 81 83 89 91

80

81 82

79 83 84 85

84. Struggle of good and evil. Wood. Unsigned. Ex Walter Behrens Collection (Plate 9, No. 414). Ex Mark Hindson Collection. The *rakan* strives to raise the rosary while the devil strives to bring it down. The netsuke symbolizes the difficulty of treading the razor's edge of the Way, of overcoming distractions and temptations —the fetters on the arms (*tekase*) and the shackles on the legs (*ashikase*).

85. Niō. Ivory. Unsigned. Pairs of Niō stand as guards at the gates of Buddhist temples. They also symbolize the metaphysical duality of nature. One stands at the right, one at the left; one's mouth is open, the other's closed. Together they utter the sacred word *aun*.

86. *Rakan* with *shishi*. Boxwood. Unsigned. Here the religious symbol is the sutra scroll. In Fig. 75 it is the priest's *nyoi*, or scepter.

87. Kannon. Wood. Unsigned. Style and character indicate the product of a maker of Buddhist images, not that of a *netsuke-shi*. Traditionally the carver of Buddhist images did not sign his name.

88. *Rakan* with *shakujō* (jingling staff). Wood. Unsigned. The staff with jingling rings is used by Buddhist monks to clear their paths of insects and thus avoid taking life. The *rakan* here is Hattara Sonja, who used his staff to control his companion the tiger.

89. Buddhist cupola (*tama*). Bamboo. *Manjū* type. Signed: Shōgen (NH 986). Shōgen was a famous Kyoto craftsman who specialized in articles for the tea ceremony. The cupola may remind us of a feature of Russian Orthodox church architecture, known waggishly as the Russian onion.

90. Lotus. Ivory. Unsigned. Collection of Hachiro Shima. The lotus is the jewel of Buddhism. It rises above the mud in which it takes root and points to the heavens. It is the symbol of purity and the throne of numerous Buddhist deities.

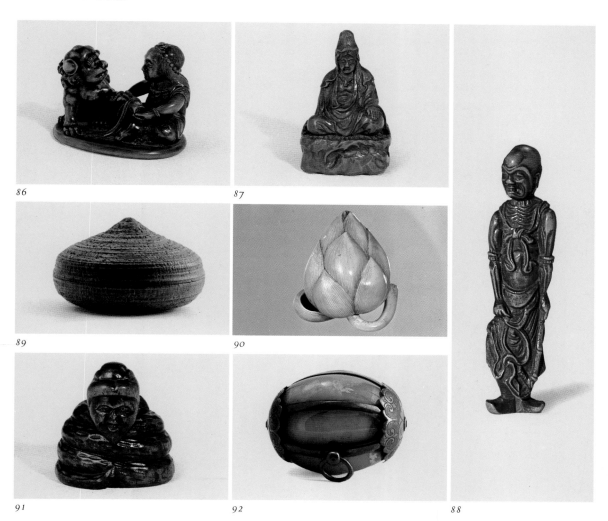

86

87

89

90

91

92

88

91. Human-headed snake. Wood. Signed: Hachigyoku (NH 170). This is probably a vestige of prehistoric snake worship. Katherine Ball, in *Decorative Motives of Oriental Art,* mentions the Engaku-ji in Kamakura, where a shrine is dedicated to a local serpent god. She also shows a printed *o-mamori* (charm) issued by a Japanese temple portraying a snake with a god's head.

92. Eyes of Buddha. Glass and silver. Unsigned. Collection of Hachiro Shima. The sphere is composed of six "eyes" like orange sections. They are inserted in carving Buddhist figures. The six eyes of Buddha see all.

8 CHRISTIAN NETSUKE

From early Edo times until the Meiji Restoration, Christianity was outlawed in Japan. Those who continued to practice it did so in secret and were known as Clandestine Christians (Kakure Kiri-shitan). What began as secret for reasons of dire necessity became secret by habit. There are estimated to be several thousand Clandestine Christians in the environs of Nagasaki today. They have no place of worship except the home of the "father," who performs Christian ceremonies. They attend their community festivals and observe Buddhist and Shinto rites but follow them with private Christian rites of their own.

An object of veneration is the Maria Kannon, supposedly a composite of the Virgin Mary and the goddess of mercy. The term is a misnomer for a common Chinese representation of Kannon with a swastika at her breast. The Clandestine Christians mistook the swastika for a form of cross and worshiped the figure as the Mother of God. Carvings combining elements of the Madonna and Kannon are usually products of the Meiji-Taisho period.

It is most unlikely that Christian netsuke existed in the early Edo period. Netsuke of Christian subjects appear to be of the late Edo or the Meiji age. In view of the strong foreign interest in netsuke, old netsuke were sometimes recarved to represent Christian subjects. Regardless of age, however, Christian netsuke are relatively rare. Figs. 97–99 show secular rather than Clandestine Christian netsuke representing apparently Christian persons and carrying Latin inscriptions probably copied from early religious tracts, relics, and coins.

93

94

93. Bearded priest. Wood. Unsigned. The European look of the face is emphasized by the beard, but the garment and whisk (*hossu*) indicate the Buddhist priest. The base is an engraved seal.

93 94 95 96

94. Priest *rakan*. Wood. Signed: Yoshihide, on a *tsuishu* label. The curly hair and beard suggest a Christian priest, the garment and amulet a *rakan*. The mixing may be intentional: a later view of a Clandestine Christian priest or an instance of artistic license that is subject to interpretation—or misinterpretation.

95. Cross. Ivory. *Manjū* type. Unsigned. The carving of the cross, though old, may be of a later date than the original netsuke.

96. Priest. Ivory. *Manjū* type. Unsigned. Professor Shuji Hasegawa, a recognized authority on the Clandestine Christians, believes that they would have interpreted the three holes in the priest's hands and head as symbolic of the nails driven through Christ's hands and feet at the Crucifixion.

97. *Kagamibuta*. Brass disk, vegetable-ivory bowl. Unsigned.

98. *Kagamibuta*. Copper disk, ivory bowl. Unsigned.

99. Woman's face. *Shibuichi*. Watch-shaped box. Unsigned. The box opens on a hinge. A metal ring serves for attachment of a cord.

97　　　　　　　　　　　　98　　　　　　　　　　　　99

COLORED NETSUKE 9

Netsuke in elephant or marine ivory that are totally colored may be legitimately regarded with suspicion. Often the color is applied like thick commercial coffee-colored stain to hide cracked or damaged material or to conceal crude or unfinished workmanship. The caution does not apply to wood netsuke. The great name in the case of colored wood netsuke is Yoshimura Shūzan, whose primary fame rested on his standing as a master painter. Shūzan added the virtues of paint to the qualities of sculpture in netsuke. Coloring may be an enhancement of sculpture, a pleasant accent or emphasis, so long as it is accomplished tastefully and does not conflict with the need for permanency as an aspect of the durability and functionalism of the netsuke.

The coloring of netsuke encompasses many styles and techniques. Jugyoku attached the frogs in Fig. 100 to a base of narwhal. They are made of stag antler, which absorbs color, especially greens and browns, readily and naturally. In this connection, we may note the realism of Sōko's cucumbers (Fig. 439). Had Jugyoku carved the entire piece, including the frogs, from a solid block of narwhal, the colors of the frogs would probably have appeared coarse or unnatural.

Shūzan's supremacy in coloring his large figure netsuke in *hinoki* (cypress) is a result of his painstaking process of priming, undercoating, and binding his thick lacquer colors to form a durable protective shell against wear of the soft wood. Carvers used various methods of priming, painting, coloring, and lacquering to obtain their effects. A few of their techniques are illustrated here. A comprehensive study of the types of color and the techniques for coloring netsuke would be interesting and valuable.

100. Frog group on rock. Narwhal and stag antler. Signed: Jugyoku, with seal Ju (NH 408). The rock is narwhal. The frogs are carved of separate pieces of stag antler.

101. Neophyte priest. Colored boxwood. Signed: Kyūsai (NH 576). The novice falls asleep while practicing meditation. Amusingly, the gong that he strikes to assure wakefulness is his pillow.

102. Persimmons, chestnuts, and ants. Colored boxwood. Unsigned. Persimmons and chestnuts are associated because of their concurrent appearance in late autumn.

103. Loquats. Colored boxwood. Unsigned. Collection of Shigeo Hazama.

104. Otafuku. Colored wood. Unsigned. The chrysanthemum pattern is carved in high relief. The netsuke is modeled on a papier-mâché doll that is shaped, stiffened, and colored in small patterns.

105. The monkey Songokū. Colored wood. Unsigned. In the Chinese classic *Hsi-yu-chi* (translated by Arthur Waley as *Monkey*), Songokū, by his feats of magic, helps priest Sanzō defeat the forces of evil.

106. Fūjin, god of wind. Colored boxwood. Unsigned. This piece is confidently attributed to Keisuke of Tochigi, a rare Meiji carver. (See Fig. 415 for a signed Keisuke.) Two other Keisukes are in Japanese collections. His style is distinctive, almost inimitable, though tending to fragility.

107. Boy wearing Otafuku mask. Colored wood. Unsigned.

108. Tea picker. Colored wood. Unsigned. An unusual model of the Uji tea picker. *Ittōbori* technique. See Fig. 661.

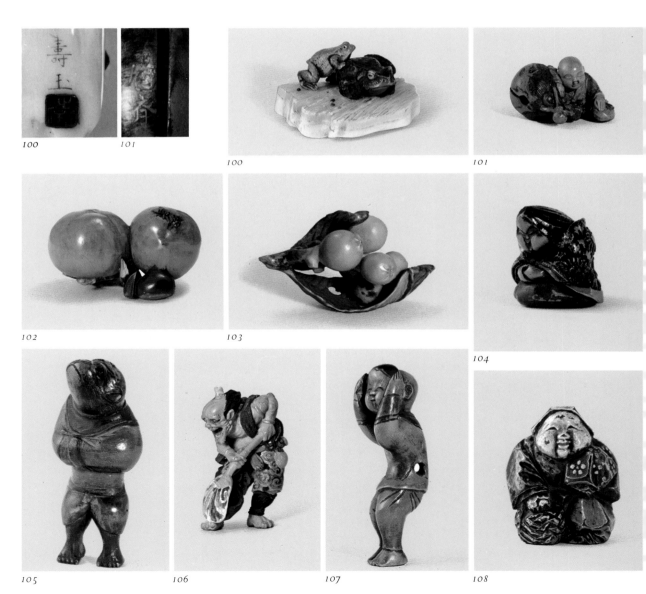

100 101

100

101

102

103

104

105

106

107

108

DOLL AND TOY NETSUKE 10

It is certain that some makers of dolls and toys turned to netsuke when the demand for netsuke was at flood tide. The greater area of association, however, is in the inspiration, the models, and the designs that the *netsuke-shi* found in dolls and toys as subject matter. Quite a number of regional toys and dolls in clay or wood were as rounded and compact in shape as the ideal netsuke. With the application of the netsuke carver's technique and materials, the clay, papier-mâché, and painted dolls and toys were reproduced in wood and ivory in the perfect functional form of netsuke. This is the reason we find many fine netsuke clearly modeled upon designs of dolls, of toys, and even of souvenirs sold at temples and shrines.

110

109. Pottery vessel. Dry lacquer (*kanshitsu*). Unsigned. The netsuke represents an elephant-shaped pottery vessel with a clamped lid. Such a lid suggests use for storage of food or drink.

110. Daikoku in a ceremonial dance. Pulverized paulownia (*kiri*) coated with pulverized oyster shell (*gofun*). Inscription: "Tosa Mitsusada painted, Sakon carved [that is, copied] this." Collection of Murray Sprung. Sakon was a doll-maker who occasionally carved netsuke, as attested by his choice of materials. See also Fig. 369.

111. Doll. Gold lacquer. Unsigned. Collection of Ruth Schneidman. The boy's disproportionately large head suggests the *gosho ningyō*, which may have served as a model.

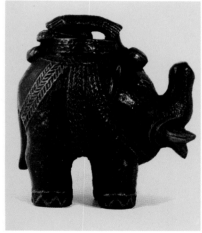

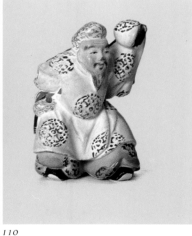

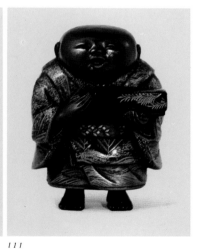

109 *110* *111*

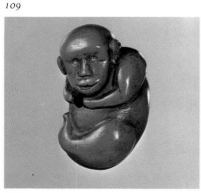

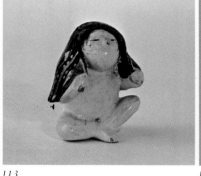

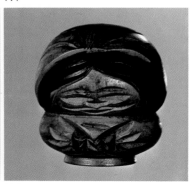

112 *113* *114*

112. Monkey doll. Copper lacquer. Unsigned.

113. *After the bath. Gofun* and colors. Unsigned. *Gofun* is a mixture of pulverized oyster shell and lacquer glue. The child dries herself with a colored towel.

114. Ainu doll. Wood. Unsigned. Ainu dolls are often carved in Nagano and other northern prefectures for sale in the Ainu villages of Hokkaido. Apparently the Ainu carvers are too few to satisfy the demand for their woodcarvings.

115. *Dairibina.* Lacquer, with ivory face. Unsigned. The *dairibina* represent seated courtiers—some say the emperor and the empress. They are popular at the Hina Matsuri (Doll Festival), celebrated on Girls' Day (March 3), when dolls representing the entire court assemblage and their appurtenances are displayed.

116. *Dairibina.* Whale tooth. Unsigned.

117. Swaying-headed tiger. Gold lacquer. Unsigned. The tiger represents the papier-mâché regional toy with a movable head mounted on springs. The slightest touch or vibration sets the head swaying in realistic movement.

118. Roly-poly. Lacquered wood. Unsigned. The original model is a toy, the Hachiman Tumbler of Kanazawa, which always returns to the upright position.

119. Sparrow. *Gofun* and cloth on *kiri*-wood base. Signed: Sashirō, with *kakihan*.

120. Kewpie doll. Ivory. Signed: Gyokuzan (NH 164). During the Meiji era this Western-style doll had an enormous vogue in Japan.

121. The Six Great Poets (three views). *Urushi* (lacquer). Unsigned. For other versions of the Six Great Poets, see Figs. 40 and 570.

119 120 123

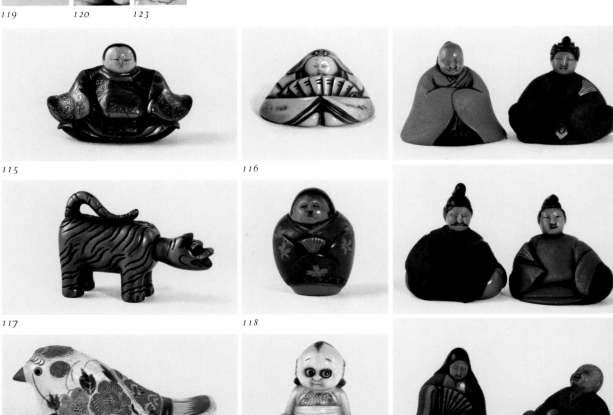

115 116

117 118

119 120 121a b c

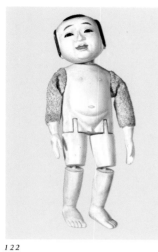

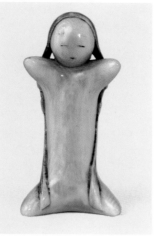

122. Puppet figure. Ivory, cloth arms. Unsigned. The head, arms, hands, and legs are articulated. Such puppet figures are sometimes used by dollmakers as bodies for dressed dolls. The moire silk joining hands and body is a type woven in the Edo period.

123. *Amagatsu.* Ivory. Signed: Masanao (NH 609). *Amagatsu* are ancient dolls made of paper and used in a ceremony to petition the gods (*kami*) for the protection of newborn children. It was believed that the evil lying ahead in an infant's destiny was transferred by protective magic to the inanimate doll.

122

123

EARTHY NETSUKE 11

The Japanese are as lusty and perverse as any other race on earth. Japanese artists have depicted carnality abundantly, and the *netsuke-shi* is certainly no prudish exception. As a peasant and popular art, netsuke portrayed the pornographic and scatologic that played so large a part in rural merriment. Being practical and realistic, the Japanese accept eroticism as belonging to the individual's "sphere of pleasure," to which no objection is warranted so long as he performs his primary duties and assumes his responsibilities. Thus the homosexual is not condemned as a homosexual but as a disgrace if he should fail to discharge his duty to his family by marrying and fathering descendants.

One often finds references in netsuke books and articles to the earthiness and lustiness of the subject matter. This is certainly true, but books and articles do not illustrate earthy and lusty subjects to convey what they mean. The obvious reason for the caution may be the line between earthy and salacious or between lusty and obscene. The line is often as sharp and contentious as the cutting edge of a *katana.* No sensible author would want to be accused of pandering to the prurient and pornographic.

In view of recent "permissiveness" in various means of communication, I have without hesitation chosen to show earthy and lusty netsuke. Their meanings are visible—clear and unabashed. One may· laugh frankly if one sees something amusing.

The problem of reproduction arises from the "hidden pleasure" netsuke, which have two positions: one open and innocent, the other secret and pornographic. The expedient I have employed here is to show the open position and to describe one or two of the secret positions. I hope that normal curiosity will be satisfied with verbal descriptions. Words may, by choice, be delicate or gross, but a picture is a picture.

These "hidden pleasure" netsuke are shown in Figs. 124, 131, 134, and 140. They are outwardly innocent but open to reveal salacious scenes. They are fine netsuke even without the additional erotic attraction. That is the virtue of fine pornographic netsuke: their quality and cleverness redeem any obscenity.

Before leaving the subject of naughty netsuke, it is worth observing that many netsuke, particularly post-Meiji examples, are often patently vulgar and obscene. They are devoid of that touch

of humor or cleverness that tends to redeem vulgarity. On the other hand, the older pornographic netsuke are often extremely clever. They put the mind to work to associate the various parts of the design into a recognition of the erotic dénouement depicted by the netsuke. As the meaning registers, one smiles and marvels at the carver's cleverness. Who can condemn while admiring or censure while chuckling?

Naughty netsuke are generally unsigned.

124. Box netsuke. Ivory, with carved lacquer panel. Unsigned. The panel is carved with the mandarin ducks of conjugal constancy. There is a false bottom revealing two lovers in fond embrace. The netsuke in both open and secret positions is reproduced in Bradley Smith's *Erotic Art of the Masters*.

125. Otafuku embracing a mushroom. Wood. Signed: Masakazu. Ex Julius Katchen Collection. The eroticism lies in the phallic symbolism of the mushroom in Japanese art and in Otafuku's embracing interest, which seems to be more than culinary.

126. Pregnant woman. Wood. Unsigned. A sash called a *hara obi* (stomach sash) is customarily tied around a woman's waist on the Day of the Dog during the fifth month of pregnancy, and a ceremony is held. The Day of the Dog is selected because the dog experiences an easy delivery.

125 129

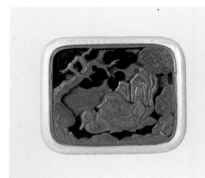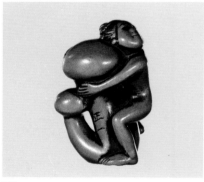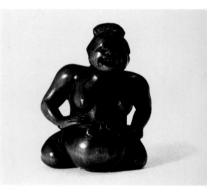

124 125 126

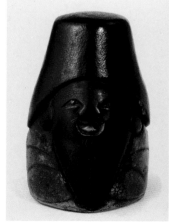

127 128 129 130

127. Jurōjin. Lacquer. Unsigned. Collection of Zenshiro Horie. Jurōjin, with his elongated dome, is an obvious phallic symbol.

128. *Ama* (diving girl). Ivory. Unsigned. Collection of Murray Sprung. The skirt, which is a separate piece, shows the *ama* entirely nude when it is removed. See also Fig. 413.

129. Nude with fan. Stag antler. Signed: Gyokuzan (NH 165). The nude is rare in Japanese art. Even figures in pornographic scenes are partially draped with kimono. The introduction of Western-style art after the Meiji Restoration (1868) counteracted the Japanese art tradition of invariably draping the female figure. Thus nude netsuke may usually be safely dated as subsequent to 1868.

130. Lovers in full embrace. Ivory. Unsigned. The style and figures are Chinese. Although the *himotōshi* appear to be original, the piece may have been converted for use as a netsuke.

131. Umbrella and lantern. Ivory. Unsigned. The umbrella tells us that it is rainy and the lantern that it is night. The piece opens along its length to show two scenes: one of a silhouetted woman scurrying along a path, the other of lovers embracing. We have a complete story: under cover of darkness, hidden by her umbrella, she trysts with her lover in an illicit affair.

132. Mushroom group. Wood. Unsigned. Most Japanese will answer emphatically, yes, it is; mushrooms are pornographic per se. But *is* it pornographic?

133. The bath. Wood. Unsigned. Bathing al fresco in the hot summer was once quite popular in rural areas. The frog is a privileged spectator. His gaze is as targeted as a laser beam.

134. Rabbit. Ivory. Unsigned. The rabbit opens to show two love scenes, one tender, the other blunt.

135. Octopus reading love book. Ivory. Unsigned. Collection of Cornelius Roosevelt. The octopus, that lecherous beast, often represented groping with eight hot hands for bare-breasted diving girls, here reads a *makura-e,* or pillow book. See also Fig. 737.

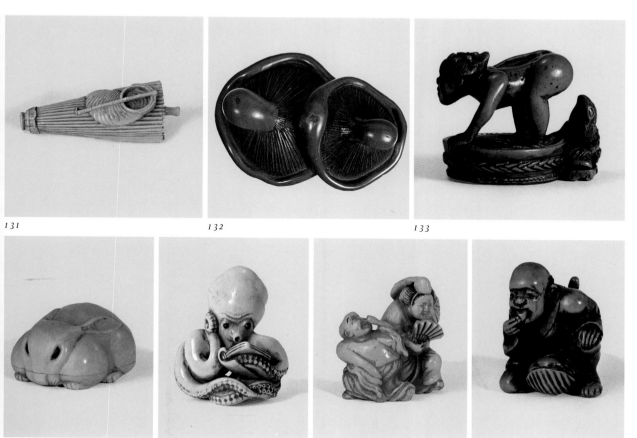

131 132 133

134 135 136 137

136. Harvest-festival skit. Ivory. Unsigned. In the dance the man is garbed as a priest, the woman is masked as Otafuku. The priest holds his nose to indicate that his partner has broken wind.

137. The taste of the clam. Wood. Unsigned. The man finds the clam suggestive and the taste delectable and reminiscent.

138. Man-woman (two views, front and back). Wood. *Sashi* type. Unsigned. Some netsuke appear innocent until their meaning and use are explained. The article represented is a dildo. It is maintained at body temperature with water warmed on a stove.

139. Otafuku and *tengu* mask. Ivory. Signed: Hidemasa. In village-festival plays the long-nosed *tengu* mask is patently phallic, and Otafuku's modesty is mocked as a veil for hidden yearnings.

140. *Mokugyo.* Wood. Unsigned. One of the fish-scale panels can be removed to reveal the universal thing-umajigs: the *lingam-yoni* in Hindustani, the *yin-yang* in Chinese, and the privates in Anglo-Saxon.

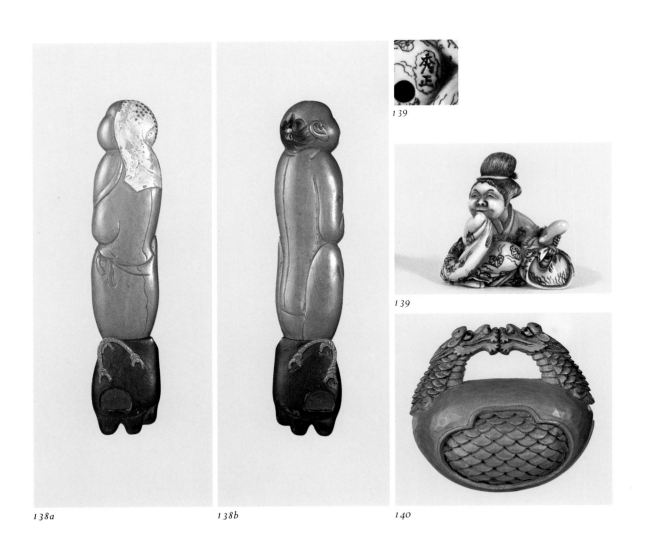

139

139

138a *138b* *140*

EUROPEAN SUBJECTS 12

The term *nambanjin* means "southern barbarian." It was applied to the Dutch and Portuguese who were permitted to trade at Nagasaki during the time when the balance of Japan was sealed against foreign contact. *Nambanjin,* by extension, includes Frenchmen, Englishmen, Russians, Americans, and other Caucasians. The term is no longer current except in a historical context. The present-day term for Caucasians is generally *gaijin,* a contraction of *gaikokujin,* meaning literally "men of a foreign country."

A derisive term for *nambanjin* was *ketō,* meaning "hairy barbarian." The term should be regarded with less resentment when we recall that in the enlightened period of ancient Greece the very word for "foreigner" was "barbarian." Today we can imagine only dimly the shocked amazement of the Japanese, whose whole world, continental and Oceanic, was peopled with black-haired, yellow or dark-skinned races, to discover a race of green-eyed, red-haired monsters, giants with huge noses and booming voices, wearing weird clothes, carrying firearms, and using mystifying instruments. The appearance of *nambanjin* was far stranger to the insular Japanese than that of all the Ashinagas and Tenagas of Chinese legend.

According to at least one Japanese historian, the numerous stag-antler netsuke of ordinary quality representing Dutchmen with legs and hats inserted separately were produced as a popular souvenir of a visit to Nagasaki, much as the Nara *ningyō* is a souvenir of a trip to Nara. These mediocre Dutchman netsuke were produced in other areas besides Nagasaki to meet the large demand. This accounts in part for the random mixing of racial characteristics, national dress, and articles carried. Many of the carvers had never seen a live foreigner but carved from hearsay, sketches, and imaginings.

Collectors'-quality Dutchmen are of course superior to the poorer products in stag antler. Nevertheless, the errors of confusing clothes, characteristics, articles, and attributes of different countries persist in the collectors' Dutchmen as well. Big noses are sometimes combined with mandarin coats, and pigtails with pantaloons. However, art born of imagination rather than observation often gains in amusement what it loses in realism.

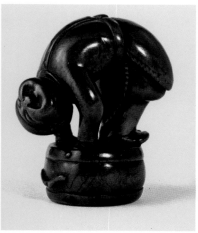
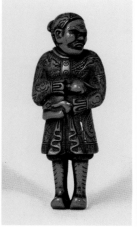
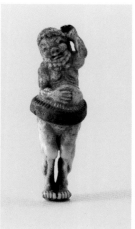

141 *142* *143* *144*

141. Acrobat on drum. Wood. Unsigned.

142. European. Wood. Unsigned.

143. European. Stag antler. Unsigned. The foreigner's girdle is made of the stag's hide.

144. Dutch sea captain. Lacquer. Unsigned.

145. European drum master. Wood. Signed: Minkō, with *kakihan*. Collection of Jeffrey Moy.

146. Dutch woman dancing. Ivory. Unsigned. The piece is very flat. The greatest thickness is 0.8 centimeter.

147. Dutchman and his kill. Ivory. Unsigned.

148. Foreigner and skeleton. Wood. Unsigned. The foreigner carries a long horn. The skeleton is a Tenaga. The meaning is unclear. When a meaning is beyond elucidation, it is well to remember that a carver may be as capricious and unaccountable as he pleases.

149. European lady. Pottery disk lacquered and inlaid, corozo-nut bowl. *Kagamibuta* type. Unsigned. The lady wears an inlaid-pearl crucifix.

150. Dutchman. Lacquered mother-of-pearl disk in a walrus-ivory bowl. *Kagamibuta* type. Unsigned. Illustrated in *Orientations*, October 1970.

151. Foreign lady. Lacquered ivory. *Manjū* type. Unsigned.

152. Foreign lady. Corozo nut (vegetable ivory). Unsigned.

153. European. Stag antler. Unsigned.

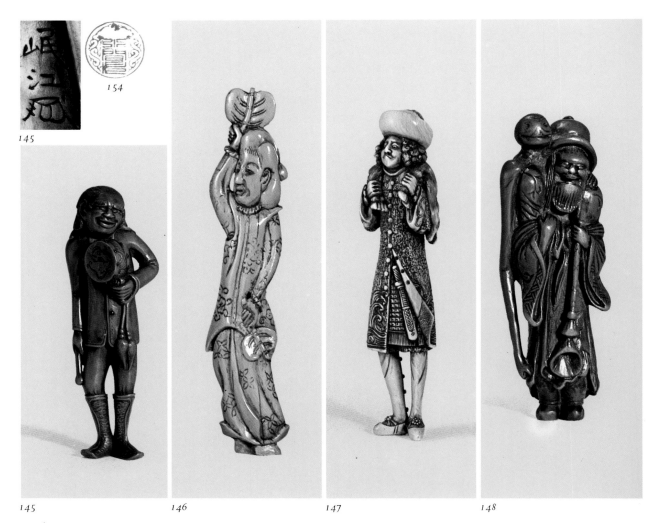

154

145

145 146 147 148

154. High-hatted foreigner. Wood. Unsigned. Engraved-seal base. The foreigner probably represents a circus barker or an impresario.

155. Foreigner. Amber. Unsigned.

156. Dutchman. Stag antler. *Manjū* type. Unsigned.

157. Kikujidō. Wood. Unsigned. The Chrysanthemum Boy is of course an Oriental subject. The representation, however, is in the typical form of a European cameo or decorative pin.

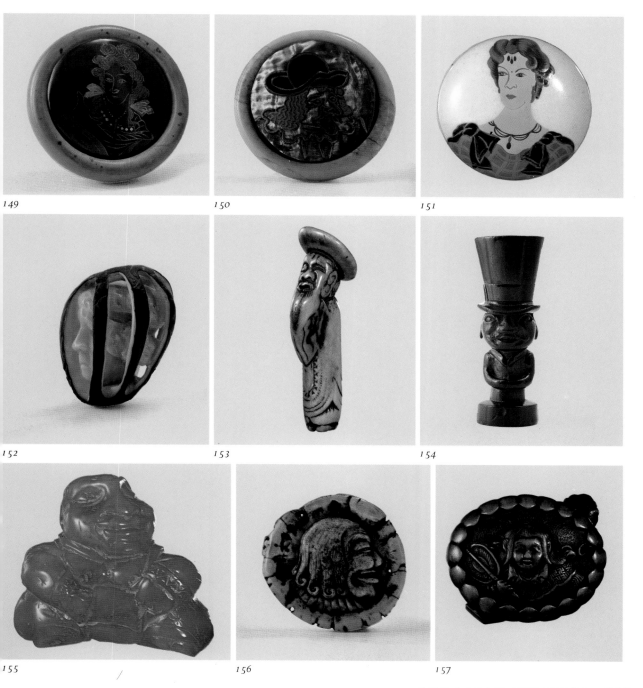

149

150

151

152

153

154

155

156

157

13 GOURD NETSUKE

The gourd may be the oldest netsuke. Its antecedents extend back to Sung and Ming, when it is portrayed at the waist of pilgrims and *sennin* for use as a canteen. It is a natural receptacle and is richly symbolic. Its abundance of seeds suggests fertility and its natural water medicinal protection. It has a lovely shape that nature varies endlessly, a distinctive texture, and an attractive coloration. Most important for its popular use, it is cheap—it grows wild.

The Japanese collected gourds for their rare and exotic shapes long before they used them as netsuke. Gourds were carried as containers on pilgrimages and picnics. They are symbolic of sakè. Tipplers aver that sakè tastes best when poured from a gourd.

As a netsuke, the small-size gourd often doubles as a container for scent or medicine. The more popular gourd netsuke is the double-bottle gourd with the slender waist, known as the *hyōtan*. *Hyōtan* in rare shapes may suggest birds, horses, or other animals. Another type of gourd often used for netsuke is the round, or pumpkin, gourd, which is usually fitted with a transverse metal pin and an eye for attachment of the cord.

In an effort to improve on nature, the Japanese sometimes bound wires around the growing gourd to shape it artificially or even grotesquely. Many *netsuke-shi* were so enamored of the gourd form that they imitated it in wood, ivory, bamboo, agate, and other materials.

The *hyōtan* was the standard of the sixteenth-century military dictator Hideyoshi. Having no standard for the sudden battle that precipitated his militant career, he plucked a gourd to use for the purpose. He swore to add a gourd to his standard for each triumph. After a victorious career, his standard comprised one thousand gourds, and the sight of it, like the appearance of a *bakemono*, struck terror to the hearts of his enemies.

163 164 165

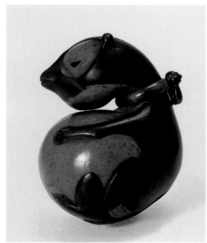

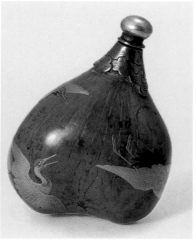

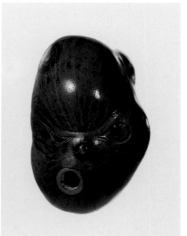

158 159 160

158. Drum-belly badger. Natural double-bottle gourd (*hyōtan*) decorated with badger in green lacquer; metal ring and eye for cord attachment. Unsigned. Collection of Edward Shay.

159. Natural bottle gourd. Gold lacquer, showing three cranes in flight; metal stopper; metal eye for cord. Unsigned.

160. Natural gourd: funny face. Natural nipple for nose, black lacquer eyes, metal-rim mouth, metal eye for cord. Unsigned.

161. Natural gourd. Metal ring and eye for attachment of cord. Unsigned. The gourd was selected and stoppered because of its animalistic appearance.

162. Pear gourd. Unsigned. Inscription, roughly rendered: "Thousands of mountains bloom in fresh green like flowers." This is a second-growth, or seed, gourd. The seed gourd, which is often pear-shaped, is as hard as wood and cuts in much the same way. The shell is very thick, as may be seen in the deeply engraved characters. The small hollow center contains the seeds.

163. Natural gourd doubling as a scent or medicine container. Swallow and autumn grasses in gold lacquer. Signed: Inaba, with *kakihan*. Inaba (family name: Kōami) is listed in Jonas's *Netsuke* and in Rokkaku's *Tōyō Shikkōshi* (History of Far Eastern Lacquer) as an eighteenth-century lacquerer.

164. Gourd. Ivory. Signed: Mitsuhiro (NH 685). Illustrated in *The Collectors' Encyclopedia of Antiques* (London, 1973). Simple and graceful, the gourd suggests a swan.

165. Gourd. Ivory. Signed: Mitsuhiro, with seal Ōhara. Collection of Michael Braun. The figure carved in silhouette relief is a begging priest. The inscription is a *haiku* (seventeen-syllable poem) by Kyorai, a follower of Bashō, the most famous of all the *haijin* (*haiku* poets): "Please show me your bottle gourd, O begging priest." The season suggested is autumn, when bottle gourds mature, and the imagery is in the figure of speech for "begging priest": a person who strikes a bowl. This is an allusion to the priest who taps his empty bowl while chanting sutras to beg for food. The netsuke itself is of special interest, for it can be positively identified from the page of Mitsuhiro's manuscript record *Takarabukuro* where he describes the subject rather elliptically as follows: "The gourd carried by a begging priest. Kyorai poem: 'Please show me your bottle gourd, O begging priest.' I have carved this poem." Most unfortunately, Mitsuhiro describes his subjects in lovely calligraphy but without the benefit of a single sketch.

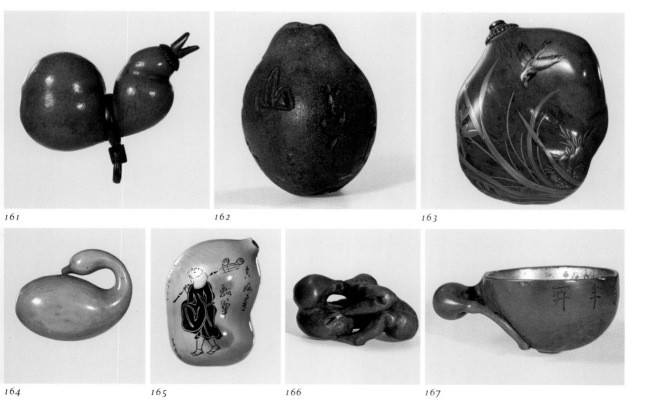

161 162 163

164 165 166 167

166. Gourd *bakemono*. Wood. Unsigned. A *bakemono* whose head is a gourd.

167. Sakè cup shaped as a half gourd. Wood. Unsigned. The inscription is a Chinese-style poem: "While feasting my eyes on the half-open cherry blossoms, I have become half-drunk." The allusion is to the tradition of warriors getting drunk on sakè as well as on beauty at cherry-blossom viewing. Like the blooming of the cherry tree, the life of the samurai was usually brief and riotous.

168. Gourd. Agate. Unsigned.

169. Natural gourd. Metal eye for attachment of cord. Unsigned. The shape may have been determined by bands during growth.

170. Tea whisks and gourd. Ivory. Unsigned. The tea ceremony (*cha-no-yu*) is also known as the way of tea and the discipline of tea. Ideally it is performed in a tiny detached room (*chashitsu*), spare and austere, set in rustic surroundings. The sounds inside the room—the boil of the water, the swish of the tea whisk, the murmured appreciation for the craftsmanship of the utensils—blend with the sounds of nature outside. The spirit of tea is simplicity, harmony, discipline, and perception. A hanging dried gourd or a single wildflower is appropriate in the *shibui* tokonoma of the traditional tearoom, while an elegant flower arrangement would be incongruous. The combination of tea whisks and gourd in the netsuke symbolizes the harmony of the tea ceremony and nature.

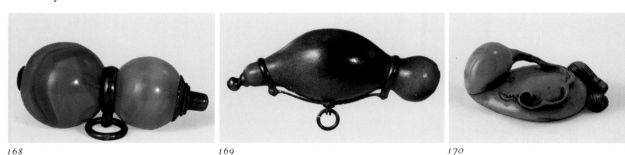

168 *169* *170*

14 HUMOROUS NETSUKE

A strain of humor runs throughout the subject matter of netsuke: tigers that are more silly than ferocious, Daruma more ridiculed than reverenced, Otafuku more lascivious than homely, and *oni* more frustrated than menacing. On other levels the humor is clever and subtle or earthy and ribald. The charge about the humorless Japanese is groundless. On the whole, Orientals smile and laugh more than Occidentals. However, Western bantering, teasing, ridiculing, ribbing, and friendly insulting are apt to be understood literally by the Japanese and resented.

F. M. Jonas, the author of *Netsuke,* the first book in English on the subject, often emphasized humor as a byproduct if not a secondary function of netsuke. The conception is certainly plausible. When the sweating laborer removed his pipe and pouch for a relaxing smoke or the indisposed aristocrat opened his *inrō* for a restorative, an amusing netsuke that produced a smile or a laugh was good psychological medicine: an antidote to exhaustion or indisposition.

171. Frightful faces (two views). Wood. Unsigned. The two facing men stretch and contort their features in a contest of frightfulness.

172. Daruma and heckler. Wood. Unsigned. Daruma meditates for long stretches, motionless and impassive. A waster tries to distract and disconcert the saint with funny faces.

173. Daimonjiya. Wood. Unsigned. Daimonjiya was a merchant of Kyoto in the eighteenth century. He was a dwarf with a huge head and was as generous as he was rich. Dolls in his image are very popular in Kansai. They are sometimes placed at the entrances to shops as symbols of success and honesty.

174. *Oni*. Boxwood. Unsigned. The *oni* itches and scratches in an agony of pleasure. Why does he scratch? Only *he* knows where it itches.

175. Man attempting the impossible (two views). Ivory. Unsigned. The man has a firm grip on the nape of his neck and tugs mightily at his loincloth (*fundoshi*). He seems to be making progress in his efforts to lift himself off the ground.

176. Resolution. Wood. Signed: Miwa, with *kakihan*. A laborer, probably suffering from a bad hangover, puts teeth in his "never again" resolution by sawing his sakè gourd in half.

177. Games with a pipe. Wood. Signed: Masayuki, with *kakihan*. Illustrated in *The Collectors' Encyclopedia of Antiques* (London, 1973). A man tries to suspend his pipe by the pressure of his lower lip. His right hand is ready to catch the pipe if it falls.

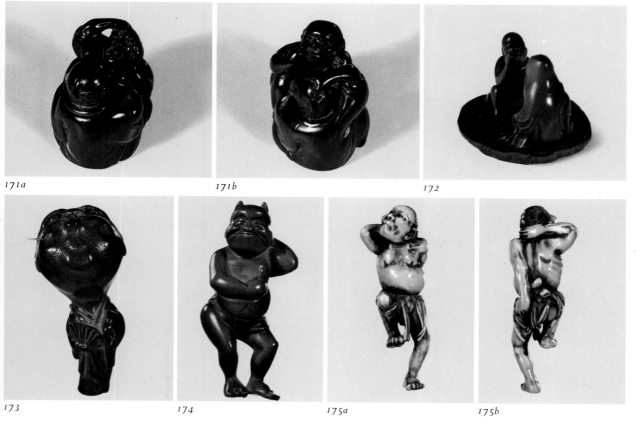

171a 171b 172

173 174 175a 175b

178. Abalone shells as sandals. Ivory. Unsigned. A villager amuses himself, and possibly others, by walking about on abalone shells as footgear.

179. Raconteur (*rakugoka*). Ivory. Signed: Jugetsu. The comic raconteur may be pretending to be Daikoku.

180. Hair style. Wood. Unsigned. The unknown craftsman ridicules an exaggerated hair style of the Edo period.

181. Fox dancer. Wood. Signed: Hidemitsu. Collection of Seishichi Fujii. A *karako*, one of those irrepressible assistants to the Chinese saints, imitates a dancing fox. He holds a cup in his teeth like a muzzle to enhance his vulpine appearance.

182. *Kappa*. Wood. Unsigned. The *kappa* assumes a posture of feminine modesty reminiscent of *September Morn*, the sensational American calendar picture of the early 1900s.

183. Otafuku bathing al fresco. Boxwood, unstained and unpolished. Unsigned. An exceedingly pregnant Otafuku bathes in the open.

176 177 179 181

176 177 178 179

180 181 182 183

INGENIOUS NETSUKE 15

The artist's effort is a combination of creativity and technique, of artistry and craftsmanship, or, in physical symbols, of hand and eye. The hand is the physical part of the creation and the eye the mental part. The most aesthetic design in the imagination and the mind is nothing if the hand fails to do its part with materials, processes, and techniques. The dream of the eye must be given substance by the skill of the hand.

The ingenious netsuke is no exception to the requirement for collaboration between hand and eye, but it makes its salient impact in terms of sheer handicraftsmanship. No matter how pleasing the design, it is the dexterity and wizardry of the carving, the mechanical virtuosity of the workmanship at which we marvel. However excellent the model, it is the execution that inspires our admiration and wonder. Our response to the ingenious netsuke is not so much "How beautiful!" as "How marvelous!" It is its technical proficiency that is unique.

How did Gyokusensai fashion the bird cage in Fig. 202 from a single block or Masanobu carve the minuscule metropolis in Fig. 188 through so small an aperture? With incredulous eyes we examine such pieces under a magnifier for a telltale line of separation or a joining or any hint of a second piece, an insertion, or an attachment. We scrutinize with almost as much concentration and care as the men who carved them. Finally we admit that there is no device, no clever technique of craftsmanship, no trick that deceived us. We conclude that the carver took the inordinate time and exercised the remarkable control and incredible patience to make the carving from a single block. Gyokusensai carved the birds on the inside through the slits between the ribs of the cage. It represents a triumph of craftsmanship, a conscientious adherence to the tenet of many *netsuke-shi* that in the interest of sturdiness a netsuke should be made from a single block.

Prodigies of technical wizardry, manual dexterity, patience, control, and even visual acuity will be seen among the netsuke shown here. The difficulties of some such feats of carving are quite obvious. Others are less so, and some may even escape notice. Two gifted recent carvers, Sōsui and Shōko, examined the Kaigyokusai oyster in Fig. 187. They were less impressed with the carving of the microminiature shrine than with the feat of perfectly fitting the two shells together by matching the undulating edges. They were in agreement that any trained carver, given sufficient time, might carve a good Miyajima but that only a genius could fit the shells together flawlessly.

184 *185* *186*

184 *185* *186*

184. *Shishi* and peonies. Ivory. Signed: Kaigyoku (NH 428). The ball of ivory is completely pierced for an outer ring of peonies and an inner *shishi*.

185. Woodman scraping a bamboo tube. Wood. Signed: Yūkōsai. The woodman is carved in full figure in the round; the whole piece is carved from a solid block. The length of the tube is 3.7 centimeters. The distance to the woodman from one end is about 1.7 centimeters; from the other, about 1.4 centimeters.

186. *Rakan* in a begging bowl. Wood. Signed: Yūkōsai. The *rakan* holds a bowl from which a waterfall spills. The upper part of his body is carved in the round.

187. Oyster (two views). Ivory. Signed: Kaigyokusai Masatsugu (NH 430). Ex Sir Trevor Lawrence Collection. Ex Frederick Meinertzhagen Collection. The oyster is held closed by one of the barnacles, which operates as a screw. It opens to reveal the famous Itsukushima Shrine at Miyajima. A note from Meinertzhagen that accompanied the netsuke states that it brought £31.50 ($153) at Christie's in 1916 during the sale of the Sir Trevor Lawrence Collection.

188. Duck. Ivory. Signed: Fuji Masanobu, with *kakihan* (NH 616). Illustrated in *The Collectors' Encyclopedia of Antiques* (London, 1973). A fine example of *anabori* carving. It is a deeply recessed carving executed through the opening of the half cherry blossom to show bridge, *torii*, shrine, boat, river, procession, and strollers. The minuscule scene extends to a depth of more than three-fourths of the thickness of the duck.

187 188 189 190a 190b

187a 187b 188

189a 189b 190

189. Shinto priest in drum (two views). Wood. Signed: Kyokusai (NH 565). Drum and figure are carved from a single solid block.

190. *Bijin* (beautiful woman). Mosaic of various materials. Signed: Sōsui tō (NH 1111). Sōsui used fifteen distinct materials in making his *bijin*. On a small square of tortoise shell, inlaid on the inside of the cover of the *tomobako,* he carved the names of the materials corresponding to the parts of the figure (see photo). The list follows: face, hands, and feet: ivory (*zōge*); eyebrows: shell (*kai*); clothes: white sandalwood (*byakudan*); eyes: black coral (*umimatsu*); belt: scarlet cherry wood (*hizakura*); mouth: hornbill ivory (*hōten*); hair: buffalo horn (*suigyū*); sash bustle: shell (*kai*); hair cord: ivory bark (*zōgehi*); hairpin: green horn (*aotsuno*); hair ornament: red lacquer (*tsuishu*); sleeve band: boxwood (*tsuge*); comb: tortoise shell (*bekkō*); book: cypress (*hinoki*); pages of book: goat horn (*yōkaku*); face in book illustration: ivory (*zōge*); hair: black coral (*umimatsu*); kimono: green shell (*aogai*) and boxwood (*tsuge*); seal: green horn (*aotsuno*).

191. *Ryūsa.* Ivory. Unsigned. The allover geometric design is an example of patience and control in laborious carving.

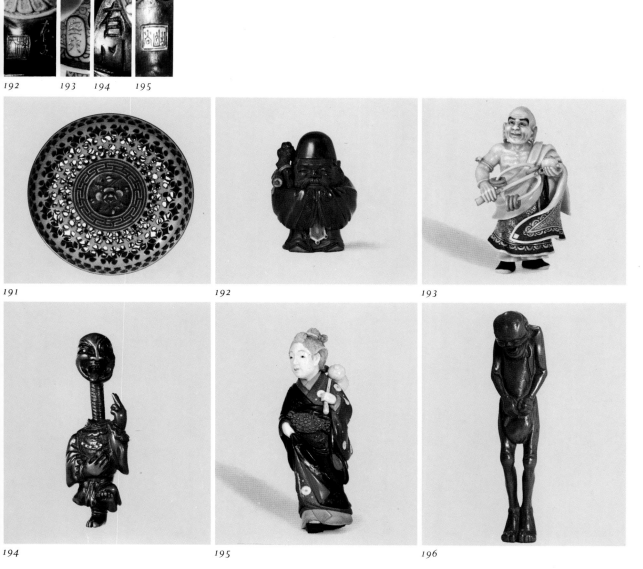

192 193 194 195

191 192 193

194 195 196

192. Fukurokuju. Wood. Signed: Tōkoku, with seal Bairyū (NH 1184). As in most of Tōkoku's work, the inlays are remarkably unobtrusive and in good taste. His technical facility is so great that the inlays escape note, just as the violin virtuoso makes the most difficult cadenza sound as simple as a scale.

193. *Rakan.* Ivory. Signed Kūya. The priest's *shakujō* (jingling staff) is carved with six loose rings. The staff and the folds of the robes are deeply undercut.

194. *Bakemono.* Wood. Signed: Yūsen (NH 1332). The goblin's head is extensible for 1.7 centimeters. The carver's technique is fairly mystifying.

195. Woman of the gay quarter. Wood with various inlays of wood, ivory, and lacquer. Signed: Yūkoku. Ex Dave and Sandy Swedlow Collection. The sakè gourd and the floral pattern of her kimono indicate that she is on her way to cherry-blossom viewing. Yūkoku was probably a follower of Tōkoku.

196. Tying a *fundoshi* (loincloth). Wood. Unsigned. Standing figures that balance are familiar in netsuke. This figure, however, balances on tiptoe.

197. Marriage cups (three views). Ivory. Signed: Jugyoku, with red seal Nao; also Jugyoku and *kakihan*. The exchange of sakè cups is the most solemn and significant part of the wedding ritual. Three cups of graduated size are used. Each cup is filled in turn by three pourings, and each is drunk in three sips by bride and bridegroom in turn. The ceremony is known as *sansankudo* (three times three is nine). The designs of Jugyoku's cups represent three exploits involving horses. The smallest shows Oguri Hangan taming a wild stallion and teach-

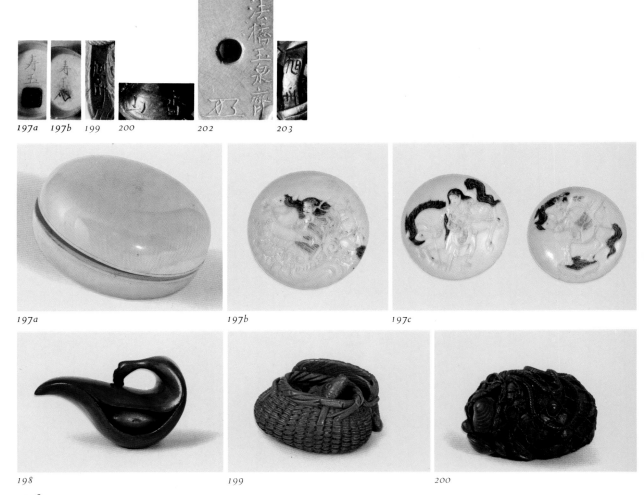

197a 197b 199 200 202 203

197a 197b 197c

198 199 200

ing it to stand on a *go* board. The middle one shows the powerful woman Kaneko Kugutsune stopping a runaway horse. The largest pictures Gentoku escaping his enemies by leaping his horse over a thirty-foot gorge.

198. Bean pod. Wood. Unsigned. The bean rolls free and turns completely around without falling out. The design is deceptively simple.

199. Fish basket. Wood. Signed: Kyokusai (NH 565). The weave of the basket, the grain of the wood, and the twist of cord are meticulously delineated.

200. Sack of clams. Wood. Signed: Kōzan. The woven cords of the sack and the individual clams are carved with meticulous care.

201. Four boys in two. Ivory. Unsigned. The design predates netsuke by a considerable period in China, where it is found in jade and other materials. Our admiration for the creator of the design is forever refreshed by later versions like this one.

202. Bird cage. Boxwood. Signed: Hokkyō Gyokusensai, with *kakihan* (NH 157). Carved from a single block of wood. The bird was fashioned within the cage with tools introduced through the slits between the ribs.

203. Basket of stones (*jakago*). Wood. Signed: Kyokusai (NH 565). Some of the stones are carved free within the basket, yet all is carved from a single block. *Jakago* are used for shoring up river banks at times of flooding.

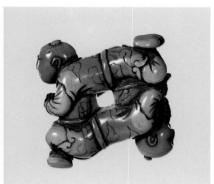
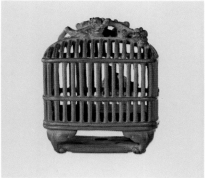

201

202

203

16 ITTŌBORI NETSUKE

Literally, *ittōbori* means carving with a single knife or cutting edge. In practice it means a style of carving in which the model is shaped in angular planes somewhat akin to those of hammered silver. *Ittōbori* is a quicker method of roughing out and completing a figure, since it eliminates several steps in smoothing, polishing, and finishing. More than one knife or one chisel is probably used in producing the *ittōbori* netsuke, but it is nevertheless certain that fewer tools and fewer processes are involved. For these reasons such netsuke are the products of craftsmen's workshops rather than of individual carvers. They lend themselves to quicker and cheaper production. They are popular as souvenirs of certain areas—for example, the Nara *ningyō* of Nara, the Uji *ningyō* of Uji, and the netsuke of the Takayama district in Gifu Prefecture, the last of which are usually carved in *ichii* (yew) wood. Nara and Uji *ningyō* are painted. The Takayama *ittōbori* is not, but the two distinctive colors of yew wood—the creamy tan and medium brown—are sometimes cleverly used for contrast —for example, the lighter face of a monkey against his darker body (Fig. 206).

Only in the Nara *ningyō,* which generally represent Noh actors, does the *ittōbori* style seem especially well suited to the subject matter. The Noh actor wears a heavy, stiff brocaded kimono. The kimono does not sweep or flow with the actor's movements but breaks into angular patterns, which are realistically represented by the angular planes of the *ittōbori* style.

The Takayama netsuke in *ichii* are not inevitably angular. They are often curved and rounded when they need to be, as, for example, in the case of birds (Fig. 205). The older Takayama netsuke are darker in color because of chemical action, as explained by C. Ouwehand in an excellent article on *ichii ittōbori* published by the Society for Japanese Arts and Crafts at The Hague, 1971. There appears to be a correlation between age and quality in Takayama netsuke, the older usually being the better—the result, perhaps, of more painstaking efforts as well as the more mellow colors.

The Sukenori frog on a lotus stem in Fig. 207 may be the missing link or transitional netsuke between the Takayama souvenir in *ittōbori ichii* for popular consumption and the identical model in boxwood so elegantly and beautifully finished, stained, and polished by Sukenaga and Sukenao and so prized by collectors. The Sukenori *ichii* is as well carved and finely expressed as its boxwood counterpart. Had Sukenori used boxwood instead of *ichii* and had he stained, polished, and finished his work as in the case of boxwood, it would probably be the equal of a Sukenaga. This is at least a plausible explanation for collectors who have wondered about the quality differences between the Sukenaga and Sukenao netsuke in *ichii* and those in boxwood.

204 *205* *206*

204. Pigeon. *Ichii*. Signed: Korenaga.
205. Crane. *Ichii*. Signed: Sukekazu.
206. Monkey. *Ichii*. Signed: Sukenori.
207. Frog on lotus stem. *Ichii*. Signed: Sukenori tō.
208. Bat. *Ichii*. Signed: Sukenaga (NH 1124). Signature not shown.
209. *Shishi*. Wood. *Kakihan* of Toen (NH 1177).
210. Horse. Wood. Signed: Toen, with *kakihan* (NH 1177).
211. Pigeon. Wood. Signed: Sukesada (NH 1126).
212. Angular frog. *Ichii*. Signed: Sukenaga (NH 1124).
213. Pigeon. *Ichii*. Unsigned.
214. Otafuku. *Ichii*. Unsigned.
215. Benkei. Red sandalwood. Unsigned.

204 205 206 207 209 210 211 212

207 208 209

210 211 212

216. Rokō Sennin. Wood. Unsigned. Inscription: "Made this in the *ittōbori* technique." Rokō is the *sennin* associated with the *minogame* (sacred tortoise), which was his transport.

213 214 215 216

KAGAMIBUTA NETSUKE 17

There are five classes of netsuke that are special: *kagamibuta,* metal, porcelain, lacquer, and mask netsuke. They have something in common—that is, they were generally made by craftsmen who were not *netsuke-shi.* It is true that some *netsuke-shi* were expert in more than one craft and were at home with lacquer or porcelain or would as soon have carved a mask as a figure, but, in the main, porcelain netsuke were made by potters, lacquer netsuke by lacquerers, *kagamibuta* by swordsmiths, masks by mask carvers, and metal netsuke by casters or wrought-metal artists. At its zenith the demand for netsuke was so great that it paid craftsmen to produce them as supplements to their main productions.

Collections concentrated in these special categories are quite natural for those who have a feel for porcelain, metalwork, lacquer, sword furnishings, or masks. Such collections may appeal as related secondary ones to collectors of Japanese porcelain, lacquer, *tsuba,* metalwork, or masks.

The literal meaning of *kagamibuta* is "mirror lid." The allusion is to the ancient polished-metal mirror used before the development of glass mirrors. By extension the *kagamibuta* type includes lids, or disks, of nonmetallic materials—porcelain, ivory, wood, horn, lacquer, stag antler, and others—that fit into bowls for use as netsuke.

All the art, materials, and techniques of the *tsuba* are found in the *kagamibuta.* The metal disks are of iron, gold, silver, brass, bronze, copper, *shibuichi, shakudō,* and *sentoku.* Like *tsuba,* the disks are sometimes pickled to give them a wide range of rare and beautiful shades. The pickling develops a sort of skin-deep patina, which, when unfortunately cut or polished away, reveals the same ugliness of the raw underlying material as the wood or ivory below the deeply patinated surface of a fine netsuke.

The ground of the lid is sometimes embellished with a fish-roe (*nanako*) surface or a stone-grain (*ishime*) surface. Relief designs are made by inlays, whether flat or raised, by incrustations and overlays, and by engraving. The making of colored pictures (*iro-e*) by means of the inlay of various materials is known as "painting with a chisel." Despite differences in nomenclature the general effects of the processes in various crafts are identical. For example, the technique of producing a

flat surface picture in metal is termed *hira-zōgan,* but the same technique, when used in lacquer, is termed *togidashi.* Engraving in ordinary even strokes is called *kebori,* or hairline engraving, but when the strokes are cut diagonally in imitation of brush strokes in painting, the technique is called *katakiribori.*

The entire art of the *tsuba* may be studied in the *kagamibuta* netsuke.

Kagamibuta netsuke seem to have been introduced in the late Edo period. Some of the greatest of the late Edo and Meiji metal artists—Natsuo, Shōmin, Temmin, and Shūraku among them—made fine *kagamibuta* netsuke.

217. *Bijin* (beautiful woman). *Shibuichi* disk, *tagayasan* (Indonesian ironwood) bowl inscribed "Utamaro ga [painted]." Unsigned. The design is copied from a print by Utamaro. It is flat-inlaid (*hira-zōgan*) in silver and copper and accented with both hairline engraving (*kebori*) and brush-stroke engraving (*katakiribori*).

218. Yasumasa and Kidōmaru. Gold disk, ivory bowl. Signed: Taizan Motozane, with *kakihan*. The raised figures are inlaid in *shibuichi,* with garments and minute textile patterns in shades of gold. Taizan's *gō* is Sekijōken. He was a Meiji-Taisho representative of this Mito-school family.

219. Ono no Tōfū. *Shibuichi* gourd-shaped disk, ivory bowl. Signed: Ryūmin (NH 861). Ryūmin, whose true name was Ono Mataemon, was a pupil of Rakumin. He worked in the latter part of the Edo period, carving wood and ivory as well as metal.

220. *Kappa.* *Shibuichi* disk, Indonesian-ironwood bowl. Signed: Yoshikiyo koku. The figure is carved in elevated relief. The technique used was *uchidashi,* or beating out the design from the reverse side. Yoshikiyo was a Meiji artist.

217 218 219 220

217

218

219

220

221

222

221. Herdboy (*ushidōji*) on buffalo. *Shibuichi* disk, ivory bowl. Unsigned. The herdboy's face is in copper and his hair in *shakudō*. The hide of the buffalo is marked with delicate, even *kebori*.

222. Sadamitsu. Iron disk, ivory bowl. Unsigned. Sadamitsu is one of the four chief retainers of Raikō. He searches for the spider demon by the light of an oil torch. The figure is overlaid on the disk, and gold relieves the monotonous tone of the iron.

223. Plovers (*chidori*) in flight. *Shibuichi* lid, ivory bowl with stylized floral design. Unsigned. The plovers are gilded in a technique that imparts an antique effect. This practice was popular toward the end of the Edo period.

224. Badger priest. *Shibuichi* disk, carved *tsuishu* bowl. Unsigned. The design is in raised relief, flat inlay, and engraving.

225. Hō-ō bird (phoenix). *Shakudō* disk in *nanako* (fish roe) ground, glass bowl. Signed: Zeraku, with *kakihan*. The phoenix, in silver, is not inlaid but attached. It required extraordinary patience, control, and technical mastery to make the circular or square patterns of raised dots in the *nanako* ground. An error was irremediable. It was a young man's work, and the casualty rate in nervous disorders was tragic. The makers of *nanako* patterns assisted the master metal carvers but did little else besides their perpetual dot making. Zeraku was a metal artist of the late Edo period.

226. Daruma. Iron disk, ivory bowl. Unsigned. The rust and roughness of the iron may exaggerate the impression of age.

225 229 230 233 234

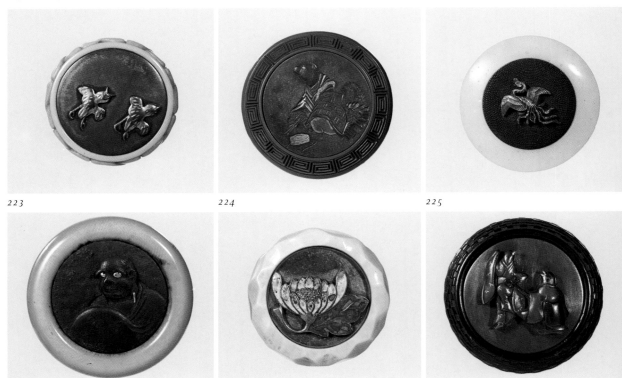

223

224

225

226

227

228

227. Chrysanthemum. Gilt disk, ivory bowl planed in the manner of hammered silver. Unsigned. The chrysanthemum and the leaf are in cloisonné enamel (*shippō-yaki*).

228. Dancing sparrows. Copper *menuki* on wooden disk with gold-lacquer ground, bowl of carved wood. Unsigned. The bowl is carved in a basket-weave design to complement the tale of the Tongue-cut Sparrow.

229. Hitomaro. *Shakudō* disk, ivory bowl. Signed: Shūraku, with *kakihan* (NH 1075). The figures of the poet and the *oni* are in gold, copper, *shibuichi*, and *shakudō*. The subject is probably Hitomaro (one of the Waka Sanjin, or Three Gods of Poetry), whose magic with words was worshiped. Even the *oni* mixes ink for him. Other Shūraku netsuke appear in Figs. 239, 241, 245, and 246.

230. Fly on *tsuba*. *Shibuichi* disk, ivory bowl. Signed: Minjō, with *kakihan*. The ground of the disk is in a very fine stone-grain (*ishime*) technique. The silver fly is inlaid. Like his father, Unno Shōmin, Minjō worked in Meiji-era Tokyo.

231. Woman with oilpaper parasol. Copper disk, wooden bowl. Unsigned. The metalwork, the design, and the technique are quite different from those of the traditional metal artists (*kinkō*). It is quite apparent that the maker learned his technique and style subsequent to the Meiji Restoration through the teaching of the new Western-style Tokyo Art School. The new craftsmanship did not follow in the tradition of the sword and *tsuba* artists. The design is reminiscent of Western calendar art.

232. Kinkō Sennin. Mother-of-pearl disk, carved ivory bowl. Unsigned.

233. *Shishi* and peony. Gold *shishi*, wooden bowl in peony shape. Signed (on bowl): Gyokusō (NH 160). The *shishi* is an old *menuki*, quite probably by one of the Gotō masters. Gyokusō carved the bowl to accommodate and complement the *shishi*.

234. Bamboo. *Shibuichi* disk, octagonal ivory bowl. Signed: Natsuo koku (NH 757). Ex Kenzo Imai Collection. The ground is in stone-grain (*ishime*) technique, the bamboo in brush-stroke engraving (*katakiribori*). The innovation of *katakiribori* is credited to Yokoya Sōmin. In this technique, one side of the groove is perpendicular, the other angular. For an example of Sōmin's work, see Fig. 659.

235. Flaming sphere. Gilt-brass disk, wooden bowl. Signed: Temmin, with *kakihan* and inscription "Sixty-nine-year-old man of this life" (NH 1171). The use of the phrase "of this life" indicates his belief in the

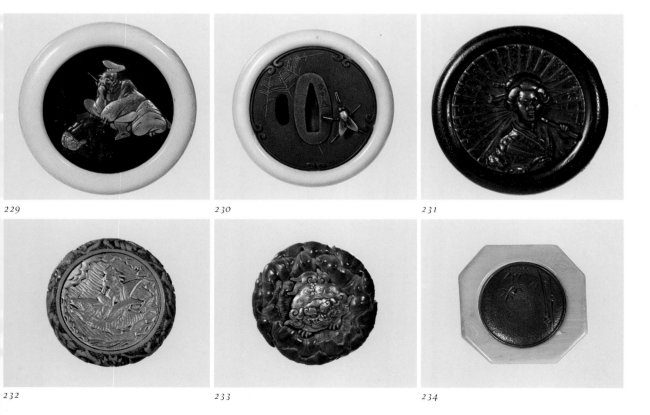

229　　　　　　230　　　　　　231

232　　　　　　233　　　　　　234

Buddhist doctrine of the transmigration of the soul—that he has lived and will live other lives. The chiseling is done in the style of brush painting. It depicts a conventionalized Buddhist flaming sphere known as a *hōju no tama*. Temmin's main period was the Tempo era (1830–44).

236. Fukurokuju. *Shakudō* disk, ironwood bowl. Signed: Seijō, with *kakihan*. The surface of the disk has a delicate stone-grain (*ishime*) ground. Seijō was a Meiji-era artist.

237. Peony. *Shibuichi* disk, ivory bowl. Signed: Jugyokusai Kazuyoshi, with *kakihan*. The peony, in silver and gold, is raised inlay (*taka-zōgan*). Kazuyoshi was a pupil of Ishiguro Masayoshi and worked late in the Keio era (1865–68).

238. *Shōjō*. Gold disk, mulberry-wood bowl. Signed: Katsuhiro. The figure is done in the *uchidashi* technique. Kagawa Katsuhiro was a pupil of Natsuo.

239. *Rakan*. *Shibuichi* disk, ivory bowl. Signed: Shūraku, with *kakihan* (NH 1075). Other Shūraku netsuke appear in Figs. 229, 241, 245, and 246.

240. Filial devotion. *Shibuichi* disk, ivory bowl. Signed: Tempo 6 [1835], autumn, Kikukawa. There are traces of gilding on the *shibuichi*. Kikukawa may not be the carver's personal name but a school name.

241. Daruma. Disk made of facing plates of iron and silver known as *chūya* (day and night), paulownia-wood bowl. Signed: Shūraku, with *kakihan* (NH 1075). Daruma holds a *kongō* (see Fig. 82). Other Shūraku netsuke appear in Figs. 229, 239, 245, and 246.

242. *Tengu* king. Iron *menuki* attached to boxwood disk, ivory bowl. Unsigned. The tassels on the cords of the *tengu* king's hat are of mother-of-pearl.

243. Water bug (*amembo*). Gold disk, amber bowl. Signed: Yoshihiko. Yoshihiko studied with Unno Shōmin and worked in Taisho and early Showa.

244. Herdsman on buffalo. Gold *menuki* on gold-lacquer disk, ivory bowl. Unsigned. The *menuki* appears to be of the middle Edo period.

245. Urashima Tarō. Gold disk, buffalo-horn bowl. Signed: Shūraku, with *kakihan* (NH 1075). Collection of Fred and Nina Thomas. Other Shūraku netsuke appear in Figs. 229, 239, 241, and 246.

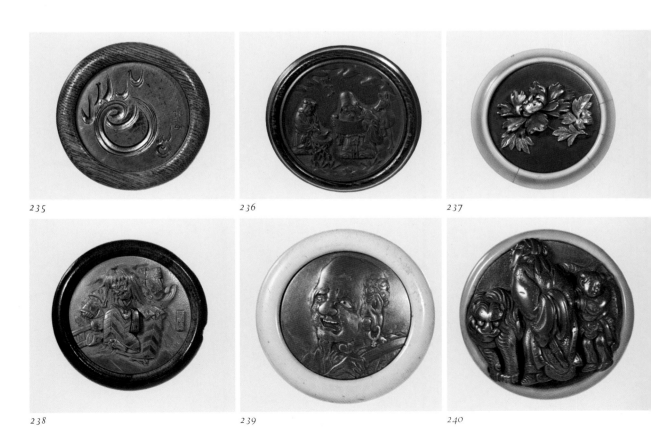

235

236

237

238

239

240

246. Jurōjin. *Shibuichi* disk, ivory bowl. Signed: Shūraku, with *kakihan* (NH 1075). The figure of Jurōjin is engraved within a conventionalized Buddhist flaming sphere (*hōju no tama*). Other Shūraku netsuke appear in Figs. 229, 239, 241, and 245.

247. Wolf with human head. *Shakudō* disk, brass bowl engraved with skeleton. Signed: Naohiro. A vivid allusion to the vanity of life.

248. Rashōmon witch. *Shibuichi* disk, Indonesian-ironwood bowl. Signed: Ryūmin, with *kakihan* (NH 866). Ryūmin was a pupil of Temmin and worked in the Meiji era.

235 236 237 238 239 240a 240b 241 243 245 246 247 248

241

242

243

244

245

246

247

248

18 LACQUER NETSUKE

As we have already noted in the introduction to the preceding section, lacquer netsuke, like the four other types named there, were in the main made by lacquerers rather than *netsuke-shi*. They are also among the older netsuke. We know from the literature and the painting of the Momoyama period (1568–1603) and the early Edo period (1603–1868) that *inrō* were used in those ages. Although entirely undecorated and severely simple, these *inrō* were accompanied by netsuke treated in similar fashion. There is every reason to believe that Kōetsu, Kōrin, and Ritsuō made harmonizing and complementary netsuke for the *inrō* that bore their names. The great Koma and Kajikawa families of lacquerers continued the policy of making *inrō* and harmonizing netsuke all through the Edo and Meiji ages, assimilating innovations and increasingly complex techniques.

Thus the entire history and development of the decorative uses of lacquer through Edo and Meiji can be adequately studied in netsuke. All the various techniques, variations, and styles found on a large scale in chests, saddles, tables, and palanquins; on a smaller scale in boxes for writing implements, for letters, for lunches, and for cakes; and on a still smaller scale in incense containers and *inrō*—all these are employed in making netsuke. In fact, one may maintain with considerable validity that the smaller the area, the more elegant, polished, and jewel-like the lacquer.

In netsuke one finds designs in a wide variety of techniques: polished flat (*togidashi*), low relief (*hira-makie*), high relief (*taka-makie*), the difficult black-on-black (*yama-makie*), carved red lacquer (*tsuishu*), dull gold finish (*fundame*), bright gold finish (*kinji*), wood-grain lacquer (*mokume*), simulated metals (*sabiji*), inlays of iridescent shell (*aogai*), strewn-gold patterns (*nashiji*), and numerous others. It is safe to say that all lacquer styles can be seen in the netsuke.

249. Otafuku. Lacquer, ivory face. Unsigned.
250. Drummer wearing *shishi* mask. Lacquer. Unsigned.
251. Otafuku as a roly-poly. Lacquer. Unsigned. Collection of Sam Broadbent.
252. Box (*hako*) and cover. Wood and lacquer. Signed: Zeshin (NH 1337).
253. Kite in form of *yakko*. Gold lacquer. Signed: Hōhoku. The *yakko* occupied the lowest rung in the samurai order. He was no more than a servant. Because of his contemptible status, he was often an overbearing nuisance and a bully among the townspeople. For protection against the samurai *yakko* the shopkeepers'

249 250 251

associations hired toughs who worked in gangs and were known as *machi* (town) *yakko*. The weapon of the *machi yakko* was a pole that bore the standard of the merchants' association that hired him.

254. *Karako. Tsuishu* (carved red lacquer). Unsigned.

255. Fox. Silver lacquer. Signed: Shōmosai (late eighteenth and early nineteenth centuries). Illustrated in *Masterpieces of Netsuke Art* (Hurtig), Fig. 90.

256. *Shōjō* as Noh dancer. Lacquer, coral face. Signed: Koma Bunsai.

257. Dragonfly on bamboo node. Gold lacquer. Signed: Tōyō, with *kakihan*. Tōyō, whose best-known art name is Kanshōsai, was a renowned eighteenth-century lacquer artist. The inscription is part of a poem, but it is difficult to guess the meaning without the missing section.

258. *Dōjō-ji. Tsuishu* (carved red lacquer). Signed: Hōran. Illustrated in *The Collectors' Encyclopedia of Antiques* (London, 1973). The Dōjō-ji tragedy performed as a Noh play is the Japanese version of "Hell hath no fury like a woman scorned." The priest Anchin's rebuff changed Kiyohime's infatuation into a venomous wrath.

259. Frog on leaf. Gold lacquer. Unsigned.

252 253 255 256 257 258

252 253 254

255 256 257 258

260. *Shishi* and *tama*. *Tsuishu* (carved red lacquer). Unsigned.

261. Sparrow. Gold lacquer. Unsigned.

262. Ants on bamboo. Black lacquer and bamboo. Signed: Zeshin (NH 1337).

263. Box of horrors. Gold lacquer. Signed: Kansai sha (transcribed or copied). Collection of Kikutaro Tsuruta. Kansai was a member of the distinguished Koma family of lacquerers. This may be the work of the second Kansai, who is revered as the teacher of Zeshin.

264. Toy group. *Guri* lacquer. Signed: Sōko tō (NH 1101). Collection of Murray Sprung. *Guri* is a technique in which alternating layers of lacquer of various colors are cut in deep scroll patterns or, as in this example, carved.

262 263 264 265 267

259 260 261

262 263 264

265 266 267

265. *Fuchigashira* (collar and cap of sword handle). Gold lacquer. Signed: Toyotame. The design shows a water wheel and bush clover. See also Fig. 659.

266. *Shishi* head. Gold lacquer. Unsigned.

267. Sparrow dance of Sado Island. Gold lacquer. *Manjū* type. Signed: Yoshiyuki saku (made).

268. Grasshopper. Gold lacquer on ivory. Unsigned. The reverse, simply carved as a bamboo node, is decorated with two gold-lacquer bamboo leaves on a dark stained ground.

269. *Shishi. Tsuishu* (carved red lacquer). Unsigned.

270. Jar-shaped container. Somada and pearl. Unsigned. Somada (named for the artist who developed it) is a technique of embedding bits of shell in shades of blue, green, and violet in black lacquer.

 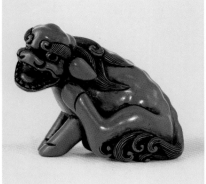 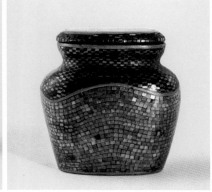

268 269 270

MANJŪ NETSUKE 19

The main expression of the netsuke art of relief carving must be sought in the *manjū* type. The name comes from that of a popular Japanese bean-paste confection in a circular, flattened form and is given to all netsuke of similar shape. By extension the *manjū* netsuke may be of any geometric form as long as it approximates a *manjū* in shape and is suitable for relief carving. Obviously a carving in the round can never be a *manjū,* although an extremely high relief carving, even one in three-quarter relief, may occasionally be found in *manjū.* The carving may be high or low relief; it may be cameo relief or sunken relief (*intaglio rilevato*); it may be an engraved or incised design like the chiseling on metal; or it may be a relief design by inlay, mosaic, or incrustation of contrasting materials.

Manjū tend to be valued less than carving in the round. If we consider that relief sculpture is no less art than carving in the round, a great difference in valuation is questionable. If we hold, as do many great critics, that painting is the greatest of all arts because it requires the solution of the most difficult representational problems, then it is also true that relief sculpture is closer to painting than is carving in the round.

Perhaps the disparaging remark of Ueda Reikichi that *manjū* were turned out on the lathe in large quantities after the great fires and destruction of the Ansei earthquake (1855) contributes to a lack of esteem for the type. That this is one of the few occasions when Ueda erred on a question of fact is amply demonstrated in ukiyo-e in which Sharaku, Toyokuni, and other eighteenth-century artists portrayed actors in fashionable garments wearing *manjū* netsuke.

271. Dispatching a wolf. Ivory. Signed: Toshishige, with *kakihan*. This may be an allusion to Sekiguchi Yatarō, one of Hideyoshi's retainers, although in one version of the story he is alleged to have strangled the beast.

272. New Year's celebration. Ivory. Signed: Seikanshi. As part of the New Year's festivities of Niigata and Akita, in northern Japan, a performer wears a weird mask and beats a drum hung from his neck. See also Fig. 429.

273. Bird. Tooth ivory and gold. Signed: Kaitō (NH 431). The inscription is a poem: "My heart softens with the spring air. I imagine new grass sprouting at Kototoi [on the Sumida River in Tokyo]. I wish I were there." Kaitō was both a metal artist and an ivory carver. His method of rendering waves indicates his debt to metalworking techniques.

274. Cat. Corozo nut in an ivory bowl. Unsigned. Collection of Frances Numano.

275. Temple construction (two views). Ivory. Unsigned. Collection of Dr. Ira Freiman. As an act of piety to please Buddha and to secure his blessing, the start of construction of a great building or temple is celebrated with the release of one thousand captive birds.

271 272 273

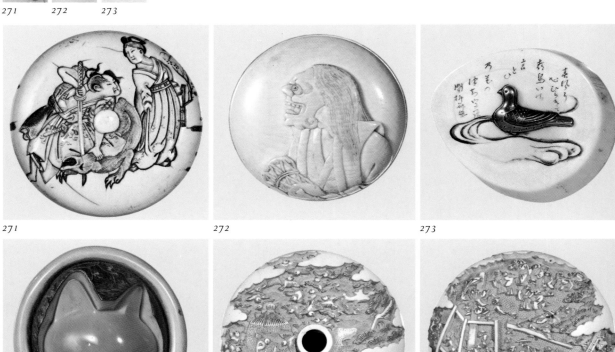

271 272 273

274 275a 275b

276. Seiōbo Sennin. Wood. Unsigned. Seiōbo is the only woman representative among the company of *sennin*. Her emblem is the magic peach—the shape of this netsuke—which gives eternal life. Her messenger is the magical bluebird of her headdress.

277. Chrysanthemums. Wood inlaid with tortoise shell, ivory, and pearl. Unsigned.

278. Nine-tailed fox. Ivory. Signed: Haku-unsai (NH 187). The allusion is to the case of fox possession of Tamamo no Mae, the favorite of Emperor Toba, who night after night depleted his health until her character as a werefox was discovered and she was dispatched.

279. Tekkai Sennin. Wood with ivory inlay. Signed: Ryūya.

280. Family crest (*mon*). Wood inlaid with gilt crest. Unsigned.

281. Chinese sage. Ivory inlaid with various metals and other materials. Signed: Ryūmin, with *kakihan* (NH 861).

282. *Shōjō*. Ivory. Signed: Dōshōsai (NH 90). The *shōjō* balances a sakè dipper on the tip of his nose as he sits beside a huge sakè jar.

278 279 281

276 277 278

279 280 281

283. Plum blossom. Bamboo, *shibuichi*, and gold. Unsigned.

284. Religious symbols. Wood, lacquer, metal, and stone. Signed: Tōkoku, with seal Bairyū (NH 1184). Ex Mark Hindson Collection. The symbols are a *teppatsu*, or begging bowl (wood); a *magatama*, or comma-shaped bead (stone); a *waniguchi*, or crocodile-mouthed gong (metal); and a *sumi* ink stick (lacquer).

285. Farmer viewing the moon. Ivory. Signed: Kishōsai (NH 492). The rabbit group on the reverse side informs us that the farmer is viewing the moon at the end of a long day.

282 284 285 286 287 288 289 290

282 283 284

285 286 287

288 289 290

286. Blind men fighting. Ivory. Signed: Zemin, with *kakihan* (NH 1335). Ex Mark Hindson Collection. Illustrated in Neil Davey's *Netsuke*, Fig. 313. Fearing robbers and not realizing that they are all in the same predicament, the blind men fall on one another in a useless imbroglio. As moneylenders, the blind were the butt of the villagers' envy and derision.

287. Narihira. Ivory. Signed: Ono Ryōmin, with *kakihan* (NH 837). Narihira, one of the Six Great Poets, is portrayed passing Mount Fuji on his way to exile in punishment for his elopement with a daughter of the Fujiwara. Narihira is the Japanese Don Juan.

288. Stealing bamboo shoots. Ivory. Signed: Hōgyokusai. The subject seems to be more than a simple farmer pulling up bamboo shoots for his dinner. The figure probably represents a vagrant *kosodoro*—a sneak thief and a filcher of farm produce—since he wears only a *fundoshi* even though bamboo shoots mature in March, a winter month.

289. Chinese bellflower. Ivory. Signed: Ryūraku (NH 869). The *kikyō* is one of the Seven Flowers of Autumn. It is the Chinese bellflower, or great bellflower, of violet-blue hue, so prominent in modern flower arrangement. As an autumn flower, it is fittingly associated with the harvest moon.

290. Teapot mat (*chabin-shiki*). Ivory. Signed: Gyokuyōsai (NH 163). A *chabin-shiki* is a decorated mat of paper or bamboo used under a teapot.

291. Chrysanthemums. Wood inlaid with pearl and ivory. Unsigned. Chrysanthemums often tend to droop. Here they are supported by a bamboo construction.

292. Chrysanthemum in flower vase. Wood inlaid with gold, coral, and pearl. Unsigned.

293. Gentoku escaping. Ivory. Signed: Moritoshi, with *kakihan* (NH 721). Ex Mark Hindson Collection, No. 976. Illustrated in Neil Davey's *Netsuke*, Fig. 414. It is interesting to note that the distinctive *kakihan*, which Hindson described as a stork, is almost identical with the *kakihan* of Kōgyokusai in Fig. 294.

294. The strong woman Kaneko. Ivory. Signed: Kōgyokusai, with *kakihan* (NH 515). Kaneko's great feat was to stop a runaway horse by stepping on his halter. For another version, see Fig. 197.

295. Nine-tailed fox. Ivory. Signed: Baihōsai, with seal Naomitsu (NH 750). For the legend, see caption for Fig. 278.

293 294 295 291 292

293 294 295

20 MASK AND FACE NETSUKE

The most familiar netsuke masks are those worn in the Noh and in the Kyōgen, the companion comedies of the Noh. This is natural, since Noh plays are performed regularly and since the principal character (*shite*) in these plays invariably wears a mask. The mask is used only occasionally in Kabuki and then usually in dance episodes adapted from the Noh. The powerful *kumadori* makeup of the Kabuki actor vitiates the theatrical value of a mask. Kabuki dramas are more popular than Noh dramas and, like Noh, are regularly performed.

The masks of the now extinct dance-drama Gigaku are usually viewed only at museums and temples, where great originals are preserved. Those of the still performed court dance Bugaku are also to be seen in museums or at occasional public performances. Those used in the *kagura* religious dances can be seen in performances at Shinto shrines. All of these, of course, can be seen in numerous books and catalogues.

To avoid repetition, the illustrations here are less of masks and more of faces: faces that, like Western gargoyles, are placed on the roofs of buildings to frighten away evil spirits; faces carved to represent living people; and faces found on pipes. Most of the Noh and Kyōgen masks seen here are such absurd travesties that their qualities as funny faces supplant their significance as masks.

296. *Onigawara* (roof, or ridge-end, tile). Wood. Unsigned. Inscription: "Oeyama." Oeyama is a mountain near Kyoto, legendarily the dwelling place of *oni* and *tengu*. The carver placed the first character of the name in the center because it allowed for better positioning of the *himotōshi*.
297. *Karasu tengu*. Wood. Unsigned. Collection of Jeffrey Moy. An architectural piece for protection against evil spirits.
298. Monkey head. Vegetable ivory (corozo nut). Signed: Sadayuki. Collection of Cornelius Roosevelt.
299. Face. Bamboo. Signed: Raikō (Yorimitsu). Ex M. Souquet Collection.

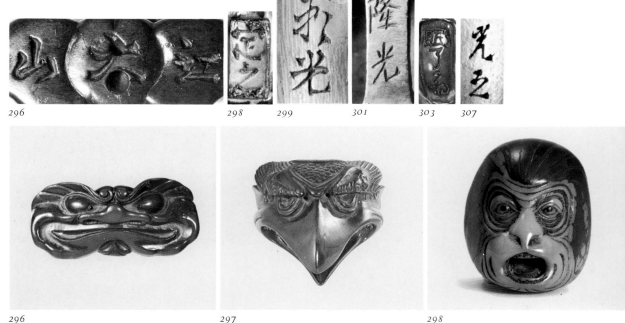

296 298 299 301 303 307

296 297 298

300. Otafuku. Stag antler. Unsigned.

301. Gigaku mask. Lacquered wood. Signed: Ryūkō. A principal distinction of the Gigaku mask is that it is large enough to cover the head, whereas the Noh mask barely covers the face.

302. Monkey face. Ink block. Unsigned. The material shows typical ink-stick crackling.

303. Laughing face. Walnut. Signed: Minryōsai.

304. Kyōgen mask: Ikkaku (One-Horn) Sennin. Boxwood. Unsigned.

305. Female face. Ivory. Unsigned. Illustrated in *Orientations*, October 1970. The photographic realism leaves little doubt that this is a face rather than a mask. The unknown carver may have portrayed a friend or a neighbor.

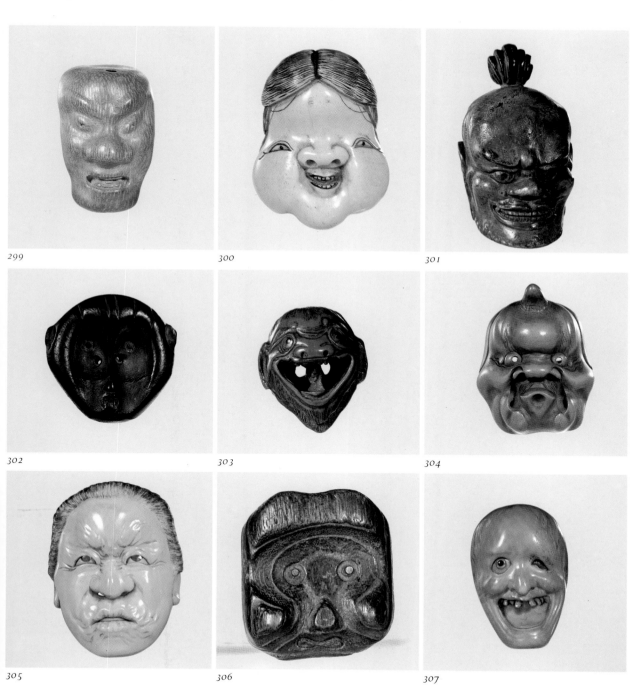

299 300 301

302 303 304

305 306 307

306. *Kappa.* Paulownia wood (*kiri*). Unsigned.

307. Ghost. Ivory. Signed: Mitsuyuki.

308. Blind singer. Wood. Signed: Gyokkō (NH 134). The representation of full head and neck is unusual.

309. *Onigawara* (roof, or ridge-end, tile). Stag antler. Signed: Koku (Kokusai; NH 527). Collection of Jeffrey Moy.

310. Head. Wood. Signed: Komin.

311. Otafuku. Wood. Unsigned. The mask of Otafuku is used in Kyōgen and even more prevalently in rural harvest festivals.

312. Dragon head, probably of *amaryū,* the rain dragon. Wood. Unsigned. Collection of Jeffrey Moy. An architectural piece used in large constructions like shrines and temples. It is usually installed as a cover at the end of a main horizontal beam and used as a base for a crossbeam or a roof beam.

313. Face. Stag antler. Inscription: "Ō" (old man). It is not clear whether the reference is to the mask or to the carver. Like the face in Fig. 305, it probably represents a living neighbor rather than a mask.

314. Demon mask. Boxwood. Signed: Sanshō, with *kakihan,* on an inlaid ivory label. In view of Sanshō's love of absurdity and exaggeration and his propensity for the belly laugh, we should not expect a conventional Noh or Kyōgen mask from his riotous imagination.

315. *Tengu* mask. Boxwood. Signed: Sanshō, with *kakihan,* on an inlaid ivory label.

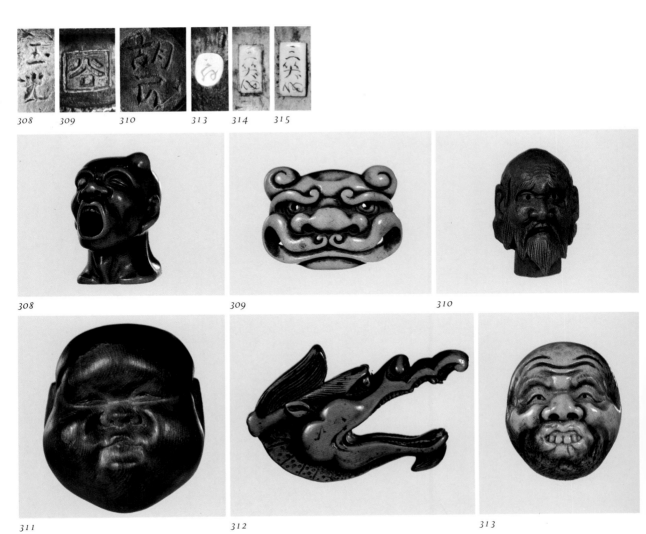

308 309 310 313 315

308 309 310

311 312 313

316. Demon mask. Wood. Unsigned. The animalistic character of the mask is heightened by the use of natural animal teeth for horns and tusks.

317. Woman's head. Ivory. Unsigned. The head was undoubtedly part of a pipe that was much used. The open mouth of the woman received the tobacoo and is severely scorched.

318. Man's head. Ivory. Unsigned. The realism is photographic.

319. Thirty-seven masks. Walnut. Unsigned. The masks are those of Noh and Kyōgen.

320. *Oni* face. Ivory. Unsigned. The piece is very flat and has a single hole for cord attachment.

321. Face. Tooth, probably bear's tooth. Unsigned.

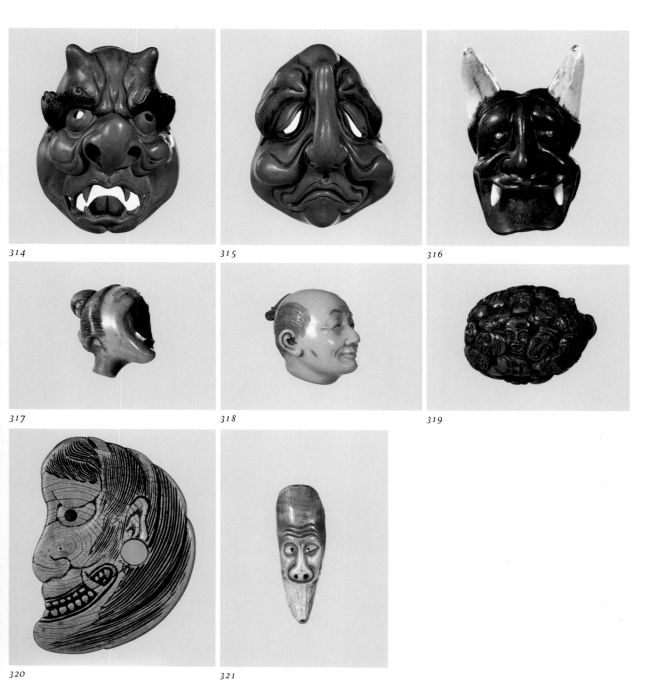

314

315

316

317

318

319

320

321

21 MATERIALS

In *The Art of the Netsuke Carver,* Meinertzhagen lists numerous netsuke materials, including such rarities as petrified egg and betel nut. In an article on netsuke appearing in the Dutch magazine *Handenarbeid* for March and April 1971, Professor M. F. Severin writes: "The netsuke is, of all art objects, the one in which the greatest variety in materials occurs." J. van Daalen has written about netsuke materials and directed netsuke exhibits with the emphasis on materials. Many collectors are as interested in materials as are collectors of snuff bottles, for whom material occupies a paramount position.

It is almost impossible to complete a collection based on netsuke materials. Materials are finite, but their application to netsuke is infinitely frustrating. There seems ever to be a horse bone, a petrified egg, or a hard dried rind to add to the list. One pottery netsuke and one porcelain netsuke will not satisfy their respective categories. There are dozens of distinct kinds of pottery and porcelain produced in the various kilns of Japan. There are dozens of metals and alloys and numerous types of lacquer. The problem of the materials collection may be where to fix the limits. There are hundreds of woods, not only domestic but imported as well. Ultimately the problem of a materials collection becomes one of identification, particularly in the case of woods. Woods that have been stained, treated, or lacquered are most resistant to positive identification.

Questions are often asked about the existence of jade netsuke. Jade is rarely seen in netsuke, and when it is, it is invariably a Chinese toggle that has been adapted for use as a netsuke. Carving jade is an entirely different matter from carving wood or ivory. Jade is much harder, and different techniques and tools are required. Nevertheless, it would be foolhardy to maintain categorically

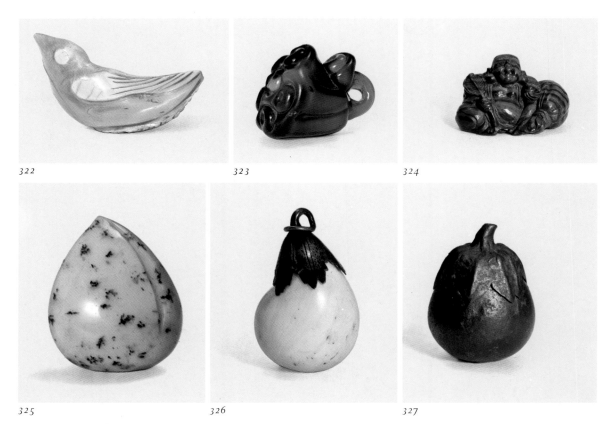

322

323

324

325

326

327

that there is no such thing as a Japanese jade netsuke. The Japanese do carve agate, quartz, and crystal, though rarely as figure netsuke. There is no reason why the same craftsmen could not carve jade. Malachite is almost as hard as jade, yet the malachite figure netsuke shown in Fig. 324 is a genuine Japanese work.

322. Bird. Mother-of-pearl. Unsigned.
323. Lotus pod. Glass. Unsigned.
324. Hotei. Malachite. Unsigned. Ex Yoshimatsu Tsuruki Collection.
325. Peach. Stone. Unsigned.
326. Eggplant. White coral and silver. Unsigned. Ex Kenzo Imai Collection.
327. Eggplant. Wrought iron. Unsigned.
328. Shōki. Pulverized buffalo horn, gold lacquer. *Manjū* type. Unsigned. The pulverized horn is mixed

329 330 333

328

329

330

331

332

333

with lacquer glue and set in a mold. There is a considerable amount of final hand carving, which accounts for varying qualities in identical models. The final result is enhanced with gold lacquer.

329. Horse on engraved seal base. Rhinoceros horn. Unsigned.

330. *Shishi*. Rhinoceros horn. Unsigned. Engraved seal base. Collection of Fred and Nina Thomas.

331. Etched horse and character for horse (*uma*). Horse bone. Unsigned.

332. Two ladies. Dried mushroom (*reishi*). Unsigned. *Tomobako* (original box) signed and sealed: Reishiō (old man Reishi).

333. Bamboo nodes. Yellow stone. Unsigned. Engraved seal base. The stone may be the jadelike stone known to the Chinese as *t'ien huang* and found in Fukien Province.

334. Buddha's hand, a citrus fruit. Clear amber. Unsigned.

335. *Shishi* head and peony. Carnelian and gold. Unsigned.

336. Stylized chrysanthemum. Leather. Unsigned.

337. *Shishi*. Gold sandstone. Unsigned.

338. Snake. Boar tusk. Unsigned; attributed to the Iwami school. Illustrated in Shichida Makoto's *Shimizu Iwao to Sono Ichimon,* Fig. 47.

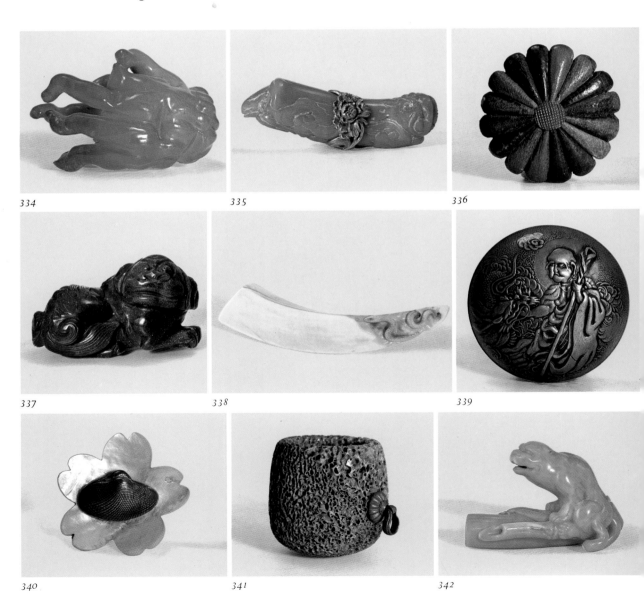

334

335

336

337

338

339

340

341

342

339. *Rakan* with dragon (Handaka Sonja). Pewter. *Manjū* type. Unsigned.

340. Cherry blossom and clam. Mother-of-pearl and silver. Unsigned. The relationship may be seasonal. Clams taste best when cherry blossoms bloom.

341. Cup. Whalebone. Unsigned. Whalebone is strong but porous and light. Despite the shape, this cup could not be used as a sakè cup.

342. Tiger and bamboo. Coral. Unsigned.

343. Daruma. Coral and silver. Unsigned. Illustrated on jacket of *An Introduction to Netsuke*.

344. Fukurokuju. Cloudy amber. Unsigned.

345. Daruma. Coral. Unsigned. Collection of Murray Sprung.

346. Clam. Woven cane. Unsigned. The rind, or skin, of the cane is finely split for weaving.

347. Insect amber and cloisonné (two views). Unsigned.

348. Cow. Tortoise shell. Unsigned.

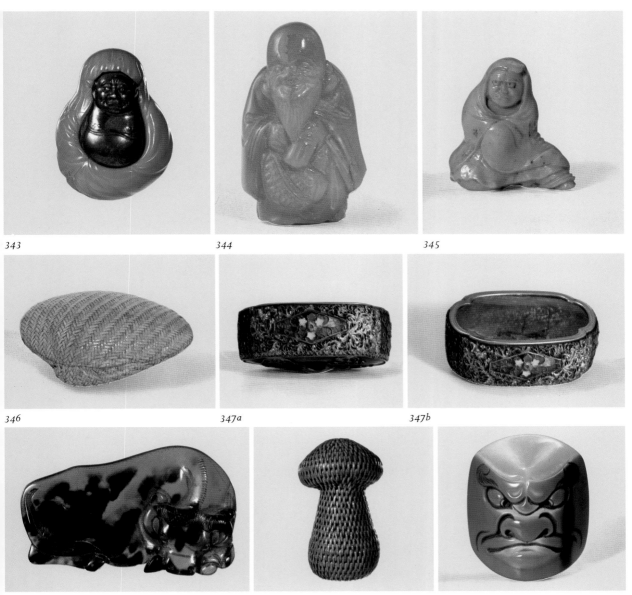

343 344 345

346 347a 347b

348 349 350

349. Mushroom. Woven cane. Unsigned.

350. Noh mask. Hornbill ivory. Unsigned.

351. Cicada. Gold leather. Unsigned.

352. Hexagonal *manjū*. Braided cane. Unsigned. Kenzo Imai states that the time needed for braiding cane in this complicated floral pattern must be measured in months and that not more than two craftsmen still living are able to do such work.

353. Crane bone. *Sashi* type. Unsigned. Ex Kenzo Imai Collection. The crane's leg bone is amazingly light in weight. The lacquer is in the tortoise-shell pattern. The crane and the tortoise signify long life.

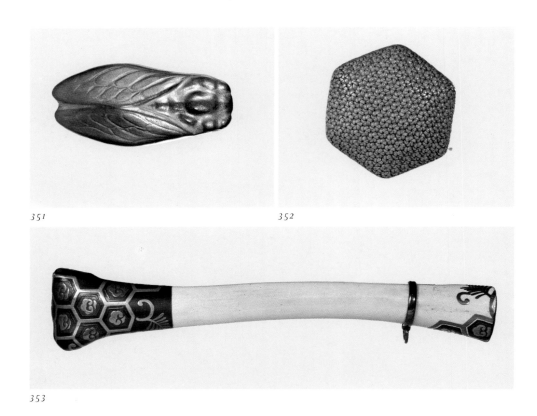

351

352

353

22 METAL NETSUKE

The craft of metalworking, like most Japanese crafts, was quite distinctly subdivided, each sub-division having its own methods and techniques, nomenclature, and traditions. The main divisions of metal artists were chasers, casters, and wrought-metal workers. Traditionally, chasers fashioned sword furnishings; casters made temple bells, censers, and architectural ornaments; and wrought-metal artists made arms and armor. Historically, all three divisions served the aristocracy, but by the later part of the Edo period the various metal artists were producing netsuke by their respective methods to meet a growing demand and, obviously, to augment their incomes.

The craft of the chasers is amply illustrated by the *kagamibuta* netsuke (Category 17) as well as

by a few of the netsuke in the present section. The owl in Fig. 355 and the Chinese *sennin* in Fig. 363 are examples of casting. The dragon in Fig. 356 and the mallet in Fig. 360 are examples of wrought metal.

354. *Kashira* fitted as a netsuke. Unsigned. Collection of Tamotsu Kuroda. The *kashira* is the metal cap at the top of a sword hilt. Alternate layers of *shibuichi* and copper are exposed in the scroll design to give the effect of *guri* lacquer (see caption for Fig. 264).

355. Owl. Bronze. Unsigned. Collection of Shiro Akai. The metal was cast, etched, and gilded.

356. Dragon. Iron and diamond. Signed: Mitsukiyo. The stone is a genuine diamond cut in antique facets.

357. Dog. Copper, *shibuichi*, and *shakudō*. Signed: Sasa Yoshihiko. In general form this is a *kashira*, but, unlike the one in Fig. 354, it is unsuitable for mounting on a sword. Yoshihiko is the metal artist's *gō*. Sasa may be his family name.

358. Hen and chicks (two views). *Shakudō* on *nanako* (fish roe) ground, with design in various metals. Unsigned. Collection of Eizaburo Matsubara. The piece strongly suggests the work of a *tsuba* maker.

359. Frog on eggplant. Iron. Unsigned. Collection of Zenshiro Horie.

360. Daikoku's mallet. Silver. Unsigned.

361. Writing-brush set (*yatate*). *Shibuichi*, with crab in copper. Signed: Masayuki. For other *yatate*, see Figs. 788 and 789.

356 *357*

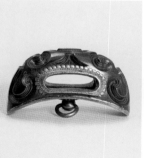

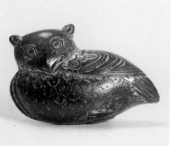

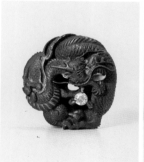

354 *355* *356* *357*

358a *358b* *359*

362. Stirrup. *Shakudō,* with arabesque design inlaid flat in gold. Unsigned. The gold lining of the inside of the stirrup is scored with an unusual stone-grain (*ishime*) ground.

363. Chinese *sennin.* Bronze. Unsigned. Collection of Harry Pincus.

364. Fukurokuju (two views). *Shakudō* and gold. Signed: Noriyuki, with *kakihan.* Collection of Anna L. Wunderlich. Noriyuki was an early-nineteenth-century metal artist of the Hamano school.

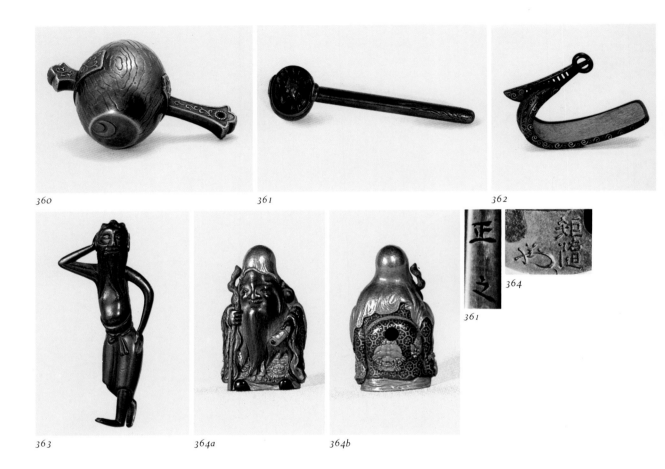

360

361

362

363

364a

364b

364

361

23 MINGEI NETSUKE

There is much confusion about the meaning of the term *mingei.* It is popularly translated as "farmers' art," a contraction of the term *nōmin geijutsu.* As farmers' art, it is viewed as a kind of amateur art: a spontaneous effort—something a nonprofessional might produce for his own use. Such an understanding is quite inaccurate. Surely the best authority on the meaning of the term is the man who coined it: Sōetsu Yanagi, founder of the Japan Folkcrafts Museum (Nippon Mingei-kan). Yanagi composed the word *mingei* in 1918 as an equivalent for "folk art" or "art of the people." It is now part of the language.

Mingei is not amateur art. It is professional inasmuch as trained craftsmen who have served lengthy apprenticeships work at producing *mingei* articles for their livelihood. It is a folkcraft in the sense that the articles are born of a community need and are inseparable from their function and use. It is spontaneous in the sense that preliminary thought is unnecessary. The craftsmen know their

jobs through thousands and thousands of repetitions. Their work is second nature and automatic. It is unself-conscious in the sense that the designs and decorations are minimal and accord with function and use. They result from a sense of fitness developed by successive communal generations. The folkcraftsman is not an individual artist but a member of a guild. He does not sign his name to the *mingei* article, whether it is a reed hat, an Otsu-e (folk painting from Otsu), or a pot.

The opposite of the *mingei* artist is the *sakka*, the *art* craftsman: the artist who works independently, expressing his individuality and creating his own designs—in short, applying his theory of art to his work. He creates art for art's sake, for beauty rather than for use. As the great protagonist of *mingei*, Yanagi found the fault with the *sakka* to be his tendency toward overdecoration, overelaboration, artificiality, contrivance, and self-consciousness. He felt that the creations of the *sakka* often collapsed of their own weight and weakness, while *mingei* remained healthy and robust by virtue of its usefulness. Yanagi's book *The Unknown Craftsman,* beautifully adapted into English by the renowned Cornish potter Bernard Leach, provides a penetrating insight into the world of folk art and Japanese aesthetics.

Netsuke have their roots in *mingei* but their flowerings in the work of *sakka*. (See introduction to Category 26.) The netsuke shown here are not *mingei* netsuke, but for the sake of convenience we may classify them as quasi-*mingei*. They exhibit a certain ruggedness, a rural character or provincialism—a quality that often causes them to be popularly mistaken for actual folkcraft products.

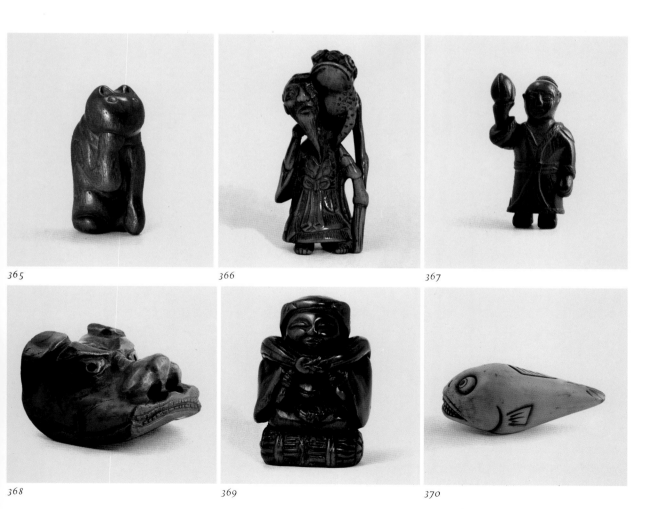

365

366

367

368

369

370

365. Cat. Wood. Unsigned. Ex Yuzuru Otsuki Collection.
366. Gama Sennin. Wood. Unsigned.
367. Religious man. Wood. Unsigned. A devotee of Confucius offers a peach to his temple.
368. *Shishi* head. Lacquered wood. Unsigned. Collection of Walter Belanger.
369. Daikoku. Wood. Unsigned. Daikoku's pedestal is a huge rice bale. See also Fig. 110.
370. Fish. Marine ivory. Unsigned.
371. Wrestler. Wood. Unsigned. Illustrated on jacket of *Collectors' Netsuke*.
372. Mask. Wood. Unsigned. Illustrated on jacket of *Collectors' Netsuke*.

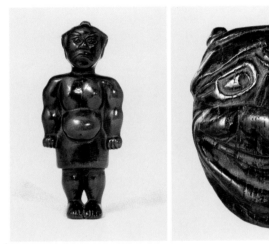

371 372

24 MISCELLANEOUS NETSUKE

"Miscellaneous" is a necessary catchall classification for those netsuke that do not fit into any of the other categories covered in this book. There was never an intention that these categories should be complete—only that they be representative and suggestive. One or two of the miscellaneous netsuke shown here may suggest interesting subject matter for unusual collections. For example, an entire collection of netsuke might be based on ukiyo-e subjects and designs or on drawings and caricatures created by Hokusai in his *Manga* and other books.

373. Personal seal of Kūya. *Byakudan* (sandalwood) simulating bamboo. Collection of Tokisada Nakamura. Kūya, who was the father of Masatoshi, carved this seal for his own use. For another example of his work, see Fig. 193. The seal is engraved at both ends, one end in elevated characters, the other in incised characters. The Japanese know the elevated characters as positive and masculine engraving, the incised characters as negative and feminine engraving. The positive seal reads "Ittensai," the negative seal "Kūya." Both names are *gō*. Kūya used this seal to sign and authenticate boxes for the *okimono* and netsuke he carved. When he was about fifty, he changed his second *gō* to Musōan, a name based on his *kaimyō,* or Buddhist name by which he would be known after his death.

374. Sharaku print. Wood. Signed: Sōsui (NH 1111). Here Sōsui has transformed a Sharaku print into a netsuke. However, he did more than copy, for he completed the actor's full figure from the original bust, as Sharaku might have done if he had been a *netsuke-shi.*

375. Laborer. Ivory. Signed: Sōsai. Sōsai was an early-twentieth-century carver who devoted the bulk of his time to *okimono* figures and only occasionally carved netsuke. Whatever he carved, whether *okimono* or netsuke, the face never changed. It was a "good" face, but it was always the same. In fact, it was his *own face.* It is therefore easy to recognize Sōsai's work without reference to his signature. His face is on all his figures. One might say facetiously that he signed with his face.

376. Stag. Ivory. Signed: Masatoshi sha (copied). Masatoshi did not copy Okatomo in a particular model. He used the word "copied" to indicate his effort to evoke the quality of an earlier period and the style of Okatomo.

377. Bronze animal. Ebony. Signed: Sōsui (NH 1111). Sōsui modeled the animal after an archaic Chinese bronze.

378. Nude. Wood. Signed: Susumu. This unusual netsuke is clearly in the stream of modern European sculpture. The inspiration for it may have been the work of Aristide Maillol. The signature is also interesting.

373 374 375 376

373 374 375 376

If the circle enclosing the strokes is taken to mean the word *maru* (round), the signature may then be Marushin. There seems to be no clue to the carver's identity, whether Susumu or Marushin.

379. Heron (*sagi*). Ivory. Signed: Masatoshi, with *kakihan*. In this piece Masatoshi endeavored to imitate the style, stain, and feel of Mitsuhiro.

380. Dutchman. Ivory. Unsigned. The feet are engraved with a seal reading "Sōhen," the name of a famous tea-ceremony family. The netsuke may have belonged to one of the tea masters who bore this name.

381. Priest. Negoro lacquer. Unsigned. The coincidental resemblance of the priest to Mahatma Gandhi is remarkable.

382. Frog. Boxwood. Signed: Masatoshi tō. Here Masatoshi endeavored to capture the spirit and character of Chinese carving.

383. Neighborhood guard. Wood. Unsigned. Ex Mark Hindson Collection, No. 1042. Illustrated in Neil Davey's *Netsuke,* Fig. 928. This piece was certainly carved from personal observation of a local neighborhood guard at his post. The graffiti on the walls of the post show how universal this type of scribbling is: the names of two streets, Second and Third; the name of a renowned Kabuki actor, Nakamura Utaemon (currently used by the sixth-generation descendant); the woman's name Naka and the man's name Tōbei linked with the sign of a house roof, indicating an affair; a similar linking of the woman's name Oito and the man's name Chōbei; and the words "Fire Watch" and "Watch Out for Fire." The guard was required to make his warning rounds every two hours. He is shown taking up his drum to start on a round.

384. Daffodil (*suisen*). Ivory and boxwood. Signed: Sōko (NH 1101). The shape of the netsuke and the placement of the signature along the edge suggest the possibility that the piece was made as an *obidome* (sash ornament) but converted to a netsuke. If so, the conversion was worthy of Sōko. The boxwood is beautifully worked to complement the design and is stained to the delicate yellow of the natural flower.

385. *Shishi* mask. Stag antler. Signed: Koku (Kokusai; NH 527). The carving is of indubitable authenticity, but just as certainly the back section and *himotōshi* are later additions. The piece is clearly composed of two sections. A plausible explanation is that Kokusai carved the relatively thin, flat facing section as a purse clasp that was later converted to use as a netsuke by the attachment of an additional section with *himotōshi*, whether this was done by himself or by someone else.

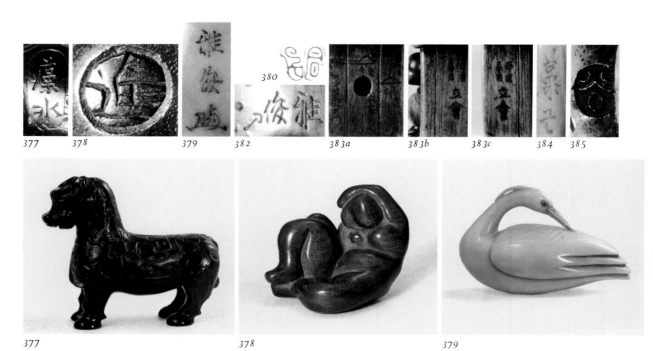

377 378 379 382 383a 383b 383c 384 385

377 378 379

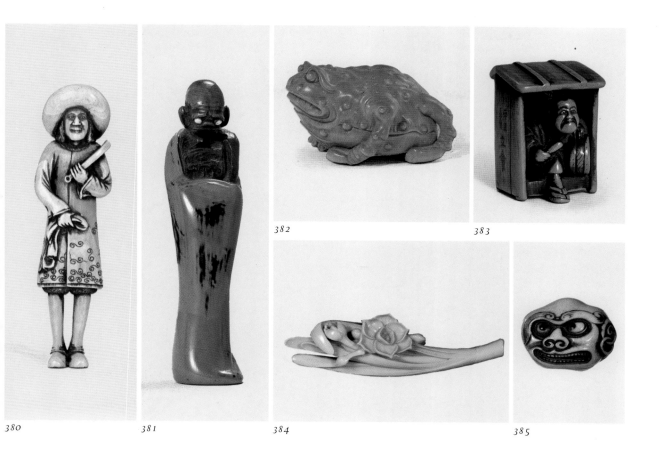

380

381

382

383

384

385

MOKUGYO NETSUKE 25

The *mokugyo* is a wooden gong that is struck from time to time with a padded stick while Buddhist priests chant sutras. In a general sense it is a musical instrument. It produces a single dull note that contrasts pleasantly with the monotonous murmur of the chanting. The purpose of sounding the *mokugyo* is to gain the attention of Buddha and to accent the prayers.

The literal meaning of *mokugyo* is "wooden fish." Originally the gongs were conventionally carved with confronting dragon-fish or dolphins and with pockets of fish scales. When the carvers reduced the size of the *mokugyo* for use as netsuke, the convention was more or less disregarded. The *netsuke-shi* introduced various creatures to form the handle of the gong and stretched and distorted the body into a myriad of forms. Like its big brother of the temple, the netsuke must be hollowed out and shaped so that it responds with a clear note when tapped with a fingernail. The basic *mokugyo* is a perfect netsuke shape.

The Japanese are quite enamored of the endless varieties and variations of the *mokugyo* and make special collections of them. The *netsuke-shi* often imitated the *mokugyo* in various materials such as bamboo (Fig. 387), stag antler (Figs. 390 and 392), and ivory.

The *mokugyo* should be distinguished from the *gyoku,* a close relative. The *gyoku* is also a wooden fish-shaped gong used in temples, but its shape is quite elongated. Instead of a handle, it is fitted with loops by which it is hung. It is struck with a heavy stick to summon the priests for meals, meditations, meetings, and prayers. An example of the *gyoku* can be seen in *Collectors' Netsuke,* Fig. 231.

386. *Oni*-handled *mokugyo*. Wood. Signed: Hōjitsu.
387. Monster face. Bamboo. Unsigned.
388. *Mokugyo* with whisk and rat. Lacquered wood. Signed: Sōkō, with *kakihan* (NH 1100). The carver is Toshiyama Sōkō and not the more famous Morita Sōko.
389. Monster with drumstick. Wood. Signed: Gyokumin (NH 148).
390. Dragons. Stag antler. Unsigned.
391. Unicorn. Wood. Unsigned.
392. Confronting dragons. Stag antler. Unsigned.
393. Dragon-fish. Wood. Unsigned.
394. Fish. Wood. Unsigned.

386 388 389

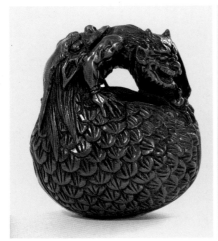

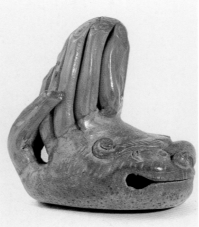

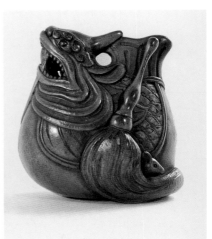

386 387 388

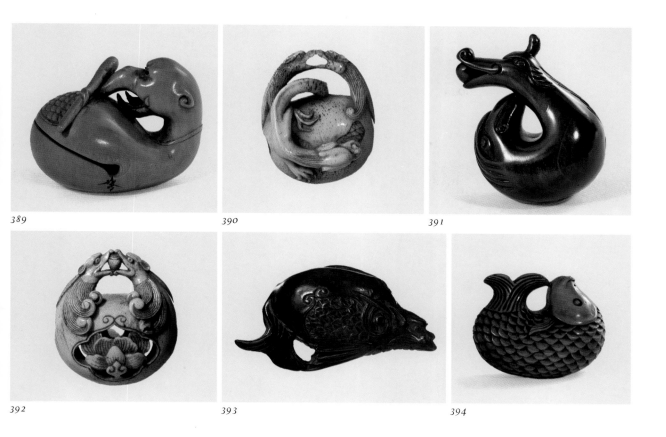

389

390

391

392

393

394

NEGORO NETSUKE 26

Some explanation of Negoro lacquer and Negoro netsuke has already been given on pages 64–65 and some relevant information about *mingei* netsuke on pages 138–39. If not true *mingei*, Negoro netsuke bear the closest relationship among all netsuke to a genuine folkcraft product. The only other candidates that might possibly qualify as *mingei* are some of the souvenir netsuke: the tea-picker *ningyō* of Uji, the Noh actor of Nara, and the *ittōbori* of Takayama. To qualify as a folkcraft product, the netsuke must be ruggedly functional, simple in form and decoration, constantly repeated, inexpensive, easily available, and unsigned. Not all Negoro netsuke satisfy these requirements of true *mingei*. Many of those shown here may be genuine folkcraft products, but others are not, even though they were produced by the same general Negoro-lacquer technique. They are disqualified as *mingei* because they are overdecorated with gold, brown, or green lacquer; because the design is elaborated beyond basic function; because the model is too "original"; or because it is signed.

395. Boy with mask. Unsigned.

396. Performer. Unsigned.

397. Blind man. Unsigned.

398. *Shōjō*. Unsigned. The drunkard's face is hidden behind his sakè cup. The stand for the cup is his head or hat.

399. Swan. Unsigned.

400. Chinese sage. Unsigned.

401. Daruma. Unsigned.

402. Dog. Unsigned. Ex W. W. Winkworth Collection.

403. Pigeon. Unsigned.

406 409 410

395

396

397

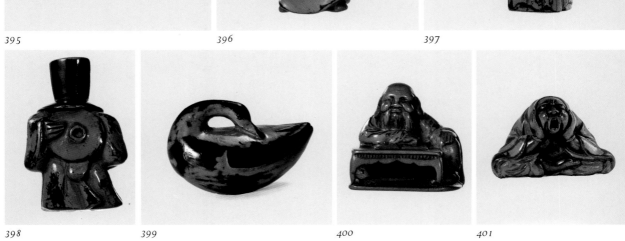

398 399 400 401

404. Stylized sparrow. Unsigned.

405. *Shōjō*. Unsigned. The drunkard's sakè cup is in one hand and his sakè jug in the other. A time and motion efficiency expert could not improve on the *shōjō's* alcoholic arrangement of hands, jug, and cup.

406. Kinkō Sennin. Signed: Tenzan.

407. Twin birds. An obliterated mark may have been a signature.

408. Mandarin duck. Unsigned.

409. Octopus. Signed: Gyokuzan (NH 164). Collection of "Sammy" Yukuan Lee.

410. Drunkard. Signed: Gyokusen (NH 156). Only faint traces of Negoro lacquer remain.

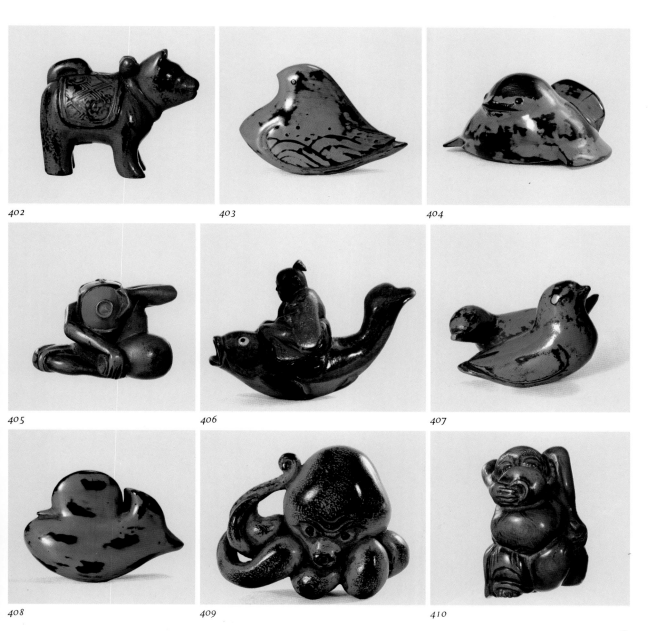

402

403

404

405

406

407

408

409

410

27 OKIMONO-TYPE NETSUKE

There are some netsuke that border on the *okimono*. They may be true netsuke, but because of size, bulk, brittleness, angularity, protrusions, or lack of compactness, they are suspected of trespass across the *okimono* boundary. Admittedly, the distinction is tenuous and usually depends on the standards of the individual collector. One collector's large netsuke is another's small *okimono,* just as one historian's Mede is another's Persian. The same group of minute figures on a mountain might be classed as netsuke or *okimono* depending upon the presence or absence of a recess or overhang carved for protection. Some pieces of *okimono* size are unquestionably accepted as *sumō* wrestlers' netsuke (see Category 28). The carving of *himotōshi* is by no means a controlling criterion. The factors of size, bulk, brittleness, angularity, and compactness all contribute to a final judgment. The netsuke shown here are considered true netsuke despite a more or less radical departure from the "ideal" netsuke on one ground or another.

411. Tiger, horse, and dog. Wood. Signed: Yoshikazu. This zodiac combination of three animals was probably a special order. One may speculate that the patron ordered the netsuke to represent the birth years of his three children or to commemorate three significant or lucky events that occurred in the years represented.

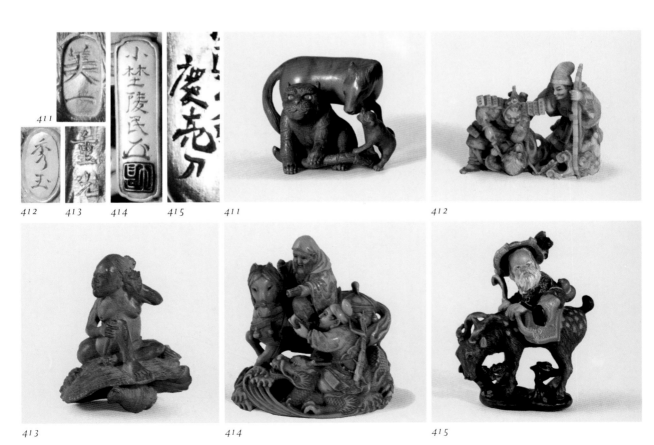

411 412 413 414 415 411 412

413 414 415

412. Killing the *nue*. Ivory. Signed: Shūgyoku (NH 1047). The *nue* is a composite beast: head of a monkey, back of a badger, scales of a dragon, and tail of a snake. Legend has it that Yorimasa and I no Hayata saved the emperor by killing the *nue*. The netsuke is rather fragile. It is of a type that was popular when the European preference was for the legendary and the quaint.

413. Diving girl resting on shell. Wood. Signed: Shigemitsu. See also Fig. 128.

414. Kōsekikō and Chōryō. Ivory. Signed: Ono Ryōmin, with *kakihan* and seal Ono (NH 837).

415. Jurōjin mounted on his stag. Colored wood. Signed: Keisuke tō. Inscription: "Painting of the five fortunes dispensed by heaven. Copied from old man Chokunyū. Keisuke carved." Chokunyū was a painter (1814–1907). The five fortunes are health, wealth, longevity, freedom from accident or misfortune, and virtue. For a netsuke attributed to Keisuke, see Fig. 106.

OUTSIDES AND MINIATURES 28

It is hardly necessary to repeat that netsuke are of miniature dimensions. The earlier ones tend to be longer or larger, the later ones shorter or smaller. This difference is the result of a normal historical development. However, the Gargantuas and Lilliputians shown here were deliberately enlarged or diminished to suit the size, sex, or age of the wearer. For example, size and bulk mark the netsuke in Fig. 420 as a typical wrestler's netsuke even without the confirmation of the inscription. Most *sumōtori* (*sumō* wrestlers) who attain championship rank weigh in the neighborhood of 300 pounds and require netsuke of proportionate bulk. The netsuke shown in Figs. 416–19 and 421–26 may be classed as wrestlers' netsuke because they are large enough to complement the most ponderous pachyderms—to crib the sports writers' favored phrase. Of course any large man, or even a small man with a special interest in *sumō* or a predilection for huge netsuke, might wear a "wrestler's netsuke."

At the other extreme, diminutive netsuke were invariably intended for women and children. Frequently the appropriateness of the subject, such as heroes, games, and fables, as well as the tiny size of the netsuke, tends to confirm their purpose for use by boys or girls. At festivals and holiday celebrations children are sometimes dressed traditionally in their gayest kimono, complete with *inrō* and netsuke. Except for the few orthodox farmers and fishermen who are still attached to their old pouches and netsuke, the last stronghold of *inrō* and netsuke is the geisha. These little women wear brightly colored lacquer *inrō* with complementary netsuke when they are engaged for a party or take part in a public dance performance. Perhaps they cling to Edo-period symbols as a defense against the encroachment of the modern golf course on the traditional teahouse.

Fig. 436 shows a microminiature. It is smaller than a child's netsuke. It was not carved to be worn by anyone but was specially miniaturized for a collector of minuscule art objects. In late Edo and Meiji, doll-size sets of tea-ceremony articles and of *inrō* with *ojime* and netsuke were occasionally produced for collectors of diminutive art objects. Tiny cabinets, meticulously lacquered, were made as containers for sets of twenty or thirty *inrō* averaging no more than two centimeters in size. The *inrō* were hung or displayed in their *inrō tansu* in exactly the same way as their life-size counterparts were. Some were signed by famous Meiji lacquerers and were prized as esoteric possessions. This Kokusai *manjū* was carved to complement such an *inrō*.

416. Ashinaga and Tenaga. Lacquer. Unsigned.

417. Ashinaga and Tenaga. Stag antler. Unsigned.

418. Ghost. Boxwood. Signed with a single character: Takeshi.

419. Aborigine with Chinese. Wood. Unsigned.

420. Wild boar. Incense wood. Unsigned. Inscription: "Presented to [the *sumō* wrestler] Hachinoura in honor of his promotion to *jūryō* [junior grade] at the spring tournament, Meiji 29 [1896], by a fan of Atsuta [Nagoya]."

418 422 423 424

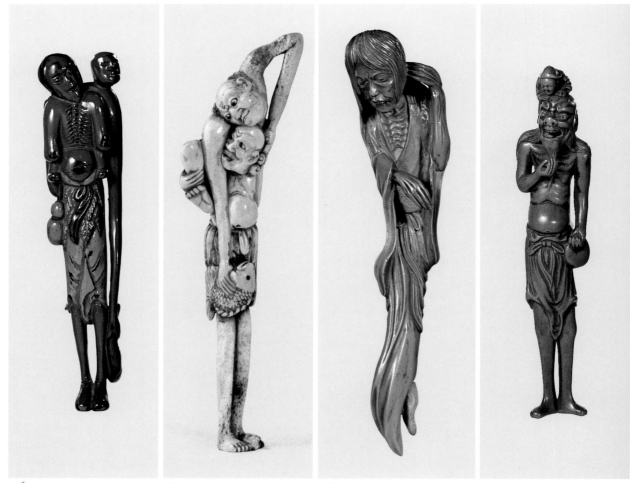

416 417 418 419

421. Snake. Wood. Unsigned.

422. Bitch and puppies. Wood. Signed: Matsuda Sukenaga (NH 1124).

423. Wolf and woman's head. Walrus tusk. Signed: Tomomasa (NH 1208).

424. Cloud dragon. Boar tusk. Signed: Kamman saku, with *kakihan* (NH 440). Inscription: "In March of the spring of Bunsei 12 [1829], living in Iwami, Kamman carved." Illustrated in Shichida Makoto's *Shimizu Iwao to Sono Ichimon*, Fig. 53. This is probably the largest of all boar-tusk netsuke.

425. *Rakan*. Boxwood. Unsigned.

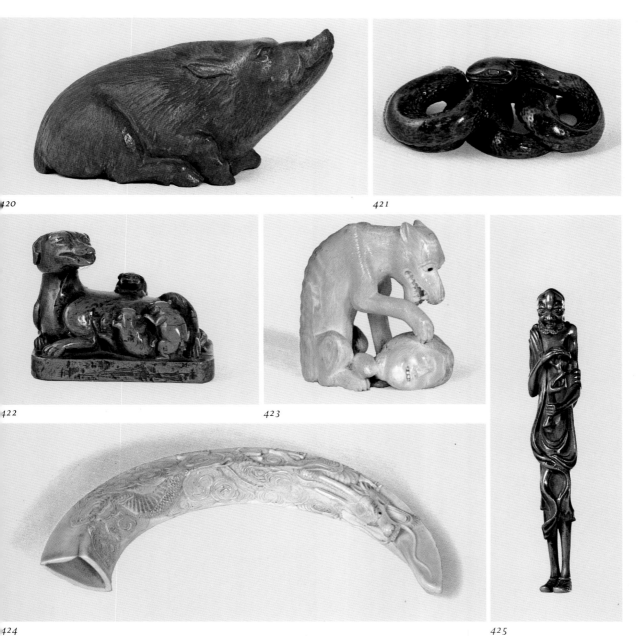

420

421

422

423

424

425

426. *Shōjō*. Metal disk, wooden bowl. *Kagamibuta* type. Unsigned.

427. Processional horse. Ivory with inlays. Signed: Yasuaki.

428. Momotarō (Peach Boy). Ivory. Signed: Masatoshi tō.

429. *Shishimai*. Wood. Unsigned. The *shishimai* originated as a devil dance to scare away evil and misfortune. It is usually performed as part of the New Year's celebration. The netsuke represents the dance as performed in northern Japan, where it is known as the Echigojishi, from the old name of Niigata. The feather headdress and the acrobatics and contortions are characteristic of the area. The dancers are said to drink vinegar daily in order to keep their bones soft and supple.

430. Otafuku. Ivory. Signed: Tameyoshi.

431. Ryūjin, king of the sea. Wood. Unsigned. Collection of Dr. Ira Freiman. See also Figs. 752 and 762.

432. Heian woman. Boxwood. Unsigned. The woman has a writing brush in one hand and a writing tablet in the other.

433. Boy and puppy. Wood. Unsigned.

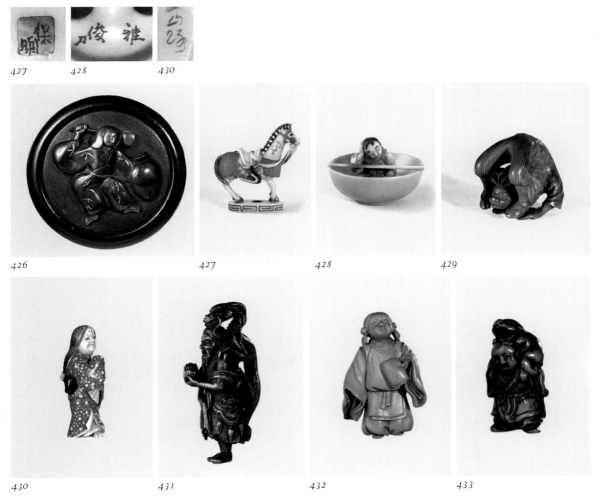

427 428 430

426 427 428 429

430 431 432 433

434. Cranes and lotus. Ivory. Unsigned. Engraved seal base.

435. *Oni*. Wood. Signed with a *kakihan*. The *oni* has a *mokugyo* and a contribution list (*hōgachō*). The meaning is hypocrisy: evil masquerading as good. See also Fig. 736.

436. Abstract design (two views). Stag antler. *Manjū* type. Signed: Koku (Kokusai; NH 527). See photograph of netsuke for signature.

437. Boy and hobby horse. Ivory with inlays. Signed: Kōgyoku (NH 513).

438. Camellia. Ivory. Signed: Sōko (NH 1101).

439. Cucumbers and eggplant. Stag antler and *umimatsu*. Signed: Sōko (NH 1101). The materials were chosen for realism. Stag antler readily absorbs a green stain simulating the skin of the cucumber, and *umimatsu* is sometimes found in the blackish-purple color of the eggplant.

440. Helmet (*kabuto*), face protector, and war fan. Ivory. Unsigned.

434 435 437 438 439

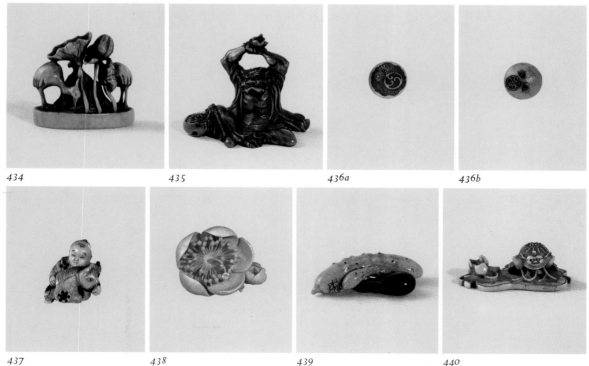

434 435 436a 436b

437 438 439 440

29 PORCELAIN AND POTTERY NETSUKE

Like the craftsmen in lacquer, metal, and masks, the potters responded to increased demand by producing netsuke in pottery and porcelain. Ceramic netsuke are found in types identified as Hirado, Bizen, Imari, Raku-yaki, Kyō-yaki, *seiji* (celadon), and others. They are found with the signatures or seals of such famous ceramists as Ritsuō, Ninsei, Kenzan, Dōhachi, Mokubei, Ken'ya, and Eiraku. However, positive identification of the kilns that produced porcelain and pottery netsuke is particularly difficult for two main reasons.

In pots, plates, bowls, and vases the lip, the rim, the foot, the color, the character of the clay, and other factors form a mass of criteria for an absolute determination of the area, if not the kiln, that produced the ware. In the case of netsuke these indicators and criteria are absent or are fewer or less reliable. Perforce a substantial amount of supposition and "feeling" enters into the identification of ceramic netsuke. The second obstacle to absolute identification is the practice of some kilns of producing reasonable facsimiles of types of pottery and porcelain that are the typical products of other kilns and areas. For example, Banko in Mie Prefecture produces wares typical of Raku and Oribe, and the kilns in the Kyoto area sometimes produce netsuke of the types associated with Hirado and Imari.

Identification of the area, source, and kiln is a fascinating pursuit for the specialist in ceramic netsuke. It requires a careful study of clays, colors, and glazes, as much so as for the collector of conventional or traditional bowls and pots. In any case, fine quality, rich glaze, good color, and originality establish a ceramic netsuke as well worth acquisition, regardless of the area or kiln where it was fired.

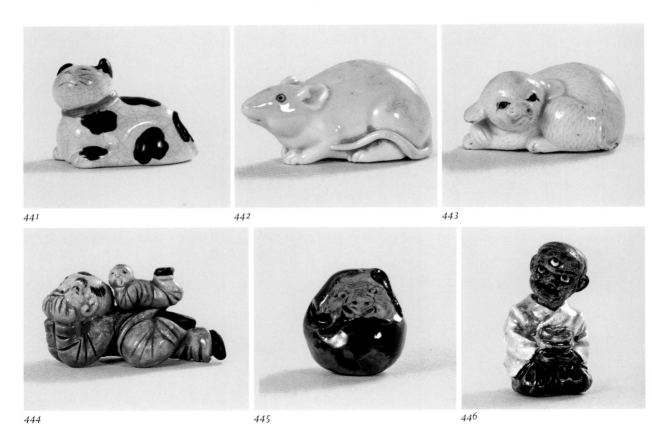

441

442

443

444

445

446

441. Cat. Kiyomizu ware. Unsigned. Ex Yuzuru Otsuki Collection. Kiyomizu ware is produced in the Kyoto area.

442. Rat. Hirado ware. Unsigned. Hirado ware is the product of a number of kilns around Nagasaki. The name comes from that of the port of Hirado, which these kilns used for their shipments. Hirado is noted for its animal subjects. The greater number of porcelain netsuke are Hirado products.

443. Dog. Hirado ware. Unsigned.

444. Children. Hirado ware. Unsigned. Illustrated in *Orientations*, October 1970.

445. Daruma. Seto ware. Unsigned. Seto ware is produced around Mino in Gifu Prefecture. Both clay and glaze in this example are characteristic of the ware.

446. Three-eyed *bakemono*. Glazed pottery. Unsigned. The goblin's head and tongue are movable. The origin of this piece is uncertain, but it was probably produced in the Kyoto area.

447. Dog. Porcelain. Unsigned. The style of the dog and the blue and white glaze are typical of Chinese porcelain style. The piece was produced in China for the Japanese market.

448. Rabbit. Bizen ware. Unsigned. On first view it is easy to mistake the pottery for wood. Bizen ware is a product of the area around Okayama. The production of the figure in a mold is typical of this ware. Some effort is usually made to conceal the mold line.

449. *Haniwa* boar. Raku ware. Unsigned. Raku is a type of pottery produced in the Kyoto area by the Raku family of ceramists, which extends back through numerous generations. It is much admired in tea-ceremony articles.

450. *Shishi*. Nabeshima *seiji* ware. Unsigned. Ex F. M. Jonas Collection. *Seiji* is the greenish-blue or bluish-green porcelain that imitates Chinese celadon. It is produced in Kyoto and in Arita in Kyushu. The Arita *seiji* seen here is of the Nabeshima type and is superior in quality.

451. Pumpkin. Hirado ware. Unsigned.

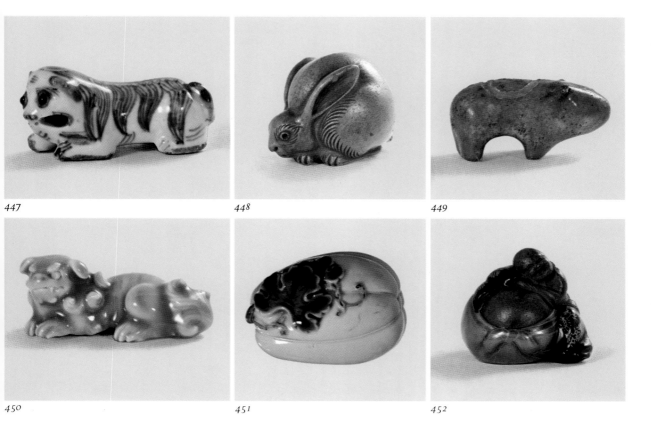

447 448 449

450 451 452

452. Hotei and his treasure bag. Pottery and gold lacquer. Unsigned. Collection of Shun'ichiro Ikeda. The combination of pottery and gold lacquer is rather unusual. The foundation appears to be Bizen ware, but it is most difficult to be certain.

453. Onna Daruma. Bizen ware. Unsigned.

454. *Shishi*. Imari ware. Unsigned. Although this piece is Imari, the potter's effort was to imitate early Satsuma ware. Imari ware is the product of a number of kilns operating around Arita in northern Kyushu. As in the case of Hirado ware, it is named after the port from which it was shipped. It is usually a colorful and highly decorated porcelain. However, some of the Kyoto kilns produce quite similarly colored porcelains.

455. *Tengu* mask. Kyoto *seiji*. Unsigned. This *seiji* displays the characteristic color of Kyoto celadon.

456. Fukurokuju. Porcelain. Signed: Zōroku. Zōroku was a ceramist of Kyoto during late Edo and early Meiji. He is well known for his ability to imitate the Ming celadons.

457. Monkey trainer. Imari ware. Unsigned. Collection of Walter Belanger.

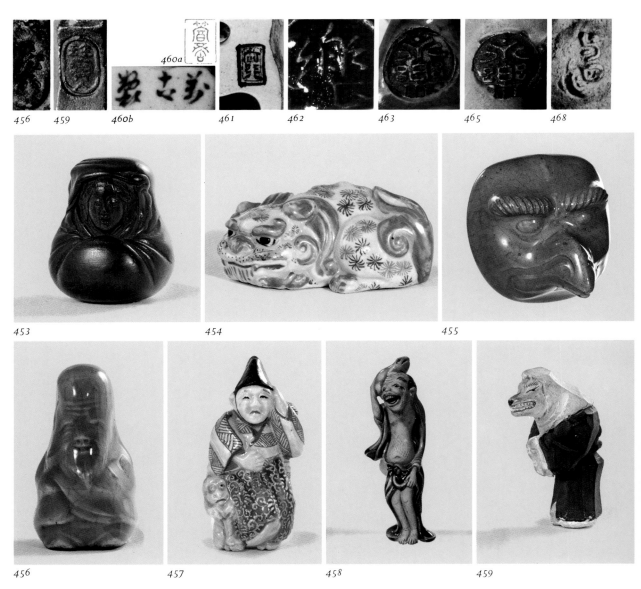

456 459 460b 460a 461 462 463 465 468

453 454 455

456 457 458 459

458. Gama Sennin. Hirado ware. Unsigned.

459. Fox priest. Pottery. Marked: Hōzan. Hōzan is the name of a kiln of the Awata district of Kyoto. The pottery is not glazed but painted. When a seal is burned into pottery or porcelain with a brand, it is called a *yaki-in*. Unintentionally, perhaps, the figure suggests the Nara *ningyō* of Morikawa Toen (see Figs. 209 and 210).

460. Sleeping boar. Banko ware. Marked: Banko-sei (manufacture of Banko). The base is an engraved seal. Banko ware is made in Mie Prefecture near Kuwana. The kilns produce many different kinds of pottery.

461. *Inu hariko*. Porcelain. Signed: Ken'ya. The design is the familiar papier-mâché box in the shape of a simplified dog. Ken'ya (1821–89) worked in Tokyo in the style of the great Kenzan.

462. Otafuku. Raku ware. Signed: Raku.

463. *Miyakodori* (gull). Porcelain. Signed: Eiraku.

464. Pigeon. Porcelain. Marked: Asahi. Asahi ware is produced in the Kyoto area.

465. *Miyakodori* (gull). Porcelain. Signed: Eiraku.

466. Kyōgen mask. Porcelain. Unsigned. Ex Frederick Meinertzhagen Collection. Illustrated in *Ikebana International,* fall-winter 1964.

467. Snail. Inlaid pottery on bamboo. *Manjū* type. Unsigned. Only the body of the snail is pottery; the shell is wood.

468. Otafuku mask. Porcelain. Signed: Yoshirō. Collection of H. Kiyomoto. Yoshirō was a Kyoto ceramist of passing fame. The inscription on the netsuke reads: "Kyō Maruyama Hiranoya." "Kyō" stands for "Kyoto." Maruyama is a park in Kyoto, and the Hiranoya is an old restaurant situated in the park. It is famous for its taros boiled with dried cod. The descendant of the Hirano family who presently operates the restaurant says that the Otafuku mask was presented to favored customers about forty or fifty years ago.

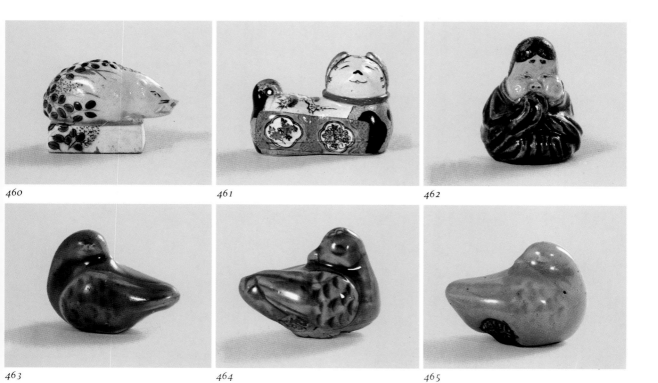

460

461

462

463

464

465

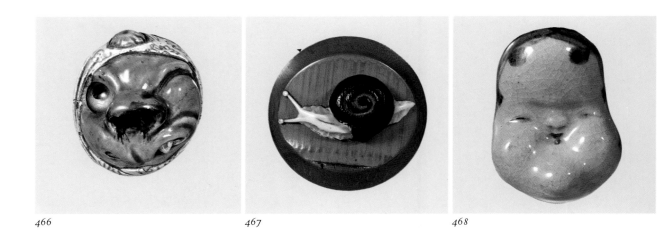

466 467 468

30 RARE ANIMALS

It is not surprising that the *kaiba,* the *kudan,* the *karyōbinga,* the *suisai,* and similar legendary animals are rare in netsuke, just as it is not surprising that the zodiac animals are common, although dragons and tigers are not counted among Japanese fauna. What is surprising, however, is the scarcity in netsuke of animals that are commonly found in the mountains and seas of Japan. Among these are the mole (*mogura,* known in some rural areas as the potato rat), the weasel, the tadpole, the seal, and the whale.

The rarity of the animal apparently did not appeal so much to the Japanese of old, who selected his netsuke to wear, as to the modern man, who purchases for his collection. There was certainly no dearth of models, had the carvers found mythical, legendary, and weird fauna generally desirable as subjects. Numerous picture books of Chinese origin were popular and prevalent in Japan, the *Ressenden* being one example among many others. These books contained depictions of animals of the sea, earth, and air that swam, crawled, or flew in any of the seven seas or six continents. They were weird monstrosities of fable, imagination, dream, and hearsay. They were reported to be found over the horizon to the west if the traveler came from the east and over the horizon to the east if he came from the west. The point may be that with the exception of the dragon, which had Buddhist connotations, the *baku,* which had its use, the *kirin,* which was associated with Confucius, and the *shishi,* which was really a Chinese Pekingese, the Japanese preferred the real animals with which they were familiar and with which they had some association. Perhaps this is fortunate. Some of the collecting zest might be lost if turtleback goats were as common as ordinary goats, if seahorses, seals, and whales were as frequent as frogs, and if pelicans were as plentiful as sparrows.

The dog and the horse are a rare zodiac combination. While they may not often be found together in netsuke, they combine very well in the dénouement of the following account, which is a fine instance of the universality of humor:

Engelbert Kaempfer recorded many of the beliefs, customs, and practices that were current when he visited Japan at the end of the seventeenth century. He writes about the great numbers of dogs found in all neighborhoods. It seems that the shogun, in accordance with Buddhist belief, blamed his lack of a male heir on cruelties he had practiced in previous incarnations. He was especially contrite and concerned about dogs, since he was born in the Year of the Dog. He therefore issued many edicts for their protection and welfare. Each neighborhood had to maintain a number

of dogs and feed them well. No one could punish a dog, not even his own, unless he explained his grievance to the local government dog keeper, who determined whether punishment was permissible according to law and precedent. Dogs that fell sick were attended by official veterinarians, and when dogs died they had to be buried ceremoniously on mountaintops. To violate the shogun's edicts or to harm a dog was an offense punishable by death. It is safe to say that during the shogun's reign dogs were better treated and fed than the peasants' children.

The Japanese tell the amusing story of a peasant of that age who grumbled and complained as he lugged a large canine corpse up a steep mountain for burial. His companion, though sympathetic, warned him of the risk to his life if his complaints should be overheard. "Besides," he said, "at least be thankful that the shogun wasn't born in the Year of the Horse."

469. Squid group. Ivory, with inlaid eyes and pupils. Unsigned. As food, squid (*ika*) is quite as popular as octopus (*tako*). Nevertheless, the squid is rarely portrayed in netsuke, while the octopus is as popular in netsuke as it is on the dinner table.

470. Cormorant on an engraved seal base. Ivory. Unsigned. The cormorant is used for fishing by night in Japanese rivers. Burning pitch hung over the side of the boat brings the fish to the surface. The fishermen tend lines looped tightly around the necks of the cormorants. The birds seize the fish in their gullets and craws but cannot completely swallow them. They are drawn aboard the boats and made to disgorge. To keep them working happily, they are allowed to swallow one small fish for every seven or eight dives. The throat of the cormorant is a marvelous instrument. It can only be described as elastic leather.

471. Mole and young. Ivory. Unsigned. The mole (*mogura*) is particularly common in farming areas, where it is sometimes known as the potato rat. Since the potato grows underground, the mole burrows underground and feeds on it. Although the mole is almost as common as the rat, it is rarely depicted in netsuke.

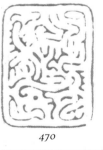

470 472

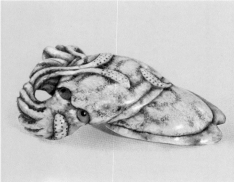

469 470 471

472. Dromedary on an engraved seal base. Ivory. Unsigned. See also Figs. 488 and 495.

473. Shiriya horse. Wood. Unsigned. Collection of Shiro Akai. There is, of course, nothing rare about the horse in netsuke, but the Shiriya is a special breed descended from the imported martial Mongolian pony and the Nambu, the native Japanese horse. The Shiriya is now on the verge of extinction.

474. Owl. Wood. Unsigned. The owl is rounded and shaped into a perfect *manjū* form.

475. Bat group. *Kurogaki* (black persimmon) wood. Unsigned.

476. Spider. Wood. Signed: Ichiō. The spider is usually rendered as the spider demon in conflict with Raikō or as ensnaring a horse in its web. It is rarely depicted in solitary form. See also Fig. 564.

477. Weasel-like animal. Black wood. Unsigned. The tail, unlike the weasel's, is hardly more than a stub.

478. Squirrel. Ivory. Signed with the dubious signature Gyokuzan, which is most likely a later addition. Collection of Viola Hall. The squirrel (*risu*) is rarely portrayed in netsuke as compared with his rodent cousin the rat. His association with grapes, on which he does not feed, is sometimes explained as a mere decorative motif originating in Sung painting. Katherine Ball, in her *Decorative Motives of Oriental Art,* offers the better explanation of the Chinese that the two are associated because the squirrel scampers everywhere, just as the vine creeps everywhere. The squirrel uses the vine for his path to home and storehouse.

479. Cow-horse. Ivory. Signed: Okatomo (NH 784). The eminent folklorist Mock Joya writes in *Things*

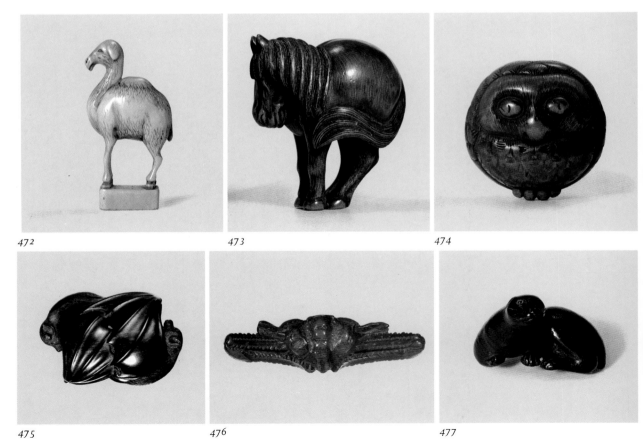

472 473 474

475 476 477

Japanese that on the island of Tanegashima, off Kagoshima, there is a unique animal called an *ushi-uma*, or cow-horse. Despite its name it is not a crossbreed of horse and cow but a true horse, although its superficial resemblance to a cow is greater. Mr. Joya says: "One seeing the animal for the first time will be unable to say whether it is a horse or a cattle [*sic*]. He has to accept it as a horse because scientists say so." Okatomo may have fashioned this strange creature after hearing reports of the *ushi-uma*. For discussion of another aspect of this netsuke, see page 57.

480. Turtleback horse. Black persimmon (*kurogaki*) wood. Unsigned. There is little reference to a horse with a carapace back, although Joly, in his *Legend in Japanese Art*, describes the *suisai* as a horned rhinoceros sometimes embellished with a carapace.

481. *Kirin*. Wood. Signed: Masatoshi, with *kakihan* (NH 630). This *kirin* is the double-horned species. See also Fig. 487.

482. Seal. *Umoregi*. Unsigned. Collection of Dr. Mineji Abe.

483. Lizard and acorns. Wood. Unsigned. The Japanese generally abhor lizards, which may account for their scarcity as netsuke. Those who believe in the medieval Chinese recipes value the lizard as an effective love potion when burnt and pulverized.

484. Parrot. Stag antler. Unsigned. Ex Julius Katchen Collection.

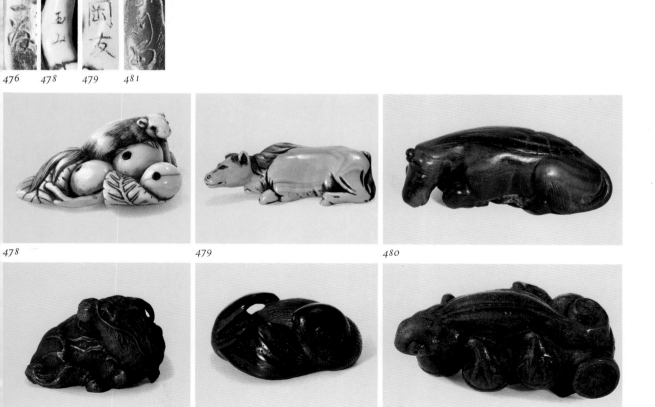

476 478 479 481

478 479 480

481 482 483

485. Lizard on chestnut. Wood. There is an inscription in *ukibori*, but only the first three characters are legible. They read: "Nippon ichi," meaning "best in Japan." Collection of Tomosaburo Fujie.

486. *Baku* group. Ivory. Unsigned. The *baku*, which resembles the elephant, is the most useful of fabulous animals. He devours our bad dreams so that we can sleep peacefully. A Japanese who is plagued with nightmares may write the character for *baku* on a paper that he slips under his pillow to insure untroubled sleep. However, some dreams are so revolting that even a *baku* may reject the repast. For other *baku*, see Figs. 489 and 493.

487. *Kirin*. Wood. Unsigned. The *kirin* has a single horn, a scaly hide, and a flaming body. For a double-horned *kirin*, see Fig. 481.

488. Dromedary. Ivory. Unsigned. See also Figs. 472 and 495.

489. *Baku*. Wood. Unsigned. For other *baku*, see Figs. 486 and 493.

490. Sea slug (*namako*). Ebony. Signed: Dōraku (NH 85). The sea slug, also known as the sea cucumber or bêche-de-mer, is a popular ingredient in Chinese and Japanese dishes. It may tantalize the Oriental palate as food but not necessarily that of the Western gourmet. It has a leathery skin, a flexible body, and numerous tentacles.

490 491 493

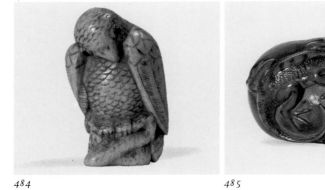
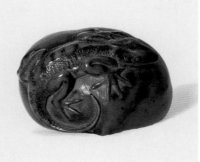

484 485 486

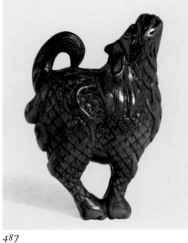

487 488 489

491. Legendary-animal group. Wood. Signed: Tōmin (NH 1192). Real animals as a class are called *dōbutsu*. Fantastic animals are called *kaibutsu*. *Kaibutsu* is a convenient term to remember when a demand is made for the positive identification of an unidentifiable species.

492. Pelican. Wood. Unsigned. The pelican, whose "bill can hold more than his belly can," is a *rara avis* in netsuke.

493. *Baku*. Boxwood. Signed: Gyokumin. For other *baku*, see Figs. 486 and 489.

494. Boarlike animal. *Umoregi*. Unsigned. The head, unlike that of a true boar, is pointed and flattened.

495. Dromedary group. Wood. Unsigned. Ex Frederick Meinertzhagen Collection. Illustrated in Meinertzhagen's *Art of the Netsuke Carver*, Fig. 128. See also Figs. 472 and 488.

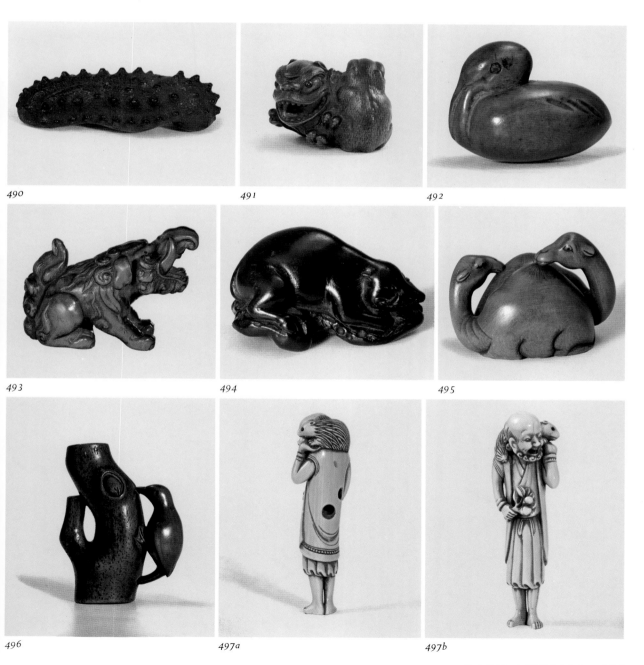

490

491

492

493

494

495

496

497a

497b

496. Woodpecker. Wood. Unsigned.

497. *Sennin* with porcupine (two views). Ivory. Unsigned. Illustrated in *An Introduction to Netsuke*. The *hari-nezumi*, or (literally) needle rat, is rarely portrayed in netsuke.

498. Seal. Ebony. Unsigned. Collection of Yoshimatsu Tsuruki. Illustrated on jacket of *Collectors' Netsuke*.

499. *Kirin* and pomegranate. Ivory. Signed: Ikkōsai. The pomegranate symbolizes fecundity—many sons. The *kirin* symbolizes good omens and auspicious occasions. Together they may express a wish for many sons with brilliant careers.

500. Goat with carapace back. Wood. Signed: Masayoshi. Illustrated in *The Collectors' Encyclopedia of Antiques* (London, 1973).

501. Whale. Ivory. Signed: Toshiaki.

502. Slug. Wood. Unsigned. The slug (*namekuji*) was originally one of the creatures of the *sansukumi* but came to be replaced by its cousin the snail. The slug is "slimier" than the snail and has no shell.

503. Winged horse. Wood. Unsigned. The animal stands on a base of conventionalized waves. Katherine Ball terms these horses *kaiba* and illustrates them with a picture by Morikuni showing wild horses running on the sea.

499 500 501

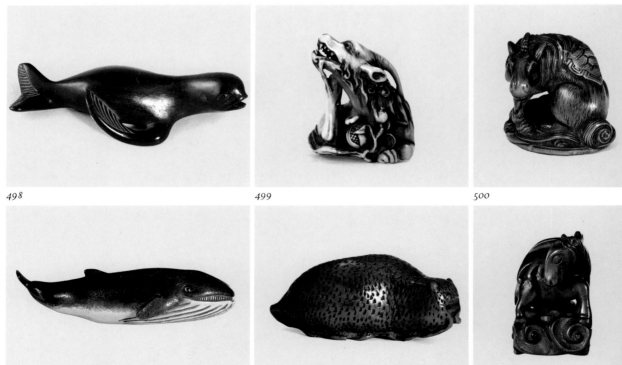

498 499 500

501 502 503

Carvers whose signatures are rarely seen, sometimes only once or twice, confront us with a minor mystery. The mystery deepens in direct relationship to the quality of the carving. In the case of carving that is poor, mediocre, or even moderately good, we may plausibly suppose that the carver was not successful and soon abandoned his efforts in favor of a more reliable source of income. In the case of the superb craftsmen, however, the mystery of his flash appearance is as inexplicable as Sharaku's in ukiyo-e.

Perhaps the most reasonable explanation for the mystery lies in the enormous demand for netsuke that swept the country and impelled numerous craftsmen to supplement their regular earnings with an occasional or a temporary spell of netsuke carving. Carvers of Buddhist images, household panels, puppets, masks, musical instruments, dolls, architectural decorations, and religious friezes already possessed the basic technique and experience for carving various materials. They had no need of a lengthy apprenticeship. Their problem was one of adaptation, and they could easily learn the special techniques and requirements related to netsuke. We must remember that these "other" craftsmen were the waves and spray of the sartorial tide of netsuke and pouch that engulfed Japan. They themselves wore netsuke and thus, from personal experience, understood their function and requirements. These "other" craftsmen are in all probability responsible for our rare and mysterious signatures on superb netsuke. They signed so few simply because they produced so few.

The signatures on the three netsuke carved by Frederick Meinertzhagen (Figs. 506, 510, and 515) are rare for the obvious reason of his English origin. His carving was an occasional pastime.

504. *Baku*. Ivory. Signed: Gechū (NH 113). Meinertzhagen lists twelve netsuke signed Gechū in his card

504 505 506

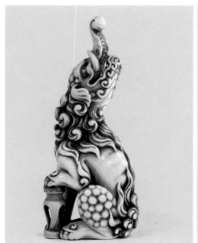
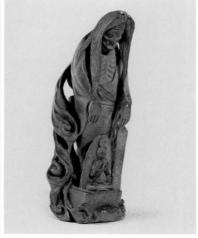
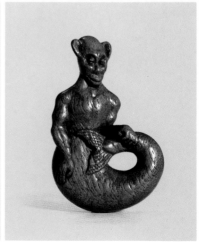

504 505 506

index maintained at the British Museum. Although this netsuke and the one in Fig. 508 were carved by Gechū, his work is rare. He is listed in the *Sōken Kishō*.

505. Ghost. Sandalwood (*byakudan*). Signed: Dōkei. Dōkei was a carver of the present century closely associated with Sōko, Sōsui, and Shōko but as a friend rather than a student. Though keenly interested in carving, he made very few netsuke.

506. Merman. Wood. Signed: Hagen (Frederick Meinertzhagen). Ex W. W. Winkworth Collection. This and the netsuke in Figs. 510 and 515 are the work of Frederick Meinertzhagen, who made the study of netsuke his lifework. He was also an artist. Both his calligraphy and his carvings have deceived Japanese, who could hardly believe they were not done by "one of us." Meinertzhagen intended a comprehensive publication exhaustively covering the entire field of netsuke, with numerous illustrations. Unfortunately he was at least one decade ahead of his time. His publisher rejected the project as uncommercial, and he had to settle for a brief distillation in *The Art of the Netsuke Carver*.

507. Frog group on lotus. Wood. Signed: Yoshizō (Ryōzō). Ex Dave and Sandy Swedlow Collection. The veining on the leaves is done in *ukibori*.

508. Shard of Bizen pottery. Wood. Signed: Gechū (NH 113). The fragment is sufficient to identify a typical Bizen sakè jug. The carving simulates the marks made by turning on the potter's wheel.

509. Mōsō and bamboo shoot. Ivory. Signed: Awataguchi.

510. Fukurokuju in phallic shape. Wood. Inscription: "Hagen [Frederick Meinertzhagen], sixty-two years old, living in England." Ex Mark Hindson Collection, No. 1054. Illustrated in Neil Davey's *Netsuke*, Fig. 905.

511. Turtle group on lotus. Black wood. Signed: Jakushi.

512. Tiger. Wood. Signed: Toyoyasu (NH 1255). The signature, rather than the carver, is rare. There is ample evidence that netsuke signed Toyomasa are the work of father and son, sometimes the one, sometimes the other. The son was Toyoyasu, who rarely signed his own name.

513. Spider. Boar tusk. Signed: Sumi Takasada saku. Inscription: "[At] Kawamoto Yuminomine [place] in Ochi-gun [district] of Iwami [Province] Sumi [family name] Takasada [*gō*] saku [made]." It is believed that Takasada is unrecorded.

514. Globefish (*fugu*) and eggplants (*nasu*). Wood. Signed: Ichiriki. The skins of the fish are mottled for

507 508 509

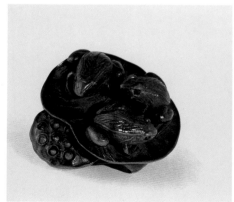

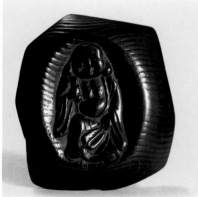

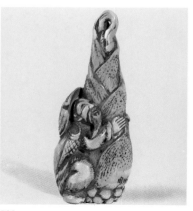

507 508 509

realism by clever use of stain. The signature is raised by *ukibori*. The combination of *fugu* and *nasu* is culinary. See also Fig. 638.

515. Fish. Wood, with eyes and teeth inlaid in pottery. Signed: F. M. (Frederick Meinertzhagen). Ex W. W. Winkworth Collection.

516. Wild-boar group. Wood. Signed: Tachikawa tō.

517. Saishi. Ivory. Signed: Miura-shi Yoshinaga. Ex Mark Hindson Collection, No. 446. Illustrated in Neil Davey's *Netsuke*, Fig. 933, and in *The Collectors' Encyclopedia of Antiques* (London, 1973). The story of Saishi is one of the Twenty-four Examples of Filial Devotion. She breast-fed her aged mother-in-law, who could

510 511 512 513 514 515 516

510 511 512 513 514 515 516

not eat solids, while her own child died of starvation. According to the Chinese ethic, her action was most laudatory. She could have many children but only one mother-in-law. Yoshinaga is not listed in *The Netsuke Handbook*. The *shi* in his *mei* means "of good family."

518. Kan'u and aide-de-camp. Wood. Signed: Joshū. Ex George A. Cohen Collection.

519. *Tengu*. Wood. Signed: Kunitaka. Collection of Hachiro Shima. The *konoha* (humanoid) *tengu* uses his elongated nose to mix *miso* (bean paste). See also Fig. 701.

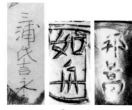

517 518 519

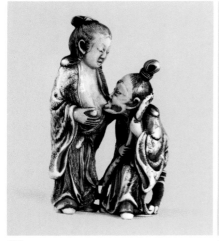
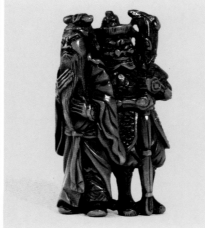
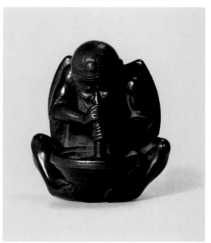

517 518 519

32 RARE SUBJECTS

Rare animals have already been taken note of in Category 30. The present section concerns itself with other subjects rarely found in netsuke.

Subject is a significant element in the desirability of a netsuke. No matter how well carved, a model that is commonly portrayed and constantly repeated has lost some of its uniqueness, and its desirability is diminished. On the other hand, a subject that is seldom seen—an incident or a personage that is rarely depicted—will often impel the collector to regard lesser quality or poorer condition more leniently.

A collection concentrated on subjects assures a high level of interest. Historians, folklorists, anthropologists, sociologists, and raconteurs could probably find in a subject-matter collection a source for dozens of interesting comments.

Several collectors have attempted to complete collections of subjects. One acquired 1,200 distinct subjects before he realized that his goal was as impossible of attainment as the recording of the complete history of the Edo period. When one attempts a subject collection, the very interpretation of the term "subject" comes into question. For example, does the customary model of the simplified, semiabstract sparrow fully represent the popular fable of the Tongue-cut Sparrow, or must other incidents be represented: the mean neighbor and her scissors, the kind man with his pet sparrow, the basket of horrors, and still other episodes and versions?

Living carvers are beginning to copy unusual subjects from rare old models and pictures. In adding rarities to their repertoires they are responding to the demands of collectors and dealers for uncommon subjects. It is apparently a better course than to carve common models repeatedly. However, they raise an issue: something is lacking; something is out of order; something disturbs and grates. There is no creativeness or originality in surveying the netsuke produced during the Edo period and selecting those subjects that were rarely carved or are especially appealing to contemporary collectors. It is a cold, deliberate plan, an uninspired effort, and a contrived operation. It is essentially a commercial enterprise. A calculated plan to produce instant uniqueness is an insincere and unworthy goal for the serious artist and carver. It is art by hindsight, not by insight.

The basis for a resolution of the issue may be perceived from a consideration of the attitudes and ideals of Masatoshi, who is also a living artist. Many of Masatoshi's netsuke are rare subjects and unusual treatments. They are, however, neither deliberate nor contrived. They originate quite naturally from his character, his interests, and his predilections. He has been absorbed since earliest childhood in the Edo period. He reads extensively about the history, folklore, legend, and customs of the period. He has accumulated a large collection of books and illustrations produced in Tokugawa Japan. In his own words, "There is no subject of the Tokugawa age that I would not like to carve." Added to this consuming interest is his reluctance to repeat a subject once he has carved it. In this respect he is unique among netsuke carvers, with the possible exception of Sessai, Jugyoku, and a few others. Again in Masatoshi's own words, "My second version will lack the spirit of the original." He finds contentment in his rather solitary life centered on family, books, and tools. As an artist, he has complete integrity and honesty. His every effort is his best effort. (See Figs. 376, 379, 382, and 428).

520. Saltmakers. Colored ivory. Unsigned. The old way of making salt was to evaporate sea water in shallow bins.

521. Severed head. Wood. Unsigned. Ex Eric R. Levett Collection. A woman criminal has been executed by decapitation. Her head has begun to decay, and maggots are feeding. The inspiration for this horrible portrayal may have been a painting by Hokusai that he produced in three or four versions. Mr. Levett bid for this unique netsuke against Meinertzhagen, Winkworth, Hindson, and others. When he showed me his

520

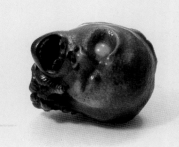
521

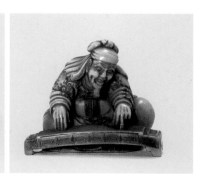
522

prize, I was infatuated with it. He promised me "first refusal," and more than ten years later he remembered. I am forever grateful and forever in his debt.

522. Chinese musician. Ivory. Signed: Okamoto Garaku. This may be a representation of the Chinese ideal of a virtuous man who leads an exemplary life—a Confucius, so to speak, or, in Japanese, a Kōshi.

523. Butei. Ivory. Unsigned. Butei was a famous Chinese statesman of the Han period (206 B.C. to A.D. 220). He is portrayed with his infant son and heir to the kingdom, Futsuryō, in his arms.

524. Pilgrim sage. Wood. Unsigned. Ex Walter Behrens Collection (Plate 44, No. 3451). Ex Frederick Meinertzhagen Collection. A Chinese pilgrim sage carries a large gourd and a huge leaf that he apparently uses for a fan.

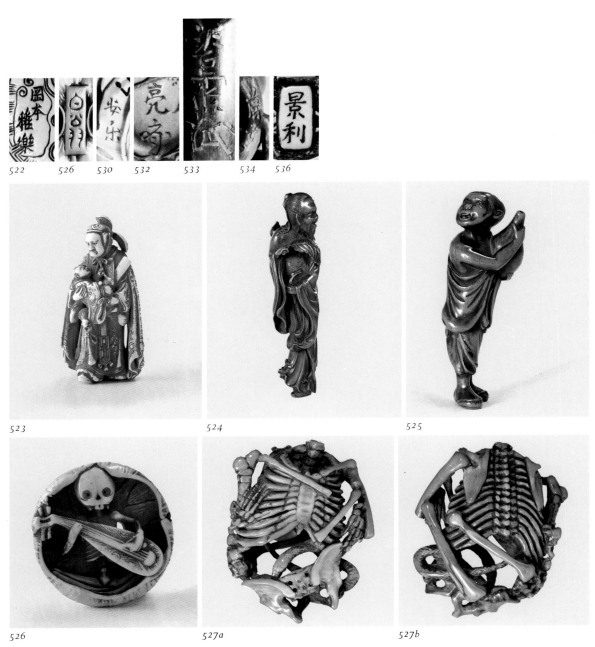

522 526 530 532 533 534 536

523 524 525

526 527a 527b

525. Water drawer. Wood. Unsigned. Good water is absolutely essential to properly brewed tea. When the capital moved from Kyoto to Tokyo, many aristocrats who had come from Kyoto sent bearers to bring them Kyoto water for tea. Certain sections of Tokyo provided better water than others, one of them being Ochanomizu (Tea Water). Thus there was a market for the water of Ochanomizu, which was considered best for tea.

526. Skeleton playing a *biwa* (lute). Ivory. Signed: Hakuō (NH 179). This netsuke is probably a reference to the Bon Festival, the time in Japan when death takes a holiday and departed souls return to visit their loved ones. Buddha and Emma-ō, the rulers of heaven and hell, and the Niō and *oni*, perpetual antagonists, have no duties during the Bon Festival. They link hands on this one occasion in fun and friendship. The skeleton rests on a lotus, the flower of Buddha, and plays the *biwa* to entertain his living relatives. See also Fig. 747.

527. Bone heap (two views). Ivory. Unsigned. Collection of Mrs. Oscar Meyer. The headless skeleton, exposed and abandoned, suggests a tragic death: the nameless traveler who sickened and died neglected or was the victim of a robber band. The absence of a head suggests death in battle, the head having been carried away for identification as proof of victory. Orientals have a special horror of death without family and ceremony. It is called *nozarashi*: leaving one's bones exposed to rain and wind.

528. Dried bonito (*katsuobushi*). Wood decorated with a bonito in gold lacquer. Unsigned. Dried bonito is an essential in Japanese cooking. The hard meat is flaked for use as flavoring or as a base for clear soup. It is widely sold as the perfect gift for almost any occasion. Although it is so common a sight on the Japanese scene, it is rarely seen as a netsuke.

529. Evil face. Wood. Unsigned. The man's features are made up of the character for "bad." He must be a cheating merchant and heartless moneylender. Inscribed in the ledgers in front of him are the names of his wretched debtors. He thinks only of ways to squeeze money out of his victims.

530. The butterfly dream of Sōshi. Ivory. Signed: Anraku (NH 2). Collection of Murray Sprung. The butterfly alighting on the slumbering man's shoulder leaves no doubt that the carver has depicted Sōshi. Sōshi dreamed that he was a butterfly. When he awoke, he pondered the philosophical distinction between imagination and reality: what is the reality of the world outside the creation of our senses?

531. Bird helmet (*torikabuto*). Ivory. Unsigned. This is the headgear worn by some of the dancers in the *kagura*, the music and dance performed in sacred ceremonies at Shinto shrines.

532. The hole-in-the-chest men (Senkyō). Boxwood. Signed: Ryōsai. Illustrated in *The Collectors' Encyclopedia of Antiques* (London, 1973). The Senkyō were a legendary race of people distinguished by a neat round hole through the center of the chest. When a Senkyō became tired, a pole was run through the hole, conveniently located at about the center of his gravity, so that his friends could carry him like a palanquin.

533. Bunshōsei. Wood. Signed: Takutaku saku (or Takufu saku), with *kakihan*. Illustrated in *Masterpieces of Netsuke Art* (Hurtig), Fig. 18. Bunshōsei, the Taoist god of literature and thought, is a demon who rides a dragon-fish (*shachihoko*) and holds a writing brush in his hand. Almost certainly this is the identical piece illustrated in the Behrens catalogue, Plate 18, No. 618.

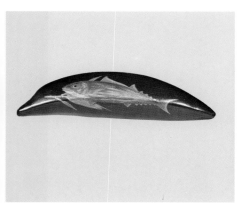

528

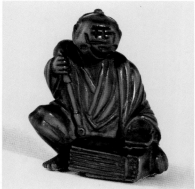

529

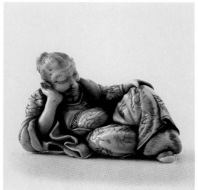

530

534. Wild grapes (*yamabudō*). Wood. Signed: Sōko (NH 1101). Wild grapes are deep purple in color and slightly sour.

535. *Sennin* riding crane. Wood. Unsigned. A number of *sennin* are represented with cranes. Specific identification is often difficult. This one may be Teirei, Jofuku, Ōshikyō, or Jurōjin.

536. Wild-boar group on coin. Ivory. Signed: Kagetoshi (NH 421). What is the significance of a boar and young standing on a coin? This is an instance of the difficulty of elucidating recondite meanings. A Japanese expert who is past eighty-eight but retains an accurate memory was perplexed until, with a flash, he recalled that the first issue of a paper 10-yen note was equal in value to a gold *koban* and was engraved with the picture of an *inoshishi* (wild boar). Just as the dollar is called a buck and the pound a quid, the 10-yen note was called an *inoshishi*. His explanation was eminently satisfying until further study revealed insuperable flaws. The coin illustrated is not a gold *koban* but a copper coin stamped 100 *mon*, and the 10-yen *inoshishi* note was not issued until 1899, which to the best of our knowledge was subsequent to Kagetoshi's death. Thus the old man's explanation, however attractive, did not accord with the facts. The correct explanation is that the animals and coin represent a rebus, a popular device much admired by Chinese and Japanese for conveying messages subtly or enigmatically through objects. The *inoshishi* group stands for many sons and descendants and the coin for a household solidly founded on wealth. Such a netsuke was an ideal gift as an expression of the wish for many sons and a rich household.

537. Face protector (*mempō*). Wood. Unsigned. When in full battle regalia, samurai wore helmets but not face protectors, which were worn only by daimyo or the shogun.

538. Book in two volumes. Wood. Unsigned. Ex W. W. Winkworth Collection. The book is the *Kokinshū*, a classic of ancient poetry. The title, the butterfly design, and the silk-cord bindings are exquisite examples of carving in delicate relief, although not *ukibori*.

539. *Karyōbinga*. Ivory. Unsigned. Illustrated in *The Collectors' Encyclopedia of Antiques* (London, 1973). The *karyōbinga* is half woman and half bird, a creature of Indian mythology. The woman-bird motif is rare in Japan but relatively common in Thailand and Indonesia.

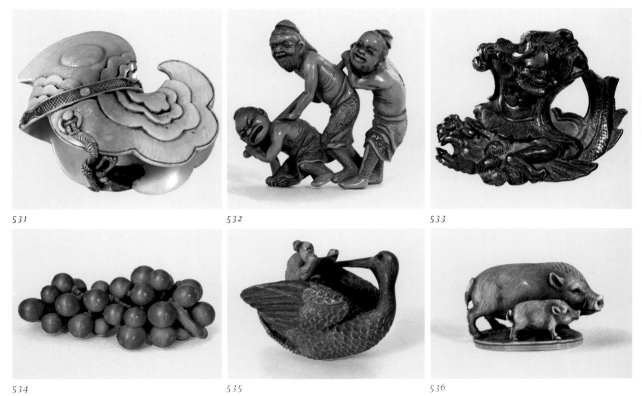

531

532

533

534

535

536

540. Monkey and mermaid (two views). Wood. Unsigned. Collection of Elizabeth Humphreys-Owen. Illustrated in *Masterpieces of Netsuke Art* (Hurtig), Fig. 97.

541. Jumping jack: Fukusuke the Storyteller. Ivory and wood. Signed: Chokusai (NH 55). The toy obtains its jumping power from a tightly wound rubber band.

542. *Bakemono* (goblin). Ivory. Signed: Sōraku. Demons and goblins of all species abound in Japanese art. Many artists have let loose their imaginations with renderings of the One Hundred Demons or One Hundred Ghosts. This particular "weirdo" is rather uncommon.

543. Self-wrestler. Wood. Signed: Sōsui (NH 1111). The man has a good grip and struggles superhumanly to gain the throw.

544. Suit of armor. Ivory. Unsigned. Ex Mark Hindson Collection, No. 141. Illustrated in Neil Davey's *Netsuke*, Fig. 1114. The suit of armor, helmet, and face protector are placed on a stand. They are sometimes proudly displayed in grand homes that boast a samurai lineage.

545. Mokuran. Wood. Signed: Tomotada. Mokuran is an outstanding example of a daughter's filial piety and courage. Her father, too ill to join the frontier forces against the barbarian invaders of China, faced disgrace and punishment. To save him from this, Mokuran donned a military uniform, impersonated him, and fought in the border warfare for twelve years before her disguise and her sacrifice were discovered.

546. *Chimaki dango*. Ivory. Signed: Sōko (NH 1101). *Chimaki* are rice dumplings (*dango*) wrapped in bamboo or reed leaves—a felicitous food associated with the Boys' Festival (Tango no Sekku) on the fifth day of the fifth month.

547. *Donguri*. Wood. Signed: Sōko (NH 1101). *Donguri* are inedible nuts similar to acorns. Country children string them on supple *sasa* bamboo as beads and toys.

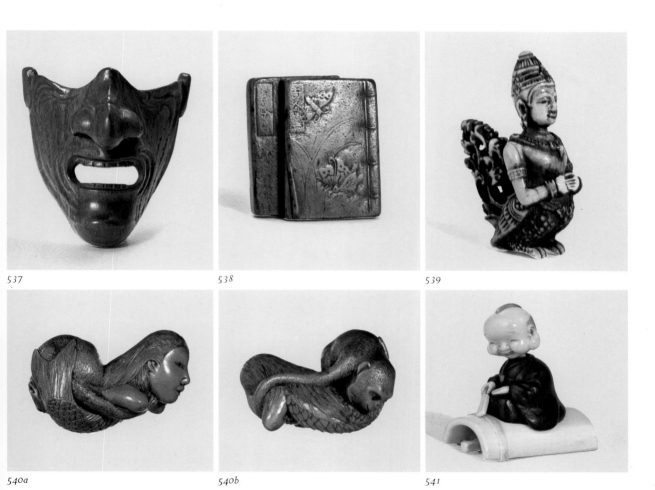

537

538

539

540a

540b

541

548. *Mushiboshi* (kimono airing). Wood. Signed: Mitsunobu (NH 698). The Japanese custom is to select one day each year to air all the kimono of the household. A dry day in autumn is usually chosen. Kimono become mildewed and insect-ridden in the moist air of Japan. Incense is burned in a hanging *kōro* to discourage the insects and impart a pleasant scent to the garments. For cleaning, kimono must be taken completely apart and then resewed.

549. *Rōnin*. Ivory. Unsigned. Collection of Douglas Cullison. Probably a masterless samurai forced by circumstances into a life of vagrancy. The pose of exaggerated defiance suggests the bombastic style of Kabuki acting known as *aragoto*. The figure may represent Banzuiin Chōbei in the Kabuki play of the same name.

550. Macrocephalic *bakemono*. Wood. Signed: Shōko (NH 1009). Shōko was plagued by nightmares. He occasionally transformed one into a netsuke.

551. Yuai. Ivory. Signed: Naokazu (NH 746). Yuai was a T'ang official whom a series of misfortunes reduced to such extreme poverty that he could not pay for his father's funeral. Not to bury a parent with all due ceremony was an unbearable disgrace. His fervent prayers were answered by heaven with a rain of cash.

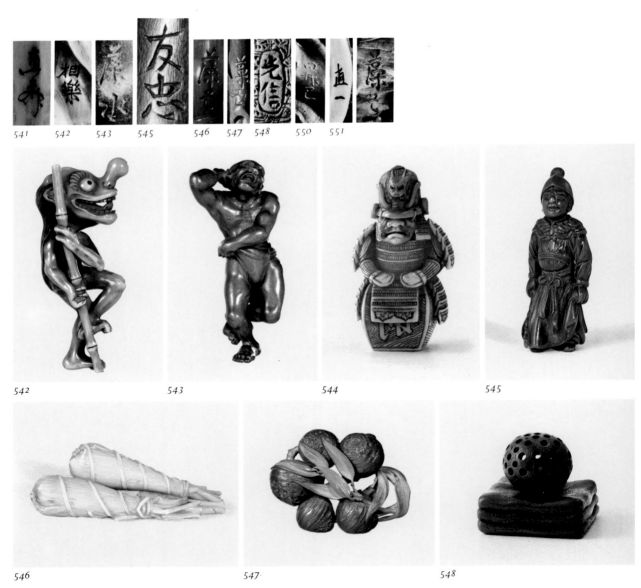

541 542 543 545 546 547 548 550 551

542 543 544 545

546 547· 548

The inscription is a Chinese-style poem: "The heavens pitied my poverty and opened their gates to rain money. Hence my happiness."

552. Goatherd. Ivory. Unsigned. The herdsman playing his flute while tending his water buffalo or ox is frequently portrayed but quite rarely as a goatherd.

553. *Oni* on grinding stone. Wood. Unsigned. Collection of Zenshiro Horie. The *oni* grins as he sits comfortably on a grinding stone. This probably represents a proverb: "Bear misfortune cheerfully. Patience may wear out a stone."

554. After the bath. Wood. Unsigned. A woman arranges her hair, holding her bath towel in her teeth and regarding her reflection in a mirror held to the back of her head.

555. *Wasabi*. Wood. Signed: Sōko (NH 1101). *Wasabi* is a condiment more pungent than horseradish. Raw fish (*sashimi*) would not be the delectable dish it is without *wasabi*.

556. Tokaido porter (*kumosuke*). Wood. Unsigned. The Tokaido coolie was hired to carry baggage from one station to another or to carry a tired traveler pickaback up a steep hill or across a stream. Stories are told of the *kumosuke* halting in the middle of a swift current and threatening to abandon his burden unless his fee was doubled. The *kumosuke* is sometimes confused with the *sumō* wrestler.

557. Man into devil. Wood. Signed: Miwa, with *kakihan* (NH 710). Usually the half-man half-beast is the badger disguised as a priest. Here the huge sakè cup and the club tell us that the liquor is the Jekyll-Hyde potion that brings out the demon in the human being. The right side is demon with claws and club; the left side is human.

558. *Kan'oke* (coffin). Ivory. Signed: Fuji Masanobu, with *kakihan* (NH 616). Ex Mark Hindson Collection, No. 1207. Illustrated in Neil Davey's *Netsuke*, Fig. 618. The *kan'oke* was a large covered bucket in which a

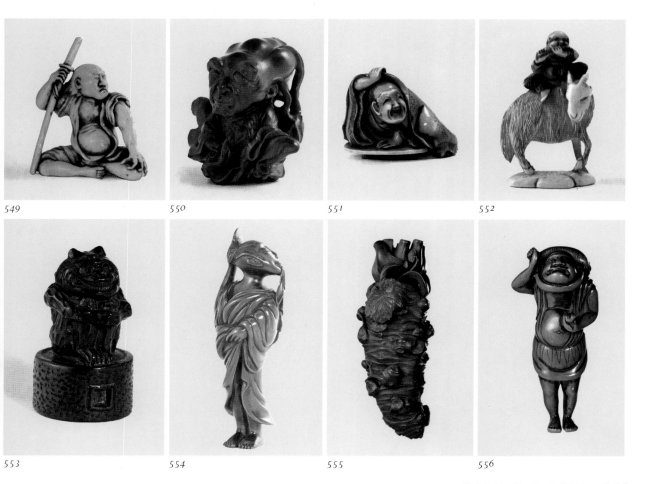

549 550 551 552

553 554 555 556

corpse was carried and buried. A pole was usually inserted under the cords for lifting and carrying. The significance of the interior scene carved behind the double-comma (*tomoe*) aperture may be as a burial ground.

559. *Ema* of fox. Wood. Signed: Sōko tō (NH 1101). The characters read: *hōnō* (votive offering). The *ema* is a painting on a five-sided wooden panel. It is usually seen at shrines and temples, where it is popular as a votive offering. The painting of *ema* requires a special technique, and fine old *ema* are collectors' items. The fox is the messenger of Inari, god of rice. The reverse side is carved with the key to a rice storehouse and the date: "Summer, Senior Wood Rat Year," corresponding to Taisho 13 (1924).

560. Shinnō, god of medicine. Ivory. Unsigned. Shinnō is the legendary discoverer of the medicinal qualities of herbs and plants.

561. *Sambōkan*. Wood. Signed: Masanobu. The *sambōkan* is a special variety of orange whose name may be translated as "three-treasures orange." Since it is an auspicious fruit, a grouping of three triples its power as a good omen.

562. Wayside shrine of Jizō. Wood. Signed: Shūgetsu (NH 1042). Jizō is the protecting saint of travelers and children. Thus his wayside shrines are usually seen on roads and in rural districts. The shrine portrayed here includes the three wise monkeys and a badger priest carved deep within.

557 558 559 561 562

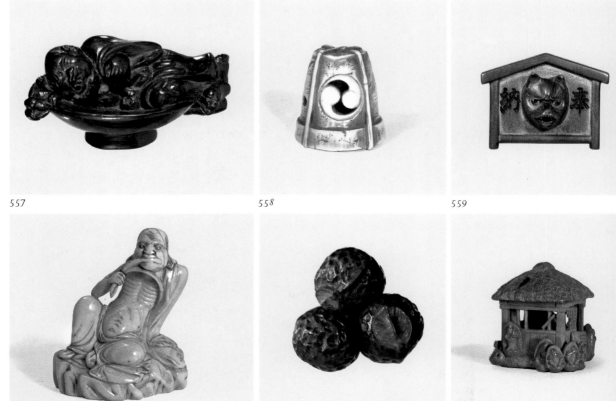

557

558

559

560

561

562

Ryūsa are *manjū* netsuke in point of basic shape. They are hollowed out to a shell that is perforated or cut away to leave the design. The generic term for the type derives from the name of the carver Ryūsa, who is credited with the innovation. It is somewhat strange that the name Ryūsa is hardly ever found inscribed on the type he originated or, for that matter, on netsuke of any type.

The *ryūsa* enjoys one great advantage over the *manjū*. It is suitable for use with the *inrō* as well as with the pouch or purse. The *manjū* is usually too heavy to complement delicate gold lacquer, while the *ryūsa* is hollowed to a thin shell and extensively perforated to a lightness appropriate for the safety of the *inrō*. The *ryūsa* may be made of almost any material. A surprising proportion of such netsuke are made of walrus-tusk ivory. The characteristic large hollow core of the walrus tusk, which militates against its use for carving in the round or for *manjū*, is by ingenuity incorporated in the cut-away design of the *ryūsa*. It may also be noted that the granulated yellowish part of the walrus tusk is often disguised by cloud, arabesque, or geometric designs. Apparently the carvers considered the yellowish mottled color unsightly or walrus ivory inferior to, or as a substitute for, elephant ivory.

565 566 567

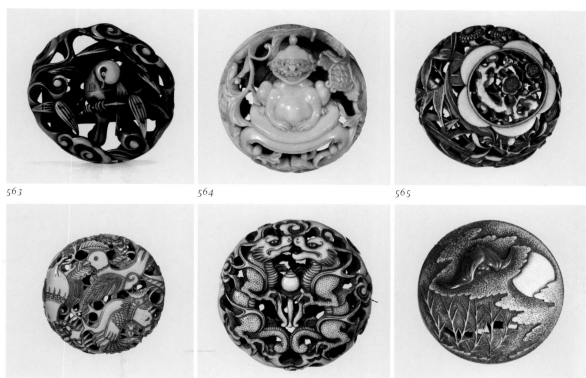

563 564 565

566 567 568

563. Perching bird. Walrus ivory. Unsigned.

564. Spider demon. Marine ivory. Unsigned. Ex Mark Hindson Collection. An allusion to one of Raikō's adventures. The reverse side shows spiders and a *mokugyo*. See also Fig. 476.

565. *Shikunshi* (the Four Gentlemanly Plants). Ivory. Signed: Tōkoku (NH 1184). The *shikunshi* are often associated in Japanese art. They are the plum blossom, the bamboo, the chrysanthemum, and the orchid.

566. Stylized pigeons. Ivory. Signed: Ryōmin. The design is overall, covering the reverse side as well.

567. Confronting dragons of the clouds. Ivory. Signed: Ryūkō. The single-horned dragons guard the sacred *tama*. Duality is represented by showing one dragon open-mouthed, the other closed-mouthed.

568. Bat. Stag antler. Unsigned. The design is of felicitous symbols: bat and full moon and, on the reverse, sacred mushrooms and the long-life character *kotobuki*. The bat and the character are inlaid in *shibuichi*.

569. Moon and rabbit. Ivory. Signed: Kozan (NH 561). The rabbit is dressed as a boatman and carries the oar with which, according to a popular fable, he rowed to the moon.

570. The Six Great Poets (two views). Ivory. Signed: Haku-un (NH 186). The signature is well hidden on the inner reverse surface of one of the poem cards. The Six Great Poets are all of the ninth century. They include one woman, the beauteous Ono no Komachi. For other versions, see Figs. 40 and 121.

571. Musical instruments. Walrus ivory. Signed: Koku (Kokusai; NH 527). The instruments include the big drum (*taiko*), the hand drum (*tsuzumi*), the mouth organ (*shō*), the flute (*shakuhachi*), and the xylophone (*mokkin*). The headdresses of the dancer and the priest complete the articles of the sacred Shinto *kagura* ceremony.

569 570 571

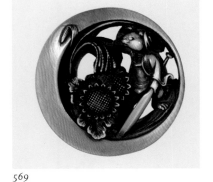

569

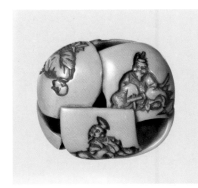

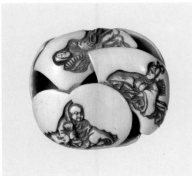

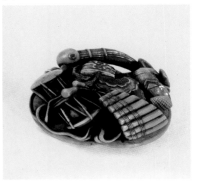

570a 570b 571

The *sashi* is worn differently from the ordinary toggle netsuke. It is an elongated shape of much greater length than the average netsuke and is thrust deep into the obi, which furnishes the support for suspending the *sagemono*. When the *sashi* is modified by a curve or hook at the bottom for catching on the lower edge of the obi for additional safety, it is called an *obihasami*.

The shape of the *sashi* afforded the carver another dimension for exercising his creative imagination. The distortion of the shapes of familiar figures and objects into the essential form of the *sashi* is often as artistic as it is amusing. Kokusai excelled at clever distortions in his stag-antler netsuke.

572. Dragon. Wood. Unsigned.
573. *Shishi* on pedestal. Bamboo. Signed: Gyokkin Eijin (Court Guard Gyokkin), with seal Chikurin, mosu (copied) (NH 133). Inscription: "Toman [a sculptor] of Kudara [in Korea] carved a stone *shishi* that guards the Great South Gate of the Todai-ji [temple] in Nara." See also Fig. 580.
574. Man wrestling fish (two views). Ivory. Signed: Ryōmin.

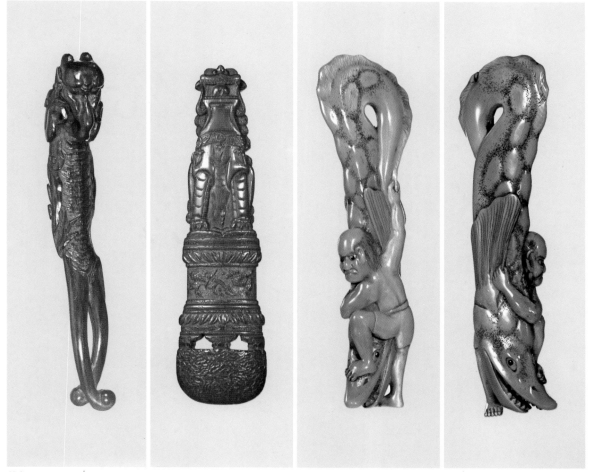

572 573 574a 574b

575. Monster face. Stag antler. Signed: Mitsuyoshi, with seal Mitsuyoshi. The design is probably derived from the gargoyle-like roof tiles that ward off demons. This is the special type of *sashi* known as the *obihasami*. It hooks on the lower edge of the obi for additional security.

576. *Kappa*. Stag antler. Unsigned. Like the netsuke in Fig. 575, this is an *obihasami*.

577. Shinto priest. Lacquer, Unsigned.

578. Unicorn. Wood. Unsigned. Collection of Eizaburo Matsubara.

573 574 575 580 582

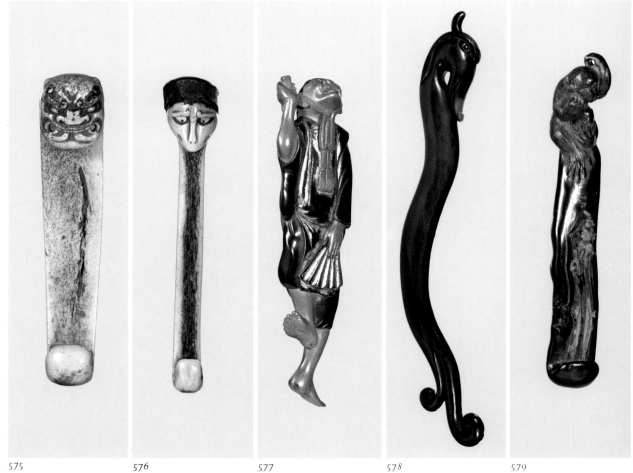

575 576 577 578 579

579. Monkey. *Umimatsu*. Unsigned. The cord runs through the monkey's paws.

580. *Shishi* on pedestal. Bamboo. Signed: Gyokkin Eijin (Court Guard Gyokkin), with seals Chiku and Rin, mosu (copied) (NH 133). Inscription: "Toman [a sculptor] of Kudara [in Korea] carved a stone *shishi* that guards the Great South Gate of the Todai-ji [temple] in Nara." This and the netsuke in Fig. 573 may be two of a series that Gyokkin carved to represent all the *shishi* that guard the various gates of the Todai-ji.

581. Stylized cicada. Bamboo. Unsigned. This netsuke is sufficiently knife-edged and flat-shaped to perform a secondary function as a paper cutter.

582. Bamboo node. Wood. Signed: Sōko koku (NH 1101).

583. No-evil monkey. Wood. Unsigned. The usual three monkeys are here combined into one that sees, speaks, and hears no evil.

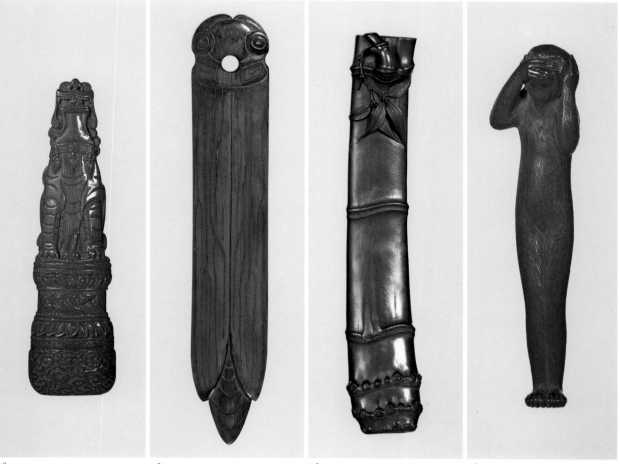

580 581 582 583

584. Monkey. Wood. Unsigned.

585. Dragon. Wood. Signed: Gyokutei. Collection of Shiro Akai.

586. Sage in pine forest. Bamboo. Signed: Sen'yū, with seal Chikumin, teppitsu. (*Teppitsu* means "engraved with a steel pen." It is a term favored by bamboo carvers.) Inscription: "I enjoy peace of mind in playing the *koto* and in reading books."

587. Eel. Stag antler. Unsigned.

588. Dragon. Bamboo. Unsigned. Ex Mark Hindson Collection.

585 586

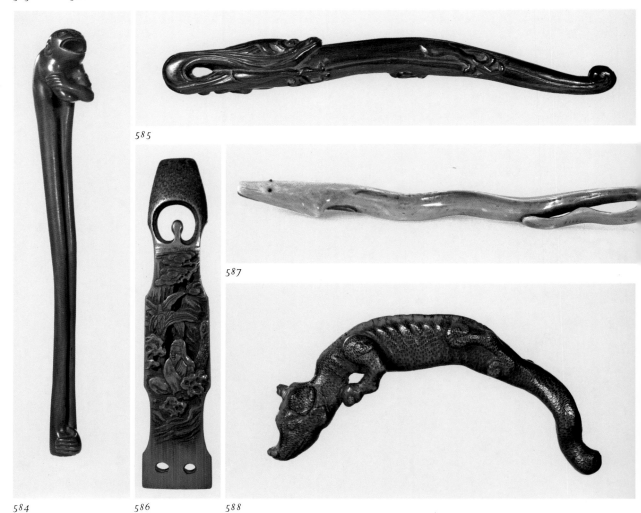

585

587

584 586 588

The designing and engraving of seals antedates netsuke by many centuries. Seals were introduced from China in ancient times. There is evidence that in 704 the emperor of Japan ordered the provinces to provide seals for the identification of official documents. Seal making is a separate and distinct art and craft. It was handed down from generation to generation, and the techniques were taught in traditional master-apprentice relationships. Some seal makers attained wide renown as master engravers. There were recognized experts in the identification of seals and a considerable literature on the subject. Many connoisseurs collected seals and owned examples of rare materials, unusual calligraphy, and fine carving. A well-designed and beautifully engraved seal might well appeal to the owner's aesthetic sense as much as the fine painting or calligraphy hanging in his tokonoma. Some connoisseurs claimed the ability to identify the material from which a seal was made by its impression on paper.

The art of seal making falls into two divisions dictated by the distinct parts comprising the seal: the handle, or grip, and the base. The handle is sculpture, whether a simple undecorated form or a carved figure or group, while the carving of the characters or monogram on the base for transference to paper is a form of engraving.

The materials used in seals are sometimes stones and metals chosen for value and durability. They may be jade, crystal, agate, coral, gold, or silver. The majority of seals, however, like netsuke, are made of ivory and wood.

In Japan, seals are more important than signatures. On important and legal documents, signatures are not recognized. Such documents must bear official seals, which are registered at local legal offices. A bright-vermilion paste is used for seal impressions. The explanation may be apocryphal, but the use of vermilion ink is said to be derived from the seal in blood that the medieval samurai placed on his pledge of allegiance.

The most prevalent form of netsuke possessing a secondary function is the netsuke that doubles as a seal.

589 590 591

589 590 591

589. Rabbit. Boxwood. Unsigned.
590. Weird animal. Wood. Unsigned.
591. *Shishi*. Wood. Unsigned.
592. Dragon. Marine ivory. Unsigned.
593. *Kirin* impression (two views). Ivory. Unsigned.
594. Camel. Ivory. Unsigned.
595. Stag. Stag antler. Unsigned.
596. *Shishi*. Boxwood. Unsigned. Collection of Shigeo Hazama.
597. Nude. Bone. Unsigned.
598. Dragon pair. Wood. Unsigned. Collection of Florence Marsh, San Francisco.

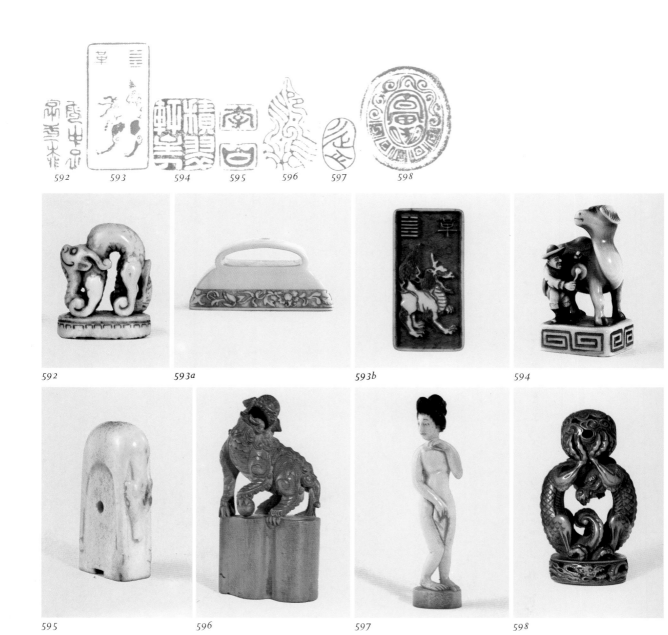

592 593 594 595 596 597 598

592 593a 593b 594

595 596 597 598

The *shishi* is one of our earliest netsuke. Like most early netsuke, it exhibits Chinese origins and influences. The subject itself originated in China, and the unabbreviated name of the animal in Japanese acknowledges China as its home: *karashishi*—more properly pronounced *karajishi*—means "Chinese lion." The animal is also known as the *komainu*, or Korean dog, indicating its dispersion to Japan by way of Korea.

Shishi is translated as "lion" only because the lion is the flesh-and-blood animal that most nearly resembles the *shishi* of legend, lore, and religion. Its actual resemblance, ignoring the vast difference in size, is to the Chin dog, or Pekingese, with its wide visage, thick mane, hair tufts, and curling tail. The *shishi* is sometimes called the "dog of Fu."

The *shishi* is probably the most common animal in netsuke—more common than the animals of the zodiac or the frog. In shape, size, pose, posture, attitude, style, carving, and treatment, it is as varied as the fish of the Inland Sea. A sizable netsuke collection might be based on the *shishi* alone. Its myriad models are inexhaustible.

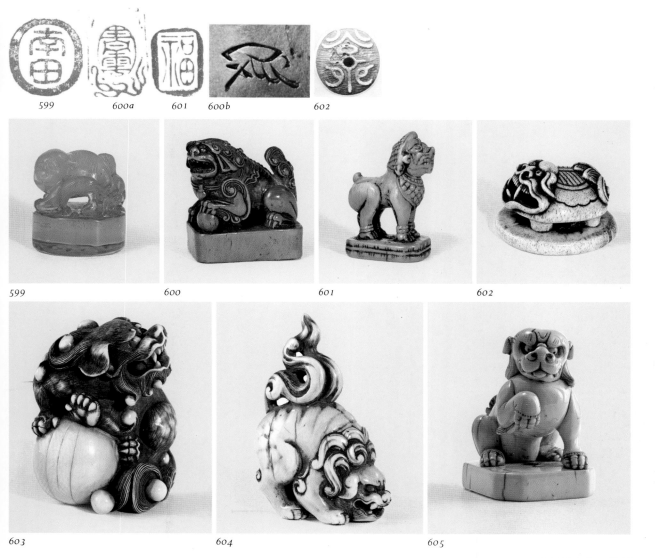

599 600a 601 600b 602

599 600 601 602

603 604 605

599. *Shishi* and young. Amber. Unsigned. Engraved seal base.

600. *Shishi*. Wood. Signed only with a *kakihan*. Engraved seal base with characters inlaid in ivory for durability. Collection of Jeffrey Moy.

601. *Shishi*. Ivory. Unsigned. Engraved seal base. Illustrated in *Masterpieces of Netsuke Art* (Hurtig), Fig. 109. This *shishi* is in the Siamese style.

602. *Shishi*. Stag antler. Signed: Kokusai (NH 527).

603. *Shishi*. Ivory. Unsigned. Ex Kenzo Imai Collection.

604. *Shishi*. Ivory. Unsigned.

605. *Shishi* on flat base. Ivory. Unsigned.

606. *Shishi*. Boxwood. Signed: Tohō.

607. *Shishi* on square base. Boxwood. Unsigned.

608. *Shishi*. Wood. Unsigned. The form is that of a Chinese archaic bronze incense burner.

609. *Shishi* group. Ivory. Unsigned. The manner of rendering the *shishi* suggests the work of Gechū. See Hindson Collection, No. 1122, and Neil Davey's *Netsuke*, Fig. 44.

610. *Shishi* on oval base. Ivory. Unsigned.

606 612 613 615 616

606 607 608

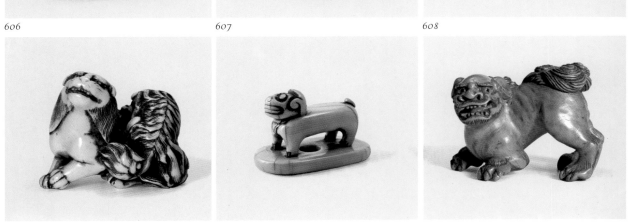

609 610 611

611. *Shishi*. Boxwood. Unsigned.

612. *Shishi*. Stag antler and red sandalwood. *Manjū* type. Signed: Koku in seal form (Kokusai; NH 527).

613. *Shishi* head. Red and gold lacquer. Signed: Yūsō.

614. *Shishi*. Red and gold lacquer. Unsigned. The form is that of an incense burner.

615. *Shishi* group (two views). Ivory. Signed: Fuji Masanobu, with *kakihan*. According to legend, the *shishi* flings its newborn cubs down a mountain cliff to test their strength. Only those that climb back are reared.

616. *Shishi*. Wood. Signed: Ryūgyoku (NH 846). The *shishi* is in the form of a Chinese bronze.

617. *Shishi*. Ivory. Unsigned. Collection of Edward Shay.

618. Romping *shishi*. Ivory. Unsigned.

619. *Shishi*. Ivory. Unsigned. The *shishi* lies half supine and plays with the *tama* he is supposed to guard.

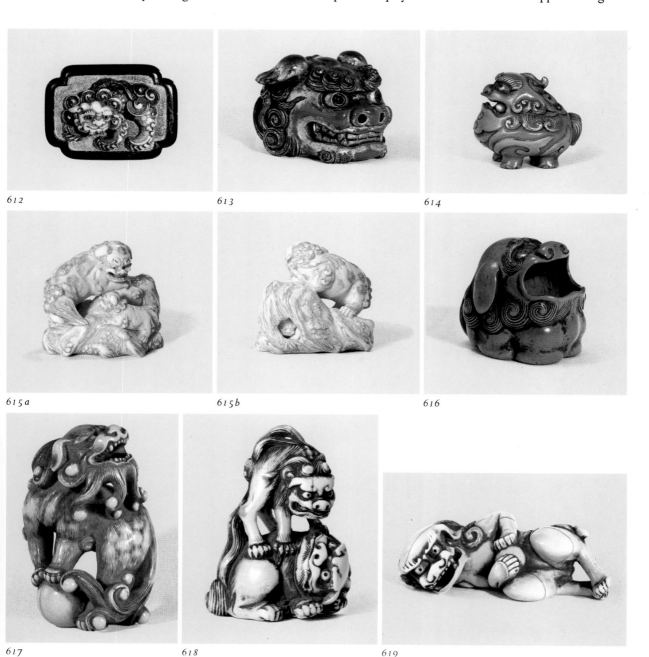

612 613 614

615a 615b 616

617 618 619

37 SILK SEALS

During the Muromachi, Momoyama, and Edo periods Japan imported large quantities of raw silk from China through the port of Nagasaki. The Chinese merchants attached seals known in Japanese as *itoin* (literally, "fiber seals" or "thread seals") to their silk shipments. After the silk had been inspected and weighed, an impression of the *itoin* was made on the receipts and documents as proof of the transaction. The seals and documents were then returned to China. *Itoin* were generally made of metal, and many of the handles were carved in the form of heads of human monsters.

The imported silk was transshipped by sea or hauled over inland highways to the main commercial centers of Japan. In Tokugawa times the territories of the various daimyo were protected by manned barriers where travelers were investigated, shipments inspected, taxes imposed, identifications checked, and security precautions enforced. The territory of each daimyo was in effect a separate country. Travelers and merchants alike dreaded the barriers.

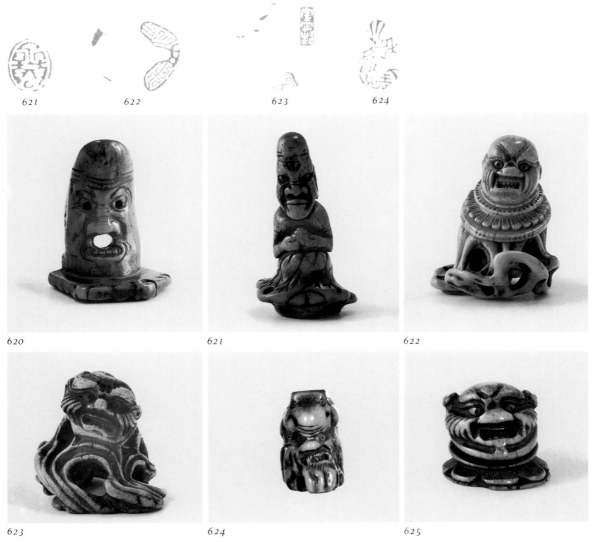

621 622 623 624

620 621 622

623 624 625

The internal shipments of silk were identified by seals that the Japanese seal makers quite naturally modeled after the Chinese *itoin*. The characters or monograms were engraved in the weird Chinese style, and the handles were carved in the shape of the heads of human monsters. The one difference was the Japanese use of stag antler in preference to copper or other metal, probably for reasons of convenience. This type of seal is distinct and is commonly known as the "silk seal."

620–25. Silk seals. The six examples shown here are typical. The material is stag antler. The seals are not signed. The subject is invariably the exaggerated foreign monster. Impressions of a few of the seals are reproduced for general interest.

SIMPLIFIED AND ABSTRACT NETSUKE 38

Sculpture is a free art form. Netsuke carving is not. On the contrary, it is rigidly restricted. The sculptor may work in any size, any material, any shape, and any style that strikes his artistic fancy. He need not worry about the parts of his work that are not viewed—for example, the base or the reverse side of a relief carving. Nor need he worry about the placement or effect of cord holes. He may carve materials as soft as clay or as perishable as butter. He may carve an object as streamlined as a smooth silver egg or as jagged as a scrap-metal conglomeration. By contrast, the *netsuke-shi* works under onerous limitations. Small size, durable material, smooth shape, and compactness are ordained by the function of a netsuke as an article to be worn. A netsuke must be finished on all sides, including the base and the reverse side of relief carvings. Cord holes must be placed so that they do not mar the design, at the same time permitting the netsuke to carry naturally—for example, facing forward if it is a figure and sitting upright if it is a quadruped. Original sculpture is a remarkable accomplishment. How much more remarkable an original netsuke created in the face of such limitations!

The particular problem exemplified by the netsuke shown here is that of shape: the requirement of a smooth, rounded outline and compactness. The *netsuke-shi* constantly strives to solve the problem of designing his chosen subject so that the outline is smooth and the shape compact. He avoids sharp angles, edges, protruding parts, and awry appendages. He resists elaboration and reduces decoration. He eliminates details.

As the *netsuke-shi* cuts and carves toward a smoother and smoother outline, a more and more compact shape, and a more and more simplified treatment, he is—whether or not he is aware of the fact—engaged in the process of abstraction. His problem is to eliminate unneeded details without destroying the essential quality of the subject or its ability to be readily recognized. An example is the quail in Fig. 645. When we compare this rendering with the typical quail by Okatomo, we realize how little there is to identify it as a quail. The Okatomo model has wings, legs, feathers, markings, and even millet, its associated grain, to insure unmistakable recognition. The unknown

carver of the quail in Fig. 645 eliminated feet and food altogether and for wings and feathers substituted body planes. At the risk of sounding obscure, we may say that the quail in the simplified bird body is recognized by its characteristic stance, the mysterious essence of the species that distinguishes it from all other birds. The carver saw with the penetrating eye of a fine artist and captured the essence of the quail in his design. It may be pure speculation, but had our carver proceeded with one further step in abstraction, we would still have a bird, but in all probability we would have lost the quail.

Birds lend themselves to abstraction and, in streamlined form, often assume perfect netsuke shapes. The goose in flight seen in Fig. 626 is another fine example of simplification and streamlining without sacrifice of the "divine essence." The goose in flight across the face of the moon is a frequent theme in Japanese poetry and painting. The subject tears a powerful emotional response from the sensitive Japanese: he hears a distant honk, he feels a cold, clear night, he knows a fearful solitude—the pain of the eternal absence of someone he loves.

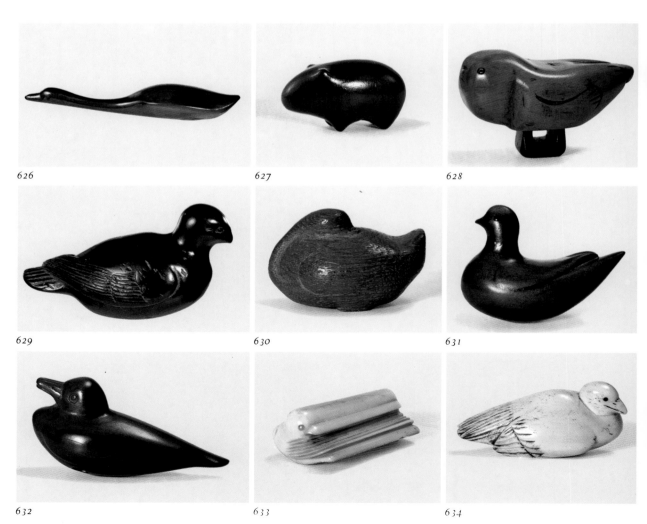

626

627

628

629

630

631

632

633

634

626. Goose in flight. Wood. Unsigned. The lone goose silhouetted against the silent moon is a frequent theme in Japanese paintings.

627. Bear. Red sandalwood. Unsigned. The shape is derived from the *haniwa* clay burial figures.

628. Toy pigeon. Boxwood. Unsigned. A separate part made of black wood was attached to accommodate the cord.

629. Pigeon. Black wood. Unsigned.

630. Swan. Wood. Unsigned.

631. Pigeon. Wood. Unsigned.

632. Duck. Wood. Unsigned. Though probably unintentionally, the duck is shaped like a hunting decoy.

633. Double-ended sparrow. Ivory. Unsigned. An identical sparrow is carved at either end. The design may be an allusion to the belief that sparrows live in pairs and are monogamous.

634. Bird. Ivory. Unsigned.

635. Dog. Boxwood. Signed: Nagahiko.

636. Crab. Whale tooth. Signed: Ono Ryōmin, with *kakihan*. Inscription: "Abstract Heike crab, using whale tooth." Illustrated in *The Collectors' Encyclopedia of Antiques* (London, 1973). The subject is an allusion

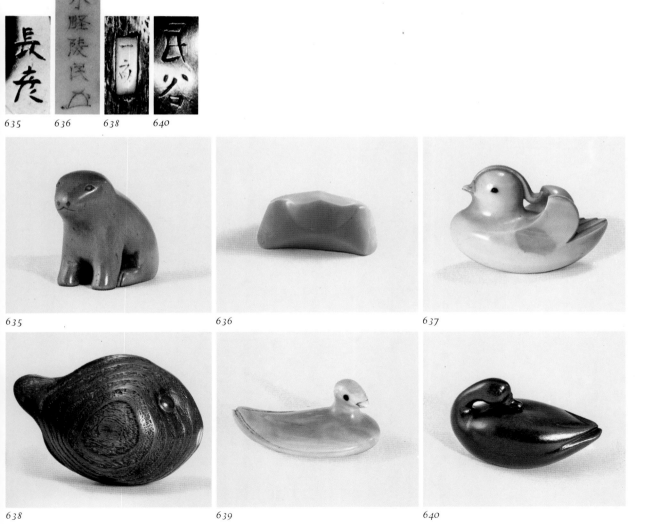

635 636 638 640

635 636 637

638 639 640

to the battle of Dannoura (1185), in which the Heike (Taira) clan were decimated. The spirits of their fallen warriors are said to live on in the local crabs now known as Heike-gani (Heike crabs). Warriors' faces are seen in the ridges and contours of the shells of the Heike-gani.

637. Stylized mandarin duck. Ivory. Unsigned.

638. Globefish (*fugu*). Paulownia wood (*kiri*). Signed: Issai, on an ivory label. See also Fig. 514.

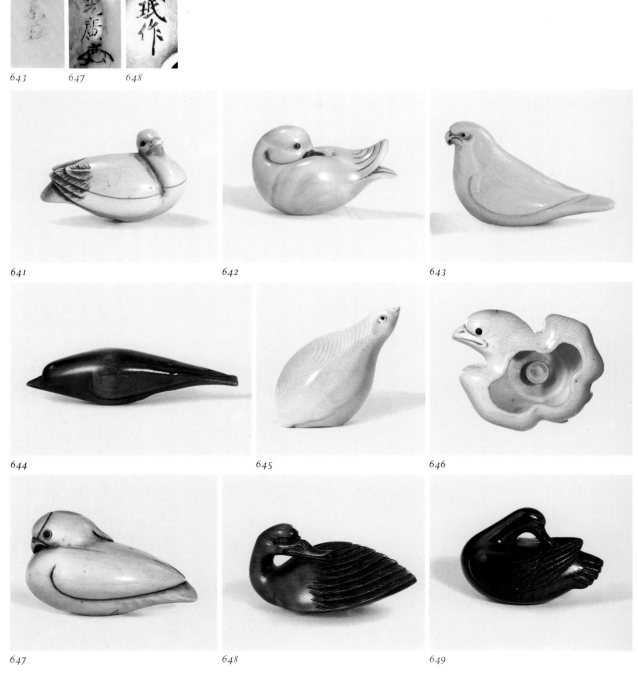

643 647 648

641

642

643

644

645

646

647

648

649

639. *Miyakodori* (gull). Ivory. Unsigned. This variety of gull is the *miyakodori,* which formerly blotted the Sumida River of Tokyo in great flocks. Their seasonal visits have now unfortunately passed into regional history.

640. Goose. Wood. Signed: Minkoku (NH 667).

641. Cygnet. Ivory. Unsigned.

642. Duck. Whale tooth. Unsigned.

643. Pigeon-hawk. Ivory. Signed: Rangyoku (NH 802). Illustrated in *The Collectors' Encyclopedia of Antiques* (London, 1973). Why should a carver concern himself with scientific identification? What matter whether the bird is half hawk or nonexistent pigeon? His goal was a lovely functional figure suitable for use with a fine gold-lacquer *inrō.*

644. Pigeon. Wood. Unsigned.

645. Quail. Ivory. Unsigned.

646. Chick. Ivory. Unsigned. It is likely that the chick is hollowed out for lightness to complement an *inrō.* The chick (*hiyoko*) is a recently hatched bird—a stage when it is difficult to say whether it is a sparrow or a hawk.

647. *Kogamo* (teal: a small wild duck). Ivory. Signed: Ōhara Mitsuhiro, with *kakihan* (NH 685).

648. Goose. Wood. Signed: Shūmin saku (NH 1060).

649. Duck. Wood. Unsigned.

650. Pigeon. Wood. Unsigned.

651. Swan. Ivory. Unsigned.

652. Duck. Wood. Unsigned.

653. Falcon. Ivory. Unsigned.

654. Sparrow. Paulownia wood (*kiri*). Unsigned.

655. Rabbit group. Bamboo bowl, boxwood disk. *Kagamibuta* type. Unsigned. The rabbits are carved in positive and negative relief, suggesting that one is dark and the other light, one male and the other female, as well as other Oriental dualities of pairs.

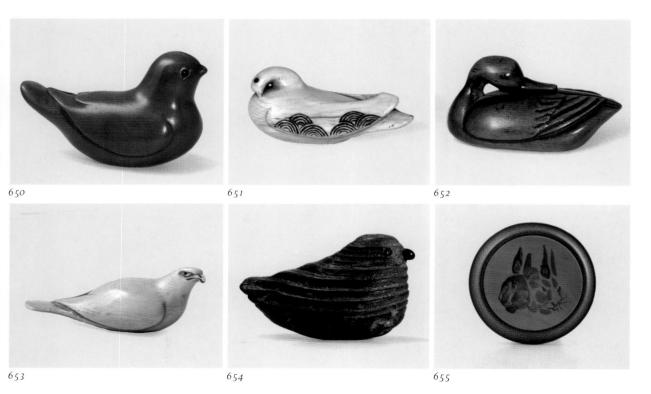

650 651 652

653 654 655

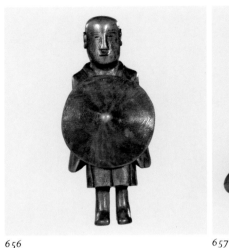

656

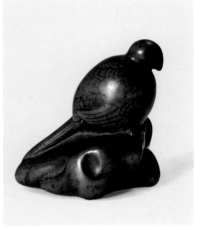

657

656. Priest Saigyō. Wood. Unsigned. An inscription in *sumi* on the inside of the hat is rubbed beyond legibility.
657. Long-tailed bird. Wood. Unsigned.

39 SIMULATED MATERIALS

A simulation in netsuke is the imitation of material. The carver treats one material so that it assumes the appearance of another, which it pretends to be. Great technical skill and imagination are essential for the successful imitation. It requires clever carving, coloring, and staining to simulate. We can be certain that the successful simulators expended enormous effort in experimentation and trial, with many failures, before they developed the processes and techniques for treating wood to look like bamboo, bark, or iron and ivory to look like stone, pottery, or porcelain.

658 659

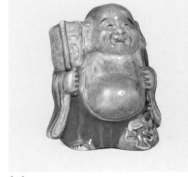

658

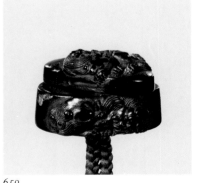

659

658. Pottery Hotei. Ivory. Signed: Chokusen. At first glance, Hotei seems slightly crude, but then one realizes that Chokusen made every sacrifice to secure a perfect simulation of pottery, including a mold line.

659. *Shakudō fuchigashira*. Ebony. Signed: Sōmin, with *kakihan* (NH 1107). Yokoya Sōmin was one of the great metal artists. He originated a style of engraving that imitated the brush strokes of painting. The *fuchigashira* is attached to a pouch with metal fittings signed Sōmin and Shōmin. See also Fig. 265.

660. Dried persimmon. Wood. Signed: Chokusai, on inlaid pearl label (NH 55).

661. Uji tea picker. Pottery (earthenware). Brand of Otowa, a kiln used by Kyoto potters. Signed: Ken (Ken'ya; NH 479). This painted earthenware simulates the Uji *ningyō* made of the wood of the tea bush in *ittōbori* style. See also Fig. 108.

662. Skeleton. Boxwood. Unsigned. Ex Tokutaro Tsuruoka Collection. The remarkable resemblance to bamboo may be unintentional. The boxwood, however, is pitted all over so that it resembles the fiber-bundle spotting of bamboo.

663. Bamboo-sheath package. Wood. Signed: Hokutei (NH 253). Bamboo sheath is cut in wide strips for wrapping fish and other foods. Like other colorful products used in packaging, it is gradually being replaced by plastic containers.

664. Iron stirrup and water ladle. Ebony. Signed: Mitsuhiro (NH 685).

665. Badger-shaped iron teakettle. Ebony. Unsigned. Inscription: "Daitoku-ji [temple]." The characters are raised by high relief carving. The name of the Daitoku-ji is inscribed because, according to one version, it is the temple where the events of the famous teakettle-into-badger folk tale occurred.

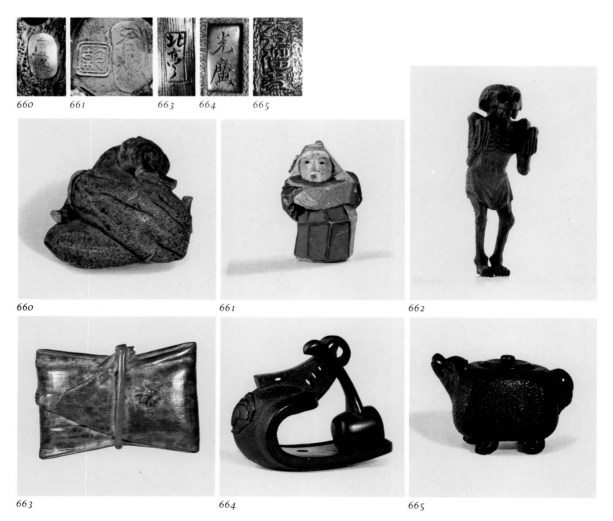

660 661 663 664 665

660 661 662

663 664 665

40 "SŌKEN KISHŌ" TYPES

In 1781 a sword expert composed a work in seven volumes on the appreciation of swords and sword furnishings. The volumes were printed by wood blocks, illustrated with line drawings, and bound in the Japanese style. The last volume was divided into two parts, one devoted to *ojime* and the other to netsuke. Fifty-four *netsuke-shi* were listed with very brief data. Among them were Gechū, Tsuji, Shūgetsu, and Mitsuharu, as well as Issai, Miwa, Garaku, Minkō, Shūzan, Tomotada, Masanao, and Okatomo. The name of the work is the *Sōken Kishō*. It represents the first reference in Japanese literature to *ojime* and netsuke. The author is Inaba Tsūryū, often referred to as Inaba Michitatsu. (The reading Tsūryū is preferred because of the custom of using the Chinese reading of one's given name in the case of scholars and literati in the Chinese classics.)

In view of the compartmented organization of Tokugawa Japan, it is not surprising that all but a few of the fifty-four *netsuke-shi* listed in the *Sōken Kishō* were from Inaba's own area of Osaka and Kyoto. Apparently he did not know the carvers of Iwami or of other areas remote from the Tokaido, the highway between the old capital Kyoto and the shogunate capital Edo. It is interesting to note that Inaba described a number of his *netsuke-shi* as carvers of Buddhist images, household panels, and false teeth or as carvers for amusement or for a hobby.

It may be the illustrations of some sixty netsuke and seals in the seventh volume of the *Sōken Kishō* that are of the greatest interest to the collector. We see the types of netsuke that were popular before 1781. The dominant trait of most of them is the pervading Chinese influence on their style and subject. It is fair to classify these early Chinese-style netsuke as *Sōken Kishō* types. Inaba himself, in commenting on the illustrations, said that we should enjoy their strangeness, even though we cannot identify them or elucidate their meanings. They make an engrossing group for those collectors whose predilection is for the bizarre and the grotesque.

666. Elephant. Ivory. Unsigned. The elephant stands on a gong. The symbolism is Buddhist and originates in India.

667. Long-haired foreigner. Whale tooth. Unsigned.

668. Badger. Wood. Unsigned. The animal is probably intended for a badger. It is shaped as though cut in half, the back of the carving being almost flat like that of an Oriental wall vase. The half shape may be an allusion to the badger's other life as a pretending priest.

666 667 668 669

669. Fish-tailed primitive. Ivory. Unsigned. Ex Kazuo Kotera Collection. This strange primitive eats a live fish, tail first. He has a thick dragon-tail appendage.

670. Taoist figure. Wood. Unsigned. Ex Hideo Taniguchi Collection. The demon is mounted on a *baku* and carries a sphere. The base is an engraved seal.

671. *Shishi*. Wood. Unsigned. The *shishi,* seated on a dragon stool, suggests a heraldic emblem of the Middle Ages. The symbols are Taoist. The base is engraved, and the separation of tail from body provides space for the cord attachment.

672. Coiled dragon-fish. Wood. Unsigned. The dragon-fish, or *shachihoko,* is often described as a dolphin. It frequently decorates the roofs of daimyo castles, the gilded *shachihoko* of Nagoya Castle being the most famous. In this netsuke, a loose ball is carved in the *shachihoko's* mouth.

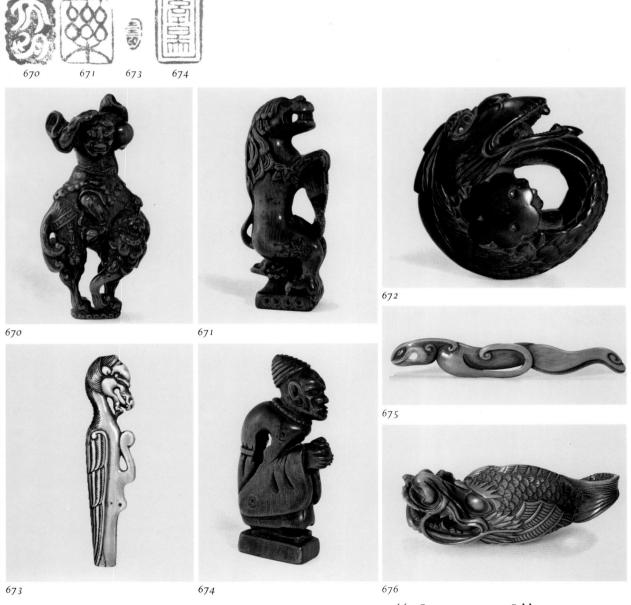

670 671 673 674

670

671

672

673

674

675

676

673. Winged dragon. Ivory. Unsigned. The base is engraved with a small seal.

674. Priest. Rhinoceros horn. Unsigned. The priest's features are Negroid, though he is probably a lama. He carries a pot and cover in his hands, apparently as an offering. The base is an engraved seal.

675. Flying dragon. Ivory. Unsigned. The netsuke may be used as a *sashi* with the cord through the dragon's mouth or conventionally with the cord between the animal's forelegs and body. The wear, however, is on the aperture in the mouth.

676. *Shachihoko*. Wood. Unsigned.

677. *Shachihoko*. Stag antler. Unsigned.

678. *Shachihoko*. Wood. Unsigned.

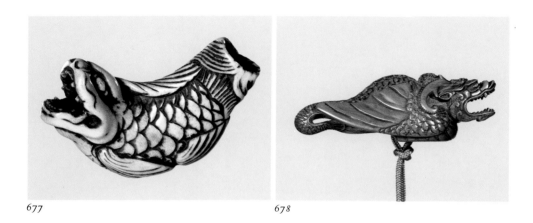

677 678

41 STAG-ANTLER NETSUKE

As stag antler is native to Japan, it is abundant and cheap in comparison with ivory. It is also harder and more durable than ivory. This is all that can be said in its favor as a material for carving. Because of its branching form, its narrowness, and its spongy uncarvable marrow, it lacks the straight shape, dimensions, and bulk of ivory—so advantageous for a free choice of design. In working with ivory the carver's first problem is the composition of his design. The ivory readily accommodates the design he chooses. Contrariwise, in working with stag antler the carver's first problem is the shape and limitations of the antler. He must compose his design to fit its intractable configuration.

The limitations of stag antler as a medium often demanded of the carver a supreme exercise of his creative talents. How otherwise was he to elicit a fine model from this recalcitrant material? The same carver who might be lazy and repetitious with a large block of ivory was forced to resourcefulness and creativity in dealing with twisting antlers, no two of which branched alike. It is relatively simple to trace a familiar design on an ample block of elephant tusk, but it may take genius to see a design in the odd joint or tine of an antler. Kokusai, Rensai, Hakusai, and a few others are the great names in carving stag antler. There are others who did not sign. Though also gifted, they appear destined to remain forever nameless.

Quite a few stag-antler netsuke, though unsigned, are attributed to Kokusai. Some of these attributions are quite plausible, even convincing. Why should some Kokusais be unsigned? An explanation may lie in Kokusai's profession. He was a habitué of the notorious Yoshiwara, the section of Edo (later Tokyo) reserved for prostitution. He wore a red coat (*akai haori*), the symbol of a male prostitute. A patron of Kokusai's craft might wish to avoid the suspicion of being a patron of his profession as well. A discreet patron might therefore prefer his Kokusais to be unsigned.

679. Woodpecker on walnut. Signed: Ren (NH 818).
680. Raiden beating his thunder drums. *Ryūsa* type. Signed: Hakusai (NH 183).
681. Bat and mushroom. Signed: Kōgetsu (NH 507).
682. European. Unsigned. The ruffled collar and the engraving on the base suggest that the figure is of European origin.

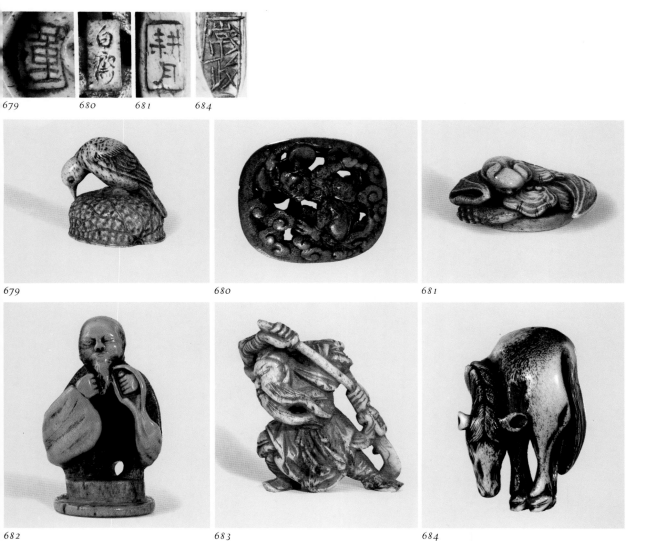

679 680 681 684

679 680 681

682 683 684

683. Kan'u. Unsigned. The Han military strategist portrayed in powerful movement.

684. Grazing horse. Signed: Tsunemasa (NH 1260).

685. Sparrow. Unsigned. The marrow and the spongy part of the antler have been removed; only a hard ring of bone remains.

686. Horse. Unsigned. The horse curves to follow the hard outer circumference of the antler.

687. Bat. Unsigned.

688. Dragon. Unsigned. Collection of Walter Belanger.

689. Bull. Unsigned.

690. Mermaid. Unsigned.

691. Elongated monkey. *Sashi* type. Unsigned; attributed to Kokusai. Collection of Walter Belanger.

692. Elephant (two views: front and back). Unsigned; attributed to Kokusai. Illustrated on jacket of *Collectors' Netsuke*.

693. Horse. Unsigned.

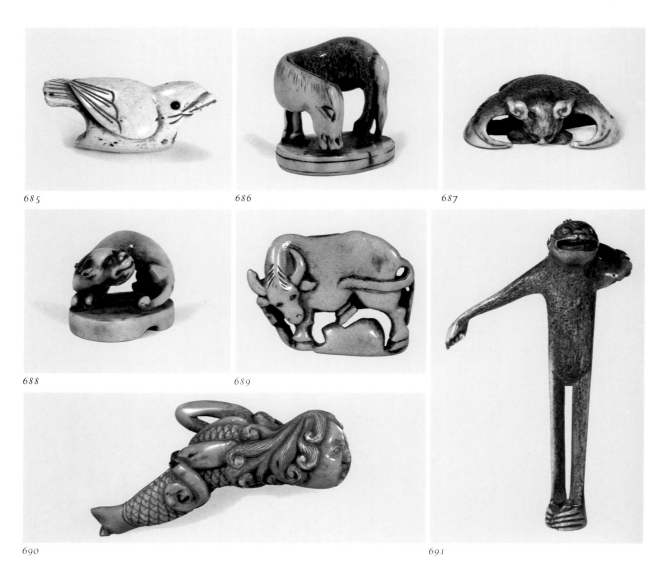

685 686 687

688 689

690 691

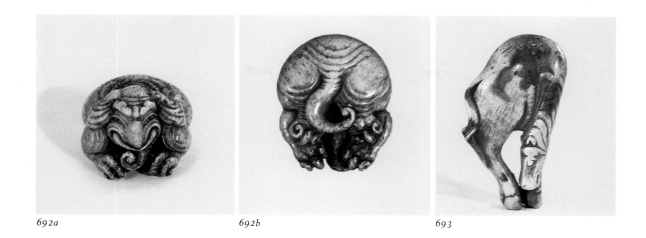

692a 692b 693

TREATMENT OF ANIMALS 42

When a carver carved an animal that was rarely carved, he had simply carved a rare animal. Clear! Perhaps his choice of a rare animal was unwitting. However, when a carver carved an animal that was commonly carved but carved it in an uncommon manner, he created an original treatment that clearly redounds to his artistic credit.

 The scarcity or rareness of a creature is an important element in the valuation of a netsuke, notwithstanding that the carver may have selected it without recognition of its rarity. However he may have hit upon it, his choice of an unusual animal adds nothing to the quality of his carving as craft or as art. On the other hand, original treatment of a common animal requires talent of a high order. Transforming the common into the uncommon demands imagination and originality. No plodding artisan could have produced the fresh treatments illustrated here.

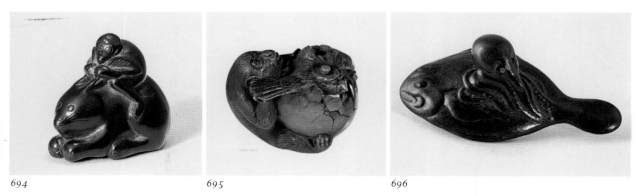

694 695 696

694. Monkey and rabbit. Wood. Unsigned. The monkey uses the rabbit's ears like the reins of a horse.

695. Monkey and hatching *tengu*. Wood. Signed: Shūzan (NH 1094). Illustrated in *Orientations*, June 1971.

696. Octopus on flounder. Burl. Unsigned.

697. Cat and rat. Wood. Signed: Sensai. Collection of Fred and Nina Thomas.

698. Head of dog. Ivory. Signed: Ishikawa Kōmei (NH 350). The dog is European in feeling. Kōmei taught sculpture in the new-style Tokyo Art School founded on Western principles. He may have carved this head in European style, or he may have "improved" a European carving.

699. Fighting rabbits. Wood. Unsigned. Rabbits that fight are as unlikely as vegetarian tigers.

700. Prawn. Wood. Unsigned.

701. *Tengu*. Wood with ivory accents. Unsigned. Illustrated in *Masterpieces of Netsuke Art* (Hurtig), Fig. 977. See also Fig. 519.

702. Ludicrous animal. Wood. Signed: Gyokkō (NH 134). The animal may be a badger. It sits upright like a human being and uses its paw almost like a hand. Two of its limbs have been replaced. Other parts are suspiciously discolored and may represent further repairs.

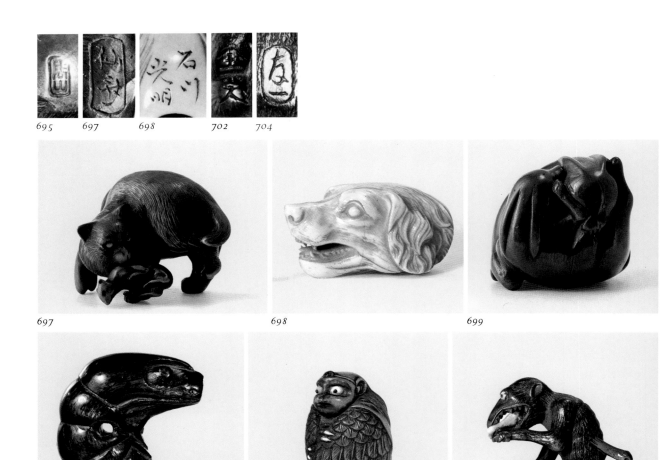

695 697 698 702 704

697 698 699

700 701 702

703. Stag. Wood. Unsigned.

704. Wolf feeding on its own paw. Wood. Signed: Tomokazu (NH 1206). Ex Dave and Sandy Swedlow Collection.

705. Monkey. Wood. Unsigned. In modern terms the monkey is an interesting study in masses and distortions.

706. Sparrow. Wood. Unsigned.

707. Cat. Wood. Unsigned.

708. Phoenix and crest. Ivory. Unsigned.

709. Dancing fox. Ivory. Unsigned. Collection of Yoshijiro Mizutani. The fox is deliberately dark-lacquered on a part of its body to indicate its ability, between night and day, to change from animal to woman and back again. The fox is an Oriental werewolf, so to speak. See also Fig. 739.

710. Horse. Wood. Unsigned. Illustrated on jacket of *Collectors' Netsuke*. The horse balances perfectly on three legs.

711. Bat (two views). Black persimmon. Unsigned.

712. Cow. *Umimatsu*. Signed: Juntoku Minkō, with *kakihan* (NH 661). Juntoku is a *gō* that Minkō rarely used. Verification of the name is found in biographical records of Mie Prefecture, where it is recorded that Tanaka Minkō was also known as Juntoku or Tadamitsu. The quality of this piece points to the work of the master, not an apprentice.

713. Frogs in clamshell. Ivory. Unsigned.

714. Goat group. Boxwood. Signed: Sukenao (NH 1125).

715. Dog. Ivory. Signed: Masanao (NH 609). The piece is extensively damaged.

716. Fox and young. Ivory. Unsigned.

717. Squirrel and grapes. Ivory. Unsigned. For the relationship of squirrel and grapes, see caption for Fig. 478.

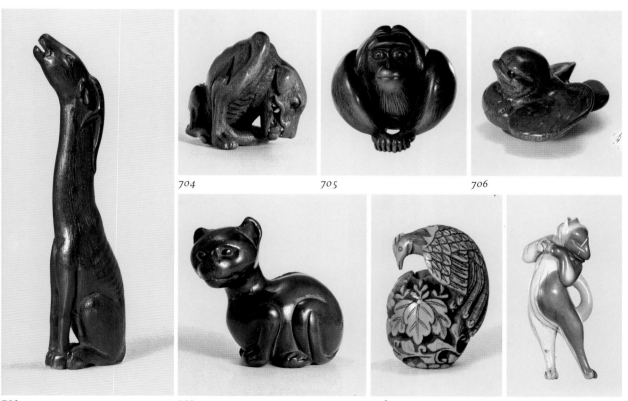

703 704 705 706 707 708 709

718. Horse. Wood. Unsigned. Illustrated on jacket of *Collectors' Netsuke*. The horse is a *sashi* type compactly designed to fit the elongated form.

719. Fox and young. Ivory. Signed: Harusada. Inscription: "[At the] foot [or base] of Mount Mikasa [near Nara]."

720. Badger. Black wood. Unsigned. The cord holes are formed by the separation of the forelegs from the body.

721. Goat. Ivory. Unsigned.

722. Bull. Ebony. Unsigned. The animal is in the unusual position of rising. The bull, in rising, straightens his hind legs first, whereas the horse straightens his forelegs first.

723. Dog and gourd. Wood. Unsigned.

724. Fox. Ivory. Unsigned.

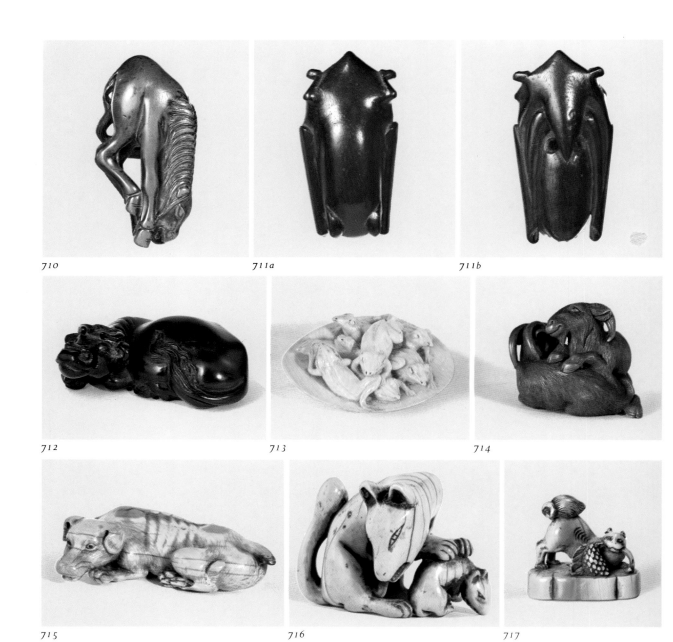

710 711a 711b

712 713 714

715 716 717

725. Rabbit. Ivory. Unsigned. Collection of Frances Numano. The rabbit is as round as the rice cakes he makes or as round as the full moon, where he dwells.

726. Weird fish. Wood. Unsigned. Illustrated on jacket of *Collectors' Netsuke*.

727. Horse. Ivory. Unsigned. Collection of Frances Numano.

728. Dog on a rock. Ivory and wood. Signed: Mitsuaki (Ishikawa Kōmei; NH 350). See also Fig. 698.

729. Goat group. Ivory. Unsigned. Collection of Anna L. Wunderlich.

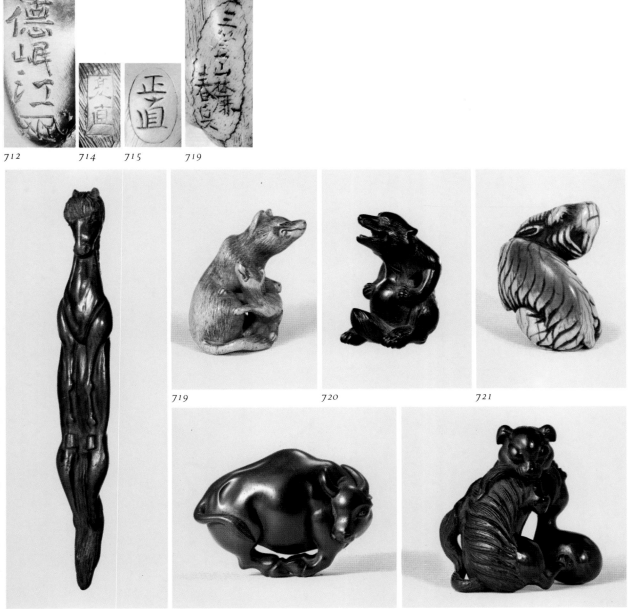

712 714 715 719

719 720 721

718 722 723

730. Horse. Ivory. Unsigned.
731. Tiger. Ivory. Unsigned. Illustrated on jacket of *Collectors' Netsuke*.
732. *Kappa* on a turtle. Wood. Signed: Toyomasa (NH 1254). Ex Mark Hindson Collection.

728 732

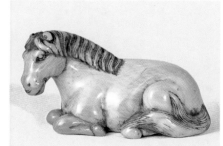

724

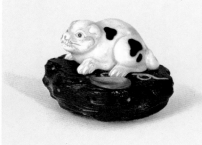

725

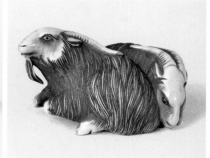

726

727

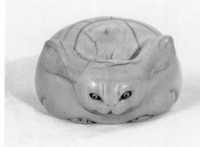

728

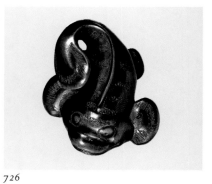

729

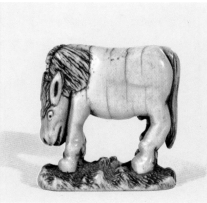

730

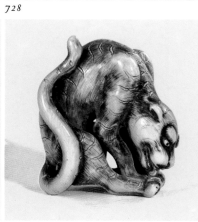

731

732

TREATMENT OF SUBJECTS 43

The remarks about the treatment of animals (Category 42) apply with equal validity to the treatment of subjects. The *netsuke-shi* who carves a rare subject may have selected it deliberately or fortuitously. In either case, as much as we may appreciate the rarity of the subject and as much as rarity may augment desirability, it adds nothing in terms of artistic merit. On the other hand, the *netsuke-shi* whose fresh and inspired treatment of a common subject is clever, ingenious, stunning, charming, or original distinguishes himself as an artist as well as a craftsman.

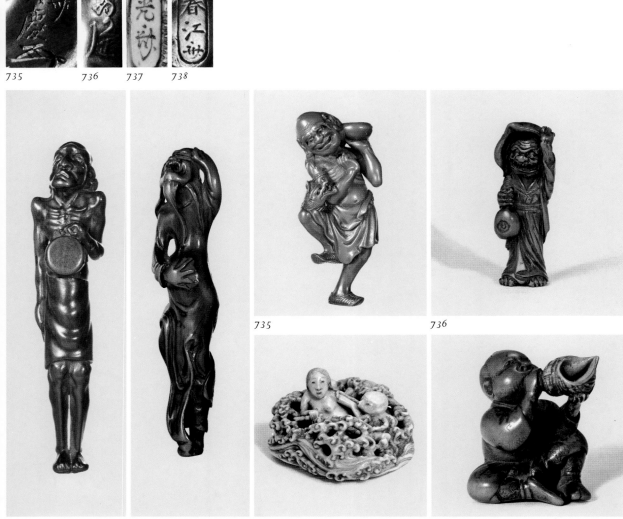

735 736 737 738

735 736

733 734 737 738

733. Primitive with drum. Wood. Signed, but characters effaced. It is probably safe to claim this piece for an early Miwa.

734. Chinese sage. Wood. Unsigned. Collection of Yonekichi Matsui. The sage performs a difficult exercise, one hand moving in a circle while the other moves horizontally.

735. Handaka Sonja. Wood. Signed: Ryūminsai Teikei, with *kakihan*.

736. *Oni*. Wood. Signed: Tametaka, in *ukibori* technique (NH 1159). Collection of Dr. Mineji Abe. The *oni* carries a sakè bottle but covers his head with a lotus leaf—an example of hypocrisy. See also Fig. 435.

737. Amorous octopus and diving girl. Ivory. Signed: Ikkōsai. Collection of Abraham Globerman. See also Fig. 135 and caption.

738. Man sounding conch. Wood. Signed: Shunkōsai (NH 1069).

739. Fox woman. Wood. Unsigned. The Japanese version of the werewolf is the fox who plays farmer's wife during the day but hunts as a fox by night. The fox wife is exposed by placing a rat near her. She cannot resist the lure, and the gentle housewife turns into the carnivorous fox. See also Fig. 709 and caption.

740. Fisherman. Wood. Unsigned. Ex Marcel Lorber Collection. A peddling fisherman shakes a noisemaker in one hand and a string of copper coins in the other as he shouts his catch.

741. Ono no Tōfū. Wood. Unsigned. The hat, umbrella, elevated *geta,* and human feet unmistakably identify the allusion to Ono no Tōfū, the statesman who was inspired to continue his efforts by the example of the perseverance of a frog.

742. Foreigner on horse. Wood. Unsigned. Ex Mark Hindson Collection. The indication is that the rider is a circus performer.

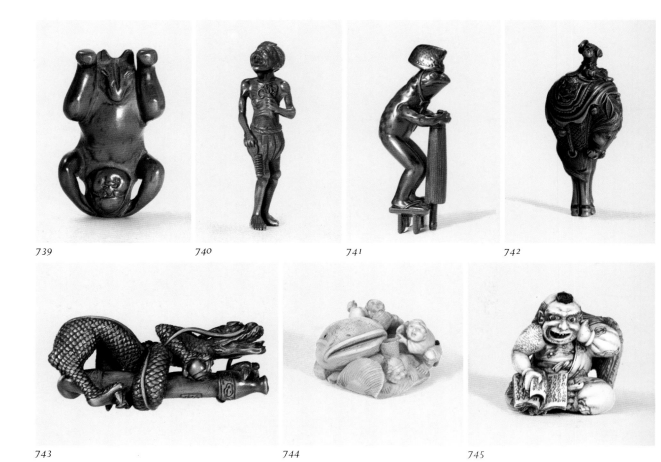

739 740 741 742

743 744 745

743. Dragon and pipe. Wood. Signed: Shūzan (NH 1090). The dragon materializes from smoke: the smoke of a *rakan's* burning bowl, the smoky clouds of heaven, or the smoky mist of the sea. Then why not from the smoke of an ordinary *chōnin's* pipe?

744. Four men and a catfish. Ivory. Signed: Chokusai, with *kakihan* (NH 55). Ridiculous efforts by four men to capture a huge earthquake fish (*namazu*). One uses a net, one tries a gourd, one holds tight to the fish's whiskers, and the fourth simply flounders.

745. *Tengu* reading love story. Ivory. Signed: Hide, with *kakihan* (NH 205). Ex Abraham Globerman Collection. The *tengu* should be studying his treatise on swordsmanship. Instead he reads a love story and tries to hide his pleasure by "biting the laugh." See Fig. 135 for an analogous subject.

746. Mermaid. Wood. Unsigned. Ex Mark Hindson Collection, No. 834. Illustrated in Neil Davey's *Netsuke*, Fig. 1151.

747. Priest and demon. Wood. Signed: Miwa, with *kakihan* (NH 710). The *netsuke-shi* often expressed the

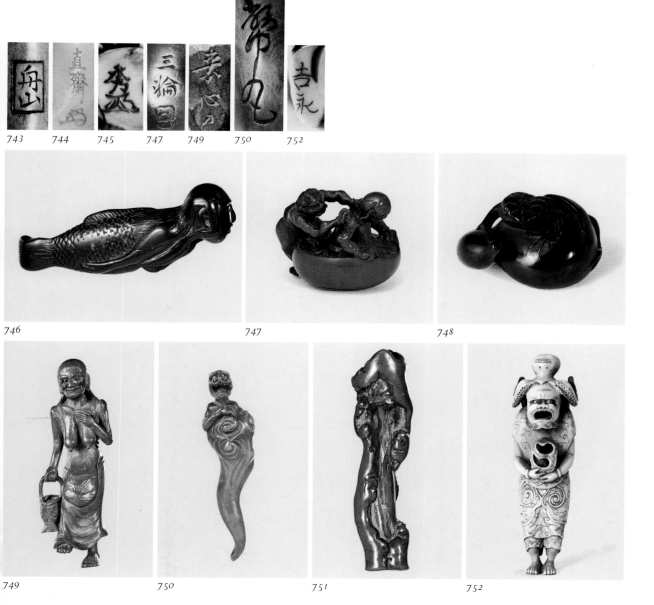

743 744 745 747 749 750 752

746 747 748

749 750 751 752

spirit of the Bon Festival by portraying the antagonistic representatives of heaven and hell in friendly relaxation and at play. They have no work because the festival is the time when death takes a holiday. Thus the demon washes the priest's back. See also Fig. 526.

748. Frog from gourd. Wood. Unsigned. Horse out of gourd is the unexpected occurrence. Frog out of gourd is the common occurrence.

749. Shōzuka Baba. Wood. Signed: Soshin tō. Illustrated in *The Collectors' Encyclopedia of Antiques* (London, 1973). Shōzuka Baba, the only female official of the Buddhist hell, is recognized by her immense height and her pendulous breasts and belly. She steals the clothes of the wicked dead and hangs them on the limbs of dead trees. She puts dead children to the endless task of building rock piles that she knocks down every night. She is not very couth.

750. Fūjin, god of wind. Wood. Signed: Heigan. Fūjin rests on his great bag of winds. See also Fig. 106.

751. Tree ghost. Wood, with stag-antler face. Unsigned.

752. Assistant to Ryūjin, ruler of the tides. Ivory. Signed: Yoshinaga (NH 1303). The assistant wears his characteristic octopus headdress. See also Figs. 431 and 762.

753. Dragon on bell. Wood. Unsigned. The subject is probably an allusion to the tragedy of Anchin and Kiyohime. For the story, see caption for Fig. 258. The style and especially the square-shaped cord hole make a strong case for an attribution to Tametaka, who occasionally carved square cord holes.

754. Pomegranates in a bowl. Ivory. Signed: Masatsugu (NH 633). The fruit and the bowl are carved of separate pieces. The pomegranate symbolizes a numerous progeny.

755. Temple servant carrying bell. Wood. Signed: Gyokusō (NH 160). Collection of Adolph Krock.

756. *Karako* riding duck. Ivory. Signed: Gyokkōsai (NH 136).

757. Daruma in lotus-leaf boat. Wood. Signed: Masayuki, with *kakihan* (NH 644). An allusion to Daruma's voyage from China to Japan to introduce the Zen form of Buddhism.

758. Servant beautifying herself. Wood. Signed: Sōko tō (NH 1101). Ex Julius Katchen Collection. In order to beautify herself, a low-class servant (*gejo*) props a mirror on a clay stove (*kamado*) on which she

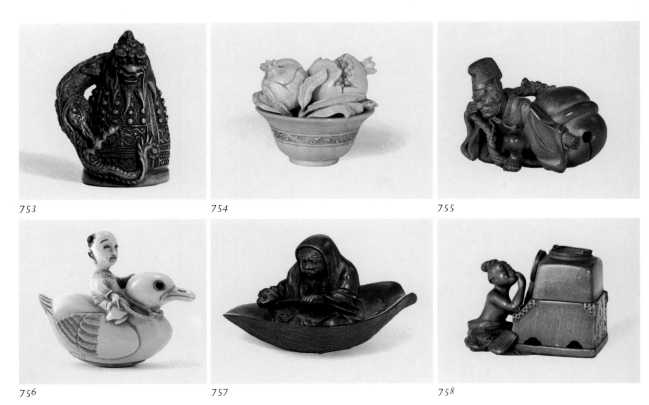

753 754 755

756 757 758

is cooking. The inscription is a sarcastic verse alluding to the contrast between an ugly woman and the pure white peony, which she vainly hopes to resemble by powdering herself.

759. Fox wife. Ivory. Unsigned. Collection of Frances Numano.

760. Boy wearing apron. Ivory. Signed: Masanao (NH 609).

761. *Sennin* with gourd. Wood. Signed: Sekkō (Yukimitsu). Collection of Ruth Schneidman.

762. Ryūjin, ruler of the tides. Wood. Unsigned. Ryūjin is the Japanese Neptune. He is usually portrayed in company with his monstrous assistant, who wears a dragon headdress. Here the two are combined in a single figure with demon claws and a dragon tail. See also Figs. 431 and 752.

763. Boy and grandmother. Wood. Signed: Hōjitsu (NH 243). The Orientals note the harmonious relationship of grandparent and grandchild, which seems to skip the strains of the generation gap.

764. Tenjiku Tokubei (two views). Ivory. Unsigned. Ex Mark Hindson Collection, No. 1059. Described in Neil Davey's *Netsuke,* No. 1062. Illustrated in *The Collectors' Encyclopedia of Antiques* (London, 1973). The legendary robber Tokubei often escaped by magically changing himself into a frog. He is commonly represented by a man in some relationship with a frog. Here the carver attempted the more difficult feat of portraying him as half man, half frog.

765. *Rakan.* Wood. Unsigned.

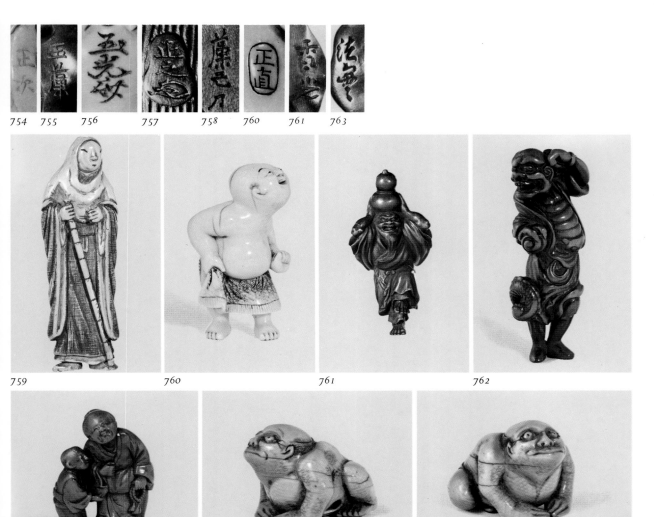

754 755 756 757 758 760 761 763

759 760 761 762

763 764a 764b

766. Jurōjin turtle (two views). Ivory. Unsigned. Ex Kenzo Imai Collection. The turtle, a symbol of longevity, is an attribute of Jurōjin. The carver cleverly combined the god and the reptile in a single body.
767. Bukkan Zenshi. Wood. Unsigned. Illustrated in *The Collectors' Encyclopedia of Antiques* (London, 1973). The security, confidence, and rapport between priest and beast is emphasized by the quiet siesta.
768. Sage and *kirin*. Ivory. Unsigned. The sage makes an offering to honor the rare appearance of the auspicious *kirin*.
769. Pilgrim. Ivory. Unsigned. The pilgrim carries a *mokugyo* hung from his neck. See introduction to Category 7 for remarks about pilgrimages.

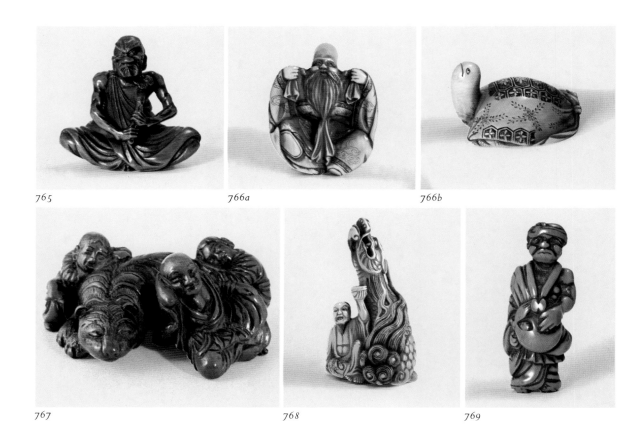

765 766a 766b

767 768 769

44 UNUSUAL SHAPES

Regardless of how interesting or attractive a netsuke may be in respect of shape, the shape should not jeopardize suitability for use. Thus a netsuke may be flat, but it must not be so radically flat and thin that it becomes brittle, and it may be long and thin, but it must not sacrifice toughness. A few collectors are especially attracted to flat, thin, or odd-shaped pieces and have collections of them. The flat ones illustrated here are carved as fully as figures in the round and are complete with *himotōshi*. Despite their extreme length and thinness, the netsuke in Figs. 774 and 775 are made of hard, tough wood. They have apparently survived through many decades.

770. Dragon. Ivory. Unsigned. Ex W. W. Winkworth Collection. The greatest thickness is 1.2 centimeters.

771. Crane. Ivory. Unsigned. Collection of Frances Numano. The bird is fully carved on both sides. The greatest thickness is 1.0 centimeter.

772. Parrot. Stag antler. Unsigned. The thickness is 0.5 centimeter.

773. Fox priest. Ivory. Unsigned. The thickness is 1.2 centimeters.

774. Ashinaga. Wood. *Sashi* type. Signed: Shōkō.

775. Ashinaga. Wood. *Sashi* type. Unsigned. Collection of Tamotsu Kuroda.

776. Rabbit. Ivory. Unsigned. Collection of Frances Numano. The rabbit is flat in shape and is carved identically on both sides. The thickness is 1.4 centimeters.

777. Belt buckle. Wood. Unsigned. The netsuke is shaped like a Chinese belt buckle. The design is the sacred mushroom.

778. Dragon in the sea. Unidentified bone. Unsigned. The shape is that of a square folded diagonally.

779. Grazing horse. Ivory. Unsigned. The horse balances well, yet its greatest thickness is only 1.0 centimeter.

774

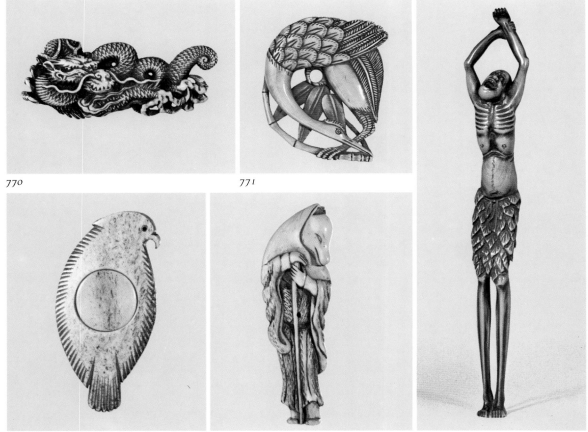

770

771

772

773

774

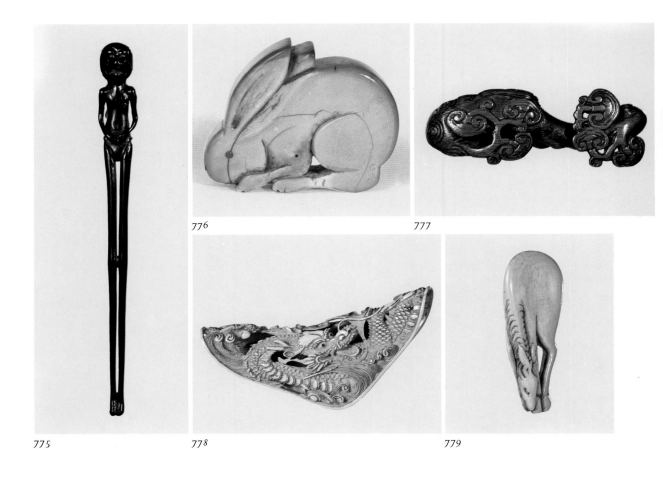

775

776

777

778

779

45 UNUSUAL TYPES

Types are like materials. There is no end to them. There is always a "new" one to add to the "complete" list. For example, there are many clasp and hook netsuke that operate on different principles from that of the *obihasami* type. Netsuke that perform additional or secondary functions, like candleholders, abacuses, spyglasses, compasses, and flint lighters, are endless in their variety.

Moreover, the subdivisions of major types may be carried to any length that suits the collector. For example, *kagamibuta* may be subdivided by shape, by material, and by technique. The *kagamibuta* may be represented by a single example for the collector who wishes to have one "for showing," but the specialist in types or in metalwork may collect literally hundreds, each differing from the others in some interesting aspect.

780. Hotei and rat. Pipe. Ivory. Unsigned. The netsuke draws well as a pipe, the channel running from a large opening under Hotei's head for burning the tobacco to a narrow opening at the soles of his shoes. The piece shows much use.
781. Rural scene. Oval box and cover for use as medicine container with an *inrō*. Ivory, various inlays, and lacquer. Unsigned. The boys appear to be fishing, one driving the fish toward the net held by the other.

782. Sakè cup (*sakazuki*). Bamboo. Signed: Gyokuzan saku (NH 166). The sakè cup is usually hardly more than a thimble. The lore and ritual of sakè drinking are comprehensively treated by U. A. Casal in *Transactions of the Asiatic Society of Japan,* December 1940.

783. Sakè cup. Lacquered to simulate boxwood and a mushroom handle. Signed: Ishio.

784. Monkey circle. Ivory. Ring type. Unsigned. The earliest representations of netsuke in paintings usually show a ring type similar in shape to the one seen here. The obi is drawn through the ring, to which a gourd and other *sagemono* are attached. Ring netsuke appear to be undecorated. If one judges solely by the age of its progenitor, the carved ring netsuke may be argued to be one of the oldest.

785. Imitation watch. *Shibuichi*. Signed: Shūraku, with *kakihan* (NH 1075). There is some evidence that such metal watch shapes with a winding stem at the top were inspired by the mysterious timekeeping instrument introduced by the Dutch. Gyokuzan is alleged to have carved a precise replica of a watch in ivory. The imitation watch served for carrying medicine.

786. Pipe case (*kiseruzutsu*). Octopus. Wood. Unsigned. The *kiseruzutsu* may be used for carrying a pipe or for resting the pipe while it cools. It functions as a *sashi* netsuke and suspends the accompanying tobacco pouch. Pipe cases and pipe rests are carved in various styles. The carving was often done by the same craftsmen who carved netsuke. Despite their fine quality, pipe cases tend to be overlooked both as a type of netsuke and as an article well worth collecting for itself alone.

787. Pipe case (*kiseruzutsu*). Cicada. Black persimmon wood, carved grain. Signed: Sen Fumei (Tomiaki)

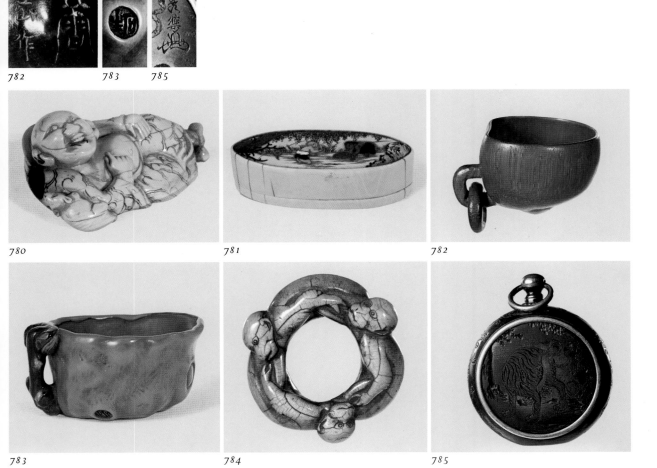

782 783 785

780 781 782

783 784 785

chōkoku (carved). Inscription: "Sen Fumei [gō of Tomiaki], follower of Seiyōdō Sei Fushun [Tomiharu], at the Ishikawa [old name of Go River], carved." Tomiaki began using his gō of Sen Fumei about 1816.

788. Writing set (yatate). Monkey. Shibuichi and gilding. Signed: Shinsai saku. Shinsai's true name was Takahashi Iwajirō. He lived in Tokyo during late Edo and early Meiji times and was an expert on construction for the shogunate.

789. Writing set (yatate). Chrysanthemum design. Shibuichi. Signed: Chōzaburō saku. Inscription: "Made by Chōzaburō, a man who lives in the white-chrysanthemum province of Izumo [in Shimane Prefecture]."

Chōzaburō, whose family name was Uga, worked during Tempo times (1830–44). He was a shirogane-shi (silversmith) as opposed to a kinkō (swordsmith). The yatate consists of a tiny writing brush concealed in the handle and an ink (sumi) container under the floral lid.

790. Belt hook. Dragon. Boxwood. Signed: Shinkoku. This type of netsuke was hooked over the upper edge of the obi in the space between the dragon's head and body. The suspension cords would run through the openings under the dragon's forelegs.

787 788 789 790

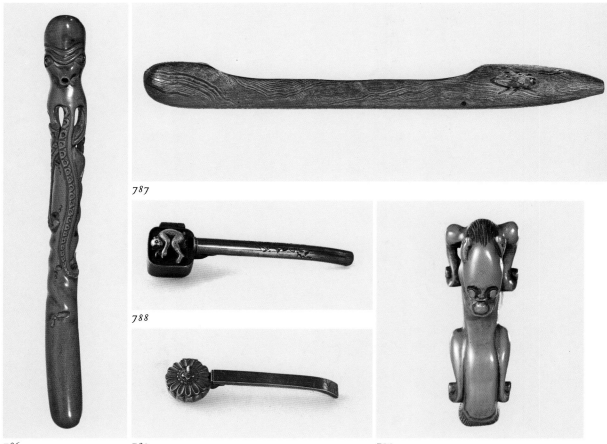

787

788

786

789

790

APPENDICES

I. CARVERS REPRESENTED

NOTE: The parenthetical notation NH together with a number refers to the index of carvers in *The Netsuke Handbook of Ueda Reikichi*. The absence of such a reference indicates that the carver is not listed in that index. The other numbers are those of the illustrations in the present book. Attributions are parenthetically indicated. Kiln marks, or brands (*yaki-in*), are not included here.

Anraku (NH 2): 530
Awataguchi: 509
Baihōsai, *see* Naomitsu
Bairyū, *see* Tōkoku
Bungyo (NH 25): 83
Bunsai (NH 27): 256
Chikumin, *see* Sen'yū
Chikurin, *see* Gyokkin
Chokusai (NH 55): 541, 660, 744
Chokusen: 658
Chōzaburō: 789
Chōzan: 50
Dōkei: 81, 505
Dōraku (NH 85): 490
Dōshōsai (NH 90): 282
Eiraku (NH 98): 463, 465
F. M., *see* Hagen
Fuji, *see* Masanobu
Fusae, *see* Senshū
Garaku: 522
Gechū (NH 113): 504, 508, 609 (attributed)
Gyokkin (NH 133): 573, 580
Gyokkō (NH 134): 308, 702
Gyokkōsai (NH 136): 756
Gyokumin (NH 148): 389, 493
Gyokusen (NH 156): 410
Gyokusensai (NH 157): 202
Gyokusō (NH 160): 233, 755
Gyokutei (NH 161): 585
Gyokuyōsai (NH 163): 290
Gyokuzan (NH 164): 120, 409, 478
Gyokuzan (NH 165): 129
Gyokuzan (NH 166): 782

Hachigyoku (NH 170): 91
Hagen: 506, 510, 515
Hakuō (NH 179): 526
Hakusai (NH 183): 680
Haku-un, *see* Haku-unsai
Haku-unsai (NH 187): 278, 570
Harusada: 719
Heigan: 750
Hide (NH 204): 745
Hidemasa (NH 212): 139
Hidemitsu (NH 215): 181
Hōgyokusai (NH 239): 288
Hōhoku: 253
Hōjitsu: 386, 763
Hokutei (NH 253): 663
Hōran: 258
Ichiō: 476
Ichiriki (NH 312): 514
Ikkōsai (NH 336): 499
Ikkōsai (NH 337): 737
Inaba: 163
Ishikawa Kōmei (NH 350): 698, 728
Ishio: 783
Issai (NH 353): 638
Ittensai, *see* Kūya
Iwami school: 338 (attributed)
Jakushi: 511
Joshū: 518
Jugetsu: 179
Jugyoku (NH 408): 100, 197
Jugyokusai Kazuyoshi: 237
Juntoku, *see* Minkō
Kagetoshi (NH 421): 536

Kaigyoku: 184
Kaigyokusai Masatsugu (NH 430): 187
Kaitō (NH 431): 273
Kamman (NH 440): 424
Kansai (NH 449): 263
Katsuhiro: 238
Kazuyoshi, *see* Jugyokusai Kazuyoshi
Keisai (NH 474): 48
Keisuke: 106 (attributed), 415
Ken'ya (NH 479): 461, 661
Kikukawa: 240 (Probably a school name rather
 than an individual name.)
Kishōsai (NH 492): 285
Kōgetsu (NH 507): 681
Kōgyoku (NH 512): 437
Kōgyokusai (NH 515): 294
Koku, *see* Kokusai
Kokusai (NH 527): 309, 385, 436, 571, 602,
 612, 691 (attributed), 692 (attributed)
Koma, *see* Bunsai, Kansai
Kōmei, *see* Ishikawa Kōmei
Komin: 310
Korenaga: 204
Kōzan: 200
Kozan (NH 561): 569
Kunitaka: 519
Kūsai, *see* Kūya
Kūya: 193, 373
Kyōen: 79
Kyokusai (NH 565): 189, 199, 203
Kyūsai (NH 576): 101
Marushin, *see* Susumu
Masakazu (NH 595): 125
Masanao (NH 609): 123, 715, 760
Masanobu (NH 616): 188, 558, 561, 615
Masatoshi: 71, 376, 379, 382, 428
Masatoshi (NH 631): 481
Masatsugu (NH 633): 754; *see also* Kaigyoku-
 sai Masatsugu
Masayoshi (NH 638): 500
Masayuki: 361
Masayuki (NH 644): 177, 757
Matsuda, *see* Sukenaga
Minjō (NH 660): 230
Minkō (NH 661): 145, 712
Minkoku (NH 667): 640
Minryōsai: 303

Mitsuaki, *see* Ishikawa Kōmei
Mitsuhiro (NH 685): 164, 165, 647, 664
Mitsukiyo (NH 688): 356
Mitsunobu (NH 698): 548
Mitsuyoshi (NH 709): 575
Mitsuyuki: 307
Miwa (NH 710): 176, 557, 733 (attrib-
 uted), 747
Moritoshi (NH 721): 293
Motozane, *see* Taizan Motozane
Mune: 31 (A single-character signature may
 be an abbreviation.)
Musōan, *see* Kūya
Nagahiko: 635
Nan'yō: 72
Naohiro: 247
Naokazu (NH 745): 551
Naomitsu (NH 750): 295
Natsuo (NH 757): 234
Noriyuki: 364
Ōhara, *see* Mitsuhiro
Okamoto, *see* Garaku
Okatomo (NH 784): 479
Ono, *see* Ryōmin (NH 837)
Raikō: 299
Raku (NH 791): 462 (Raku is both a ceramist's
 name and a kiln brand.)
Rangyoku (NH 802): 643
Reishiō: 332
Ren, *see* Rensai
Rensai (NH 818): 679
Ryōmin: 566
Ryōmin (NH 837): 287, 414, 636
Ryōmin (NH 839): 574
Ryōsai (NH 840): 532
Ryōzō, *see* Yoshizō
Ryūgyoku (NH 846): 616
Ryūkō: 301
Ryūkō: 567
Ryūmin (NH 861): 219, 281
Ryūmin (NH 866): 248
Ryūminsai: 735
Ryūraku (NH 869): 289
Ryūya: 279
Sadayuki: 298
Sakon: 110
Sanshō (NH 903): 314, 315

Sasa Yoshihiko, *see* Yoshihiko
Sashirō: 119
Seijō: 236
Seikanshi: 272
Sekkō: 761
Sen Fumei: 787
Sensai: 697
Senshū: 44, 45
Sen'yū: 586
Shigemitsu (NH 969): 413
Shinkoku: 790
Shinsai: 788
Shōgen (NH 986): 89
Shōko (NH 1009): 550
Shōkō: 774
Shōmosai: 255
Shūgetsu (NH 1042): 562
Shūgyoku (NH 1047): 412
Shūmin (NH 1059): 648
Shunkōsai (NH 1068): 738
Shūraku (NH 1075): 229, 239, 241, 245, 246, 785
Shūzan (NH 1090): 743
Shūzan (NH 1094): 695
Sōhen: 380 (This is the name of a famous tea-ceremony family.)
Sōkō (NH 1100): 388
Sōko (NH 1101): 264, 384, 438, 439, 534, 546, 547, 555, 559, 582, 758
Sōmin (NH 1107): 659
Sōraku: 542
Sōsai: 375
Soshin: 749
Sōsui (NH 1111): 190, 374, 377, 543
Sukekazu: 205
Sukenaga (NH 1124): 208, 212, 422
Sukenao (NH 1125): 714
Sukenori: 206, 207
Sukesada (NH 1126): 211
Sumi Takasada, *see* Takasada
Susumu: 378
Tachikawa: 516
Taizan Motozane: 218
Takasada: 513

Takeshi: 418
Takufu, *see* Takutaku
Takutaku: 533
Tametaka (NH 1159): 736, 753 (attributed)
Tameyoshi: 430
Teikei, *see* Ryūminsai
Temmin (NH 1171): 235
Tenzan: 406
Toen (NH 1177): 209, 210
Tohō: 606
Tōkoku (NH 1184): 192, 284, 565
Tomiaki, *see* Sen Fumei
Tōmin (NH 1192): 491
Tomokazu (NH 1206): 704
Tomomasa (NH 1208): 423
Tomotada (NH 1216): 545
Toshiaki: 501
Toshishige: 271
Tōyō (NH 1252): 257
Toyomasa (NH 1254): 732
Toyotame: 265
Toyoyasu (NH 1255): 512
Tsunemasa (NH 1260): 684
Yasuaki: 427
Yorimitsu, *see* Raikō
Yoshihide (NH 1290): 94
Yoshihiko: 243, 357
Yoshikazu (NH 1293): 411
Yoshikiyo: 220
Yoshinaga: 517
Yoshinaga (NH 1303): 752
Yoshirō (NH 1308): 468
Yoshitomo (NH 1312): 49
Yoshiyuki (NH 1316): 267
Yoshizō: 507
Yukimitsu, *see* Sekkō
Yūkoku (NH 1325): 195
Yūkōsai: 185, 186
Yūsen (NH 1332): 194
Yūsō: 80, 613
Zemin (NH 1335): 286
Zeraku (NH 1336): 225
Zeshin (NH 1337): 252, **262**
Zōroku (NH 1339): 456

2. NETSUKE WITH INSCRIPTIONS

NOTE: For the purposes of this list, all words additional to the carver's name, the *kakihan,* and the words "carved" or "copied" are considered inscriptions. The numbers are those of the illustrations in this book. In the case of Figs. 44 and 45, the inscriptions are found on the *tomobako* (original boxes) and in this respect differ from the others listed here, which are all carved directly on the netsuke.

44.	Kannon	313.	Face
45.	Kannon	383.	Neighborhood guard
49.	Raconteur	415.	Jurōjin mounted
61.	Cash on a string	420.	Wild boar
67.	Bell	424.	Cloud dragon
69.	Signboard	468.	Otafuku mask
70.	*Kinuta* (wooden mallet)	485.	Lizard on chestnut
71.	Three animals	510.	Fukurokuju
72.	Strongbox	513.	Spider on boar tusk
79.	Niō	538.	Book in two volumes
110.	Daikoku	551.	Yuai
162.	Pear gourd	559.	*Ema* of fox
165.	Gourd	573.	*Shishi* on pedestal
167.	Sakè cup	580.	*Shishi* on pedestal
202.	Bird cage	586.	Sage in pine forest
216.	Rokō Sennin	636.	Crab
217.	Beautiful woman	656.	Priest Saigyō
235.	Flaming sphere	665.	Badger-shaped iron teakettle
240.	Filial devotion	719.	Fox and young
257.	Dragonfly	758.	Servant beautifying herself
273.	Bird	787.	Pipe case
296.	*Onigawara*	789.	Writing set

3. NETSUKE WITH KAKIHAN MINUS SIGNATURE

NOTE: The numbers are those of the illustrations in this book.

70. *Kinuta* (wooden mallet)
209. *Shishi.* The *kakihan* in this case is well known and is easily recognized as the identifying mark of Toen (see Fig. 210). Very few *kakihan* on netsuke can be positively identified.

Among the exceptions are those of Minkō, Mitsuhiro, Miwa, Moritoshi, and Toen.
435. *Oni*
600. *Shishi*

4. UNCOMMON MATERIALS ILLUSTRATED

NOTE: Ordinary materials such as boxwood, elephant ivory, and stag antler are not included here. The numbers are those of the illustrations in this book.

agate: 168
amber:
 clear, or honey, amber: 334, 599
 cloudy, or beeswax, amber: 155, 344
 insect amber: 347
bamboo:
 abnormal growths: 41, 48, 57, 58
 chikkon (vertical root): 43, 50
 Hotei-chiku (Hotei-belly bamboo; also
 called Buddha-belly bamboo): 46
 kikkōchiku (tortoise-shell bamboo): 49
 rhizome (horizontal root; also called *chik-
 kon*): 42, 52
 sasa: 26
 sesame-seed bamboo (*gomachiku*): 39
 solid culm: 51, 54, 55, 59
 toramonchiku (tiger-mark bamboo): 40
 whiskers roots (*higene*): 47
bone:
 crane bone: 353
 horse bone: 331
 unidentified bone (probably buffalo): 778
 whalebone: 341
cane:
 braided cane: 352
 woven cane: 346, 349
carnelian: 335
combined materials:
 amber and cloisonné: 347
 bamboo, *shibuichi,* and gold: 283
 coral and silver: 343
 gofun and cloth: 119
 iron and diamond: 356
 ivory and cloth: 122
 mother-of-pearl and silver: 340
 pottery and lacquer: 452
coral:
 red coral: 342, 345
 stone coral: 83
 white coral: 326
glass: 92, 323

gofun (pulverized oyster shell): 113, 119
gourd: 158–61, 162 (seed gourd), 163, 169
horn:
 buffalo horn: 65
 pulverized buffalo horn: 328
 rhinoceros horn: 329, 330, 674
hornbill: 350
ink block (solid *sumi*): 302
inlays:
 aogai (green shell): 190
 aotsuno (green horn): 190
 hizakura (scarlet cherry wood): 190
 kai (shell): 190
 pottery: 467
 yōkaku (goat horn): 190
 zōgehi (ivory bark): 190
lacquer:
 burnished lacquer: 82
 copper lacquer: 112
 guri lacquer: 264
 kanshitsu (dry lacquer): 109
 Somada lacquer: 270
 tsuishu lacquer: 254, 258, 269
leather: 336, 351 (gold leather)
malachite: 324
metal:
 cast bronze: 355
 pewter: 339
 shakudō: 358, 362, 364
 silver: 7, 360
 wrought iron: 327, 356, 359
mother-of-pearl: 322
mushroom:
 dried mushroom: 332
 monkey's-chair mushroom: 13
nut:
 corozo nut (vegetable ivory): 152, 274, 298
 walnut: 303, 319
porcelain:
 Asahi: 464
 Hirado: 442–44, 451, 458

Imari: 454, 457
Kiyomizu: 441
Kyoto *seiji:* 455
miscellaneous types: 447, 456 (signed Zō-
roku), 461 (signed Ken'ya), 463 (signed
Eiraku), 465 (signed Eiraku), 466, 468
Nabeshima *seiji:* 450
Seto: 445
pottery:
Banko: 460
Bizen: 448, 453
glazed pottery: 446
Hōzan: 459
painted pottery: 459, 661
Raku: 449, 462
rind of bitter orange: 16
root, *see under* bamboo, wood
stone:
gold sandstone: 337
miscellaneous types: 21, 325
t'ien huang: 333

tooth:
bear tooth: 71, 321
whale tooth: 116, 636, 642, 667
tortoise shell: 348
tusk:
boar tusk: 338, 424, 513
narwhal tusk: 100
walrus tusk: 423, 563, 571
umimatsu: 579, 712
umoregi: 482, 494
wood:
burl: 14, 15, 24, 696
byakudan (white sandalwood): 373, 505
ebony: 72, 377, 659, 664, 665, 722
kiri (paulownia): 306, 638, 654
pulverized wood: 67 (fragrant wood), 110
(*kiri*)
red sandalwood: 215, 627
root: 17, 20, 22, 25
tagayasan (Indonesian ironwood): 11, 217,
220

5. COLLECTIONS REPRESENTED

NOTE: The numbers are those of the illustrations in this book.

Abe, Dr. Mineji: 482, 736
Akai, Shiro: 355, 473, 585
Behrens, Walter: 84, 524, 533
Belanger, Walter: 368, 457, 688, 691
Braun, Michael: 165
Broadbent, Sam: 251
Cohen, George A.: 518
Cullison, Douglas: 549
Freiman, Dr. Ira: 275, 431
Fujie, Tomosaburo: 485
Fujii, Seishichi: 181
Gercik, Abram and Lou: 24
Globerman, Abraham: 737, 745
Gorham, Hazel: 3
Grauer, Melanie and Ben: 1
Hall, Viola: 478
Hazama, Shigeo: 103, 596
Hindson, Mark: 29, 84, 284, 286, 293, 383,

510, 517, 544, 558, 564, 588, 732, 742,
746, 764
Horie, Zenshiro: 127, 359, 553
Humphreys-Owen, Elizabeth: 540
Ikeda, Shun'ichiro: 452
Imai, Kenzo: 234, 326, 353, 603, 766
Johnston, Brigette Horstmann: 5
Jonas, F. M.: 450
Katchen, Julius: 125, 484, 758
Kiyomoto, H.: 468
Kotera, Kazuo: 669
Krock, Adolph: 755
Kuroda, Tamotsu: 354, 775
Lawrence, Sir Trevor: 187
Lee, "Sammy" Yukuan: 409
Levett, Eric R.: 521
Lorber, Marcel: 740
Marsh, Florence: 598

Matsubara, Eizaburo: 358, 578
Matsui, Yonekichi: 734
Meinertzhagen, Frederick: 187, 466, 495, 524
Meyer, Mrs. Oscar: 527
Mizutani, Yoshijiro: 709
Moy, Jeffrey: 145, 297, 309, 312, 600
Nakamura, Tokisada: 373
Numano, Frances: 274, 725, 727, 759, 771, 776
Otsuki, Yuzuru: 365, 441
Pincus, Harry: 363
Roosevelt, Cornelius: 135, 298
Schneidman, Ruth: 111, 761

Sharpe, Isobel: 29
Shay, Edward: 158, 617
Shima, Hachiro: 90, 92, 519
Souquet, M.: 299
Sprung, Murray: 110, 128, 264, 345, 530
Swedlow, Dave and Sandy: 195, 507, 704
Taniguchi, Hideo: 670
Thomas, Fred and Nina: 245, 330, 697
Tsuruki, Yoshimatsu: 324, 498
Tsuruoka, Tokutaro: 662
Tsuruta, Kikutaro: 263
Webb, F.: 75
Winkworth, W. W.: 402, 506, 515, 538, 770
Wunderlich, Anna L.: 364, 729

BIBLIOGRAPHY

(books and articles referred to in the text)

Ball, Katherine M. *Decorative Motives of Oriental Art*. London and New York, 1927

Bing, S. *Collection of S. Bing*. Paris, 1906

Brockhaus, Albert. *Netsuke*. Leipzig, 1909 (in German)

Bushell, Raymond. *Collectors' Netsuke*. New York and Tokyo, 1971

———. *An Introduction to Netsuke*. Rutland, Vermont and Tokyo, 1971

———. *The Wonderful World of Netsuke*. Rutland, Vermont and Tokyo, 1964

———, adaptor. *The Netsuke Handbook of Ueda Reikichi*. Rutland, Vermont and Tokyo, 1961

Cammann, Schuyler. *Substance and Symbol in Chinese Toggles*. Philadelphia, 1962

Casal, U. A. "Some Notes on the Sakazuki and on the Role of Sake Drinking in Japan." *Transactions of the Asiatic Society of Japan*, December 1940

Cholmondeley, L. B. "More Information About Japanese Netsuke." *Connoisseur*, 1923

Collectors' Encyclopedia of Antiques, The. London, 1973

Davey, Neil K. *Netsuke*. London, 1974

Gilbertson, Edward. "Japanese Netsukes." *Studio*, January 15, 1894

Gonse, Louis. *L'Art japonais*. Paris, 1883

Gunther, H. A. "Netsuke of Medical Interest." *Transactions and Proceedings of the Japan Society, London*, vol. 32, 1934–35

Hillier, Bevis. "Japan's Miniature Masterpieces." *Times Saturday Review*, September 4, 1971

Hindson, M. T. "Netsuké Artists." *Antique Collector*, March–April 1951

Hokusai (Katsushika Hokusai). *Hokusai Manga* (Caricatures by Hokusai), 15 vols. 1814–78

Horodisch, Abraham and Alice. "Netsuke Studies." In *The Fascinating World of the Japanese Artist*. The Hague, 1971

Huish, Marcus B. *Japan and Its Art*. London, 1889

Hull Grundy, Anne. "Botanical Netsuke." *Antique Collector*, April 1961

———. "Netsuke Carvers of the Iwami School." *Ars Orientalis*, vol. 4, 1961

———. "Netsuke by Nanka and Nanyō." *Oriental Art*, Autumn 1961

———. "Stagshorn and Other Quaint Netsuke." *Oriental Art*, Autumn 1960

Hurtig, Bernard. *Masterpieces of Netsuke Art*. New York and Tokyo, 1973

Ikebana International, Fall-Winter 1964

Inaba Tsūryū (Michitatsu). *Sōken Kishō* (Appreciation of Superior Sword Furnishings). Osaka, 1781

Joly, Henri L. *Legend in Japanese Art*. London, 1908 (reissued 1967)

———, editor. *Catalogue of the W. L. Behrens Collection of Chinese and Japanese Art*, 4 vols. London, 1913–14 (reissued 1966)

———, editor. *Catalogue of the H. Seymour Trower Collection of Japanese Art*. London, 1913

Jonas, F. M. *Netsuke*. Kobe, 1928 (reissued 1960)

Joya, Mock. *Things Japanese*. Tokyo, 1958

Meinertzhagen, Frederick. *The Art of the Netsuke Carver*. London, 1956

Migeon, Gaston. *Chefs-d'oeuvre d'art japonais*. Paris, 1905

Mitsuhiro. *Takarabukuro* (Bag of Treasures): a manuscript dated 1838

Monkey. See Wu, Ch'eng-en.

Netsuke: Study and Advice for Connoisseurs, Collectors, and Dealers (magazine edited by Franz Weber), May 1960 through April 1961

Orientations, October 1970, June 1971

Ouwehand, C. "Some Notes on Ichi-i Ittōbori." In *The Fascinating World of the Japanese Artist.* The Hague, 1971

Ressenden: a sourcebook of drawings of Chinese hermits

Rokkaku, Shisui. *Tōyō Shikkōshi* (History of Far Eastern Lacquer). Tokyo, 1932

Sankaikyō: a sourcebook of drawings of ghosts, goblins, and demons

Severin, Mark F. "Netzuki" (Netsuke). *Handenarbeid,* March–April 1971

Shichida, Makoto. *Shimizu Iwao to Sono Ichimon* (Shimizu Iwao and His School). Shimane Prefecture, Japan, 1970

Sladen, Douglas. *Queer Things About Japan.* London, 1904

Smith, Bradley. *Erotic Art of the Masters.* Secaucus, New Jersey, 1974

Suikoden: a sourcebook of pictures of Chinese hero bandits

Trower, Seymour. "Netsukés and Okimonos." *Artistic Japan,* 1888–91

Uyeno, Naoteru, editor. *Japanese Arts and Crafts in the Meiji Era* (English adaptation by Richard Lane). Tokyo, 1958

Weber, V. F. *Koji Hoten.* Paris, 1923

Winkworth, W. W. "Netsuke." *Antiques International,* 1966

———. "The T. S. Davy Collection of Netsuké." *Antique Collector,* July–August 1949

Wu, Ch'eng-en. *Monkey* (translated by Arthur Waley). New York, 1943

Yanagi, Sōetsu. *The Unknown Craftsman* (translated and adapted by Bernard Leach). Tokyo, 1972

GLOSSARY-INDEX

NOTE: Numbers in italics are those of illustrations and/or their captions; page references are in roman type. As a rule, names of carvers, uncommon materials (except their Japanese names), and collectors mentioned only in the captions are omitted here, since they are indexed in Appendices 1, 4, and 5, respectively. When such names appear in the text proper, they are indexed here.

abstract netsuke, 205–10

acrobat, 141

Adachigahara, demon of: a cannibalistic hag who fed on the flesh and blood of children and maidens

Adam, P., sale, 34

adopted and adapted netsuke, 89–91

Ainu: an aboriginal race of Caucasians whose dwindling population is centered around Shiraoi in Hokkaido, 34, 35; Ainu carving, 32, 114

ama: woman diver, 128, 413, 737

amagatsu: good-luck doll, 123

amaryū: rain dragon, thought to be responsible for storms, 312

amateur carvers, 92–93

amembo: water bug, pond skater, 243

anabori: cavern carving, deeply recessed carving, 188

Anchin, see Dōjō-ji

angel, see tennin

Animal Collection, 73–74

animals, see under specific names; see also animals of the zodiac, birds, combined animals, fish, legendary animals, unspecified animals

animals of the zodiac, 32, 80–81, 411

Anraku, 46; see also Appendix 1

aogai: green shell, inlay of iridescent shell in lacquer in Somada technique, 136, 190, 270

aotsuno: green horn, 190

apsara: Indian word for Buddhist angel; see tennin

aragoto: bombastic and exaggerated style of Kabuki acting, 549

archer, see Mongolian archer

Arita: a type of porcelain produced at a group of kilns located around Arita as a center in Saga Prefecture, Kyushu, and including Imari, Kaiemon, and Nabeshima, 450

Arita seiji, see Nabeshima seiji

Asahina Saburō: the Japanese Hercules. His feats of strength are legendary. He tugged so hard at the armor worn by Soga no Gorō that he tore it apart.

Asahi-yaki: tea-ceremony ware produced in the Kyoto area, 464

Ashinaga and Tenaga (Longlegs and Long-arms): two legendary neighboring races, the one consisting of absurdly long-legged people with very short arms and the other of absurdly long-armed people with very short legs. They cooperated in catching fish. 39, 45, 148, 416, 417, 774, 775

Asiatic and Oceanic subjects, 65, 94–95

Atchley, Virginia, 75

auction sales: in Japan, 45; in London, 29; see also sales

aun: sacred word uttered by the two Niō standing guard at gates of Buddhist temples. One inhales and says "a" with open mouth; the other exhales and says "un" with closed mouth. 85

badger, 52, 58, 158, 224, 668, 720

badger teakettle: emblem of a popular folk tale about a badger who disguised himself as a teakettle. When the priest put the kettle on to boil, the badger could not stand the heat and reverted to his true form, the kettle's legs turning into paws and the spout into his head. 665

bakemono: goblin or monster in humanoid form seen in umbrellas, lanterns, and

pumpkins. *Bakemono* have legs and are thus distinguished from ghosts, which have none. *166, 194, 263, 446, 542, 550*

baku: mythical beast endowed with an elephant's trunk. He is a benefactor of manking, since he devours bad dreams and nightmares. *84, 174, 486, 489, 493, 504, 670*

Ball, Katherine M., *91, 478, 503*

ball, twisted, *26*

bamboo, *96*

bamboo netsuke, *96–98*

bamboo seals, *98–100*

bamboo sheath, *663*

Banko: a type of pottery, *460*

Banzuiin Chōbei: erstwhile samurai who became a *yakuza* (gangster) and *machi-yakko* leader in Edo, *549*

Bashō: the most eminent of the *haiku* poets, a group credited with exerting great influence on the subject matter and treatment of netsuke, *165*

baskets, *see* containers

Basūsen: one of the Twenty-eight Blessed Ones of the Myoho-in, *77*

bat, *208, 475, 568, 681, 711*

bathing al fresco, *133, 183*

bear, *627*

beautiful woman, see *bijin*

Behrens, W. L., *37, 38–39, 67*; catalogues, *28, 30–31, 38, 49*; collection, *30–31, 41*; notebooks, *38*; sale, *30–32*

bekkō: tortoise shell, *190, 348*

bell, *67, 753*

belt buckle, *777*

belt hook, *790*

benefit of study, *82–85*

Benkei: a large and powerful mountain priest who became the faithful retainer of the medieval hero Yoshitsune, *215*

Benten: goddess of music, the only woman among the Seven Happy Gods, *34*

Best Collection, *74–75*

betel nut, *148*

bijin: beautiful woman. Utamaro was famous for his *bijin* prints. *190, 195, 217, 231, 432, 554*

Bing, S., *39*; sale, *31, 37*

Birch, Michael, *75*

bird cage, *123, 202*

bird helmet (*torikabuto*), *531*

birds: chicken, *358*; cormorant, *470*; crane, *205, 434, 535, 771*; duck, *124, 188, 408, 632, 637, 642, 647, 649, 652*; goose, *626, 640, 648*; gull, *463, 465, 639*; hawk, *643, 653*; heron, *379*; owl, *355, 474*; parrot, *484, 772*; pelican, *492*; phoenix (*hō-ō*), *225, 708*; pigeon, *204, 211, 213, 403, 464, 566, 628, 629, 631, 644, 650*; plover, *223*; quail, *645*; sparrow, *50, 119, 228, 261, 404, 633, 654, 685, 706*: swan, *399, 630, 641, 651*; unspecified birds, *17, 43, 53, 202, 273, 322, 407, 563, 634, 646, 657*; woodpecker, *496, 679*

bits and pieces, *100–102*

biwa: Japanese lute, *526*

Bizen: a type of pottery, *170, 448, 453, 508*

blind men, *286, 397*

boar (*inoshishi*), *420, 449, 460, 516, 536*

Bon Festival: Feast of Lanterns, when spirits of the dead return to visit the living, *51, 526, 747*

Bon *odori*: Bon Festival dance, *51*

book, *538*

box, *see* containers

boxwood (*tsuge*), *128, 190*

Boys' Festival (Tango no Sekku): a festival celebrated on the fifth day of the fifth month and now known as Children's Day. Large, colorful cloth carps are flown from poles as symbols of courage. *546*

Brancusi, Constantin, *44*

bridge post, *64, 65*

British Museum, *26*

Brockhaus, Albert, *37, 39, 41*

Brundage, Avery, *41*

Buddhist articles: eyes, *92*; kongō, *82*; magatama, *284*; nyoi, *80*; shakujō, *88, 193*; sumi, *284*, tama (or *hōju no tama*), *89, 235, 246, 567, 619*; teppatsu, *284*; waniguchi, *284*

Buddhist netsuke, *103–6*

buffalo, *221, 244*

Bukkan Zenshi: ancient Chinese priest often portrayed in fraternal association with a tiger, *767*

bull, *see* cow

Bunshōjo, 39

Bunshōsei: Taoist god of literature, 533

Butei: famous Chinese statesman of the Han period, 523

byakudan: white sandalwood, *190, 373, 505*

byōbu: folding screen, often of six panels, used as a movable partition and covered with silver or gold leaf if not painted or otherwise decorated, 47

camel, *59, 472, 488, 495, 594*

Cammann, Schuyler, *3*

Carré, Jacques, *75*

Casal, U. A., *45, 81, 782*

cash on string, *61*

cat, *274, 365, 441, 697, 707*

catalogues: Adam, 34; Behrens, 28, 30–31, 38, 49; Bing, 39; Reiss, 33; Trower, 30

chabin-shiki: teapot mat, *290*

cha-no-yu: tea ceremony, *170*

chashitsu: tearoom, *170*

chessman, *1*

chidori: plover, *223*

chikkon: vertical root of bamboo, *43, 50, 96*

children, *74, 201, 433, 437, 444, 760, 763*

chimaki dango: rice dumplings wrapped in bamboo leaves, *546*

Chinese, *27, 28, 281; see also* Chinese Gama Sennin, *karako,* Liu Hai

Chinese character and style of early unsigned netsuke, *65*

Chinese Gama Sennin, *10*

Chinese shoes, *3*

Chinese toggles, *5, 8, 10, 64, 89*

Ch'ing: a Chinese dynasty (1644–1912)

Chōkarō: a *sennin* usually represented with a gourd from which emerges a magic horse, *32*

chōkoku: carved, sculptured

Chokunyū: painter (1814–1907), *415*

Cholmondeley, L. B., *27*

chōnin: townsman, tradesman, *743*

Chōryō and Kōsekikō: Chōryō retrieved a slipper that had fallen from the foot of Kōsekikō into a dangerous river. Kōsekikō rewarded him with a scroll on military strategy—a work that he studied and applied to win great victories and fame. *414*

Christian netsuke, 106–7

Christie's: one of the great London auction galleries, 26, 29

chūya (literally, "day and night"): facing plates of iron and silver, *241*

clam, *200, 340, 346*

Clandestine Christians, 106

Clifford, Henry, 36

coffin (*kan'oke*), *558*

coin-headed dancer, *35*

collecting: activities related to, 51; benefit of study for, 82–85; preparation for, 82–84; by subterfuge, 48–51; three levels of collectorship, 84–85; wasteful, 51, 52

collections, types of: animal, 73–74; best, 74–75, comprehensive (horizontal, study and teaching), 51–53; damaged, 56; perfect, 56, 61; quintessential, 76–78; signed, 61; specialized (in-depth, vertical), 52, 78–82; unsigned, 61, 62, 63–64; *for specific collections, see by name; see also* sales

collectors: as dealers, 23–24; compared with dealers and investors, 18, 20, 22–24; complaints of, 17; knowledgeable, strategy of, 70–71; pioneer, observations of, 25–28; rich, 24–25; by subterfuge, 48–51; three levels of collectorship, 84–85; *see also specific collectors by name*

colored netsuke, 107–8

combined animals, *71, 411, 694–97*

commercialism among carvers, 185

Comprehensive Collection, 51–53

condition as determinant of value, 54–55

Conried, Hans, 50

containers: bamboo sheath, *663;* basket, *66, 199, 203;* box, *72, 124, 252, 263, 461;* jar, *109, 270;* sack, *200;* sakè cup, *167, 197, 341, 782, 783;* tea caddy, *62*

cow, *71, 348, 689, 712, 722*

cow-horse, *479*

crab, *8, 636*

cross, *95*

cypress, see *hinoki*

daidai: bitter orange, *16*

Daikoku: one of the Seven Happy Gods, representing the wealth of the land. He is usually portrayed with rice bales. *110, 369*

Daimonjiya: eighteenth-century Kyoto merchant, *173*

dairibina: sitting dolls representing courtiers, *115, 116*

Daitoku-ji: large and famous temple complex in Kyoto, *665*

damage, *53–60*; examples of, *57–58*; as related to age, *55*; as related to price, *55, 58*; as related to quality, *59*; repairs and restorations distinguished, *53*

Damaged Collection, *56*

damage spotter, *59–60*

dances and dancers, *51, 57, 136, 181, 250, 267, 272, 429*

Dannoura: site of crucial battle (*1185*) between Heike and Genji clans, *636*

Daruma (Bodhidharma): Indian Buddhist missionary credited with introducing Zen practices to Japan. He is ridiculed in netsuke for his interminable meditations. *25, 103, 120, 172, 226, 241, 343, 345, 401, 445, 757*

Davy Collection, *27*

Day of the Dog, *126*

dealers, *19, 20, 22–23*; as collectors, *22–23*

dealers' sales, *69*

deer, *376, 415, 595, 703*

demon, *314, 316, 670, 747, 749*; see also *oni*

d'Ennery Collection, *41*

diving girl, see *ama*

dōbutsu: real animals, *491*

dog, *174–75, 357, 402, 422, 433, 443, 447, 461, 635, 698, 715, 723, 728*

Dōhachi: ceramist, *170*

dojin: aborigine, native, *31*

Dōjō-ji: title of a Noh play based on the anger of Kiyohime when she was spurned by the priest Anchin. Her fury turned her into a serpent, whereupon she coiled herself around the bronze temple bell under which Anchin had taken refuge and, through the force of her wrath, burned him to death. A bronze bell with a serpent or a figure wearing the *hannya* mask symbolizes the tragedy. *258, 753*

doll and toy netsuke, *109–11*

Doll Festival, *see* Hina Matsuri

dolphin, see *shachihoko*

donguri: inedible nut resembling an acorn, *547*

dragon, *312, 356, 390, 392, 424, 567, 572, 585, 588, 592, 598, 673, 675, 688, 743, 753, 770, 778, 790*

dragon-fish, see *shachihoko*

dried bonito, see *katsuobushi*

drum, *23, 571*

drunkard, *176, 410*; see also *shōjō*

Dutchman, *65, 380*; *see also* European subjects

earthquake fish, see *namazu*

earthy netsuke, *111–14*

Ebisu: one of the Seven Happy Gods, representing the wealth of the seas. He is usually portrayed with a sea bream. *77*

Echigojishi: *shishimai* of Niigata Prefecture, *429*

edibles: fruits, *102, 103, 325, 334, 534, 561, 660, 754*; vegetables, *132, 198, 288, 326, 327, 349, 359, 439, 451, 514, 555*; others, *200, 340, 346, 528, 546*

Edo (Tokugawa) period: *1603–1868*

Egyptian deity, *6*

Eiraku: ceramist, *170*; *see also* Appendix 1

elephant, *666, 692*

ema: votive tablet offered to a temple or a shrine in piety or supplication. The *ema* was formerly a five-sided panel with a painting of a horse as a substitute for the animal itself. In more recent times almost any subject is considered suitable for an *ema*. *50, 559*

Emma-ō: king of the Buddhist hell and judge of the dead, *81, 526*

Engaku-ji: temple in Kamakura, *91*

entertainers and performers, *49, 178, 179, 396, 522, 526*

European subjects, *65, 115–17*

extrinsic qualities of netsuke, *see* quality

face protector (*mempō*), *440, 537*

fads, trends, and vogues in netsuke, *73*

family crest (*mon*), *280*

farmer, *285*

filial devotion, *240, 509, 517, 545, 551*

fish, *20, 42, 370, 394, 514, 515, 587, 638, 726, 744*; see also *shachihoko*

fisherman, *31, 740*

five fortunes, *415*

Fletcher, Mark, 36, 41, 67; sale, 35–36

flowers: chrysanthemum, *227, 277, 291, 292, 336;* lotus, *8, 90, 323, 434;* peony, *233, 237, 335;* others, *283, 289, 340, 384, 438, 565*

foreigner, *65, 667, 682, 742; see also* European subjects

Forty-seven Rōnin, *31*

Four Gentlemanly Plants, see *shikunshi*

fox, *41, 255, 278, 295, 559, 709, 716, 719, 724*

fox priest, *459, 773*

fox wife, *739, 759; see also* Tamamo no Mae

frog, *8, 13, 47, 100, 207, 212, 259, 359, 382, 507, 713, 748*

fruits, *see* edibles

fuchigashira: collar (*fuchi*) and cap (*kashira*) of sword grip, made in pairs in harmonizing or complementary designs and materials, *265, 659*

fugu: globefish, blowfish. It is a delicacy that must be prepared with extreme care, since the liver and ovaries are lethally poisonous. Deaths from *fugu* poisoning are often reported in the news. *514, 638*

Fūjin (Fūten): god of wind. He is always represented as a humanoid demon with horns and claws, usually holding a bag from which he releases the winds. *106, 750*

Fukurokuju: one of the Seven Happy Gods. As the god of wisdom, he is portrayed with an elongated head to hold his enormous intellect. His attribute is the scroll of wisdom. *236, 344, 364, 456, 510*

Fukusuke: a macrocephalic dwarf who attained great fame in the Meiji era as a comic raconteur and entertainer, *541*

fundame: in lacquer, a flat gold or silver ground in a dull finish, *136*

fundoshi: loin cloth or breech clout, sometimes the sole garment worn by male laborers in hot weather, *175, 196, 288*

fusuma: sliding door or partition of paper over a wooden frame, often decorated, *47*

Fūten, *see* Fūjin

gaijin, gaikokujin: foreigner, Caucasian, *115*

Gama Sennin: the *sennin* whose attribute is the toad—often a toad of the Chinese three-legged variety, *10, 37, 46, 366, 458*

games, *107, 171, 177, 253*

Ganesha: elephant-headed Indian god of wealth and worldly wisdom, *33*

Garaku, *212*

Gaskell, J. Bellhouse, sale, *34*

Gechū, *212; see also* Appendix 1

gejo: low-class female servant, *758*

Gentoku: Chinese emperor-hero who escaped from a besieged castle by leaping on horseback over a deep ravine, *197, 293*

Gercik, Abram, *75*

geta: wooden clogs, *48*

getemonoya: secondhand or junk shop, *89*

ghost, *307, 418, 505, 751*

Gigaku: dance-drama of ancient origin in which the principals wore masks. It is now extinct, having been supplanted by Bugaku (court dance). *144, 301*

Gilbertson, Edward, 26, 41; sale, 32–33

Gillot sale, *31*

Glendining: principal London auction gallery for Japanese art until about 1964, 29, 36

globefish, see *fugu*

go: board game with checkerlike stones, similar to chess but more complicated

gō: art name. An artist may use and discard several *gō* during his career. It is a matter of whim. Carvers are invariably known by their *gō*. *373*

goat, *500, 552, 714, 721, 729*

goatherd, *552*

gofun: pulverized oyster shell, *110, 113, 119*

Gojo Bridge: bridge in Kyoto where Benkei challenged passersby and deprived them of their swords

gomachiku: sesame-seed bamboo, *39*

Goncourt Collection, *41*

Gonse, Louis, *39, 41, 67*

gosho ningyō: dolls that usually represent nude boys less than six years old. The heads are inordinately large, and the bodies are covered with *gofun* or chalk. *111*

Gotō: famous family of sword and metal artists extending through many generations, *233*

gourd netsuke, *118–20*

Gozu: ox-headed demon of hell, *81*

Graham, June, 81

Greenfield, Charles A., 41, 75

grotesqueries, *81, 91, 521, 526, 527, 529, 532, 558, 662*

guard, *383*

Guest sale, 41

Gunther, H. A., 67, 81; sale, 34–35, 41

guri: technique in which alternating layers of lacquer of various colors are cut in deep scroll patterns or carved, *264*

Gyokkō, *58; see also* Appendix 1

gyoku: wooden fish-shaped gong, *160*

Gyokusai, 40

Gyokusensai, *123*

Gyokusō, *45; see also* Appendix 1

Gyokuzan (Asahi Gyokuzan), *30; see also* Appendix 1

Hachiman tumbler, *118*

haijin: haiku poet, *165*

haiku: seventeen-syllable poem. It is terse, subtle, seasonable, and swift in its imagery. *165*

hair style, *180*

hako: box (and cover), a type of netsuke, *124, 252, 263*

Hakusai, *214*

Handaka Sonja: the *rakan* whose companion and attribute is the dragon, *37, 339, 735*

haniwa: clay figures of persons, animals, and objects placed on tomb mounds in ancient times, *449, 627*

hara obi: stomach sash, *126*

harinezumi: porcupine, *497*

Hasegawa, Shuji, 96

Hattara Sonja: the *rakan* whose companion and attribute is the tiger, *88*

Hayashi Collection, 41

Heian: historical period (794–1185), *432*

Heike (Taira): one of the two great clans (the other was the Genji, or Minamoto) that fought for dominance in the twelfth century, *636*

Heike-gani: Heike crab, *636*

helmet (*kabuto*), *440, 531*

henro: Buddhist pilgrimage, *103*

Hidemasa, 31

Hideyoshi (Toyotomi Hideyoshi), *118, 271*

higene: whiskers roots (of bamboo), *47*

Hillier, Bevis, 44

himotōshi: apertures and channel carved in netsuke for attachment of cord, *38, 54, 62, 89, 164*

Hina Matsuri: Doll Festival, *115*

Hindson, Mark, 22, 28, 67; collection and sale, 39, 40, 41, 60, 61

hinoki: cypress, a wood that is velvety to the touch but too soft for a durable netsuke, *107, 190*

Hirado: a fine porcelain made by a number of kilns around Nagasaki, *170, 442–44, 451, 458*

hira-makie: gold lacquer decoration in low relief, *136*

hira-zōgan: a type of inlay in metal, *131, 217*

Hitomaro: one of the most celebrated Japanese poets and a member of the Waka Sanjin, or Three Gods of Poetry, *229*

hiyoko: newly hatched bird too young for field identification, *646*

hizakura: scarlet cherry wood, *190*

hōgachō: list of contributors of alms, *435*

hōju no tama (also *hōju, tama*): flaming sphere, the fiery jewel of Buddhism, *64, 65, 89, 235, 246, 567, 619*

hokkyō: an honorary title conferred on painters and sculptors, *202*

Hokusai, *156, 521*

hole-in-the-chest men (Senkyō), *532*

hōnō: votive offering, *559*

hō-ō bird: the phoenix, one of the Four Celestial Animals of China. The others are the dragon, the *kirin,* and the bushy-tailed tortoise. *225, 708*

Horodisch, Abraham and Alice, 81

horse, *71, 210, 329, 331, 427, 473, 479, 480, 503, 684, 686, 693, 710, 718, 727, 730, 779*

hossu: Buddhist priest's whisk, usually of long white hair, used to gently sweep aside insect life in order to avoid its destruction, *93*

Hotei: one of the Seven Happy Gods. He is the Japanese Santa Claus, loves children, and carries with him an inexhaustible bag of treasures. *324, 452, 658, 780*

Hotei-chiku: Hotei-belly bamboo, *46, 49*

hōtei: hornbill ivory, *190*

Hōzan: kiln in the Awata district of Kyoto, *459*

Huish, Marcus, 26

Hull Grundy, Anne, 73, 81

human-headed snake, *91*

humorous netsuke, *120–22*

hyōtan: double-bottle gourd with slender waist, 118, *158*

ichii: yew wood, 128, *204–8, 212–14*

Ichiyūsai, 30

ika: squid, *469*

Ikkaku Sennin: One-Horn Sennin, *304*

Ikkan, 62, 81

Ikkōsai, 34

Imai, Kenzo, 22, 46, *352*

Imari: type of porcelain made by kilns operating around Arita in Kyushu, *12, 170, 454, 457*

imitation watch, *785*

Inaba, Tsūryū (Michitatsu), 212

Inari: god of rice and harvests, fox deity, *559*

ingenious netsuke, *123–27*

I no Hayata, *see* Yorimasa

inoshishi: wild boar; *see* boar

inrō: sectional case or box worn suspended from the obi by a cord on which the netsuke serves as a toggle, 31, 89, 136, 165, 193

insects, *8, 46, 230, 243, 257, 262, 268, 347, 351, 476, 513, 581, 587*

intrinsic qualities of netsuke, *see* quality

inu hariko: papier-mâché box in form of simplified dog, *461*

investors, 18–19, 20; negligible effect of, 19; risk taken by, 18–19

iro-e: technique of making colored pictures by inlaying metals of various hues, 130

ishime: stone-grain surface produced by metal artists, 130

Issai, 212

itoin: seal, usually of copper, used for marking cloth, 204–5

Itsukushima Shrine (Miyajima), *187*

Itsumin, 32, 38, 40

ittōbori (literally, "single-knife carving"): a style of carving in which the model is shaped in angular planes, 128

ittōbori netsuke, 128–30

ivory as carving material, 214

Iwami carvers: carvers who inhabited the Iwami area, now part of Shimane Prefecture. They made frequent use of boar tusk for their netsuke. 38, 39, 81, 212

jade, 148–49

jakago: basket of stones. *Jakago* are used for shoring up river banks during floods. *203*

Japan Folkcrafts Museum (Nippon Mingei-kan), *154*

Jizō: guardian saint of children and travelers, *562*

Jofuku: one of several *sennin* whose attribute is the crane, *535*

Joly, Henri, 30–31, 38–39, 49, 67

Jonas, F. M., 120

Joya, Mock, *479*

Jugyoku, 107, 185; *see also* Appendix 1

Jurōjin: one of the Seven Happy Gods. He is the god of longevity and is often portrayed with a turtle or a crane. *4, 127, 246, 415, 535, 766*

Kabuki: stylized spectacle composed of drama, dance, music, and recitative, *144*

kabuto: helmet, *440, 531*

Kaempfer, Engelbert, 174

kagamibuta (literally, "mirror lid"): a special type of netsuke comprising a lid and a bowl, 72, 81, 97, 98, 130–35, 426

Kagesue: warrior who raced Takatsuna across the Uji River for the honor of being the first to face the enemy

Kagetoshi, 75; *see also* Appendix 1

kagura: sacred ceremonial dances, usually performed at Shinto shrines, 144, *531, 571*

kai: shell, *190*

kaiba: wild horse that runs on the sea, 174, *503*

kaibutsu: fantastic animal, *491*

Kaigyokusai, 21, 32, 40, 45, 46, 67, 71, 72–73, 74, 75; *see also* Appendix 1

kaimyō: Buddhist posthumous name, *373*

Kajikawa: renowned family of lacquer artists, 136

kakemono: hanging scroll with painting or calligraphy or both, 47, 48

Kakiemon: a type of porcelain, 65

kakihan: written or carved seal or monogram as distinguished from a stamped or impressed seal

Kakkyo: paragon of filial devotion whose sacrifice led to the discovery of a pot of gold

Kakure Kirishitan: Clandestine Christians, 106

kamado: clay stove, 758

kamban: signboard, 69

kami: gods, spirits of ancestors, 123

Kaminari: god of thunder and lightning, also known as Raiden and Raijin

Kamman, 81; *see also* Appendix 1

Kaneko Kugutsune: legendary powerful woman whose great feat was to stop a runaway horse by stepping on his halter, 197, 294

Kannon: Buddhist goddess of mercy, 44, 45, 83, 87, 103, 106

kan'oke: coffin, 558

Kansai: district surrounding and including Kyoto and Osaka, 173

kanshitsu: dry lacquer, 109

Kan'u: military strategist of Han China, 518, 683

kappa: legendary river denizen who drowns small boys when they swim in rivers against their parents' orders, 60, 182, 220, 306, 576, 732

karajishi: see *shishi*

karako: Chinese child, usually portrayed attending a divinity, 12, 46, 89, 181, 254, 756

karamono: Chinese article or Chinese-style article, also known as *tōbutsu*, 65, 89

karasu tengu: see *tengu*

karyōbinga: mythological creature of Indian origin, half woman and half bird, 174, 539

kashira: metal cap at top of sword hilt. It is paired with the *fuchi*, which is the collar of the handle, and together they are called the *fuchigashira*. 354, 357

katakiribori: metal engraving in the manner of brush strokes in painting, 131, 217, 234

katana: Japanese sword

katsuobushi: dried bonito, used for flavoring or as base for clear soup, 528

kebori: hairline engraving or carving, 131, 217, 221

kemono: hide- or fur-bearing animal, 71

Ken'ya: ceramist, 170; *see also* Appendix 1

Kenzan (Ogata Kenzan): famous ceramist, 66, 170, 461

ketō (literally, "hairy barbarian"): Caucasian, Westerner, white man, 115

Kidōmaru: bandit who tried to kill his brother Yasumasa but was charmed by Yasumasa's playing the flute, 218

kikkōchiku: tortoise-shell bamboo, 49

Kikujidō: the Chrysanthemum Boy, an exile who wrote magic messages and poems on chrysanthemum leaves, 157

kikyō: Chinese bellflower, 289

kimono airing (*mushiboshi*), 548

kinji: bright gold finish in lacquer, 136

kinkō: highest category of metal artists, producers of swords and sword furnishings, 231, 789

Kinkō Sennin: the *sennin* who rides a huge carp, 35, 232, 406

kinuta: wooden mallet for fulling cloth; also the title of a Noh play, 70

kiri: paulownia, paulownia wood, 110, 306, 638, 654

kirin: legendary animal with a horn (or horns), hooves, and a flaming hide, 35, 174, 481, 487, 499, 768

kiseruzutsu: pipe case, sometimes also used as a pipe rest, 786, 787

Kiyohime, see *Dōjō-ji*

Kiyomizu: a type of pottery made in Kyoto, 441

knot, 18

koban: the most common gold coin of the Edo period, 72, 536

Kōetsu (Hon'ami Kōetsu): famous lacquer artist, 66, 136

kogamo: teal, small wild duck, 647

Kōgyoku, 77, *see also* Appendix 1

Kokei, 66

Kokinshū: classic of ancient poetry, 538

Koku: single seal-type character used as abbreviation by Kokusai; *see* Kokusai

koku: carved

Kokusai, *35, 73, 81, 165, 195, 214, 215; see also* Appendix 1

Kokusempūriki: one of the 108 bandit heroes of old China, *28*

Koma: family of famous lacquer artists, *136*

Komachi (Ono no Komachi): the only woman among the Six Famous Poets (Rokkasen) of ninth-century Japan, known as a great beauty, *570*

komainu: Korean dog, *201*

kongō: Buddhist ritual implement accredited with great power, *79, 82, 241*

konoha tengu: see *tengu*

Kōrin (Ogata Kōrin): famous painter and lacquer artist, *66, 136*

Kōsekikō, *see* Chōryō and Kōsekikō

Kōshi: Japanese name for Confucius and for a wise and saintly man, *522*

kosodoro: sneak thief, filcher of farm produce, *288*

koto: stringed musical instrument resembling a zither, *586*

kris handle, *11, 89*

Kroch, Adolph, *81*

kudan: legendary animal with the body of a bull, a bearded human head, and supplementary eyes on each side of its body, *84, 174*

kumadori: exaggerated makeup used for *aragoto* roles in Kabuki, *144*

kumosuke: Tokaido porter, *556*

kurogaki: black persimmon wood, *475, 480*

Kutani: a type of porcelain, *65*

Kyōgen: comic interludes between Noh dramas, *144*

Kyōgen mask, *304, 319, 466*

Kyōmin, *31*

Kyorai: famous *haiku* poet and follower of Bashō, *165*

Kyoto *seiji*: Kyoto celadon, *455*

Kyō-yaki: Kyoto ceramics, *170*

laborers, *185, 375, 520, 525, 556*

lacquer netsuke, *136–39*

lantern, *131*

Leach, Bernard, *155*

legendary animals, *56, 174, 491, 590*; goat with carapace back, *500*; horse with cara-

pace back, *480*; karyōbinga, *539*; nue, *412*; suisai, *480*; unicorn, *391, 578*; winged horse, *503*; see also *baku, kirin, kudan*

Levett, Eric R., *22, 41, 67, 521*

limitations on netsuke carvers, *205*

Liu Hai: Chinese god of wealth, *5*

lizard, *483, 485*

machi yakko: hired toughs, *253*

magatama (literally, "curved jewel"): comma-shaped bead, *284*; see also *tomoe*

Maillol, Aristide, *378*

makura-e (literally, "pillow pictures"): manual of lovemaking, *135*

malachite, *149*

Malay, *29*

mallet, *70, 360*

manga: drawings, especially caricatures. The Hokusai *Manga* is especially famous as a sourcebook of ideas for *netsuke-shi. 156*

manjū: a type of netsuke named after a popular bean-paste confection in a round, flattened form, *39, 72, 77, 89, 95, 96, 139–43, 151, 156, 267, 328, 352, 436, 467, 474, 612*

Maria Kannon: the goddess of mercy represented as the Virgin Mary, *106*

Masamitsu, *35*

Masanao, *33, 35, 57, 58, 62, 66, 69, 80, 212; see also* Appendix 1

Masanobu, *123; see also* Appendix 1

Masatoshi, *185; see also* Appendix 1

Masatsugu, *40; see also* Appendix 1

mask and face netsuke, *73, 97–99, 144–47, 304, 319, 350, 466*

masu: measure for liquids and solids, *44*

material as intrinsic quality, *20, 21–22*

materials of netsuke, *148–52; see also specific materials and* Appendix 4

mei: inscription, including signature

Meiji era: *1868–1912*

Meiji Restoration: restoration of the emperor as head of state in *1868*

Meinertzhagen, Frederick, *22, 27, 33, 41, 60, 67, 181, 187, 504, 506, 510, 515*

Mellin Collection and sale, *60–61*

mempō: face protector, *440, 537*

menuki: hilt ornament for Japanese sword, usually made in pairs, *233, 242, 244*

mermaid, merman, *506, 540, 690, 746*

metal netsuke, 152–54

Migeon, Gaston, *39*

Ming: a Chinese dynasty (1368–1644)

mingei: folk art, folkcraft, 92, 154–55, 161

mingei netsuke, 154–56, 161

miniature netsuke, *see* outsizes and miniatures

Minkō, 34, 66, 80; *see also* Appendix 1

minogame: legendary bushy-tailed tortoise, *216*

miscellaneous netsuke, 156–58

Mitchell, Charles, *76*

Mitsuharu, *212*

Mitsuhiro, 34, 35, 55, 74, 75, 84; *see also* Appendix 1

Mitsusada, *46*

Mitsutoshi, *46*

Miwa, *37*; *see also* Appendix 1

miyage: gift, souvenir, *67*

Miyajima: island in the Inland Sea where the famous Itsukushima Shrine is located, 123, *187*

miyakodori: a species of gull, *463, 465, 639*

mogura: mole, *174, 471*

mokkin: xylophone, *571*

Mokubei: famous ceramist, 66, *170*

mokugyo: wooden gong used in Buddhist rituals, 159–60

mokugyo netsuke, *14, 140,* 159–60

mokume: wood grain, a technique employed in both lacquer and metal to simulate wood grain, *136*

Mokuran: the heroine who disguised herself as her father and took his place in battle. She is one of the Twenty-four Paragons of Filial Piety. *545*

mole: *see mogura*

mollusk, *19*; *see also* clam, oyster

Momotarō: the Peach Boy, hero of a popular fairy tale, so named because he was born from a peach, *428*

Momoyama period: 1568–1603

mon: family crest, *280*

Mongolian archer, 36, *37*

monkey, *24, 105, 112, 206, 298, 302, 540, 579, 583, 584, 691, 694, 695, 705, 784, 788*

monkey trainer, *457*

monogatari: romance, tale, *92*

Moore, Henry, *44*

Morikuni: artist, *503*

Moritō: villain of a medieval tale. He unintentionally beheaded Kesa, whom he desired and who changed beds with her husband in order to save his life and his honor. *31*

mosaic netsuke, *190*

Mōsō: one of the Twenty-four Paragons of Filial Piety. When his mother, in the depth of winter, asked for boiled bamboo shoots, he shed hot tears of frantic frustration as his shovel barely scratched the frozen ground. His tears melted the frost, and he was able to dig out the shoots. *509*

mosu: copied

Muromachi period: 1336–1568

Murray, Anthony, *81*

Musée d'Ennery, *41*

mushiboshi: kimono airing, *548*

musicians and musical instruments, *54, 218, 522, 526, 571*

Nabeshima: a type of porcelain, *65*

Nabeshima *seiji*: celadon produced in the Arita area, *450*

Nakamura Utaemon: famous Kabuki actor. The name is inherited like a mantle and is currently used by the sixth generation. *383*

namako: sea slug, sea cucumber, bêche-de-mer, *490*

namazu: catfish, earthquake fish, *744*

nambanjin (literally, "southern barbarian"): a Dutchman, a Portuguese, or any other Caucasian, *115*

Nambu: the native Japanese horse, *473*

namekuji: slug, *502*

name sales, 68–69

nanako: fish roe, a term used in metalwork to indicate a ground of raised dots in a regular pattern, 130, *225, 358*

Nanka, 73, *81*

Nan'yō, 73, *81*; *see also* Appendix 1

Nara-e-bon: books of romantic tales illustrated by amateur painters, *92*

Nara *ningyō*: *ittōbori* netsuke of painted wood sold as souvenirs of Nara, 115, 128, *459*

Narihira: the Japanese Don Juan and one of the Six Great Poets, *287*

narwhal: tusk of the Arctic dolphin, *100, 107*

nashiji (literally, "pear ground"): gold particles sprinkled on a lacquer ground, 136

natsume: a type of tea caddy, 62

Natsuo, 40, 131; *see also* Appendix 1

Negoro lacquer and Negoro netsuke, 64–65, 161–63, *381*

netsuke as sculpture, 44, 82, 205

netsuke-kō: guild worker in making netsuke as distinguished from the independent *netsuke-shi*, or art craftsman, 66

netsuke-shi: art craftsman in the carving of netsuke, 66

Nihombashi: the main bridge of Edo, *64*

nine-tailed fox: an allusion to the legend of Tamamo no Mae, *278, 295*

ningyō: doll; *see* doll and toy netsuke, Nara *ningyō*, Uji *ningyō*

Ninsei: famous ceramist, 66, 170

Niō: powerfully muscled guardian deities whose statues are placed in pairs at the gates of Buddhist temples, 37, 79, *85*, 103

Noh: formalized dance-drama in which the main character (*shite*) wears a mask, 128, 144

Noh mask, *319, 350*

nozarashi: bleached bones exposed to wind and weather, death away from family and friends, *527*

nude, *129, 378, 597*

nue: legendary composite beast with head of a monkey, back of a badger, scales of a dragon, and tail of a snake, *412*

nyoi: Buddhist priest's scepter, 75, *80*

ō: old man, occasionally used by a netsuke carver as an addition to his signature, *313*

obidome: sash ornament

obihasami: *sashi* netsuke with curved end for additional security, 195, 230, *575, 576*

Oceanic subjects, 2, 9, 31, *419, 669, 733*

octopus (*tako*): *135, 409, 469, 737, 786*

Oeyama: mountain near Kyoto, legendarily the dwelling place of *oni* and *tengu*, *296*

Oguri Hangan: medieval samurai among whose exploits was the taming of a wild stallion, *197*

ojime: sliding bead through which cord of netsuke and *inrō* passes, 40, 212

Okatomo, 40, 57–58, 60, 62, 66, 69, 73, 205, 212; *see also* Appendix 1

Okatomo horse, 40, 60, 73

Okatori, 55

okimono: ornament for shelf or tokonoma. As a carved object, the *okimono* is usually larger and less compact than the netsuke and, unlike the netsuke, requires no place for attachment of a cord. 38, 39, *164*

okimono-type netsuke, 83, 164–65

o-mamori: amulet or talisman to invite good fortune and protect from evil, *44, 91*

Omoto, Giichi, 81

oni: demon, devil, fiend. The *oni* form a pantheon causing winds and storms, thunder and lightning, waves and floods, or general mischief. 37, 120, *174, 320, 435, 553, 557*; *see also* demon, Fūjin, Raijin, Ryūjin

onigawara: roof tile at ridge end, used in gargoyle fashion to frighten away evil spirits, *296, 309*

Onna Daruma: Daruma in female form, a burlesque of the unlikelihood of a woman's maintaining silence for lengthy meditations, *453*

Ono no Komachi, *see* Komachi

Ono no Tōfū: statesman whom the perseverance of a frog inspired to continue his efforts, *219, 741*

Oribe: a type of pottery produced at the Mino kilns in Gifu. It is characterized by a green glaze and bold designs. 170

Ōshikyō: a *sennin* associated with the crane, *535*

Otafuku (also known as Ofuku, Okame, Uzume): She is the epitome of the likable, homely housewife and is usually represented in ribald performances at village harvest festivals. Her mask is sometimes used in the Kyōgen. 104, 120, 125, 136, 139, *183, 214, 249, 251, 300, 311, 430, 462, 468*

Otowa: kiln used by Kyoto potters, *661*

Otsu-e: folk paintings made by craftsmen in the city of Otsu, 64–65, *155*

outsizes and miniatures, 165–69

Ouwehand, C., 128

ox-headed demon of hell, *see* Gozu

oyster, 123, *187*

pedigree in netsuke, *39, 67–68*

Perfect Collection, *56, 61*

petrified egg, *148*

pilgrim, *65, 103, 524, 769*

pilgrimage, see *henro*

pipe (*kiseru*), *743, 780*

pipe case, see *kiseruzutsu*

plover, see *chidori*

poets, see Hitomaro, Narihira, Rokkasen

porcelain and pottery netsuke, *170–73*

porcupine (*harinezumi*), *497*

pottery fragment, *508*

pottery netsuke, see porcelain and pottery netsuke

prawn, *700*

pregnancy, *126, 183*

price, prices: characteristic work for top, *71–73*; cheap, *25–36*; at dealers' sales, *69*; discrepancies between sales, *69–70*; exorbitant, *25*; influence of condition on, *55*; influence of fads and trends on, *73*; influence of pedigree on, *67*; influence of signature on, *61–62*; influence of size on, *43*; in Japan, *44–46*; movement of, *29–37, 40–41, 43–44*; at name sales, *68–69*; proper level of, *43–44*; reasons for cheapness of, in Japan, *46–48*; reasons for cheapness of, in the West, *42–43*; reason for increase in, *36*; sudden surge in, *40–41, 43*; surveyed, *30–36*; thousand-dollar barrier in, *36–37, 39*

priest, *76, 77, 93, 94, 96, 101, 136, 189, 381, 577, 656, 674, 747, 767*; see also fox priest

Priest Saigyō (Saigyō Hōshi): warrior who followed his lord into retirement as a monk no longer concerned with worldly affairs or wealth, *656*

quail, abstract, compared with Okatomo model, *205–6*

quality: damage and repairs as affecting, *54, 55*; intrinsic and extrinsic, *20–21, 37, 39, 67–68*; material as factor in, *21–22*

Quintessential Collection, *76–78*

rabbit, *134, 448, 569, 589, 655, 694, 699, 725, 776*

raconteur, see *rakugoka*

Raiden: god of thunder and lightning, also known as Kaminari and Raijin, *680*

Raijin (Kaminari, Raiden): god of thunder and lightning

Raikō: medieval hero who vanquished the spider demon, *476, 564*

rakan: chief disciples and missionaries of Buddha, of whom there are sixteen according to Japanese teaching but eighteen according to Chinese teaching, *31, 37, 65, 75, 84, 86, 88, 94, 186, 193, 239, 339, 425, 735, 765*

rakugoka: storyteller, comic raconteur, *49, 179*

Raku-yaki: Raku ware, a type of pottery produced in Kyoto, *170, 449, 462*

Ransen, *55*

rare animals, *174–80*

rare carvers, *181–84*

rare subjects, *184–92*; by modern carvers, *185*

Rashōmon witch: gigantic witch who, inhabiting the south gate (Rashōmon) of ancient Kyoto, terrorized the city and was finally vanquished by Watanabe no Tsuna, *248*

rat, *442*

recondite meanings, *148, 536*

red coat (*akai haori*): sign of a male prostitute in the Yoshiwara, *215*

reishi: a type of mushroom, *332*

Reiss sale, *33*

Rensai, *214*; see also Appendix 1

repairs and restorations, see damage

Ressenden: picture book of Chinese origin portraying legendary people and animals, *174*

restorations, see damage

rich collectors, *24–25*

riders, *30, 58, 68, 221, 244, 415, 535, 552, 732, 742, 756*

ring-type netsuke, *784*

Ritsuō: lacquer artist and ceramist, *66, 136, 170*

Rokkasen: the Six Great Poets of ninth-century Japan, *40, 121, 570*; see also Komachi, Narihira

Rokō Sennin: the *sennin* whose attribute is the *minogame*, *216*

rōnin: vagrant or masterless samurai, *31, 549*

Roosevelt, Cornelius, 81

ryō: measure of gold weight equal to 18 grams or a *koban*, 72

ryokan: traditional-style inn or hotel, 69

Ryūjin: the Japanese Neptune, god of the sea, storms, and tides, *431, 752, 762*

Ryūsa, *193*

ryūsa: a type of netsuke in the shape of a *manjū* but hollowed out and with a perforated design, *32, 72, 191, 193–94, 680*

Ryūsen Zōsai, 36

sabiji: lacquer simulating metal or rust, 136

Sadamitsu: one of the retainers of Raikō who helped find and destroy the spider demon, *222*

sage, *281, 400, 523, 524, 530, 768*

sagemono (literally, "hanging object"): *inrō*, pouch, purse, or other article suspended by the netsuke, *195*

sagi: heron, *379*

Saigyō, Saigyō Hōshi, *see* Priest Saigyō

Saishi: one of the Twenty-four Paragons of Filial Piety. She breast-fed her aged mother-in-law while her child starved to death. *517*

sakazuki: sakè cup, *167, 197, 341, 782, 783*

sakè cup, see *sakazuki*

sakka: art craftsman or individual artist as contrasted with *mingei* craftsman, *155*

saku: made, carved

sales: Adam, *34*; Behrens, *30–32*; Bing, *31, 37*; Clifford, *36*; in Cologne, *39, 45*; dealers', *69*; Fletcher, *30, 35–36*; Gaskell, *34*; Gilbertson, *32–33*; Gillot, *31*; Guest, *41*; Gunther, *34–35, 41*; Hindson, *39, 40, 61*; Levett, *41*; in London, *39*; in London as central marketplace, *29*; Mellin, *60–61*; name, *68–69*; Reiss, *33*; Sharpe, *35*; Streatfeild, *35*; Streatfield, *28*; Tebbutt, *34, 41*; Tomkinson, *33–34*; Trower, *30*; *see also* price

saltmakers, *520*

sambōkan: three-treasures orange, an auspicious fruit, *561*

samurai trappings, *265, 354, 357, 362, 440, 537, 544, 659, 664*

sansankudo (literally, "three times three is nine"): the most significant part of the wedding ritual, in which sakè is drunk from three cups of graduated size, *197*

Sanshō, *30*; *see also* Appendix 1

sansukumi: combination of snail, snake, and frog symbolizing an endless system of check and countercheck. The snake can eat the frog, and the frog can eat the snail, but the snail is poisonous to the snake. The three are thus mutually deterrent. *502*

sasa: a variety of small bamboo, *26*

sashi: elongated type of netsuke thrust deep into the obi for support, *37, 63, 72, 79, 80, 195–98, 353, 691, 718, 774, 775*

sashimi: sliced raw fish, *555*

Satsuma: a type of pottery and porcelain produced in Kyushu, *65, 454*

scenic views, *187, 188*

sculptural value of netsuke, *44, 82, 205*

seal (animal), *32, 174, 482, 498*

seal of Kūya, *373*

seals, *65, 199–200*; *373*; *see also* bamboo seals, silk seals, Tibetan seal

Sear, F. J., *49*

sea slug (*namako*), *490*

sei: make, manufacture

seiji: celadon, *170, 450, 455*

Seiōbo Sennin: the only woman among the *sennin*. She is usually portrayed with the peach of longevity. *276*

Sekiguchi Yatarō: one of Hideyoshi's heroic retainers, *271*

Senkyō, *see* hole-in-the-chest men

sennin: Taoist hermits of forest and mountain who live inordinately long lives, *37, 65, 363, 497, 535, 761*; *see also* Chōkarō, Gama Sennin, Ikkaku Sennin, Jofuku Sennin, Jurōjin, Kinkō Sennin, Ōshikyō, Rokō Sennin, Seiōbō Sennin, Teirei, Tekkai Sennin

sentoku: brass alloy found in *tsuba* and other sword furnishings, *130*

servant, *755, 758*

Sessai, *37–39, 185*; wrestler-group netsuke by, *28, 31, 37–39*

Seto: a type of ceramic ware, *445*

Severin, Mark, *75, 81, 148*

sha: copied, copy

shachihoko: dragon-fish, monster-headed fish, dolphin, *393, 533, 672, 676–78*

Shaen: Taoist sage who was so poor in his youth that he had to study by the light of glowworms

shakudō: alloy of copper and gold producing hues of purplish black, *130, 225, 229, 236, 247, 357, 358, 362, 364*

shakuhachi: bamboo wind instrument roughly similar to the clarinet but popularly referred to in English as a flute, *54, 571*

shakujō: Buddhist priest's jingling staff, *88, 193*

Sharaku, *181, 374*

Sharaku print, *374*

Sharpe, Isobel, *67*; sale, *35*

shi: of good family—a rather uncommon addition to a signature, *517*

shibuichi: alloy of copper and silver frequently found in sword furnishings, *99, 130, 217–21, 223, 224, 229, 230, 234, 237, 239, 240, 246, 248, 354, 357, 361, 785, 788, 789*

shigure: autumn drizzle, *69*

shikunshi: the Four Gentlemanly Plants—plum blossom, bamboo, chrysanthemum, and orchid, *565*

Shinnō: god of medicine, *560*

Shinto: the basic religion of Japan, a form of nature, spirit, and ancestor worship

Shinto priest, *189, 577*

shippō-yaki: cloisonné enamel, *227, 347*

Shiriya: breed of horse descended from the martial Mongolian pony, *473*

shirogane-shi: silversmith, as distinguished from *kinkō*, or swordsmith, *789*

shishi: Chinese lion, usually portrayed with curly hide, exaggerated mane, and bifurcated or trifurcated tail; also known as *karajishi* (Chinese lion) and *komainu* (Korean dog). He is the guardian of temples. *30, 55, 65, 75, 86, 174, 184, 201–3, 209, 233, 260, 266, 269, 330, 335, 337, 368, 385, 450, 454, 573, 580, 591, 596, 671*

shishimai: lion dance, the New Year's dance to scare away evil spirits, devil dance, *57, 429*

shite: principal character in a Noh drama, who wears a mask, *144*

shō: mouth organ, *571*

shoga: collective term for calligraphy and painting, *47*

shōjō: mythical red-faced, long-haired creature

who drinks inordinate amounts of sakè, *238, 256, 282, 398, 405, 426*

Shōki: legendary Chinese hero of huge size and enormous strength, the nemesis of demons and *oni*, *328*

Shōko, *123*; *see also* Appendix 1

Shōmin (Unno Shōmin), *131, 230*

Showa era: 1926–

Shōzuka Baba: frightful female administrator of the Buddhist hell, *749*

shrine, *187, 562*

Shūgetsu, *212*

Shuōsai, *46*

Shūraku, *131*; *see also* Appendix 1

Shūzan (Yoshimura Shūzan), *107, 212*

signaling by conch, *738*

signature, *60–66*; concern with, *63–64*; found on about half of all netsuke, *60–61*; presence or absence of, on similar or identical models, *61–63*; reason for, *65–66*; reason for absence of, *62, 64, 65*; value of, *61, 63–64*

signboard (*kamban*): *69*

Signed Collection, *61*

silk seals, *204–5*

simplified and abstract netsuke, *205–10*

simulated materials, *210–11*

Six Great Poets, *see* Rokkasen

skeleton, *148, 526, 527, 662*

Sladen, Douglas, *26–27*

slug (*namekuji*), *502*; *see also* sea slug

snail, *467*

snake, *22, 91, 338, 421*

Soga no Gorō, *see* Asahina Saburō

Sōhen: name of a famous tea-ceremony family, *380*

Sōken Kishō: the first book in any language to deal with netsuke, *1, 11, 65, 89, 212*

Sōken Kishō types, *1, 11, 212–14*

Sōko, *45, 55, 107*; *see also* Appendix 1

Somada: technique of inlaying shell fragments of blue, green, and violet in a lacquer ground, *270*

Songokū: the monkey in the Chinese classic known in English as *Monkey*. By his feats of magic he assists the priest Sanzō in overcoming the forces of evil. *105*

Sōshi (in Chinese, Chuang-tzu): Chinese

philosopher and follower of Lao-tzu, *530*

Sōsui, *123*; *see also* Appendix 1

Sotheby: one of the great London auction galleries, *29, 41*

Specialized Collection, *52, 78–82*

spider demon, *564*; *see also* Raikō, Sadamitsu

square *himotōshi, 753*

squid (*ika*), *469*

squirrel (*risu*), *478, 717*; and grapes, *478*

stag-antler netsuke, *73, 81, 215–16*

stems and leaves, *48, 63, 234, 333, 582*

stone, *21*

study, importance and value of, *82–85*

suigyū: water buffalo, buffalo horn, *190*

Suikoden: history of the 108 bandit heroes of old China, *28*

suisai: legendary animal, a rhinoceros with a carapace back, *174, 480*

suisen: daffodil, *384*

Sukenaga, *62, 128*; *see also* Appendix 1

Sukenao, *128*; *see also* Appendix 1

Sukenori, *128*; *see also* Appendix 1

sumi: black ink (India ink) used in calligraphy and painting, *284, 302, 656, 789*

sumōtori: sumō wrestler, *165*

Sung: a Chinese dynasty (960–1279)

sutra: Buddhist scripture, *86*

tagayasan: Indonesian ironwood, *11, 217, 220*

taiko: big drum, *571*

Taisho era: 1912–26

Taiwanese, *38*

taka-makie: high-relief design in lacquer, *136*

Takarabukuro: Mitsuhiro's manuscript record of his netsuke designs, *165*

takarabune: treasure ship, usually pictured with the Seven Happy Gods as passengers, *34*

Takatsuna, *see* Kagesue

Takayama: city and surrounding area in Gifu Prefecture where *ittōbori* netsuke are made; also known as Hida Takayama, *128, 161*

taka-zōgan: raised inlay in metalwork, *237*

Takeuchi, Kyūichi: instructor at Western-style Tokyo Art School in the Meiji era; also a critic, *65*

tako: octopus, *135, 409, 469, 737, 786*

tama, see *hōju no tama*

Tamamo no Mae: fox woman often represented as a nine-tailed fox, *278, 295*

T'ang: a Chinese dynasty (618–907)

Tango no Sekku, *see* Boys' Festival

Taoist: believer in Taoism, a Chinese religion and philosophy based on the doctrines of Lao-tzu; Taoist figure, *670*

tea caddy (*natsume*): *62*

teakettle, *665*

tea picker, *108, 661*

teapot mat (*chabin-shiki*), *290*

tea whisk, *170*

Tebbutt, A. E., *67*; sale, *34, 41*

Teirei: a *sennin* associated with the crane, *535*

tekase and *ashikase*: fetters on arms and shackles on legs, *84*

Tekkai Sennin: the *sennin* who is able to breathe out his spiritual essence, *279*

Temmin, *131*; *see also* Appendix 1

temple construction, *275*

Tenaga, *see* Ashinaga and Tenaga

tengu: legendary mountain-dwelling winged creatures, *33. Tengu* are of two types: the *karasu* (crow) *tengu*, which has a bird body and a vicious curved beak, and the *konoha tengu*, a preternaturally long-nosed humanoid who wears the peculiar tiny hat of the *yamabushi*. *Karasu tengu, 297, 695, 701; konoha tengu, 242, 519, 745*; see also *tengu* mask

tengu mask, *139, 315, 455*

Tenjiku Tokubei: legendary robber who could disguise hmself as a frog, *764*

tennin: Buddhist angel, usually portrayed floating among clouds, *78*

teppatsu: priest's begging bowl, *284*

teppitsu: technique of engraving with steel pen or stylus, much favored by bamboo carvers, *586*

Three Gods of Poetry (Waka Sanjin), *229*

Three Wine Tasters: Buddha, Confucius, and Lao-tzu, who differ in their responses to sakè, just as their doctrines differ, but whose goal, like the sakè, is identical

Tibetan seal, *7*

tiger, *117, 342, 512, 731*

tō: carved

tōbori: Chinese carving or Chinese-style carving, 65, 89

tōbutsu: Chinese article or Chinese-style article, 65, 89

Toen, *459; see also* Appendix 1

toggles, *see* Chinese toggles

togidashi: lacquer design polished flat with the ground, 131, 136

Tokaido: the great highway between Edo and Kyoto, 64, *64*, 556

Tōkoku, *45; see also* Appendix 1

Tokugawa period, *see* Edo period

Tokyo Art School: the first school established in Japan (Meiji era) to teach art in accordance with Western principles, 65

Tomkinson, Michael, 67; sale, 33–34

tomobako: original box for an art object, made or signed contemporaneously by the artist, *44, 45, 190, 332*

Tomochika, 46

tomoe: claw- or comma-shaped design of which the double version forms a complete circle and represents the *yin-yang* duality, *558;* see also *magatama*

Tomohisa, 79–80

Tomokazu, 34, 62, 66, 69, 81; *see also* Appendix 1

Tomotada, 35, 40, 55, 62, 66, 69, 212; *see also* Appendix 1

Tongue-cut Sparrow, *185, 228*

toramonchiku: tiger-mark bamboo, *40*

torikabuto: helmet shaped like a bird's head, *531*

toy, *117, 118, 264, 541, 547; see also* doll and toy netsuke

Toyomasa, 62; *see also* Appendix 1

Toyotomi Hideyoshi, *see* Hideyoshi

treatment of animals, 217–22

treatment of subjects, 223–38

trick netsuke, *194, 201*

Trower, Seymour, 25, 27, 29, 67; collection and sale, 30

tsuba: sword guard serving to protect the hand from the cutting edge of the blade, 31, 81, 130, 230

tsuishu: carved red lacquer, cinnabar lacquer, 89, 94, 136, *190, 254, 258, 260, 269*

Tsuji, 212

tsuzumi: hand drum, small drum tapped with naked hand or fingers, *571*

turtle, *15, 511, 732, 766*

uchidashi: in metalwork, beating out the design from the reverse side, *220, 238*

Ueda, Reikichi, 48, 139

Uji: city near Kyoto famous for the quality of its tea

Uji *ningyō*: tea-picker doll, a souvenir of Uji, usually made of tea-bush wood, *108, 128, 161, 661*

ukibori: special technique for raised relief carving, *8, 485, 507, 514, 736*

ukiyo-e: genre pictures, woodblock prints, *54, 76*

umbrella, *131*

umimatsu (literally, "sea pine"): a black coral, *72, 190, 439, 579, 712*

umoregi: jet or peat, a semipetrified wood showing no grain, 38, *72, 482, 494*

unicorn, *391, 578*

unsigned netsuke, 60–65; collection of, 61, 62, 63–64; by Kokusai, 215; reason for, 62–63

unspecified animals, *377, 477, 494, 702*

unusual shapes, 228–29

unusual types, 230–32

Urashima Tarō: the Japanese Rip van Winkle, *245*

urushi: lacquer or lacquerware, usually distinguished from gold and silver lacquer, *121*

ushidōji: herdboy, *221*

Utamaro, *217*

Uyeno, Naoteru, 29

vajra, see kongō

van Daalen, J., 81, 148

vegetables, *see* edibles

Victoria and Albert Museum, 26

Waka Sanjin: the Three Gods of Poetry, *229*

waniguchi: crocodile-mouthed gong, *284*

war fan, *440*

wasabi: Japanese horseradish, *555*

watch, *785*

water bug (*amembo*), *243*

Weber, Franz, *50*

Weber, V. F., 41, 67
Weil, George, 75
whale, 501
Wight, Harry, 28
wild boar, see boar
Winkworth, W. W., 22, 27–28, 33, 41, 42, 67, 71
wolf, 247, 271, 423, 704
Wrangham, E. A., 75
wrestler, 371, 543
wrestler-group netsuke by Sessai, 28, 31, 37–39
wrestlers' netsuke, 37, 165, 420

xylophone (*mokkin*), 571

yaki-in: brand (seal) in porcelain, 459
yakko: samurai servant, footman, 253
yamabudō: wild grapes, 534
yamabushi: mountain priests who sometimes engaged in politics and fought as warriors
yamabushi tengu, 33
yama-makie: lacquer technique of black on black, 136
Yanagi, Sōetsu: founder of the Japan Folkcrafts Museum (Nippon Mingei-kan), 154, 155

Yasumasa: flutist who played so sweetly that his brother was deterred from killing him, 218; see also Kidōmaru
yatate: writing set consisting of a brush and ink, 361, 788, 789
yōkaku: goat horn, 190
Yokoyama, Kohachiro, 44
Yorimasa: medieval hero who, along with I no Hayata, killed the *nue*, 412
Yoshitomo, 35; see also Appendix 1
Yoshitsune (Minamoto Yoshitsune): great medieval hero who led a martial and adventurous life on behalf of the Genji (Minamoto) clan
Yoshiwara: section of Edo (and of early-modern Tokyo) reserved for prostitution and related amusements, 215
Yuai: T'ang official whose filial devotion was rewarded by heaven, 551

Zen: form of Buddhism traditionally said to have been brought to Japan from China by Bodhidharma (Daruma), 757
zeni: Edo-period coin, 61, 72
zōge: ivory, 190
zōgehi: ivory bark, 190
Zōsai, see Ryūsen Zōsai

The "weathermark" identifies this book as a production of John Weatherhill, Inc., publishers of fine books on Asia and the Pacific. Supervising editors: Meredith Weatherby and Ralph Friedrich. Book design: Meredith Weatherby. Layout of illustrations: Dana Levy and Nobu Miyazaki. Production supervisor: Mitsuo Okado. Composition and printing of the text: General Printing Company, Yokohama. Engraving and printing of color plates: Dai Nippon Printing Company, Tokyo. Binding: Okamoto Binderies, Tokyo. The typeface used is Monotype Perpetua, with hand-set Perpetua Light Titling for display.